ZONES **of** *EXPERIENCE:* **the** *ART* **of** LARRY BELL

ZONES of EXPERIENCE:

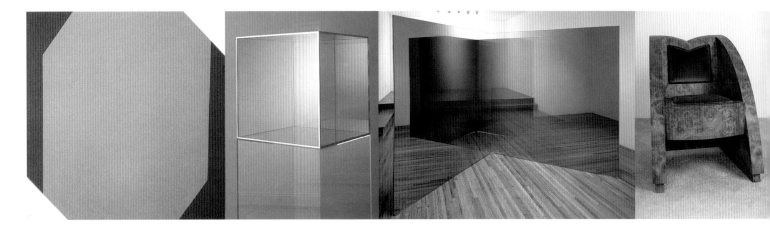

the *ART* of LARRY BELL

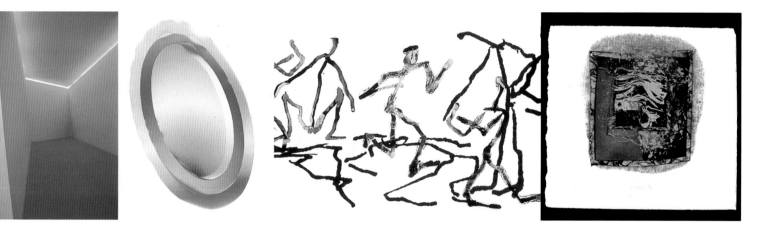

FEBRUARY 16 – MAY 18, 1997
THE ALBUQUERQUE MUSEUM

This exhibition has
been made possible
in part due to the
generous support of
Mr. Peter B. Lewis,
of Cleveland, Ohio.

All the works in this
exhibition are loaned
courtesy of the artist
unless otherwise noted.

This catalogue has been
published in conjunction
with the exhibition,
*Zones of Experience:
the Art of Larry Bell,*
which was organized by
The Albuquerque Museum.

©1997
THE ALBUQUERQUE MUSEUM
2000 Mountain Road, NW
Albuquerque, New Mexico
87104

Library of Congress
Catalogue Number:
94-12045

Contents

7 **I**ntroduction
Dr. James Moore, Director
Ellen Landis, Curator of Art

9 **C**houinardtime
Dean Cushman

19 **S**trange Days: Conversations with the Doctor
Douglas Kent Hall

29 **L**arry Bell: Understanding the Percept
Peter Frank

45 **S**haping Light: Light & Illusion in the Work of Larry Bell
Douglas Kent Hall

53 **I**n Reflection
Larry Bell

65 Z O N E S **o f** E X P E R I E N C E : **t h e** A R T **o f** L A R R Y B E L L

141 **P**late List | **E**xhibition List

145 **L**arry Bell: Biography & Bibliography

159 **L**arry Bell: Collections

160 **L**enders to the Exhibition

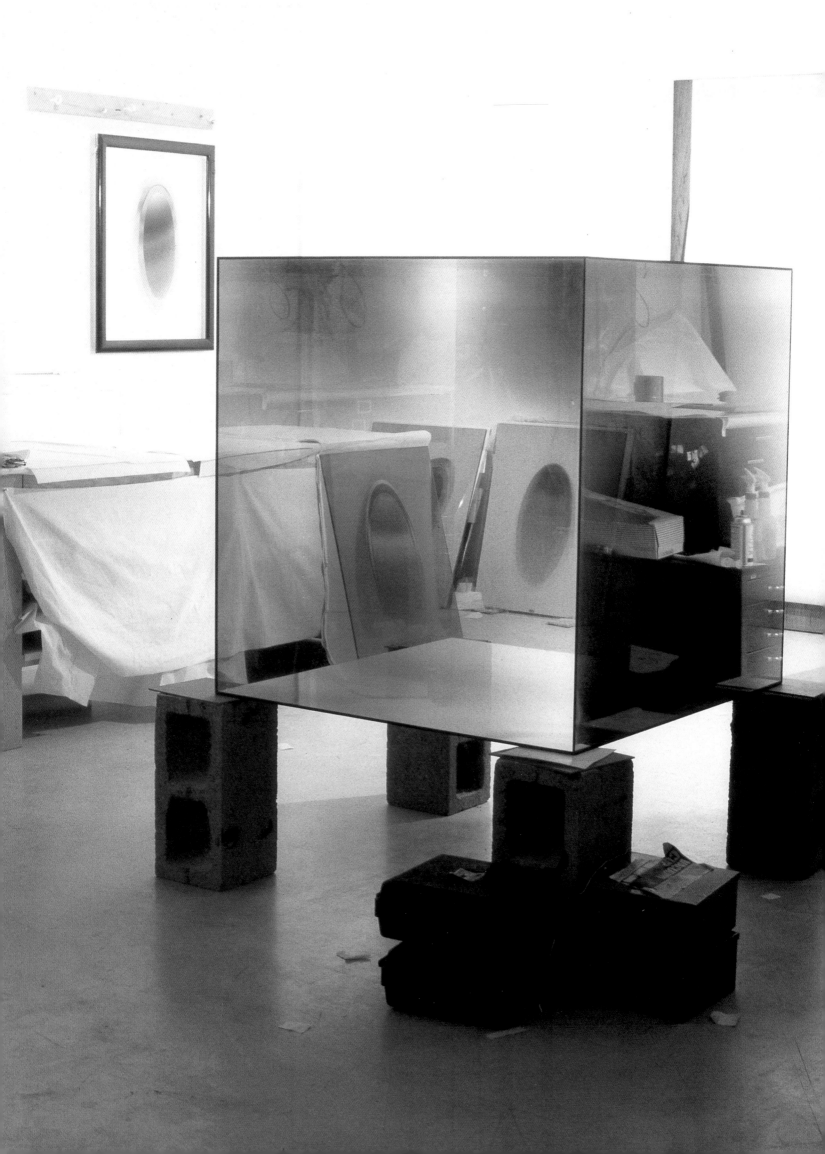

By the early 1970s most students of the history of art knew something of the work of Larry Bell...he was the one who made the "glass boxes." As discussion of his sculpture became more frequent in the critical discourse of minimalism, he became included in many books that surveyed contemporary art. Jack Burnham, in his groundbreaking *Beyond Modern Sculpture,* mentioned Bell's "glass box constructions which nearly dis-

ple in form, the process of making them and their effect on the viewer was much more complex. The elegant and sophisticated look of the finished product disguised its inception in a kind of controlled chaos in the studio.

When conceived, this exhibition began as a list of the various "products" that represented Bell's career to date. But as plans for the installation progressed, it became apparent that

Introduction

James Moore / Director — **Ellen Landis** / Curator of Art

solve into invisibility in the feat of optical titillation."[1] Sam Hunter, in *American Art of the 20th Century,* sought to work several variations on this sort of description, from "subtly inflected color continuums from sheets of faintly colored optical glass,"[2] to "intimate, alternately opaque and transparent glass boxes,"[3] and "virtually invisible panels of optically coated glass."[4] Inevitably, the inclusion of these sculptures in the canon of the history of art led to a certain stereotyping on the basis of style. By the time Peter Plagens wrote *Sunshine Muse,* the first survey to concentrate on contemporary art of the West Coast, Larry Bell was a central figure in what came to be called the "L.A. Look."[5] Plagens grouped Bell with Robert Irwin, Craig Kaufmann, Ed Ruscha, Billy Al Bengston, Ken Price, John McCracken, Peter Alexander, DeWain Valentine and Joe Goode around the notion that they all made "cool, semitechnological, industrially pretty art." As he elaborated,

The patented "look" was elegance and simplicity, and the mythical material was plastic, including polyester resin, which has several attractions: permanence (indoors), an aura of difficulty and technical expertise, and a preciousness (when polished) rivaling bronze or marble. It has, in short, the aroma of Los Angeles in the sixties—newness, postcard sunset color, and intimations of aerospace profundity.[6]

Although Bell's work has evolved in a number of directions over several decades, he is still known to many as the artist who made those glass boxes. While the early boxes were sim-

a sense of the process was a highly important, perhaps necessary, aspect of understanding this art. This was a way of linking Bell's ideas over time and moving away from the early critical stereotyping of his work. Moving about the studio, manipulating materials directly, Bell seemed to work more in the manner of an abstract expressionist, always investigating, experimenting, improvising. It is this spirit of improvisation, a particular intuitive quality of mind, that this exhibition and catalogue wish to convey.

The Museum wishes to thank Larry Bell for his generosity of spirit as well as his willingness to share his work, his ideas, his process and his time. He has allowed the museum staff the freedom to learn the complexities and appreciate the creativity that results in an art conceived by his unique sensibility. Appreciation is also extended to Janet Webb for her patience and understanding in designing this catalogue, allowing for the substantial modifications that occurred with the change in focus of the exhibition.

The Museum is grateful to those individuals and institutions who have so graciously lent the works which comprise the exhibition. Their fondness for the artist and esteem for his aesthetic has been most encouraging. They have been generous participants and their eager cooperation has made the preparation of this exhibition a pleasure.

Special acknowledgments go to Suzi Furlan and Philippa Falkner for their constant dedication to this project; their support made the many and varied parts of this complicated project come together cohesively. ∎

1. Jack Burnham, *Beyond Modern Sculpture: The Effects of Science and Technology on the Sculpture of this Century* (New York: George Braziller, 1968), 162. | **2.** Sam Hunter and John Jacobus, *American Art of the 20th Century* (Englewood Cliffs, N.J.: Prentice-Hall, Inc. and New York: Harry N. Abrams, Inc., 1973), 384. | **3.** Ibid., 430. | **4.** Ibid., 492. | **5.** Peter Plagens, *Sunshine Muse: Contemporary Art on the West Coast* (New York: Praeger Publishers, Inc., 1974), Chapter 8 and passim. | **6.** Ibid., 120.

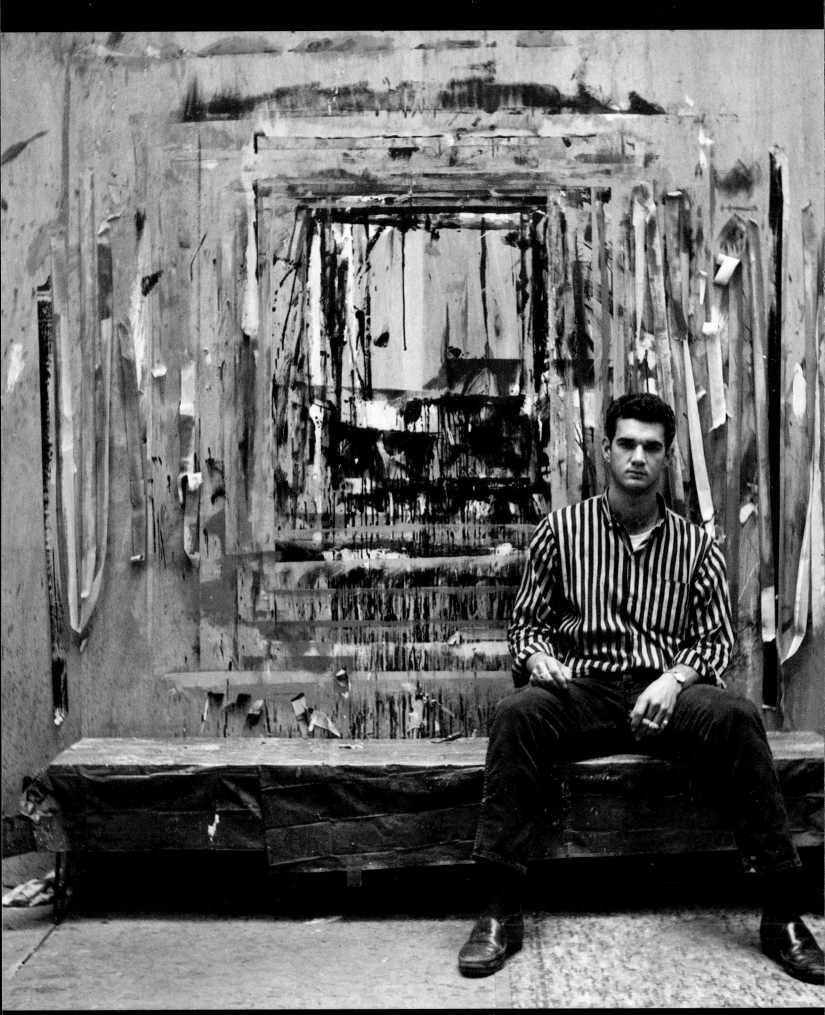

LARRY BELL IN MARINE STREET STUDIO, VENICE, CALIFORNIA, CIRCA 1959. PHOTOGRAPHER UNKNOWN.

When I was asked by The Albuquerque Museum to write about the time Larry and I were at Chouinard Art Institute I was delighted. But when I sat down to actually write the piece I realized that, yeah, yeah, while it had been easy to agree to do, it was going to be hard to deliver—I mean, we were talking about events 35 years long past.

Chouinardtime

Dean Cushman

Yes, Larry and I had shared rooms in an apartment house called the Shalimar, shared classes at Chouinard, shared an admiration for several of our instructors, but our personal lives, friends, and interests were fairly autonomous. Had we hung around together more, I might have realized my education and potential as a painter and not the feather merchant I became. Well, might-have-beens are part of memory, right?

There are matters about which I could easily write. I could write about Chouinard's importance and contribution to American and California art. I could write about Ferus Gallery's influential stable of artists, their effect on art in Los Angeles, and on those of us who dreamt of being artists. I could write about the artistic and social trends of that time and place that might provide useful insights for a portrait of the artist.

I even could make things up.

Every memory is tinged with fiction, isn't it? Who would know, except Larry and me. Happily he had the same idea and was amused by the idea. However I promise that what I have dredged up attempts the truth, given the distortions and lacunae of time that have, undoubtedly, simplified the actors and the facts.

One other caveat. I admit a bias toward the man and his work.

10 What I'll call Chouinardtime brackets the years 1958 to 1960. Three spaces also dominate and encapsulate that era: spaces as much emotional and philosophical as physical.

Space One: *The Shalimar where Larry and I lived.* The Shalimar was an exotic and exuberantly pink palazzo on Hoover street, hovering close to downtown Los Angeles. Silent about its dubious rumor to have once belonged to Charlie Chaplain, it had become a rooming house that rented to an unlikely crew of co-habitants that included a taxi driver who kept huge scrapbooks on the Holocaust, two continually quarreling ILGWU ladies, a feisty widow with a shrine to Eisenhower, several other art students, and Larry and me who had the only full apartment and he a studio in the basement.

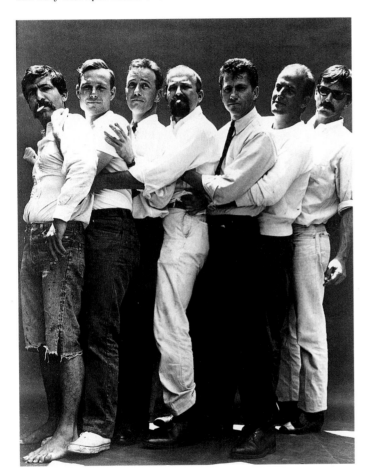

FERUS GALLERY ARTISTS, 1959. JOHN ALTOON, CRAIG KAUFFMAN, ALLEN LYNCH, ED KIENHOLTZ, ED MOSES, ROBERT IRWIN, BILLY AL BENGSTON. PHOTOGRAPH BY PATRICIA FAURE.

Space two: *Chouinard Art Institute where we went to school.* Chouinard was a quick four-plus blocks from the Shalimar. The school was founded in 1921, and during the ensuing years had developed a reputation for the quality and innovation of its educational methods, its outstanding and diverse faculty, and the breadth and expertise of its alumni. But by Chouinardtime the school peered over a precarious economic precipice and faced a serious identity crisis. In an attempt to ameliorate the situation and its tensions, founder Nelly Chouinard, then in her late 70s, called an old friend,

Walt Disney (with a long connection to the school that is a story in itself). Disney brought a variety of accountants, directors, educators and psychologists to begin a restructuring and eventual dissolution of the school. It would prove to be a painful journey that deeply affected those of us who were students at the time.

Space Three: *Ferus Gallery, where we first saw the Real Thing*—examples of the art that would change our lives. From Chouinard, you drove west out Wilshire or Melrose to La Cienega, turned right, and half-way to Barney's Beanery you came to 736A, a demure white building, that for a short nine years was the showplace for a stable of extraordinary Los Angeles artists who became Larry's friends, role models, mentors, and eventual colleagues.

That then, the milieu of Chouinardtime.

I don't remember how I first met Larry. Probably it was through Aaron Cohen, an advertising major who preceded me as Larry's Shalimar room-mate. Everyone at Chouinard knew Aaron and he knew everyone. He was everyone's big brother, and I believe—I know—that Aaron's commitment to Chouinard, to art, and to developing his skills was a positive example for both Larry and me.

That first year Larry was only one of the many new and interesting people I was meeting. It was not, however, a good year for him. He had yet to find his *raison d'etre* for being at Chouinard. He had to wait for a specific incident to trigger that awareness and bring it to the forefront. It is a story he has told before, but it's relevant to Chouinardtime, so let's retell it.

Larry was thrilled by the racial and social mix of the student body, as was I. It was truly exciting to be around so many different life styles, opinions, and talents. One particular friend Larry had made was a Korean War veteran. Finding they shared many of the same feelings about the school and classes, they'd get together for a daily chat, usually in the school patio between classes. On this particular occasion they walked the block from school to MacArthur Park, settled down under a tree away from the dogs and the drunks, to eat lunch and talk. The veteran was worried. Worse, he was scared. Classes weren't going well, and to prove his case he pulled out a batch of drawings from his knapsack for Larry to judge. They looked okay to Larry. In fact, they looked terrific, but to the vet they just didn't meet his expectations. At first Larry couldn't recognize it was the same problem dogging him. The cartoon drawings that his relatives and high school buddies thought great were a long way from what he was seeing done around him at Chouinard. He just didn't seem to be getting it. His friend's concerns cut too close to home, and he made a flip remark that upset the vet who, in no uncertain terms, laid down the stakes facing him: he was almost thirty years old, he had gambled his time and GI Bill on Chouinard, it might be the

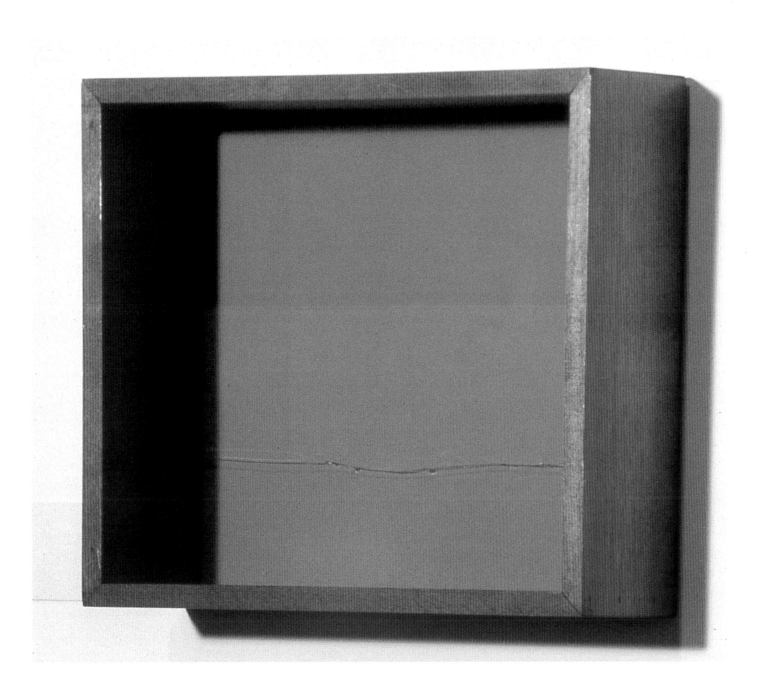

PLATE 2, UNTITLED, 1959. GLASS, WOOD, PAPER, 12" x 14" x 3". COURTESY OF MICHAEL ASHER COLLECTION.

12 last chance he has to make something of his life. The message hit home. From that moment on Larry began to think seriously about his own future, about who he was and what he wanted—aspects of his life he'd never considered with much depth until then.

He has said that he felt as if he were in a Looney-Toons cartoon—you know, where the coyote chases the roadrunner, firm in the belief he can catch him but usually finding himself running off a cliff with only the power of his imagination keeping him up. When he looks down reality hits, and he rockets earthward. Kersplat! So Larry decided to take a break from school, try to understand what his act was, and hopefully get it together. Treading air was too scary.

Scoring a small glass panel and setting it in a box backed with colored paper, he was thoroughly engaged with the way the crack, the reflection of the crack, and the shadow of the crack looked against the paper ground.

While he was at the framer's he made half-a-dozen or so of these constructions. I remember those pieces well. Hermetic, delicate, prescient, not only did the boxes pre-date by nearly five years the mirror and glass work Larry would do, but they used the materials and announced the themes of light and surface which he would devote his career to exploring.

Although no longer a full-time student, Larry did sign up for Bob Irwin's evening watercolor class where I was also enrolled. I was happy to see Larry again. He was a very likable

LARRY BELL, IRVING BLUM, KEN PRICE, BILLY AL BENGSTON, JOHN ALTOON, 1962, BEHIND FERUS GALLERY. PHOTOGRAPH BY PAT BEER.

Who knows why things work as they do, but fortuitously, he found work at a framing shop in the San Fernando Valley, close to his childhood home. During downtime he messed around with scraps of glass and other materials including some pre-made shadow boxes that were lying about the shop. He noticed how glass both reflected and transmitted light.

guy: curious, with a wild sense of humor and played a loud 12-string guitar—a memory coming up.

The first night of that class happened to be very significant for Larry. Of all our Chouinardtime it is one that I particularly remember. I have told it dozens of times to people who know Larry's work because I believe it is the night that Larry de-

cided to become Larry, to become an artist. And it brought him back to school full time.

Before I relate the scene, let me give a moment to Bob Irwin. When Irwin began teaching at Chouinard he wasn't much older than we students. The difference, and one that really mattered, was Irwin was a practicing artist. He'd recently had a show which had garnered good reviews but disappointed him. The work seemed a dead end, and caused him to rethink what art was and what it could and could not do. There were many times in class that he appeared to be working out problems of gesture, consistency, authenticity, process, preparation, responsibility, work habits, spontaneity—all manner of things that he and we aspiring artists were to meet everyday alone in the studio.

Irwin told Lawrence Wechsler, "My ideal of teaching has been to argue with people on behalf of the idea they are responsible for their own activities; that they are really...the question; that ultimately they are what...they have to contribute. The most critical part of that is for them to begin developing the ability to assign their own tasks and make their own criticism in direct relation to their own needs and not in light of some abstract criteria. Because once you learn how to make your own assignments instead of relying on someone else, then you have learned the only thing you really need to get of school, that is, you've learned how to learn. You've become your own teacher. After that you can stay on...but you'll already be on your own." [1]

Irwin worked with each of us at that fundamental moment in our development he speaks of, helping us to understand and recognize the terrain and encouraging us to find ways to move on. As a result he made us feel like partners in the quest that we were just beginning, but which few instructors other than he, Richards Ruben, Emerson Woelffer, or Robert Chuey were willing to share.

It probably would be rash to say that without Irwin, Larry might not have found his way as an artist, but I personally cannot imagine Larry's commitment to himself and to art otherwise.

And so it was that that evening in Irwin's class Larry set up to my right and behind me. He had his paper clipped on a board, the board on an easel, paints, brushes, sponges at the ready. As usual, Irwin had prepared a still life. The objects were never the issue, only what we did with them. At some point, either out of insight or frustration (it really doesn't matter) and, having nothing to lose, Larry gambled. He took a sponge well loaded with red paint and imprinted it on the paper, rinsed out the color, dipped the sponge in yellow and stamped that, then went after a huge blue blot.

It was a completely spontaneous and intuitive reaction to the still life: responses toward which Irwin had been pushing

us. In that moment Larry was still the roadrunner alone in mid-air, but unlike the roadrunner this time his imagination kept him aloft. To this day Larry relies on a spontaneous and intuitive means of working as the only way to stay afloat.

It's now 1959. Aaron had graduated and I had taken over the Shalimar apartment. Larry asked if he could have his space back, and I agreed. From then until Larry left school completely he became an active, participating Chouinardian. It was a tough, talented, competitive group.

I guess every Chouinard alumnus believes his or her years at the school were special, their classmates outstanding. Let me assure you that the period that Larry and I were there produced an unusually large number of heavy-weight con-

JUDY HENSKE AND BELL, 1959, IN VENICE, CALIFORNIA.
PHOTOGRAPH BY FRED GERLACH.

tenders in all aspects of art. To omit them in favor of Larry would distort the record, deny the mutuality of that space and moment I call Chouinardtime, and ignore important influences (in both directions). I'm thinking of Ed Ruscha, Joe Goode, Ed Bereal, Ron Miyashiro, Llyn Foulkes, Charlie Frazier, Jerry McMillian, Don Bachardy, Stephen Von Heune, to name only a few. Along with Larry they would be the source of Southern California art for the next two decades.

We were all miners after the precious ore of our imaginations. The search often made for stiff competition. Competition that included our choice of teachers, courses, work habits, buddies, even bedmates, but primarily was based on seriousness of intent and skill. Skill, of course, could be developed; intention was a barometer of our seriousness. There was no excuse for ignoring or discounting either and to so do was worse than not applying them at all. We were expected to make full use of our intelligence, energy, and devotion. Talent was beside the point. Yet, such self-consciousness did not result in egotism. We were genuinely interested in what others were doing—if it was interesting—and there was an

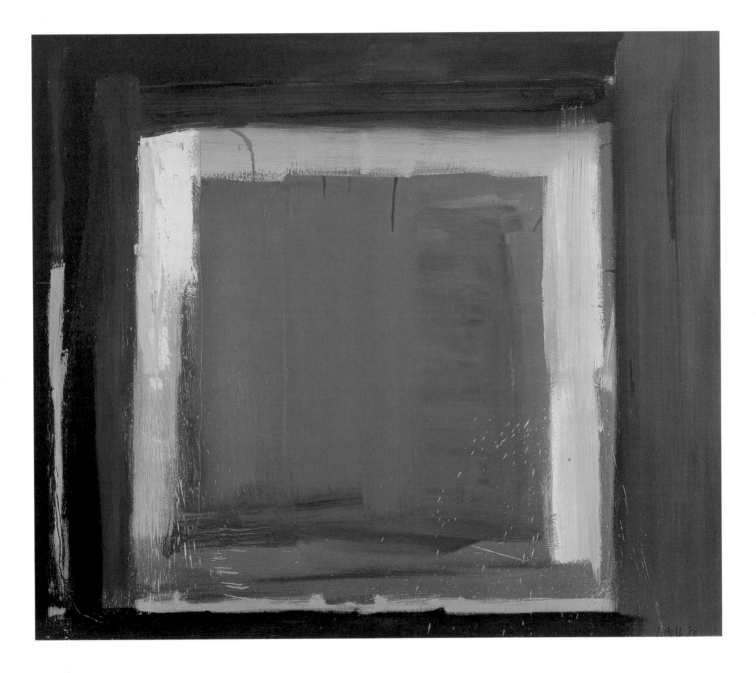

PLATE 4, L. BELL'S HOUSE, 1959, OIL ON CANVAS, COLLECTION OF VIVIAN ROWAN.

extraordinary amount of generosity available. Students and instructors alike willingly shared their time, their knowledge, and their proficiency.

Saturday nights in those days, a local radio station played folk music from 7 to midnight. I was a dedicated listener, so I was happy that Larry played a 12-string guitar.

Think of it, 12 strings! I was amazed. It gave a great booming sound and I thought that neat. He also brought into our digs at the Shalimar the sounds of Leadbelly, Sonny Terry, Pete Seeger, the Weavers, and Woody Guthrie. One song of Guthrie's, about the death of Mexican illegals, wiped me out and still does. I remember asking Larry to play it whenever he took out the guitar.

KEN PRICE AND BELL, CIRCA 1962. PHOTO BOOTH PICTURE.

He also brought, in person, Judy Henske. You've heard of the men—Judy was something else entirely. She too had a great booming sound like Larry's guitar that I thought deserved as much renown as the guys. She sang at the Unicorn, a very typical folk club of the time in Los Angeles, where Larry later worked as a bouncer and occasionally played. Judy made several albums in the early sixties which I still own and when I want an instant return to Chouinardtime I play.

Larry's 12-string guitar and the music that went with it was as much a part of Chouinardtime for me as Larry's wicked chuckle, his Sonny Bono thrift shop clothes, and his continually surprising work that was entirely different from anyone else at school.

That year Larry was seldom at the Shalimar. Either he was in his basement studio, out with his girlfriend Ida Rose, at the Unicorn, or at Barney's Beanery with Irwin and LA/Ferus Gallery artists Ken Price or Billy Al Bengston.

For a while Larry idolized Billy Al, and Bengston let him. I did not think Bengston was neat at all. I found him arrogant, controlling, and bitchy as a Sunset Boulevard queen. He

frightened me, but I liked his work. I didn't understand why Larry thought he was so great, and I still don't. Yet, there's no doubt that Bengston was as important as Irwin in Larry's development as an artist, and I could argue that Bengston's constant needling was the perfect counter to Irwin's sweeter, more intellectual manner.

At school, besides Irwin, other instructors who in one way or another fed Larry were Emerson Woelffer, Richards Ruben and especially Bob Chuey. Larry tells me he was drawn to Chuey's stories about Matisse and Brancusi and trusted his advice and criticism. I think I never took a class with Chuey and probably for that reason don't remember him other than as being heavy-set and a pipesmoker.

It was through these instructors that we came to learn and began to understand not only the late greats like Matisse and Brancusi, but contemporaries like DeKooning, Pollack, Motherwell, Guston, and the "glorious" New York School. Most of us had decided to carry on the Abstract Expressionism/action painting aesthetic. Not Larry, although his geometric imagery was very "painterly" and remained that way until Liquid-Tex helped him to apply the even-coated surface he so admired in Elsworth Kelly. Nor do I remember him ever showing much interest in Surrealism or Pop, influences that were quickly making inroads among some of us, like Llyn Foulkes and Ed Ruscha.

I do know that once Larry had found planar and orthographic forms he quickly separated himself from the group. Not everyone understood this fascination: particularly Herb Jepson, who had become the *eminence grise* of the school.

Founder of the Jepson Art Institute and later director of the Otis Art Institute, Jepson was a highly respected teacher and art authority in Los Angeles. He had theories galore about creativity that he had abstracted from John Dewey and semanticist Alfred Korzybsk, and during his classes he expounded magnificently on them. To me, they sounded very metaphysical: something to do with the need to let one's energy flow and develop an alertness to and an awareness of that energy as a generative process. He thought Larry's obsession with squares was wacko—literally—and sent him to see the school psychologist brought in by the Disney team. It proved an educational lapse on his part, for whatever his opinion, his theories were probably totally incompatible with the direction Larry was moving.

It was a stupid situation that never should have happened, and it greatly upset Larry who, because of it decided he was through with Chouinard. Bengston and Irwin had been on his butt for months anyway, telling him to leave, based on the premise you didn't really start making art until you were away from the security of school, in your studio, alone, and faced with the challenges of a blank canvas. That and that alone was

16 proof of the health of your mental state and your commitment to art.

From that moment on, Larry left Chouinard, if not in body certainly in mind. I was seeing less and less of him at school and at the apartment. His Chouinardtime spaces were changing to the Unicorn, the Beanery, Ferus, and the Venice Beach studios of Irwin, Bengston, Price, and Ed Moses. It was about this same time that he did a painting that would prove to be a significant leap of faith.

After working through the night in his basement studio at the Shalimar he finished a piece that brought with it an incredible charge. The canvas seemed to sum up all those hundreds of investigative drawings he'd been doing and which Jepson

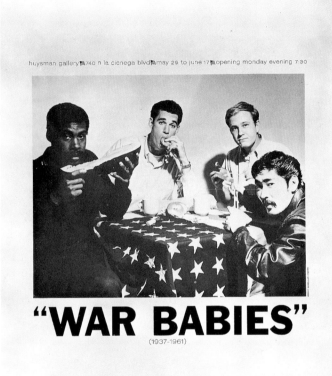

The clock had run out on Chouinardtime. Larry had done the painting on his own, in his own studio, in his own manner. He had created his house. It was time to live in it.

Larry leapt off and away, but not alone. With Irwin, Bengston, and shortly Kenny Price, tracking and backing him, he took his tuition money and found a studio. There he prepared to work out painting problems by himself, learning on his own what it meant to meet the responsibility of being an artist.

(LEFT) WAR BABIES POSTER FOR EXHIBITION AT HUYSMAN GALLERY, 1961. ED BEREAL, BELL, JOE GOODE AND RON MIYASHIRO. PHOTOGRAPH BY JERRY MCMILLAN.
(RIGHT) INSTALLATION OF BELL'S SECOND EXHIBITION AT FERUS GALLERY, 1963. PHOTOGRAPH BY FRANK THOMAS.

had so misunderstood. The result was an honest, spontaneous and intuitive response to the canvas. Moreover, it came with the stamp of his soul. It was a big event and he wanted to share it. He dragged the nascent thing, still wet and only barely begun to breathe, up the stairs, took down a recent piece of mine, upped his usurper in its place, and went to bed.

A couple of hours later I woke, and saw the work. It spoke to me exactly as it had to Larry. He remembers that I shook him awake, saying, "That's the goddamned best painting I've ever seen. That's fantastic!" I probably did. The painting was titled *L. Bell's House*, and I remember thinking: Exactly right.

I stayed in Chouinardtime another year then went to work as Merchandizing Manager for a local import chain. Later I taught in the Theater Arts department at a junior college in the Valley for a couple of years, and in 1964 moved east to work as a commercial writer in television.

Three years after leaving Chouinard, Larry hung his first show at Ferus. He was on his way to establishing his place in the history of American art.

That's it. The memory irises out to black. I read over what I've just written and feel it is incomplete. I think it's because a friend is more than a few anecdotes. A friend enriches and

changes one's life and I have barely touched on how Larry did that. I have left out the quiet times and the pleasure of his company. I have left out how much I respect his persistence to walk on air, and that he has done it so successfully. I have left out the laughs. I have left out the moments I can't tell because they're raunchy and personal and because, finally, they're no one's business.

I did not see Larry again until a July evening in 1990 when I visited Taos and heard him say, "You haven't changed a bit," and thinking neither had he. Of course that's nonsense. So very much had changed for both of us, but it was a fine way of beginning again.

And now, five years later, after many hours together and all the work he's completed, can I put Chouinardtime and the present together? Much I know now explains a lot back then. For example, his undiagnosed congenital hearing loss. It undoubtedly affected his understanding in classes and probably contributed to the insecurity about his work—work which has maintained a visual logic and an intellectual investigation begun during Chouinardtime. I am impressed how eloquently he discusses that work: an ability that, back then, he would have doubted he would ever have. I am happy to have the ragged ends of time stitched together. ∎

1. Lawrence Weschler, *Seeing is Forgetting the Name of the Thing One Sees, A Life of Contemporary Artist Robert Irwin*, (California: University of California Press, 1982), p. 120

I am tempted to say that in his studio at Venice Beach—the Venice in California—at the edge of the ocean, with the enormous weight of American art extending as far to the east as New York, Larry Bell rose to the moment and embarked on a brilliant career that has spanned more than three decades and given him an audience in all the major art centers of the world. Those are the facts, of course, but not the story I wish to tell.

Strange Days
Conversations with the Doctor

Douglas Kent Hall

I admire Larry Bell as much for his humanity as for his art. I know him for his generosity, his obsessions, his friendship, and the warmth of his laughter. Having said that, there is always an underlying fear that some glitch in memory will bring the whole thing asunder. However, with Bell I shall take my chances.

The cool brilliance of Larry Bell's art left a powerful impression long before I could count him a friend. From the moment I saw his work, I was struck by a haunting and illusive quality that I have never been able quite to reconcile—an impact resulting from the ambiguous dichotomy created by icy industrial materials and the rich warmth that each piece radiates: one sees it trapped in a precise glass cube, or in a disc of pure light dancing on a square of black canvas.

In the mid-sixties, I wrote a review of a show in a Portland or Seattle museum that included a few of Larry Bell's works. I may even have met him at that time. Or I may have met Dr. Lux. In fact, I may have encountered both Bell and Lux. Those were, indeed, strange days. . . .

20 Larry Bell and I began our talks in his Taos studio, a large building that functions like a combination warehouse and space station. While huge industrial pumps throb to remove air from his tank, creating a vacuum which will allow him to activate a bank of specially fitted electrodes and diffuse quartz and platinum onto the paper and other items inside, we pass through a small courtyard bathed in sunlight to his office. A glass cabinet along the west wall holds his collection of rare and strange guitars, an original Leadbelly model from Sears, for example, as well as rare Gibsons and Martins, and those crafted by various obscure makers; at least fifty other instruments, still in their cases, stand on the floor. Shelves on the opposite wall are filled with volumes of art and poetry.

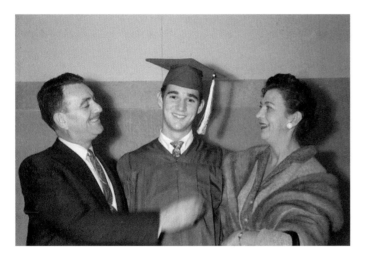

HIGH SCHOOL GRADUATION, 1957. PHOTOGRAPH BY ROBERT BELL.

Bell makes his way to a desk squeezed into a corner near the south window. He pushes back his black Borsalino hat with its rattlesnake band and props his elkskin boots on a corner of the cluttered desk. With broad shoulders, emphasized by a horse-blanket plaid jacket, a full head of black hair, dark, penetrating eyes, and a short salt-and-pepper beard, he is a commanding presence. His habit of leaning toward you when he speaks, perhaps because of his hearing problem, and his frank smile add to the effect. Watching him select a fresh Honduran cigar from a box, I realize that his hands are surprisingly delicate and expressive, the hands of a musician. He removes the paper ring and cellophane then prepares the cigar with his small Swiss Army knife, paring off the end and flicking it neatly into the wastebasket. He takes out a wooden match, but before he strikes it he begins to talk.

Bell, a natural storyteller, speaks with passion and humor. Though Chicago was his birthplace, he grew up in the San Fernando Valley, "on comic books, television, and movies," and his sensibility is decidedly Californian. The Valley was never an artist's arena, except for fanatics of the roadster and dragster, beautifully utilitarian transformations that I suggest may have affected the process he followed through the shaped

canvas to the glass cube. Bell shrugs and claims not to have been into cars, then adds: "I liked cartoons."

From a flat file, he lifts out a stack of pen and ink drawings he made during high school, inspired by an English cartoonist named Roland Emma. "Emma had toured America and drawn his impressions. *Life* magazine came out with a huge color spread of them. It was so fantastic. I didn't know anything about painting—Picasso or anything. But I thought this guy was the best artist. He drew these funny sort of spindly figures, not abstract, but sort of abbreviated. I don't think I thought what he did was art; I thought it was cartoons. I made a distinction between the two things. After that, I started drawing cartoons. You might say that that's the first artistic thing I was interested in doing."

Bell recounts his high school days with little enthusiasm. He recalls no challenging teachers, which may account for his failure to distinguish himself academically. "Actually, I was sort of a flake," he smiles, with characteristic candor. "But I was interested in drama. I took a lot of drama and acting classes. I thought maybe I would get involved in theater. That never happened. When I finally graduated I wasn't prepared for anything. I had no plans to go to school and no plans to go to work. At one point, my folks said to me: 'You can get a job, you can go to school, you can join the Army, but you can't sit around here and watch TV anymore.' It was as simple as that."

A university was out of the question. Bell had neither the classes nor the grades to satisfy admissions. Junior college would have thrown him back with the deadbeats he'd known in high school. "The only alternative," he declares, "was some kind of professional school where you buy your admission and they train you to do something. The thing that occurred to me first was art school—because of the cartoons. Actually, I had won a PTA scholarship to an art school the previous summer. I decided I'd go to the same school and learn to be an artist. I had no idea what the hell I was talking about."

The school was Chouinard—more recently incorporated into Cal Arts—which specialized in fine arts, advertising, commercial art, and cartooning. "The two academic courses that I started out with, literature and semantics, were the most interesting classes I'd had all my life. I was fascinated. The instructors were fantastic. And I actually did pretty well. But I wasn't doing too good at painting and drawing, and at my level I couldn't get in the cartooning department. Chouinard was the training ground for people who went to work for Walt Disney. All his animators and designers came out of this school. I would have to hang on for three or four years before I could have a shot at working with those kind of teachers. I didn't have much drive or inspiration. So, I quit going to school full-time."

19 YELLER

20 CRAB

21 BOSS

22 EXECUTIVE

23 SLOB

24 SINGING TEACHER

25 NEVER SATISFIED

26 SHOP TEACHER

27 P.E. TEACHER (FEMALE)

PLATE 1, TEACHERS, #19-27, CIRCA 1955, INK ON NEWSPRINT, 17" x 14".

22

He worked as a maintenance man in a bowling alley during the day and attended one night class, in watercolor painting. The instructor was Robert Irwin, an exceptional artist whose reputation had just begun to develop. "He was a fantastic guy," Larry recalls. "I was this seventeen year old, just out of high school, and I was in a rut. I mean, there are not too many jobs worse than being a janitor in a bowling alley. I didn't feel I had all that much going for myself artistically. But I came to class every Wednesday night, prepared with my paper and watercolors. One night I did this watercolor painting and the teacher came over and said it was fantastic. He said it was the most incredible thing he had ever seen. He called the whole class over to see this example of what he called the spontaneous use of watercolor material. Everyone else had been doing these thin, pale color renditions of a still life. I was being very expressive, letting the paint splash around but still controlling it. I had enjoyed making that picture, but I didn't expect any recognition. It was like getting a shot of B-12. People kept coming over and complimenting me on it and I didn't know what to think. The next day I quit my job and enrolled back in school full-time."

Bell pauses to draw the wooden match along the underside of his desk and touch the flame to the cigar. Smoke still clouding around his face, he resumes the story.

The experience in Irwin's class rekindled his enthusiasm and gave him direction. However, it fired him up in a way that not all teachers were prepared to meet. Someone in administration had allowed him to take an advanced class in drawing. "This teacher was held in high esteem by almost everyone. The interesting thing about his class was that he would put student work around the walls and all of it looked the same. It was his way of telling everyone how he wanted the drawings to look. While everyone was doing these washy pen drawings on manila paper he would walk around class talking about Zen and metaphysics. I couldn't draw the figure for anything, and I was feeling really inadequate. Then, in one of his lectures he said something that snapped on a light in my brain. I realized that what he was talking about had nothing to do with figure drawing. He was talking about a state of mind that allows you to draw with confidence and ease, no matter what you were drawing. I got a whole bunch of paper, barricaded myself in a corner, and started drawing rectangles and squares—line drawing on the paper. Other people would work on one drawing for two or three sessions and I would be doing about fifty an hour. Paper was just flying all over the place. I was out of the way and I wasn't paying attention to the model—unless she happened to be good looking."

Bell sucks at his cigar. "This teacher never said anything to me. He never even looked at my stuff. Finally one day he asked what I was doing. I told him I appreciated what he had been talking about and that I really understood he was talking about a concept of feeling that allowed you to work with fluid movement without thinking too much about details, etc. He said he was glad I'd picked up on that and that he wanted me to talk to this man, this aesthetic advisor, who was seeing students who had a different point of view."

Bell's demeanor shifts. Although he continues the story, his tone is decidedly darker. He lifts his feet off the desk, balances his smoldering cigar on the edge of an ashtray, and crosses his arms. This is not a gesture of resolution; it reflects instead his attitude toward a memory he would as soon not recall. "I saw him four or five times, telling him about where I was coming from and how my work was developing. I was feeling great about it. One day the guy I was rooming with

BILLY AL BENGSTON AND BELL, 1962. PHOTOGRAPH BY WILLIAM CLAXTON.

says: 'I think your painting has come a hundred miles since the beginning of the semester. It's amazing to see this kind of flowering.' I said I thought it had something to do with Steinberg. 'Steinberg?' he said. 'Yeah, Jepson told me to set up this thing with Steinberg.' 'What do you talk to Steinberg for?' 'Steinberg's this aesthetic advisor and Jepson said I should tell him about my work.' My roommate got this white look on his face and said, 'Man, that guy's a shrink. The school hired him to weed out the weirdos.' My whole world just collapsed. I had thought that for once I was making decisions about my work and where I was going and this guy had just set me up because he thought I was some kind of nut.

"I went to the school, took out all my stuff, and I never went back."

The experience left Bell despondent; he was torn up, but toughened. He found a job at the Unicorn, a bar in Hollywood, and he continued to paint on his own in a garage behind his apartment. "I had such bad feelings about the episode at Chouinard that when things started going well with my work and I was asked to teach at different places I wouldn't have anything to do with it. I had such bad feelings about how schools set kids up and brutalize them in the most insidious ways. Now I realize that the guy did me a favor. I was crushed, but I kept working. I had met other artists whose work I really liked—Ken Price, Bob Irwin, Billy Al Bengston,

BELL WITH HIS FIRST VACUUM COATER, NEW YORK STUDIO, 1966.
FROM A POSTER FOR 1967 EXHIBITION AT PACE GALLERY.

Frank Stella, Don Judd, Ellsworth Kelly—and I tried to emulate their lifestyles."

In the cramped garage studio, Bell launched a series of abstract canvases. He remembered the fluidity he had discovered in Irwin's watercolor class and brought it to bear on this new work; his forms became simpler, more organized, the edges harder. Perhaps the transformation had something to do with his treatment at Chouinard. No matter what provoked it, he liked what was happening. Using a process of step-by-step elimination, he gradually reduced the imagery to a single shape on raw canvas. At one point, as a way of achieving a surface and depth he wanted, he introduced glass into the paintings. "I painted modifications of the space in that shape

on shaped canvas and pretty soon I realized that I was doing illustrations of volumes. I decided to stop painting illustrations of volumes and go ahead and make the volumes themselves. That was the point at which I became a sculptor.

"I had been painting pictures of the cubes, so I decided to make one. I got the glass, coated it, and assembled the first cube. I stood and looked at it, and I thought it was the most beautiful thing I'd ever seen in my whole life. I couldn't believe it. My buddies came over and said: 'Jesus!' Bengston, who was my idol and my mentor, the guy I wanted to be as-good-as in everything, looked at the cube and got real huffy. In a funny way, he started to discourage me from making them. It was real expensive. I had hocked everything to get the piece done.

BELL WITH GUITAR COLLECTION, TAOS STUDIO, 1985. PHOTOGRAPHER UNKNOWN.

He said: 'You can't afford to make these. If you could afford to make them then I would be making them.' I never forgot his saying that to me. Finally I had done something that he wanted. That was all I needed. I went after it tooth and nail."

He continued to work at the bar to support himself and his art. Materials to generate the glass sculptures took all the money he could scrape together and the pieces proved tedious to make. He could complete no more than eight in a year. However, the cubes created an impact in the art world and his reputation began to grow.

Bell consults his watch and announces that we should return to the tank. The weather has changed, and as we pass through the courtyard large flakes of snow are falling. In the studio, the tank is now completely purged of air. Bell mounts a chair high enough to allow him to peer through a small porthole-like window. Around it, taped to the side of the tank are a photograph of his youngest child, scrawled notes about the materials he is currently coating, thumbnail sketches of pieces he wants to make, and a polaroid of Igor, his Bulldog. Holding his cigar in his teeth, the cold ash jutting upward, he fiddles the switches and dials to regulate the diffusion sequence.

"There," he says after a moment, "see that?" He moves aside and directs my attention into the tank. I make out the orange glow of the electrodes but nothing more. Experience shows him what I am unable to see—until later, when the tank is opened.

Shortly after his earliest successful cubes, Bell discovered the industrial coating process that eventually induced him to purchase his own tank. "I was after a certain surface treatment on a single piece of glass that would reflect on both sides rather than taking two pieces of mirror, making the pattern the same, and sandwiching them back to back. I wanted it all on one piece of glass."

Someone he knew suggested a process called aluminizing

before. He called them a pair of platters. One time I heard him play a song by the Four Lads called 'Skokian' that he paired with an older song by the Weavers called 'Wimoweh.' I was turned on to 'Wimoweh' and went off to find some Weavers records, which were very scarce. Among the ones I did find was a tune by the Weavers called 'The Benoni Song,' which I thought was fantastic. I had this singer friend named Judy Henske. One day I made the mistake of playing her the 'Benoni Song.' She just got totally hysterical. She thought it was the dumbest most stupid song she had ever heard. And after that she started calling me Benoni.

"In my other life, I was hanging around artists like Kenny Price and Billy Al Bengston—that whole group of people.

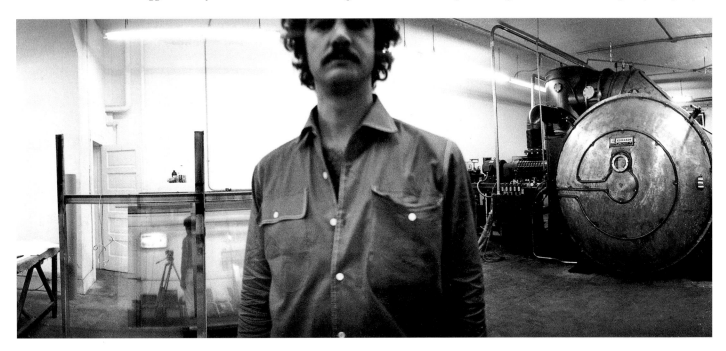

MARKET STREET STUDIO, VENICE, 1969-70. PHOTOGRAPH BY LARRY BELL.

or vacuum metalizing. In the Yellow Pages, he found a firm in Burbank that did vacuum coating. "The owner showed me a sample chip of a front surface mirror. It was the same on both sides. I asked if you could mask it off in different places. He said you could do anything you wanted. He explained all the problems with the process. I took him a piece to run a test on. It did exactly what I wanted. From then on, I had him doing all my stuff. After I'd etched my glass or sandblasted it, whatever I was doing, I would take it to this guy and he'd run the coating."

One of Bell's friends intimated that Bell had been nick-named Dr. Lux because of his use of light, his technical skill, the stuff that drives his work. "Not at all," Bell says. He peers momentarily into the tank. The electrodes are spent, the shot over. Bell relaxes, settling back in his chair, rolling the cold cigar in his mouth. "When I was quite young," he says, "I was into folk music. There was a D.J. in L.A. named Ira Cooke who used to pair up popular songs with hits from ten years or so

Bengston and I would go on these thrift store sojourns to buy duds. If he bought one suit for ten cents, I would buy twenty. Whatever money I got I just spent. If we all went out to dinner I'd pick up the tab—even if I had no money at all. Those guys started calling me Luxury because of that extravagance. I introduced Judy to them and she put the two nicknames together as Biluxo Benoni. I began playing that character called Biluxo Benoni. I think I did it because I felt I had to be a special kind of person to satisfy myself in the presence of these great people like Bengston and Price and Irwin. When we'd go out to social events, like art openings and museum parties, I'd dress up in one of my thrift store suits, put on a false mustache and weird glasses, fix my hair so it stood out all over the place, and become Biluxo Benoni.

"Sometime later, Billy Al shortened Luxury to Lux. Somehow in the process I ended up Ben Lux. From then on, I became that character. I hid out in a lot of places as Dr. Lux, sometimes as this kid from the San Fernando Valley. Then, at

a certain point I decided to stop dressing up and just be me; for one reason or another, the name Ben Lux, or Dr. Lux, just stuck."

I ask if he has reached a state where he no longer needs the image, the illusion.

"My ambition hasn't diminished at all in terms of the things I'm interested in going after," Bell replies. "But things have changed from the time when I thought it was important to have an edge of absurdity. I don't think about Dr. Lux much anymore. He's sort of a joke person now. Somebody gave me a jacket with DR. LUX embroidered across the back. Now when I wear it I have this feeling of being Dr. Lux, as if that was the name of my high school or something. I have this feeling that

be put to rest in a spot and radiate the beauty with which Bell had imbued it. Environment altered the piece, became part of the piece. Each work, in turn, acquired a life of its own in its particular space.

In his uncanny ability to exploit this property of glass lies Bell's particular genius. Light is his medium. And his music. He shapes the world with his art. His pieces absorb; and they radiate. Rooms, buildings, outdoor areas become part of the experience, part of the scenario. The viewer, too, shares an involvement. No one escapes. What you wear, where you stand or move adds to the illusion.

Bell himself has been swept into the process to the extent that he has created furniture, lights, and entire environments.

(LEFT) BELL WITH HIS VACUUM TANK, TAOS STUDIO, 1989. PHOTOGRAPH BY DOUGLAS KENT HALL. (RIGHT) BELL'S TAOS OFFICE, 1985. PHOTOGRAPH BY LARRY BELL.

as I walk around people read Dr. Lux on the back of my jacket and know that I come from that high school."

Initially, Bell spoke of the Dr. Lux experience as a kind of schizophrenia, a state necessary to make up for an inadequacy he felt when he was among his more savvy art friends. In a recent conversation, however, he summed it up in a different, more thoughtful manner: "It had something to do with the fact that I sort of started at the end. I began with these perfectly complete pieces, all polished and finished. They were the kind of thing you would get around to doing eventually, once you had matured into your career. But I was making them in the early period of my career. I knew what I wanted to do and I did it. Clean perfect lines, the concept clear, the product realized."

To achieve this end, glass provided a flawless surface, an answer to his frustrations concerning the texture of canvas and the opacity of oil or acrylic. Glass freed him, allowing him to transcend the piece. Glass in combination with ethereal thin film deposits became pure illusion. It was, however, illusion just beyond his control. He could shape it; he could etch it or coat it; but he could not completely control every detail of what it ultimately became. A glass piece refused simply to

There is no end to his discovery, his invention. In the course of generating a recent proposal for a commission and making it palatable to the client, he wrote a small narrative, warping the essential facts of the history of ancient Sumer to fit his particular need.

No matter what new material he explores, Bell keeps coming back to glass. He attempts to translate the qualities he achieves on glass to other surfaces, other materials. For example, his series of elegant vapor drawings on paper, their thin coatings identical to those he lays onto glass, assume a mysterious other-worldliness.

Years ago, Bell stopped using canvas partly because its texture obviated the uniform, machined look he wanted in his work. Lately, following the success of the works on paper, he began to work on linen again; he has reconciled image and surface with the technology he uses on glass and the collages joined to canvas achieve an enormous depth, becoming a *trompe l'oeil.*

Bell's unique abilities were recognized early in his career by a number of other master illusionists. In fact, during the period of Biluxo Benoni and Ben Lux, Marcel Duchamp paid a visit to Bell's studio. With Duchamp were the English artist

Richard Hamilton and the American artist and benefactor Bill Copley. "I heard this knock at the front door. My friends always came to the back door. So I was careful to peek out through a crack in the window to see who was knocking. I thought it might be the building inspectors or something. I didn't know these three guys but they said they wanted to look at my art so I decided to let them in. The little guy, Copley, did the introductions. I didn't catch their names, but I kept thinking there was something familiar about the old guy who didn't say anything, though I didn't know why or where I might have seen him. Then, because of a comment Copley made—something like, 'Well, Marcel, can't you just make it out of balsa wood—' I realized who he was.

out the rack that holds materials he has just coated. Sheets of exotic paper, sometimes crumpled or overlaid with netting, have been transformed into new material, components for his collages. He lays the pieces in piles, working slowly, carefully, committing to memory each new element; there are surprises that delight him; there are failures, too, and those he rips up and tosses in the trash.

Suddenly, the intercom crackles. Bell's assistant announces that the tour has arrived.

"Are they early?"

"No."

"What time is it?"

"Eleven-thirty."

TAOS STUDIO, 1979. PHOTOGRAPH BY LARRY BELL.

"I was in shock after that. Hamilton kept talking about my work, explaining things to the old man. Most of what he said was not correct. Finally I had to correct him."

About Duchamp, Bell is expansive. "He was a hero, a legendary person. Here was this guy, this major figure out of the history of modern art standing in my studio and he was looking at my work. Nothing like that had ever happened to me before. I didn't know what to think. When I say I was in awe of his presence, it's an understatement. I was terrified."

He is silent for a moment. "Come on," he says, "let's look at this shit."

In the clean room, wearing white cotton gloves, Bell rolls

Reluctantly, he pulls off his white gloves.

Into the studio from a chartered bus, its diesel engine continuing to throb out in the driveway, files a museum group from New York, people with expensive shoes and bags. Though they have appeared as strangers at his door, Bell treats them with his customary warmth. He shakes hands with each one and politely asks them to sit for a brief introduction to his work. The spirit of Dr. Lux emerges, Bell assuming the role of performer. Like a puppet master disappearing into the mysterious dark above his small stage, he dims the main lights, intensifies spots already directed to a piece centered on the wall, and begins to draw his audience into the illusion. He

reappears, overflow from the spot highlighting his features and casting his shadow on the wall; he talks the group through the process of creating the piece before them, a small canvas that catches the light and appears to dance on the studio wall.

Bell discusses the methods and materials he used to achieve this particular canvas. He is affable and his manner so engaging that his words become a smooth legerdemain. He dazzles the group with talk of process to the extent that the work remains separate, its mystery intact. He reduces a complex formula that took hours and hours of his own effort to derive to a simple nuts and bolts discussion, making the underlying process sound deceptively elementary, a mere reductive exercise. He mentions that so many millimicrons of inconel or gold, platinum or blood, were released in the vacuum chamber and they are deposited upon the surfaces of materials he has arrayed in the tank. He emphasizes that no pigment is involved, that the color shift is wrought from a spectrum defined by the thickness of the thin film deposit. The materials were chosen, arranged, and fused to the canvas.

Bell is masterful at his craft. Either his tools are complex, or they are simple—depending upon your own point of view.

Yet, no matter how simple one might make the description of his nine ton vacuum chamber—Bell claims to the museum group that it is "just like a light bulb"—this piece of coating equipment, large enough to walk into and costing a few hundred thousand dollars, is a decidedly more complicated tool than, say, a mallet and a handful of chisels or a palette and a few brushes.

That, of course, is not the point. By involving these viewers in tools, materials, and process, in the same way that a magician beguiles his audience to mask the movement of his hands, Bell avoids direct talk about the finished piece. He eliminates fear of the abstract nature of his art, making the museum group feel comfortable. While they might assume he is taking the mystery out of his work, the opposite is perhaps true. He heightens the enigma, masking it with familiarity. The art is left to stand or fall, to make its own statement. Just as his audience begins to feel enough at ease to begin exchanging comments, Bell lifts the piece from its hanger, turns it completely over, hangs it upside down, and then, without a word, steps back into the dark. ∎

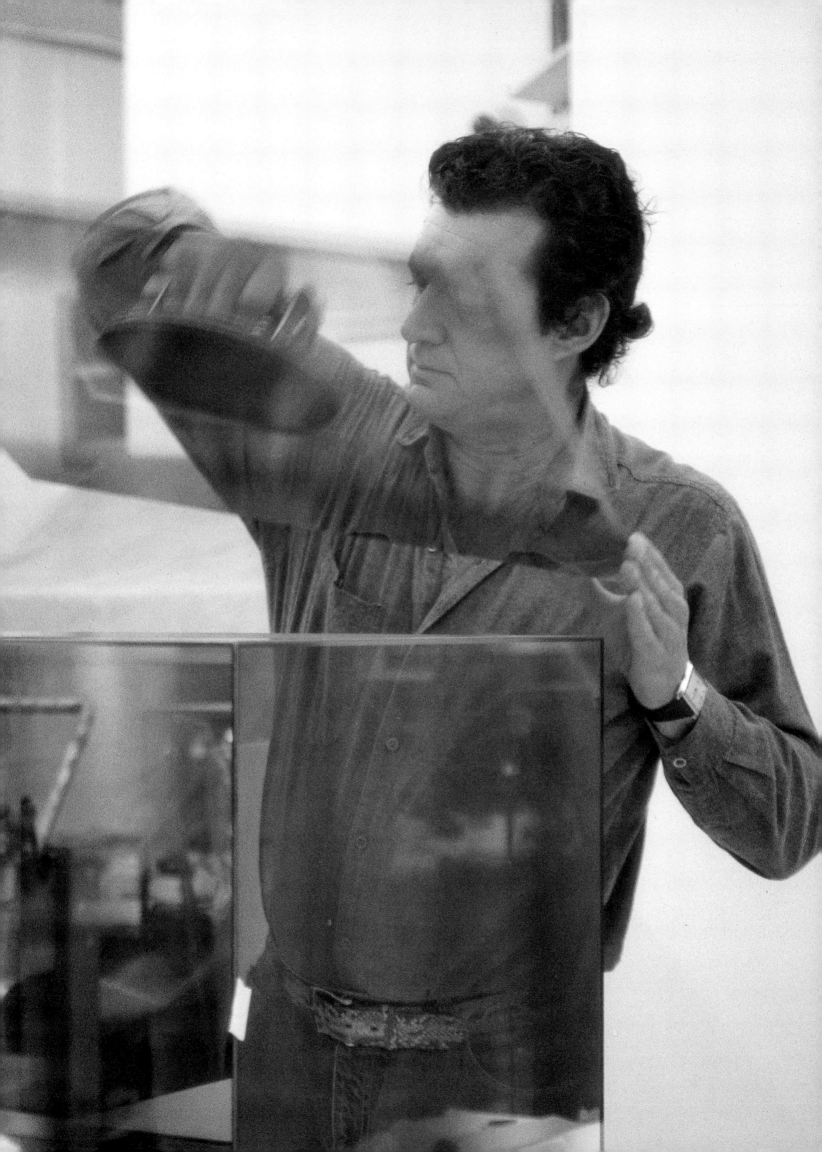

Two basic courses of inquiry in current art investigate the nature of sensate comprehension. One course, stressing idea, knowledge, and intellection, looks at language and human activity, process and research as the defining mechanisms of experiment. Such conceptual art, inducing philosophical thought and (initially) cerebral play, proposes that the statement of intention or circumstance suffices as artistic expression. The other course, stressing exterior phenomena,

Larry Bell
Understanding the Percept

Peter Frank

interior intuition and the shape and nature of basic visual experience, examines the relationship in the human mind of what is seen, and how it is seen, to what is known, and how. The material processes and, conversely, verbal formats common to Conceptual Art are not the focus of Perceptual Art; rather, Perceptualism looks at, and exploits, the mechanisms of understanding by stimulating the mechanisms of visual apprehension. In both Conceptualism and Perceptualism the dictum of Marcel Duchamp—"the viewer completes the work of art"—pertains. What differs is how the viewer makes that completion, and how the work of art functions, socially and physically, as a result of that completion.

Perceptualism may examine how artwork, singly and collectively, is comprehended; but it still argues with, more than it accepts, optical sensation. As opposed to the stark simplicity of Minimalist artwork, to which they bear superficial similarity, the objects, non-objects and quasi-architectural spaces produced by artists associated with Perceptualism subvert visual, and by extension epistemological, apprehension. If Frank Stella insisted that, in his early, proto-Minimal paintings, "what you see is what you see," a Perceptualist demonstrates that

what you see is never only what you see, may not be what you see from one moment to the next, and may not even be what is actually there. This is more than fool-the-eye parlor magic: Perceptualism is a serious inquiry into, and elaborate exploitation of, the vagaries of human sensate perception.

The artist and influential pedagogue Robert Irwin is recognized as the philosophical center of the Perceptualist tendency, and if the movement has a geographic and chronologic center, it is recognized as Los Angeles in the 1960s, when "Fetish-Finish" and "Light & Space" emerged as signal Perceptualist tendencies. Arguably, however, the most successful Perceptualist—successful in terms of exemplifying the lineaments of Perceptualism to a broad public—is Larry Bell.

of the object to the art experience every bit as critically as Conceptual Art has. The irony resides in the fact that the art audience of the 1960s grasped the Perceptualist position as a result of seeing it in things. Bell was making objects that demonstrated how elusive, unfixed and undependable objects actually are. Objects, Bell showed, are the launching pads, not the residences or the targets, of perception. What you see is never all you see—nor is what you see all there is to see.

Bell first came into contact with Irwin while a student at Chouinard Art Institute in the late 1950s (before that school metamorphosed into the California Institute of the Arts). At Chouinard he also met most of the artists—teachers, students, friends of Irwin's and just plain hangers-on and -around—who would constitute the close-knit community in which his early development took place. Like them, Bell took a studio in a

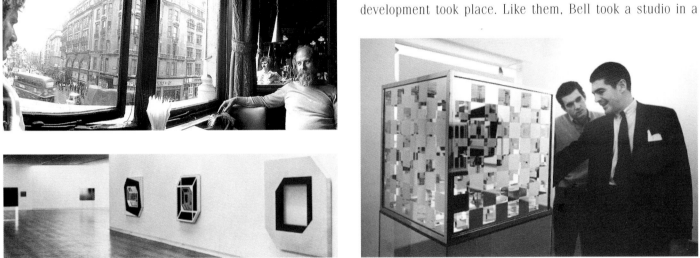

(LEFT, TOP) ROBERT IRWIN AND BELL IN LONDON, 1970, ON THE OCCASION OF THE "BELL, IRWIN, WHEELER" EXHIBITION AT THE TATE GALLERY. WIDE LUX PHOTOGRAPH BY LARRY BELL. (LEFT, BOTTOM) INSTALLATION OF WORKS FROM 1961 AND 1962, PASADENA ART MUSEUM, PASADENA, 1972. PHOTOGRAPH BY FRANK THOMAS. (RIGHT) BELL AND IRVING BLUM WITH BETTE AND THE GIANT JEWFISH AT FERUS GALLERY, LOS ANGELES, 1963. PHOTOGRAPH BY FRANK THOMAS.

Bell, who grew up in Southern California and was an early acolyte of Irwin's, achieved recognition earlier and more rapidly than many of his compeers. His earliest refined Perceptualist artworks, box-objects constructed of etched and mirrored glass panes, made Perceptualism seem immediately understandable and even sensuous. Still, in those coy, immediately appealing objects Bell was already maintaining the argument with the optical (as opposed to the physical) integrity of artwork that characterizes his oeuvre throughout. From the moment he began moving beyond the traditional bounds of painting and sculpture, Bell's concern was with the relative visibility of artwork, how the context in which a viewer experiences artwork affects that visibility, and what exactly constitutes visual "fact."

Bell's success in promulgating Perceptualism resulted, ironically enough, from his ability to "concretize" Perceptualist attitudes and experience, that is, to give it form, substance, and even heft. Perceptualism is an emphatically non-, even anti- concrete position, questioning the centrality

storefront in Venice, a down-at-the-heels seaside community whose maritime light and affordable rents attracted artists. Unlike his comrades, however, Bell enjoyed rapid recognition.

"The most important attention for me in the early years was from my peers," Bell has stated. "That I would receive any attention at all for this work, was gravy."[1] Thanks to his associations, and to the distinctiveness and adventurousness of even his earliest work, Bell showed at both the Huysmans and the Ferus galleries—the only galleries in Los Angeles exhibiting local experimental art—not long after each opened. In these youthful outings, Bell showed the shaped hard-edge acrylic canvases he had begun developing while still in school (although at Chouinard they had been rendered more loosely, in oils). These subtly diagrammatic paintings bend, cut corners, repeat segments, shift materials and even imply cubic volume while at the same time evincing an uninflected flatness. Under the sway of Irwin's emphasis on perception, Bell hit early on upon ways of manifesting how-you-see-it-how-you-don't questions.

Soon, Bell decided to incorporate clear and mirrored glass into his increasingly intricate linear and planar compositions. He had first used glass in a series of small collage-constructions made from spare material while working in a frame shop in 1959 and 1960.[2] By bringing glass into the large paintings, Bell not only enhanced their illusory suggestions of depth, but brought the space, and the events, in front of the paintings into them. As Barbara Haskell observed, "In *Conrad Hawk*, his first painting to include glass, the distinct separation between the viewer and the object begins to break down as the viewer's image is subtly reflected by the glass and becomes a visual element of the piece... By combining both mirrored and transparent design elements in the glass construction paintings

clear reading is offset by the vertical striping of the nearest plane. The planar interplay became even more thorough with the introduction of the oval, replacing the parallelogram as the primary surface motif.

It was the cubes "painted" with (actually coated in the form of) ovals which Bell exhibited in New York, first in group surveys of California art at Sidney Janis and Pace, then in a one-man show, also at Pace. Bell moved to New York, prompted in part by the success of these shows (the solo exhibition sold out on the first day) but also by the access he was offered to the metallic coating technology on which he was coming more and more to rely.[4] He purchased a vacuum coater for his New York studio, experimented with different substances, and con-

(LEFT) INSTALLATION OF CUBES AT PACE GALLERY, NEW YORK, 1965. PHOTOGRAPH BY HOWARD HARRISON.
(RIGHT) BELL AT STEDELIJK MUSEUM, AMSTERDAM, 1967. PHOTOGRAPHER UNKNOWN.

and by recessing one glass sheet behind the other, unexpected spatial ambiguities are created which would not occur were Bell to have used only mirrored glass."[3]

By the time Bell had his second one-person show at Ferus, his paintings had shrunk, climbed off the wall and completely integrated the clear and mirrored glass as a pictorial material. In fact, the free-standing box constructions relied far more on glass than on paint on canvas as they continued, and amplified, Bell's interest in confounding perception. The earliest boxes contained within them, coated onto the glass or even defining their perimeters, the angled contours and beveled edges with which the paintings had inferred three-dimensionality; the illusion of volume was thus conflated with actual volume.

While most of these boxes tended to be shallow rather than cubiform, by the beginning of 1963 Bell had fabricated several whose edges were all of equal length. As well, the patterning of the mirrored glass became more complex, providing ever more elaborate and eye-bending interplays of multiplanar interfacing. An open, non-mirrored area on one plane can be seen clearly from one angle, but from another angle such a

centrated on the new format he had devised shortly before leaving Los Angeles, dispensing altogether with geometric surface designs. In New York Bell coated the cubes with delicately modulated mists of chrome and silicon monoxide— effectively merging the color-field approach increasingly prominent among New York painters with the late-industrial technology he and his fellow Los Angeles "fetish-finish" artists favored. In this manner Bell began creating the super-thin layers of pigment, and concomitant shifts in luminosity, tone, and color blend, that would come to characterize his work for the next two decades.[5]

In New York Bell hung out not with the color-field painters, but with hard-edge and proto-Minimalist artists such as Donald Judd, Neil Williams, Frank Stella, and John Chamberlain (who was himself experimenting with new technologies at the time). He had a "wonderful time" in New York, but had enough after about a year and moved back to his studio in Venice. Unfortunately, Venice had become more physically dangerous, zoning laws hostile to storefront residency were being enforced, and the war in Vietnam loomed, the draft

32

threatening Bell and his contemporaries. Bell's friends in L.A. welcomed him back with mixed emotions; he could feel their jealousy and resentment at his success in New York. Amidst this alienation, Bell also experienced several years of frustration waiting for completion and delivery of the large coating device he had ordered built for him. He wanted to work larger, to break out of the cube into free-standing formats. In the meantime, the cubes were themselves growing bigger, straining towards that breakthrough.

"The most interesting thing about the cubes for me was where the corners came together, and the way the color faded from the corners toward the center of the glass in each piece," Bell recalls.[6] In his last cubes, comprising the Termi-

decontainment, as it were, of once-interior space and the further suspension of the fine hazes of color in fully accessible formats. Bell recalls now that the cubes' coatings "met at an interesting gradient, that suggested I develop the next step focusing just on the right angle relationship of the corners.

"If I did this I could make them bigger, which was something I wanted to do anyway. The cubes could not get much bigger for practical reasons of handling, with the methodology I was working with. It was my feelings at the time that just making the cubes bigger would not do much for me. I wanted to do something that incorporated the peripheral vision that 'daydreamers' have a propensity for."[7]

Bell's abandonment of the cubes constituted an almost lit-

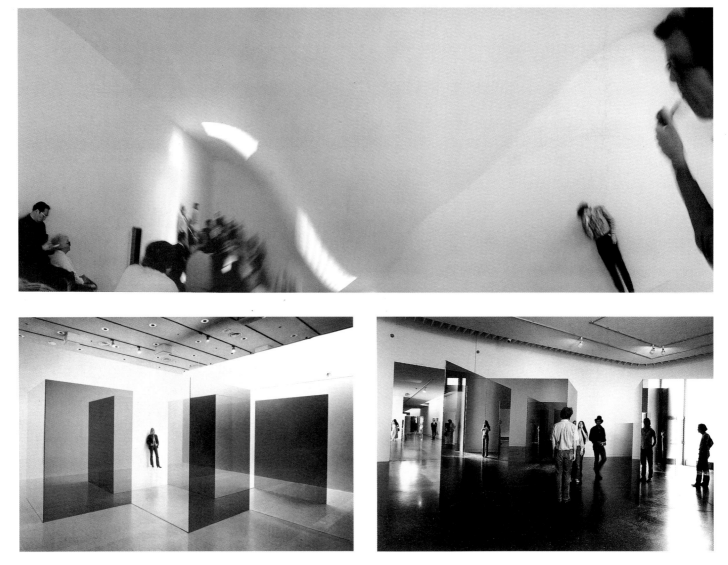

(TOP) SYMPOSIUM ON HABITABILITY, VENICE, 1970. WIDE LUX PHOTOGRAPH BY LARRY BELL. (LEFT) INSTALLATION OF UNTITLED STANDING WALL SCULPTURE AT WALKER ART CENTER, MINNEAPOLIS, 1969. PHOTOGRAPH BY ERIC SUTHERLAND. (RIGHT) INSTALLATION OF SEVERAL STANDING WALL SCULPTURES AT PASADENA ART MUSEUM, 1972. (NOTE BELL WITH HAT.) PHOTOGRAPH BY PATRICIA FAURE.

nal series, he did away with the chrome-plated framing edges, revealing without interruption the color activity that had come to focus in the corners. He also enlarged the cubes, allowing them to reach a dimension of 40 inches all around. The next logical step was out of the cube altogether—the

eral breakthrough. It was not an easy thing to achieve technically, and it puzzled that segment of Bell's audience that had come to expect, even depend on, his cubic format (a format which other Perceptualist sculptors emulated in various ways). But it was a necessary step for Bell, both in cultivating

LEANING ROOM, *UNDER CONSTRUCTION IN LARRY BELL'S VENICE STUDIO, 1970, APPROXIMATELY 65' x 28'. (NO LONGER EXISTS). PHOTOGRAPH BY LARRY BELL.*

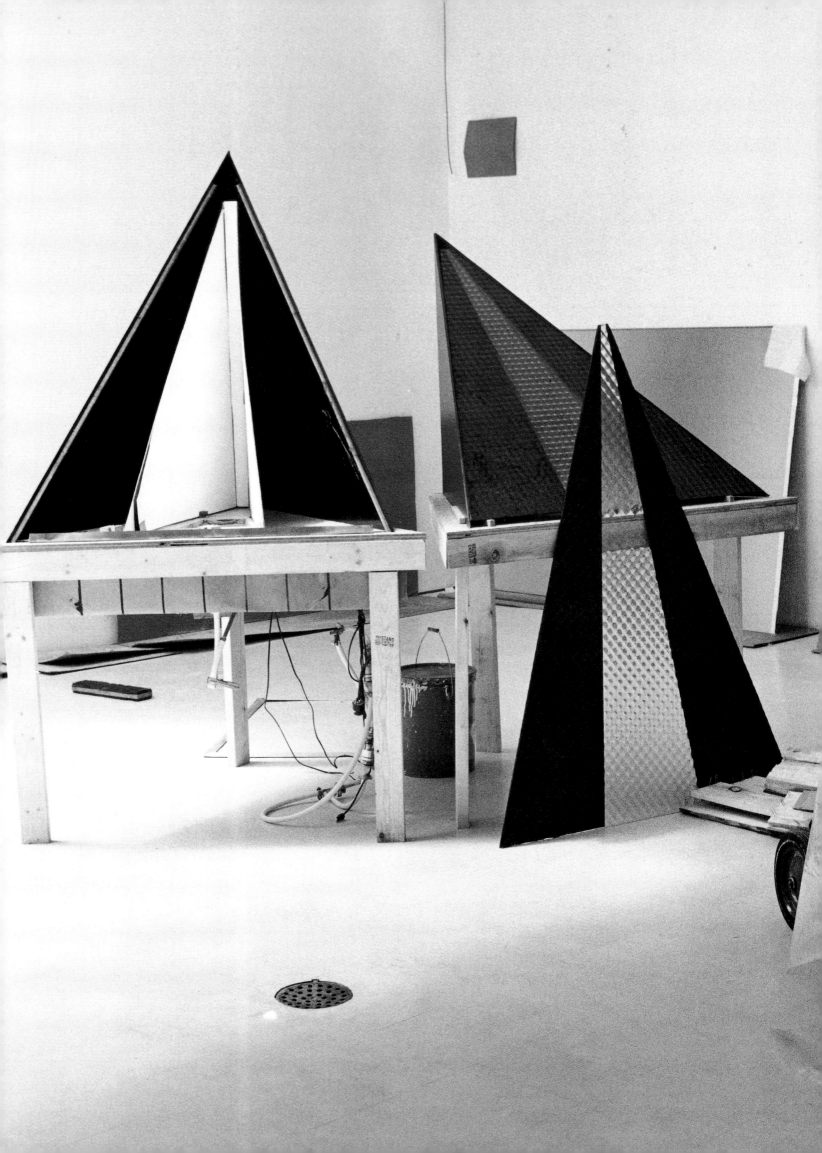

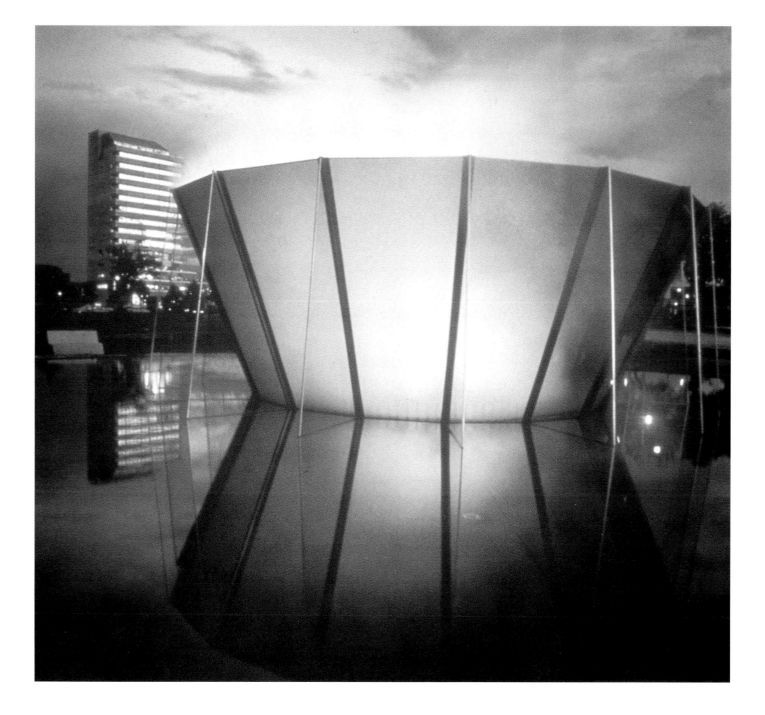

(OPPOSITE PAGE) MODELS OF THE IMPROBABLE FLOW, 1980. TAOS STUDIO. PHOTOGRAPH BY TONY VINELLA.

(ABOVE) THE SOLAR FOUNTAIN BY BELL AND ERIC ORR, 1983, INSTALLATION NEAR DENVER PERFORMING ARTS CENTER. PHOTOGRAPH BY JOHN HEALY.

MOVING WAYS, 1982, GRADIENT WINDOW INSTALLATION PIECE AT THE FEDERAL BUILDING IN SPRINGFIELD, MASSACHUSETTS. PHOTOGRAPH BY THOMAS P. VINETZ.

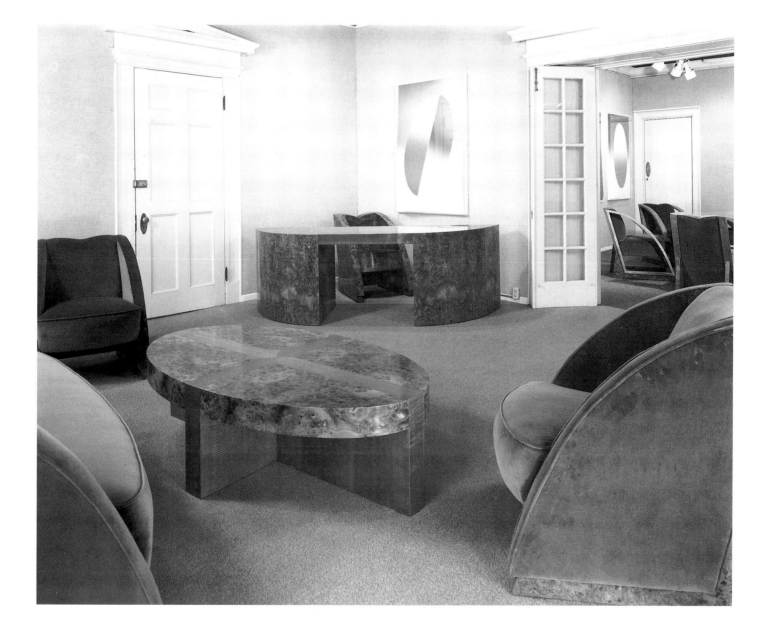

THE FURNITURE DE LUX, *1981, INSTALLATION AT TRISOLINI GALLERY, UNIVERSITY OF OHIO, ATHENS. PHOTOGRAPH BY RICHARD RUDNIAK.*

the logic of his work and in satisfying the restlessness he had felt since returning from New York.[8] The expansion of the visual and physical field of experience allowed Bell to capitalize even more on the interplay of gradient reflections in his glass surfaces, an interplay so subtle that, as viewers moved their heads, the color seemed to shift hue or intensity, or to disappear completely. In the new, more expansive format such color shifts would affect viewers' perception, not just of the objects, but of surrounding space.

The actual fabrication of the free-standing glass-wall pieces began around the time Bell participated in an ambitious research symposium, a project whose results critically focused and reinforced his inquiry into perceptual psychology, phenomenological philosophy, and their applications to art and architecture. In 1970, with Robert Irwin, psychologist Edward Wortz, and scientists at Garrett Airesearch, Bell organized the first International Symposium on Habitability, a NASA-sponsored colloquium which brought together artists, architects, urban planners, physicists, psychologists, engineers and others in a multi-tiered investigation of "applied perception." Among the work Bell and Irwin did for the Symposium, which met in their studios, was the designing and building of various structures fashioned to affect perception liminally but dramatically. While Irwin modified the given environment, playing with the distinction between interior and exterior, Bell constructed two entire rooms designed to subvert sensation and communication. While more radical and physically encompassing than the free-standing glass-wall sculptures, these rooms, and the discussions that engendered them and they in turn provoked, fed directly into the sculptures.[9]

Writing on the occasion of Bell's 1972 Pasadena retrospective, curator Barbara Haskell noted of the then-new "walls" that Bell had "severed his link with traditional sculpture by creating works that are no longer isolated objects whose boundaries can be established. There is no perceptual separation between the actual sheets of glass and their illusory reflections—both are perceived as equal physical realities.... [T]he walls have an ambiguous spatial existence. They intentionally activate and encompass the surrounding space.

"Removal of the pedestal and metal edge eliminates any visual defining frame of reference and enhances the elusiveness of the space. The completely architectural scale of the walls contributes to transcending the 'object' by engaging the major portion of the viewer's field of vision."[10]

The arrangements of inconel-coated[11] vertical glass panels Bell began fabricating in 1970, most of which stand at least six feet in height, in fact determined quasi-architectural spaces. Indeed, as Bell began exhibiting them, he found it appropriate to arrange them in formal relationship to the rooms they occupied, as well as to one another. Their gross conformations inter-

acted dynamically with those of the surrounding walls, while the intricate interplays of their neutral gradated reflections and areas of transparency and opacity redoubled as they engaged one another and the room in the viewer's perception. Bell sought to maximize the free-standing sculptures' interactive and self-effacing qualities, just as if they *were* architecture. In this respect Bell distanced himself once more from East Coast Minimalism which, while arrogating the form, volume, and social and physical space of furniture and architecture, insisted on objecthood and sculptural integrity. (By the same token, however, the free-standing pieces paralleled, even anticipated, Dan Graham's post-Minimalist mirror-wall works.[12])

The most ambitious of the glass-wall sculptures was *The Iceberg and Its Shadow*, consisting of 56 large panels which can be assembled in myriad different combinations. Despite its immensity *The Iceberg and Its Shadow* was seen in a number of different configurations, as it went on an extended tour of American museums immediately after its 1974 fabrication and was acquired by the List Art Gallery at the Massachusetts Institute of Technology, which installed and reinstalled it, on campus and in various sites in the Boston area, for an additional three years. Although designed for indoor spaces, *Iceberg* became the touchstone for Bell's approach to large public, including outdoor, sculpture for the rest of the 1970s and into the '80s.[13]

Bell's concentration at this time on large, adventurously configured sculpture—some including atmospheric manipulation with light, water, and other enhancements, and many installed *en permanence* in public sites—resulted from a variety of factors. In 1973 he left his native Los Angeles, relocating to Taos, New Mexico (to "control his distractions," as he put it). The brilliant light and emphatic spaciousness of the high desert encouraged a more expansive approach, in terms both of size and of formal elaboration. The 1970s also saw a propitious expansion in American art patronage, especially in government and corporate sponsorship of public art projects; this established a whole new class of patron for Bell's work, a class that required precisely the kind of decorous, physically self-contained, yet intricate and engaging structures for which Bell had become known.

Through contact with certain of these patrons, Bell became aware of new material combinations and new possibilities for perceptual expansion and modulation. One particularly influential encounter was with Dr. Harold Edgerton, the well-known pioneer of high-speed stop-motion photography and inventor of the strobe light. Edgerton introduced himself to Bell on the occasion of the installation of *The Iceberg and Its Shadow* at Massachusetts Institute of Technology and invited the sculptor to his laboratory. Edgerton's continuing investigation into the strobe light's effect on optical perception fascinated Bell, who

attempted to incorporate some of them into proposals for sited pieces.[14] These proposals, initiating the *Improbable Flow* series, were not realized, but other works in the series were constructed and exhibited.[15]

Bell's most radical public work (to date) is *The Moving Ways*, designed in 1981-1982 for the atrium of the Federal Building in Springfield, Massachusetts and consisting entirely of tinted windows integrated into the overall architectural scheme (designed by Cannon Associates).[16] But the most dramatic is *The Solar Fountain*, a collaboration with Los Angeles artist Eric Orr begun in 1978 and completed in 1983, when it was installed on a plaza in downtown Denver adjacent to the Center for the Performing Arts.[17] Incorporating a device for

WORK IN PROGRESS ON ELLIPTICAL VAPOR DRAWINGS, 1983, TAOS STUDIO.
PHOTOGRAPH BY WALTER CHAPPELL.

producing artificial fog, *The Solar Fountain* refracts natural light through a complex interplay of gold-tinted glass surface and enveloping moisture. Bell and Orr called it a "solar fountain" because, as they noted in their introductory statement to the project, "it uses more sunlight than water."[18]

Another unusual public project, *The Floor Lamp*, was never realized, but spawned quasi-utilitarian spin-offs. Designed for the lobby of the Sacramento County (California) main jail, *The Floor Lamp*, along with a whole series of light-providing sculptures Bell began making in 1980 (and continues to fabricate intermittently), was derived from several "prism shelves" he had formulated in the early 1970s. The floor lamps, coated on both sides with thin films of silicon monoxide and aluminum, cast their conical light onto perpendicular glass panels, which refract the light into spectral colors. In their initial exhibitions Bell underscored the lamps' functional nature by combining them with environmental arrangements of the furniture he was making at the same time (and, again, continues sporadically to make). The elliptical shape of the cast lights echo the parabolic curves determined by the edges

of his coffee tables, the arms of his chairs, the legs of his desks, the sides of his sofas, and other prominent contours in his designs.

Made of highly finished, naturally patterned hardwoods and upholstered with stuffed cotton or leather, the idiosyncratic but coherent furniture sets hark back to Art Deco and even Jugendstil. They represent not simply a foray into functional design, however, but an investigation—renewed from the 1963 coated glass boxes—of the ellipse. "I was first attracted to the ellipse by the symmetry and beauty with which it complemented the severe right angles of the cubes," Bell wrote in a self-published catalogue.[19] In another such catalogue, he recalls, "[b]ack in 1965 [finding] a chair I immediately recognized as something special in a junk store near my studio in New York. The first thing that attracted me to it was the shape. It was a quarter-ellipse on the sides, very similar to the ellipses I had used as a design motif on the first glass cube sculptures I made. Just as important, it was comfortable. I decided that when I had the time and the money, I would build a few more just like it to use.

"Fifteen years later, I finally did it. Two gifted artisans from Taos, the woodworker Ed Paul and the upholsterer David Steiner, did the work. We started out building a series of chairs, all very similar, with the quarter-ellipse sides. I called them the *Chairs de Lux*. Soon I expanded the project to include a sofa, desk, sideboard and tables—which I called the *Furniture de Lux*. At an installation in Detroit I decided to combine one of the glass chairs with a glass sculpture. I called the installation *Chairs de Lux*, and that led to the game. The chairs in the game are tiny versions of the *Chairs de Lux*."[20]

Bell also continued his investigation of elliptical forms in many of the Vapor Drawings he began making in 1978. The drawings conform to a number of geometric configurations, however, exploiting the modifications each form visits on the viewer's perception of light and color.[21] Light and color themselves prove fugitive in the Vapor Drawings, which are fabricated like the sculpture in the vacuum chamber. In fact, the series began serendipitously when vaporized metal coatings in the chamber stuck to a sheet of paper by mistake. While on glass, as Charles Guerin notes, "these coatings allow the spectrum to be simultaneously transmitted and reflected with variations being created by the different thickness of the coatings," on paper "the coatings interfere with light reflected and dispersed."[22]

Later in the 1980s Bell began a re-examination of his classic box format, a re-examination that continues. He has also continued to produce free-standing glass-wall pieces. There is wide formal variation in these recent box and free-standing pieces, and, while returning to certain compositional, and of

40 course perceptual, concerns of the 1960s and '70s, Bell does not duplicate earlier works. Clearly, he never exhausted the formats he was investigating two and three decades ago.[23]

At the same time, Bell has been employing his "traditional" vacuum-chamber technology in the production of newly formatted series. Certain recent works incorporating inconel-and-silicon-monoxide-coated glass surfaces, for instance, surround those surfaces with black denim framing panels, panels so wide that they read as part of the overall composition. The deep, velvety black of the denim does not simply set off the high-toned, translucent colors on the glass; it maintains the luminosity of those colors with its own rich inkiness—its "negative radiance," as it were.

Setting the support material—handmade paper or canvas—on the press table, Bell thereupon composes intricate arrangements of various sheets and bits of paper-thin materials, materials as diverse as mylar, rice paper, cellophane, transparent laminating films, window screening, newsprint, and even brushstrokes.[24] These have been coated in the vacuum chamber with thin films of metallic and non-metallic substances. In arranging dozens of these layers to be laminated Bell seeks to optimize their various light-responsive qualities. In doing so, he "freezes" what had been a spontaneous process of composition, preserving the textures of the collage elements' original folds and contours (which he often enhances with incisions—most recently in the form of his initials, a sly

WORK IN PROGRESS ON MIRAGE PIECES, 1989, TAOS STUDIO. PHOTOGRAPH BY DOUGLAS KENT HALL.

Concurrent with all this work in old and new vacuum-chamber-produced modes, Bell has generated a veritable avalanche of another type of work altogether. The Mirage Works constitute a new series, or several series, whose formal premise is markedly different from the rest of his oeuvre. While geometry and architectonic structure have determined the shape of everything else he has done in his career, in the Mirage Works Bell has devised a painterly, even improvisational approach, one that actually depends on collage technique. Furthermore, rather than employing only his vacuum chamber in fabricating the Mirage paintings and drawings, Bell engages another, albeit related, industrial device: a mounting press.

way of "signing" the pieces) and also creates the illusion of folds and contours that were never there.[25] Actual textures, of course, disappear in the mounting process, the hot press fusing the materials to the support material beneath a smooth layer of laminate.

If the Mirage Works differ formally from all his previous work, they operate perceptually on the same premise that has always motivated Bell's art. That is, these collage-paintings and collage-drawings question the nature of perception: their appearance elusive and conditional, dependent on specific and ambient light and on the viewer's relative position to them. (Indeed, as reviewer Todd Baron has remarked, the title

of the series is "an obvious nod to the irony of illusion that allow[s] one to 'see' with the eye the most metaphysical image available to a painter: light itself."[26]) As the artist, quoted by Meg Scherch, asserts, the Mirage paintings are "extensions of my investigations of light and surface, irrespective of what the substrate or the platform that I work off of appears to be." Significantly, Scherch notes that Bell's earliest paintings were "also somewhat illusionistic, in the sense that they presented hard-edged, abstract configurations that could be read as isometric volumes."

Are the Stickmen, then, also "extensions of my investigations of light and surface?" Not literally, that much is certain. These stick figures in various poses and positions, rendered as

WORK IN PROGRESS ON THE STICKMAN SERIES, 1994, TAOS STUDIO.
PHOTOGRAPH BY PAUL O'CONNOR.

drawings, black and white paintings, and huge bronze sculptures (and smaller maquettes), emerged in 1994 from Bell's playing with technology even more advanced than his vacuum chamber. But these images, originally computer doodles—and the first work in Bell's oeuvre to reference the human figure—don't fit into Bell's thinking simply because they are born of latter-day mechanisms. The Stickmen did not become Bell's art until he realized that the positions the figures were assuming gave them dramatic import, vis á vis one another and the viewer both. The Stickmen are perceptual stimuli different from anything else Bell has done; they engage in and alert us to a hermeneutic construct different from that (or those)

addressed in the context of Perceptualism. They bring to the fore Bell's conceptual turn of mind, until now the side of the artist that was never professionally exposed.

Or almost never. In certain of his catalogues Bell revealed a gift for simple, elegant and imaginative prose, a quirky wit and an almost incongruous literary erudition. There even exists an enduring alter ego of Bell's, the ubiquitous Dr. Lux (ubiquitous, that is, for anyone who knows Bell and his history personally).[28] If nothing else, the Stickmen are ciphers for this aspect of Bell's sensibility, notations towards a more verbal, even narrative point of view—but one that still seeks to question perception (albeit the perception of ideas) with the positing of indistinct, multivalent circumstances.

What are the Stickmen? What are they doing? What are they for? How much of the written account that accompanies the Stickman sculpture project—a narrative that goes into some detail about the proto-historical people of Sumer (who gave us the Epic of Gilgamesh)—is fact, or genuine archaeological theory, and how much is Bell's (or, for that matter, Dr. Lux's) fictional elaboration? How long will Bell follow this atypical line of inquiry? Will he further develop the Stickmen's narrative possibilities? Will he abandon them as an aberration? Will he subsume them into his more typically opticentric work (thus conflating in a way the precepts of Conceptualism with those of Perceptualism)? And what technology will Bell employ to do what he chooses to do?

As they must in any "mid-career retrospective," the answers to those questions await. So does the inevitable question about Bell's next purely Perceptualist body of work (if any body of work can be "purely" anything). We cannot be sure that it will extend the free-standing walls or give the Mirage method a new wrinkle, or even revert back entirely to the glass boxes. We can only be sure that it is imminent. Bell's is a restless mind, ever more eager to reveal different facets of itself to the audience and to respond in turn to varied outside factors. The act of perception, after all, is a permanent feedback situation. Larry Bell's gift is to have fed back to the public not what he has wanted them to see, but the fact that they see, and comprehend the act of seeing, in several ways at once. ■ LOS ANGELES, DECEMBER 1995

1. Bell, Larry, from a letter to the author, August 15 1995, p. 4. | **2.** "In my spare time," Bell has written, "I took scrap glass and cut it to fit some shallow wooden shadowboxes sold in the shop. I'd score the glass, break it in half, and then put the two pieces back together, mounted in the shadowbox with a piece of blue wrapping paper stretched across the back. The one break in the glass created three lines—one a reflection from the break, one the shadow of the break, and the break itself." From Bell, Larry, "Another Lesson," in *Larry Bell: The Sixties*, Santa Fe: Museum of Fine Arts, Museum of New Mexico, 1982, p. 4. | **3.** Haskell, Barbara, *Larry Bell*. Pasadena, CA: Pasadena Art Museum, 1972, n.p. | **4.** "In shipping the work to New York, several cubes were damaged... I needed to find a glazier

who could fabricate the glass the way I wanted, and somebody who could do the same kind of surface coatings that I was having done at that time in California... I found in the Yellow Pages a guy who had the same kind of vacuum deposition equipment that the fellow in California had, and used it to metallize toys. He charged me a fair amount of money to shut down one of his novelty metallizers to do this work for me, and he also suggested that I get into doing it myself, because he thought I could save myself a lot of money. He told me he'd teach me how to run it." Bell, Larry, "First Person Singular," in Raspail, Thierry, ed. *Larry Bell: Works from New Mexico*. Lyon: Musée d'Art Contemporain, 1989, p. 16. | **5.** "Eventually I needed to change the work again, and eliminated the elliptical images and concentrated on

the investigation of the cubic volume with just light passing through it — just to simplify the thing, and eliminate what was no longer interesting to me. So I started doing pieces that had no pattern on the surface. It was a little scary." Bell, *op. cit.*, p. 17. | **6.** *ibid.* | **7.** Bell, Larry, letter to the author, *op. cit.* | **8.** "The excitement of starting a new series of improbable work was stimulating.... It also made me realize that I had to change the studio equipment to handle larger works and this led to a year of research into the best way to make the pieces. I tried to find a company that would coat the large pieces I wanted to make but there was no one who had the facility. Companies offered to tool up to do them but the costs were excessive. I made a series of large right angle sculptures of ½-inch-thick clear

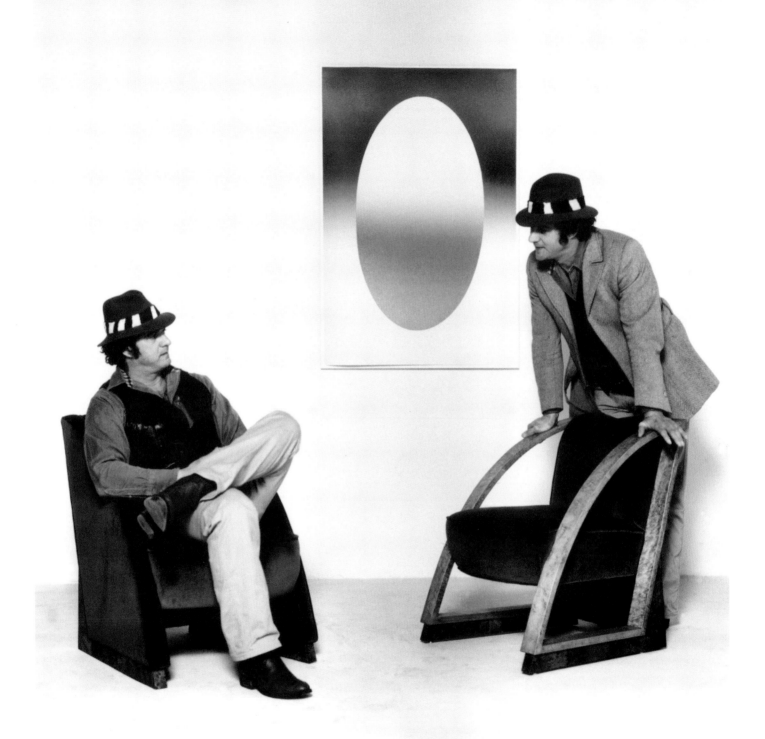

PORTRAIT OF BELL AND DR. LUX WITH CHAIRS DE LUX, *1981. PHOTOGRAPH BY J. GORDON ADAMS.*

and gray glass. Panels simply adhered to each other balanced in the weight of their own vertical thrust." Bell, Larry, in Raspail, *op. cit.* p. 17. | **9.** Bell writes that he "became interested in the thought of sculptures as seen from the inside out. That led me to thinking about the quality of light that might be inside a cube, or inside any kind of a sculpture that let light in, but you couldn't get in it... I tried to make the space disorienting, with a color that wasn't quite any color, and no shadows. I called it *The Leaning Room.* ▪ One wall that ran alongside a busy street in Venice had windows on the top, and I boxed in areas of the wall that coincided with the real windows in the building, but blocked them off, so there only appeared to be windows. The face of the openings of these apparent windows was covered with a translucent white plastic, and behind that were fluorescent lights on dimmers. In the daytime you walked into a room that seemed to be illuminated by daylight — except there were no shadows. If the sun went down while you were in the room, it was a real shock to go outside, because you left a room full of daylight to find it was dark outside. The room appeared to be lit by daylight because the walls, ceiling, and floor were painted with a slightly yellowish color that was the same color as white walls in a certain kind of daylight. But shadowless. So there was a strange collapsing of time, and a disorienting quality [to] the light and color." Bell, Larry, in Raspail, *op. cit.*, p. 18. ▪ Melinda Wortz recalls that "Bell prepared two meeting rooms in his studio [for the conference]. In one, the acoustics were so poor that no one could hear unless chairs were pulled closely together. And a second room, painted black and lit by a single bulb, was so unpleasant that people didn't meet there at all, but reassembled on the beach instead." Wortz, Melinda, "Larry Bell: An Overview," in Raspail, p. 64. Despite the aggressively nasty character of these rooms, they provided Bell with formal and conceptual models for the very successful residential, office and gallery spaces he designed in the late 1980s. |

10. Haskell, *op. cit.* | **11.** Inconel is an alloy of nickel and chromium. Bell applied (and continues to apply) it to the glass surfaces by vaporizing it in his vacuum chamber. | **12.** Especially when enhanced with a video component, Graham's installations, like Bell's, confound a viewer's comprehension of space and spatial relations through an elaborate interplay of reflections. However related, Graham's early installational works are only superficially similar to Bell's. Indeed, that similarity does not even pertain on the level of literal superficiality: the surfaces of Bell's glass walls, nuanced and potentially variable in every direction, provide an experience entirely different from that afforded by Graham's uniformly opaque, reflective barriers. Still, Bell and Graham shared an interest in upsetting viewers' notions of space. While Graham's mirrored panels play labyrinthine games of multiplication, engaging and reconfiguring primary reflections, Bell's play subtle games of uncertainty, interposing primary and secondary reflections with unobstructed through-views. The only true point of contiguity is in the two artists' rejection of illusory tricks; both are satisfied to stimulate and disorient eye, mind, and body through the use of straightforward reflection, however distorted in Graham's case and however variegated in Bell's. | **13.** *Iceberg's* panes of glass, as described by Jan Butterfield, "are either clear or a rich, smoky gray; along their bottoms or tops drift vaporized wisps of blue. Beveled at the top, their prismatic edges make a crisp, clear line of light and/or rainbow color. The clear panes are the 'iceberg,' and the gray ones the 'iceberg's shadow.' The title for the pieces evolved, Bell says (in 'Gallery Notes,' published by the Santa Barbara Museum for its 1976 showing of the piece), because he 'began to think about the idea of the piece being like an iceberg, because there were so many inherent possibilities in the structure and combinations that at any one time you would only be seeing the tip.' Nevertheless, it is not overwhelming. Based on increments of human scale, it remains plausibly 'human': the panes are no wider than the width of the artist's arms, the height that can be reached by jumping on tip-toe." Butterfield, Jan, "Larry Bell: Transparent Motif," *Art in America,* Vol. 66 no. 5 (September/October 1978), p. 95. | **14.** In the documentation for *The Improbable Flow,* proposed for the large garden atrium of IBM's world headquarters in New York City, Bell wrote of the strobe-related phenomena Edgerton had demonstrated for him: "He had simply re-adjusted the pulse of the strobe flash to create an appearance of water flowing up into a hydrant. He was able to change the speed of the strobe which caused the water to appear to slow

down in its flow, stop in its flow and go backward up the hydrant." Bell sought to re-create this effect in the proposed fountain-sculpture, to the point where "coloring the water with a fluorescent dye might be necessary." | **15.** In the brochure to Bell's 1983 exhibition at the Arco Center for Visual Art in Los Angeles, Center director Fritz Frauchiger writes that *The Improbable Flow, Maquette #4* "is a transitional work. In fact, the artist thinks of its as an extension of his own studio... A curtain of water falling from the ceiling is illuminated by high-speed stroboscopic lights. The light's frequency can be adjusted to arrest our perception of the downward flow of water, so that we see what appear to be droplets suspended in space. It can also be adjusted to make the water appear to flow upward. Standing next to the piece, we hear the water as it splashes into its collector trough and feel the rush of its descent, but we perceive the water as unmoving." | **16.** In a local journalist's approving report, *The Moving Ways* is described as "horizontal bands of windows at the second, third and fourth levels of the atrium" in which "Bell applied specially manufactured window film in three densities of gray so that the strip of glass 'reads' (left to right) from light to dark, then dark to light, then again light to dark as one's eye moves toward the top of the building." From the glass-walled elevator on the building's north side "one sees glimpses of the big atrium space alternately through light gray, then very dark, nearly violet glass." From the balcony or the floor of the atrium, the office workers seen "through the interior windows in the building's south side... are barely visible through the dark windows, but the fluorescent fixtures float like lavender UFOs... Tinted to allow only a 50 percent light transmission, these dark panes also function as black mirrors, reflecting lights and movement from the building's opposite side." Karson, Robin, "A new work of art is distinguished by its color," *The Sunday Republican,* Springfield MA, March 20 1983. p. D-6. | **17.** This was not Bell's only, nor even his first, collaborative work. In 1974 he was invited to submit a proposal for a project in La Défense, the large, featureless International-Style office complex on the northwest edge of Paris. "Feeling that the addition of a contemporary sculpture garden would simply perpetuate the spirit in which the project was conceived," Melinda Wortz notes in her account of the project, "Bell responded by reconsidering the conceptual premises underlying the construction of La Défense and, by extension, any new development. To this end he called upon a cross disciplinary group of friends to pool ideas and energy in behalf of La Défense. The proposal eventually submitted in Paris [and exhibited at Sonnabend, Bell's Paris gallery] evolved through the cooperative efforts of artists Larry Bell, Newton Harrison and Robert Irwin, architect Frank Gehry, psychologist Edward Wortz, and Joshua Young." Wortz, Melinda, in Raspail, *op. cit.,* p. 70. Wortz's account includes a detailed description of this "Don Quixote Collective", its multi-faceted proposal, and the interaction among the Collective's members. | **18.** The statement (written to pitch the project rather than describe it post facto) continues: "The vessel stands 10 feet tall and has a base diameter of 30 feet. The sides of the vessel are coated with thin films of a material that appears similar to gold and reflects near the I[nfra-]R[ed] region of the spectrum. A commercial device used for the protection of the citrus trees will be coupled with the vessel and will produce a fine water mist or fog. As the sun [rises] high enough in the sky to see inside the vessel, the panels... reflect into the fog, appearing as gold bars. The heat in these reflective bars will cause the moisture to evaporate and move, by natural convection, from the hot side to the cool side, where the moisture will re-condense. The viewer, should he be standing with the sun at his back, looking toward the darker side, will see the phenomena of rainbows, etc., as the moisture re-condenses. We want to place the entire project in a reflecting pond so that it appears to sit on top of the water. The pond should be 20 [feet] greater in diameter than the base of the fountain." |

19. Bell, Larry. *On the Ellipse.* Taos: self-published, 1983, p. 3. | **20.** Bell, Larry. *Chairs In Space: The Book of the Game.* Taos: Webb Design Studios, 1984. p. 12. *Chairs In Space* was installed in a number of versions and configurations in a number of exhibition venues, leading to the sophisticated games of relative placement, played out on a checkerboard, described in detail in this book. Bell created two *Game de Lux* editions, each consisting of a table bearing the playing board, four chairs (more severe versions of the *Chairs de Lux,* made of lacquered wood in one edition, plexiglass — with embedded light

source — in the other), and the playing pieces, colored miniature chairs standing ⅜-inch tall. | **21.** Of the Vapor Drawings, Dinah McClintock observes that "[t]he shimmering areas of perceived color which seem to vie for space within the surface and the modulations which Bell achieves in the intensity of the perceived hues combine to effect an undulating, expansive quality similar to the breathing quality of Rothko's meditative canvases. Yet at the same time the ability of the thin films to reflect and refract natural light fixes and locates the physical surface of the image." McClintock also notes that "Bell's use of paper insets to create simple geometric shapes within the image disrupts the continuity of the optical space which he has established. However the consistent radiance and iridescence of the surface unifies the space visually. The space becomes simultaneously shallow and profound, and the tension between depth and the integrity of the surface plane no longer disrupts the viewer's visual experience." McClintock, Dinah, "Light, Space and Surface," in Otten, Willam G., ed. *Larry Bell: Light on Surface.* Laguna Beach CA: Laguna Art Museum, 1988. p. 6. | **22.** Guerin, Charles. *Larry Bell: Vapor Drawings.* Laramie: University of Wyoming Art Museum, 1995. n.p. | **23.** "When I moved to New Mexico in the '70s," Bell states in a recent interview, "I was in the middle of explorations of large glass sculptures. I found that it was difficult to get the kinds of materials I worked with and it was also hard to find good help... Subsequently I decided that I could not carry on with that body of work and expect it to sustain itself. So the glass pieces were never finished and I never resolved the issues I had introduced. I recently discovered a fabricator in Germany who can do glasswork of the nature I used to do, and since they're set up to do it, they do it much better than I ever could. I've commissioned them to make a series of eight large pieces which are based on drawings of works that were never realized in the '70s. The new pieces are four panels of glass that I put together to make a single tableau...." Quoted in "The Universe of Larry Bell," The magazine, Vol. III no. 10 (May 1995), p. 13. | **24.** Writing about the greater spontaneity the Mirage Works allow Bell, Meg Scherch notes that, "Ironically, the most shocking elements in the Mirage Works is one which might almost stand as a sign of improvisation: the gestural brushstrokes. Though the mirages are impeccably crafted and beautiful, when I first saw the slashes of banal white paint across the elegant and lyrical effects of the vapor coatings I thought an act of desecration had been committed. The paint seemed foreign, an intrusion, like graffiti on a billboard or a moustache on the Mona Lisa. It was like hand markings applied to a photograph, marks which seem to interrupt the continuity of the imagery sealed in the surface emulsion. At the very least, the vapor coatings, now incorporated into the construction, had lost the pristine specialness they had in Bell's Vapor Drawings. ▪ The gestural marks are broad swipes of paint. Bell covers large sheets of plastic film with them and, after they are dry, cuts out those he wants and incorporates them into the mirage construction. The plastic sheets hanging in the studio give the appearance of elaborate, Abstract Expressionist shower curtains." Scherch, Meg, "Larry Bell: Vapor Drawings," *Artspace,* Vol. 12 no. 4 (Winter 1988-89). p. 19. | **25.** "The collages lent themselves to a variety of emotional stimuli," Bell has written. "The components were made for each run of work. Making those components was affected by my state of mind. Combining them allowed a release of feelings that were frozen into the imagery. In the last series of Mirage Works, I got more personal with the imagery. I did this by personalizing the components. There is nothing more spontaneous, improvisational, and intuitive than a person's signature. ▪ Most of the components were generated with some aspect of my initials [introduced] into the various layers... Example: A sheet of clear Mylar may have been cut very quickly with a sharp blade. The strokes of the blade cutting the letters L.B. through the plane. The opening of the Mylar plane with this release allowed an otherwise impossible convolution to take place with the plane when I twisted it." Letter to the author, *op. cit.* p. 2. | **26.** Baron, Todd, "Larry Bell," *Artscene,* Vol. 11 no. 7 (March 1992). p. 21. | **27.** Scherch, Meg, *op. cit.* | **28.** It should be noted that, while the pseudonym "Dr. Lux" would seem appropriate to an artist engaged with light, it actually devolved early on from an affectionate nickname given Bell by his friends for his generosity and sometimes less-than-frugal habits.

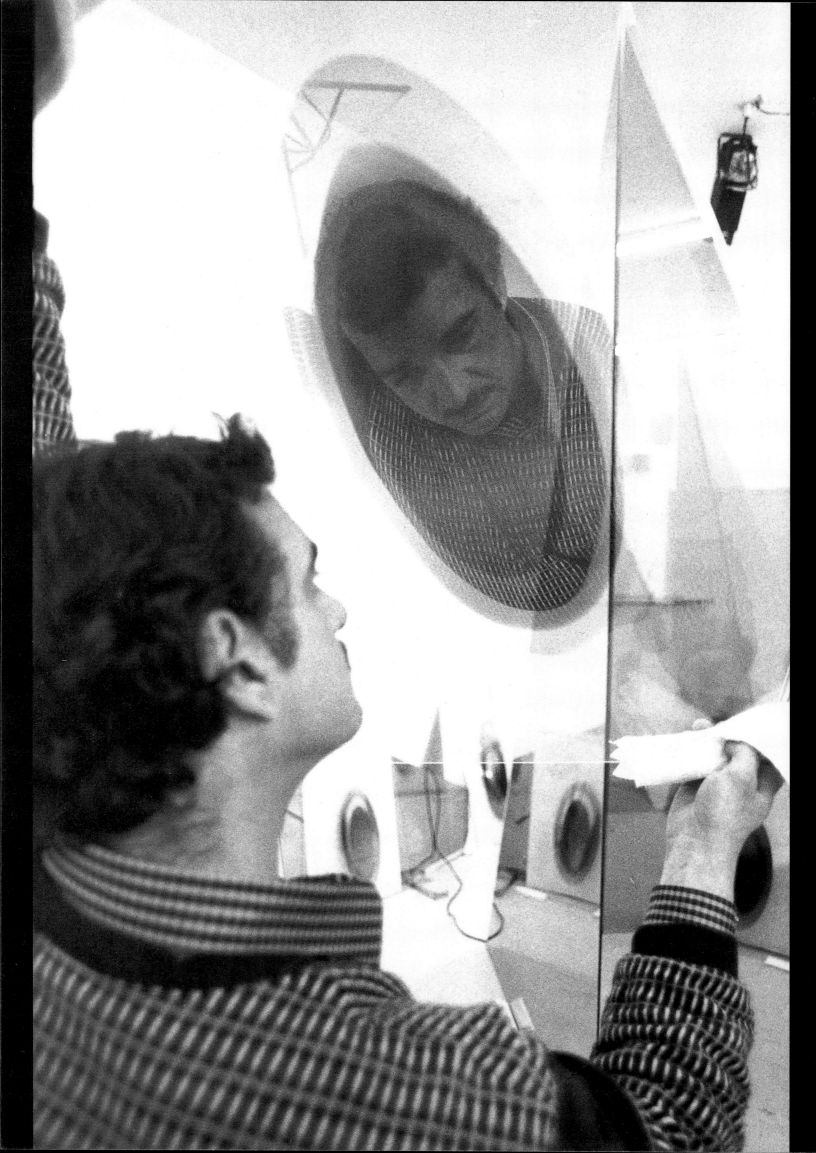

most experiences are unsayable,

they happen in a space that no word has ever entered,

and more unsayable than all other things are works of art,

those mysterious existences,

whose life endures beside our own small, transitory life.

—Rainer Maria Rilke

Shaping Light
Light & Illusion in the Work of Larry Bell

Douglas Kent Hall

Two qualities stand out in Larry Bell's work: light and illusion. No matter what materials he chooses to use or how he shapes them, these elements, light and illusion, frame his production and define his objective.

Bell works in a circle. Perhaps not a perfect circle. By all appearances his circuitous course looks more like an ellipse, which is a circle seen from, say, a forty degree angle, a shape which has inspired so much of his art. As he moves along a continuum, conceiving of new projects and formulating ways to realize them, Bell loops back again and again to ideas and methods he developed earlier. He makes no attempt at repetition; he simply draws to each new idea everything he has previously learned that will help bring the project to life.

Bell conceives and executes every piece with a profound sense of purpose. An indefatigable worker, he devotes long hours to formulating concepts and assembling materials. Once he pushes past the investigative phase of a project, once he solves the technical problems necessary to generate the art, the pieces flow with seemingly little effort. Not everything happens at once, of course, or in an orderly fashion. And not every idea comes to fruition. Far from it. Certain projects reflect

BELL IN HIS TAOS STUDIO, CIRCA 1984. PHOTOGRAPH BY DOUGLAS KENT HALL.

years of preparation—conscious and unconscious. His most recent output, for example, small light paintings crafted from pieces of various unused elements shelved in his studio for years, now number in excess of fourteen hundred.

A brief and eccentric art education at Chouinard left Bell disillusioned though no less determined. He received his best training in his own studio by painting his way out of abstract expressionism. He gave up the constraints of oil paint for the speed and more satisfying surface he could achieve with acrylics. He began to gravitate toward sculpture by snipping away at his canvases. If he had a method it was purely intuitive.

His talent developed rapidly; and with it emerged the habit of laying down an idea and then circling back at some later period, as if to reconsider it from another light. The glass cubes, his earliest work to attract widespread attention, grew out of paintings that suggested sculpture. In fact, a foreshadowing of the cubes and of many other series that would occupy his time for decades is embodied in his 1960 painting called *Little Orphan Annie*. So named for its orange color, *Little Orphan Annie*, with its hard-edge imagery, its preoccupation with surface, and its carefully chopped corners manifests Bell's frustration with the two-dimensional canvas and with painting itself. The acrylic forms on the canvas mirror in reverse the shape of the canvas itself and suggest a three-dimensional reading.

Bell's involvement with glass happened in a similar manner. During the early 60s, he made frames for a living. He cut glass and mirror, and became intrigued by the potentiality of those materials. He began by constructing small shadow boxes, using glass he had broken and then reassembled and positioned so the line of the break was cast on the back of the box.

By 1962, he had begun incorporating glass into his canvases, possibly in response to a desire for a surface more uniform than canvas that would also allow him a sense of expanded depth. *Conrad Hawk*, for example, assimilates glass into the painting almost as a basic exercise to contrast surface textures. *Lux at the Ferus* goes a step further, introducing moving doors inside the piece that can be activated to change the interior light, an attempt at the quality of illusion he would later achieve through a more complete mastery of his materials. In *Ghost Box* he renders into perspective the cube shape; a square glass piece inset into the canvas acts as a kind of quirky commentary upon the illustrated volumes contained in the painting itself. In fact, *Ghost Box* serves as a sketch to outline his subsequent pieces and provides a neat illustration of his *modus operandi*.

Bell investigates all available possibilities and options, often considering improbable methods and materials, and then allows intuition to dictate his best move. No clear-cut periods divide his production; he advances from idea to idea and then he regresses. He takes a bold step, makes his statement, then circles back. Seen in an exhibition, his work appears to follow a systematic progression, almost as if the thinking were complete before the painting or fabrication began. The reason for this lies in the fact that his craftsmanship is flawless, the details repeated with mechanical perfection. Nonetheless, no particular series of work appears to be concluded, and no pattern emerges to explain his digressions.

One possible reason for Bell's returning to previous ideas may be that he himself is never fully satisfied. Invariably, he retraces his steps—as in the later cubes (made in the 1970s and 1980s) and his most recent canvases ("painted" in the 1990s)—infusing the next output of pieces with the energy, methods, and sometimes even the materials left over from work he has just completed. *Death Hollow, The Aquarium, Untitled (Magic Boxes)*, and numerous other works from the early 60s indicate that practice. Upon careful consideration, one can see how they prepared the way for the glass cubes. On the other hand, a particular cube, *Larry Bell's House (part II)*, uses as its motif—presented almost as a whimsical footnote—a repeat of the kind of imagery featured in his earlier paintings.

In Bell's hands, common industrial elements—glass and paper, mirror and chrome, fabric and mylar—take on noble qualities. The first cubes, including those mentioned above, exploited the complexities of the glass surface as well as the relationship of planes and shapes rendered on the glass. Mirrored, etched, sandblasted, painted, these cubes had the solid look of objects. Although they seemed jewel-like in the perfection of their craft and though they were often reflective or partially translucent, they remained specific—contained objects that manifested a certain volume.

For a brief time, in fact, critics and theorists, in their attempts at putting Bell in a niche, identified him with the Minimalists, singling out the early cubes as examples. Though not as impersonal as Marcel Duchamp's readymades, which exemplify the Minimalist intent, Bell's cubes embodied—partly due to his skillful use of industrial materials—the machined look of an assembly line piece. Superficially, his cubes fit the criteria of the manufactured object. But as objects they proved infinitely too interesting and complex to satisfy the entire Minimalist doctrine. Some of the most intriguing, most beautiful, and clearly not so minimal cubes depicted a series of ellipses, a powerful geometric figure that would reappear as an important element in many of his best pieces.

Glass, the hard-edge look, the perfect finish, the automotive or industrial precision and everything it implies, all characterize aspects of Bell's work and place him within the

framework of the best West Coast art, a baroque modern tradition he shares with Billy Al Bengston, Ken Price, Craig Kaufman, Robert Irwin, Peter Alexander, James Turrell, DeWain Valentine, John McCracken, Doug Wheeler, Ed Ruscha, and others.

However, Larry Bell's art stands apart from the work of many of his West Coast peers. His output as a whole avoids the mental constructs that make contemporary art tedious by presenting instead an astonishing visual integrity. His pieces resonate with ethereal beauty. Individual works created of technically complex elements that might be explained on one level in purely technical or scientific language come across as sensuous and vibrantly romantic.

Griffin's Cat (1980), a Vapor Drawing on paper *EL 25* (1981), and a mixed media work on canvas from the Mirage Works *The Old Dirt Road* (1989), illustrates this point. He shapes and surface-coats his glass components according to experience; from that point on, light resonates, initiating the illusion and affecting a subtle and unending change until ambient space becomes part of the piece. In the Vapor Drawing *EL 25*, for example, the light playing back from the paper, through the coating, shifts both the color and intensity that govern the relational values of the image. *The Old Dirt Road*, with its complex overlaying of collage elements and a rich color mix of pigments in addition to the ephemeral metallic coatings, draws in light and returns it with a surprising display of

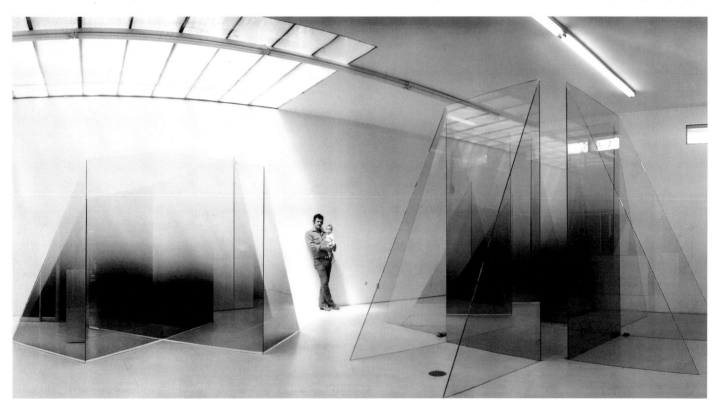

HOMAGE TO GRIFFIN, *1980, COLLECTION OF VALLEY BANK, RENO, AND* THE DILEMMA OF GRIFFIN'S CAT, *1980, COLLECTION OF SAN ANTONIO MUSEUM OF ART.*
½" COATED GLASS, TAOS STUDIO INSTALLATION. PHOTOGRAPH BY GUS FOSTER.

In about 1970, Bell reached the realization that his work dealt primarily with light, the perceptible volume of light, and the illusion issuing from the interplay between form and light. He had only to teach himself a vocabulary that would allow him full range to express that point. The cubes he created in the 70s and 80s, with the more exotic coatings, that depended less on definite patterns to their sides, did in fact transcend the constraint of sculptural object. They became volumes of light that expanded subtly and challenged the viewer to question the idea of perception.

Light is Bell's chosen medium. Illusion, then, is the magic that makes it perform. Light serves him as both a tool and a product. A consideration of differently conceived and executed pieces such as a large glass sculpture *The Dilemma of*

depth. Like many of the other Mirage Works this piece achieves an illusory quality equal to the cubes.

Without detouring into the brain-field theories of the Gestalt psychologists, one can say simply that vision depends on perceived electro-magnetic wavelengths continuously fed to the brain through the eyes. Illusion, in turn, issues from the constructs set up in the brain in response to what one sees and how it is altered by various entities either singly or in combination—optical materials, color, reflection, etc. For Bell, then, the mere shape or form of a work, a cube, for example, or a mitered glass panel engages his attention less than how that object performs in light. As a form, the cube is simple, elemental, and in that simplicity, elegant. Precisely because of their deceptive simplicity the cubes radiate,

48

reflect, attract, and contain light; one might also say light inhabits the cubes, acts upon the immediate surfaces, illuminates existing space, and engenders the illusion of space. In any case, light sparks their life, produces in them an inherent energy that advances beyond form. And in each piece the exchange and interchange between light and form, light and space, light and light appear to be infinite.

If he sometimes shows a preoccupation with technical matters, he melds that scientific demeanor with the illusionist qualities noted above, or with techniques borrowed from the film culture. In the celluloid world the constructs are deftly masked or left offstage. With that in mind, Bell creates space that can be entered, a situation that can be experi-

The complexities of light dominate these mature works. Confusion between surface and coating precipitates change in ambient space. The pieces mirror themselves or a larger or smaller rendering of themselves and constantly shift color and shape as the viewer moves around them and observes how the planes undergo change and interact with environmental space. As a particular piece engages the viewer, its changing shape, color, and spirit give evidence that the solid object, the measurable glass, is only the beginning of the experience.

The various effects Bell produced within the cubes and around the cubes appear dramatically more pronounced in the larger, seemingly less complicated pieces created from

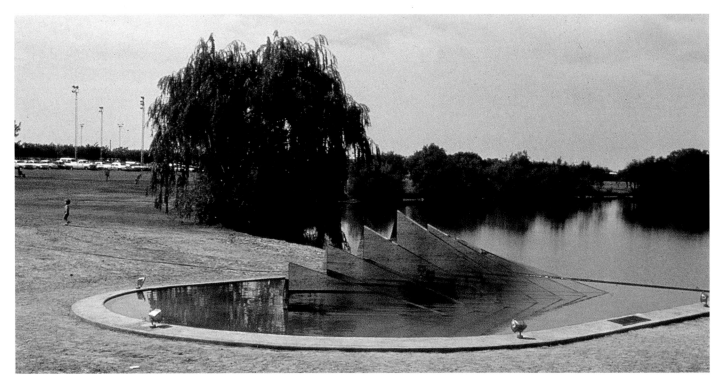

THE WIND WEDGE, 1982, 14 PANELS, ½" COATED GLASS, COLLECTION OF ZOOLOGICAL GARDENS, ABILENE, TEXAS. PHOTOGRAPH BY LARRY BELL.

enced, a circumstance that carries seeing beyond the limits of simple recognition. Even in the studio, surrounded by the clutter of the workplace, his pieces generate illusory and metaphysical impressions. In a gallery setting where the effect can be regulated to a greater degree the consequence is magical.

At the end of the 60s, when Bell briefly moved away from the cube, which could be perceived as both container and object, and turned to standing sculpture, eliminating at least part of the rigid right angles and expanding the scope of his investigation, his world became at once less complicated and more ordered. In pieces as varied as *The Iceberg and its Shadow, The Cat, The Wind Wedge,* and *The Pink Compass* his fascination appears to lie with surface and volume and the illusion of volume as well as the extent to which he can employ the panels to attract and alter light on a broad scale.

simple standing panels. Interestingly, no opportunity exists for a clear or "pure" view of the sculpture once it has been fabricated. Perhaps that is, in part, the artist's point. Surface-coated in a vacuum, they can never again exist in a vacuum, can never be seen independent of their environment. Indeed, their environment, consisting of gallery fixtures or lack of fixtures, the color and texture of the walls, ceiling and floor, become part of the piece. People too are transformed. Again, light plays the dominant role. Constantly in flux, the pieces flow, they appear to liquefy; they seem to disappear, then re-form.

Glass itself presents infinite possibilities—as it is perceived at the moment as an element known by experience. (The message is different, for example, from plastic, which shares similar properties of light transmission.) The slight flaws in glass as well as its optical properties of surface and

edge distortion add to the experience of viewing Bell's glass sculpture. The idea of fragility speaks to the viewer, soliciting judgment, inviting caution, heightening the effect; this familiar quality is adumbrated by the soft flow of light and the sound echoing from object to object, object to wall, object to ceiling. Thus the illusion is compounded, reconfigured, and made more complete.

As Bell's confidence and understanding grew, so did his ability to utilize the properties of glass. Large six by eight foot standing glass panels, coated in Germany in 1994 and shown in Paris and Los Angeles, recall a densely coated standing wall Bell created in 1971 and an untitled piece done three years later. However, the newer pieces carry a less substan-

work a halcyon quality. Even the most vibrant pieces instill a pervasive sense of quiet. A special consciousness, an essence initiated as form, light, and space come into concert. Light reminds us that it is indeed light, that it possesses color and substance, but that it is also arbitrary. And an understanding of this arbitrary quality is of vital importance to comprehending his overall design.

Bell expresses less interest in presenting a particular object as an entity than in defining and exploring the limits of perception that the object inspires—whether it is a cube, canvas, or larger glass sculpture. He sets out to define both the ways of seeing and the possible nuances of vision. Therefore, much of his enthusiasm lies with the gradations

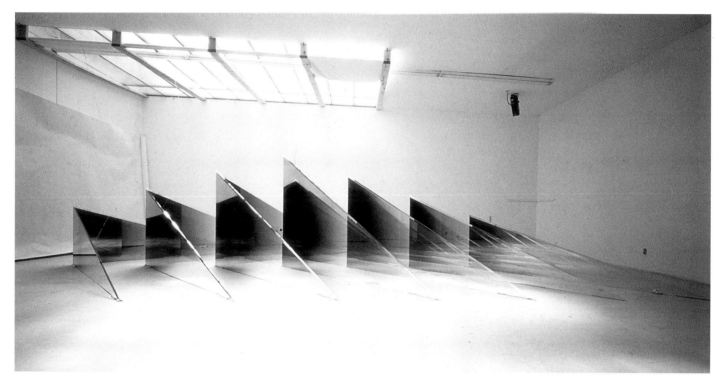

THE WIND WEDGE. *INSTALLATION IN TAOS STUDIO, 1982. PHOTOGRAPH BY J. GORDON ADAMS.*

tial coating, allowing light to flow, which initiates a subtle dichotomy between room and illusion of room. The effect is similar to the feeling produced by the large cubes of the mid-80s, especially those finished without stainless steel frames. Light moves freely, generating a profound overall impact. The consequence of so many reflecting surfaces on the sculptures, defined by varying degrees of opacity or translucence on each of the several surfaces, causes the object or the illusion of contained light in the object to float, to hang and flow, like mist rising from a pond. In this context, the piece visually becomes both the object and the environment it creates around itself. Space can be empty or full—substantive or void.

Illusion in Bell's work is not entirely visual. For all the turmoil of his studio activity, amplified by heavy equipment and complicated and precise processes, he achieves in his best

and values of light, in the way light can shift space and alter or suspend our sense of time.

Larry Bell uses light with as great an effect as any artist alive. Even after experiencing the impact of a large number of his pieces, one would be wrong to say his design is to control light. Bell himself has admitted that light is impossible to control. He surrenders to the seductive power of light and allows his imagination full play.

The use of glass in sculpture, with its three-dimensional qualities, requires one kind of intelligence, one kind of esthetic; the use of canvas and paper, with their two-dimensional limitations, requires another. This is the stuff of academic discussion. Bell chose to ignore these rules. He began with the two-dimensional plane, struggled until he stretched it into another dimension in which painting imitated sculpture, moved on to the cube, a strictly sculptural shape, then years

50

later spiraled back to paper, to canvas, to the flat surface. In so doing, he brought to paper, to the two-dimensional plane, a separate knowledge, the legerdemain he had developed in his efforts to shape, etch, and coat glass.

Paper reflects light and absorbs light in a manner very different from glass. The artist's powerful curiosity allowed him to ignore that idea. In creating the Vapor Drawings, he experimented by applying film deposits onto paper similar to those he applied to glass. In the beginning, paper demanded a design as formal as the paintings and the early cubes. The ellipse emerged once more, less perfectly realized, but shimmering with a rich flow of light. Varying ribbons, bands, and other formal elements appeared on the Vapor Drawings of the

cated and largest (*Moses X-ing the Delaware* measures 96"x283"), bring together the elements used in earlier series. His palette is limitless; color transmitted from the pieces is dazzling and bold, or it is muted and subtle. The texture of canvas, with its imperfections, the very quality that once drove him to use glass, becomes the perfect repository for assemblage on this scale. He manages space like a classicist, creating forms on the canvases with an inventory of materials as diverse as crumpled Japanese paper, bits gleaned from failed Vapor Drawings, fabric, and mylar coated with quartz or inconel. The ideas are masterfully resolved. In other images, he spreads generous painterly strokes of acrylic paint onto laminate films, a glue that disappears with heating to leave

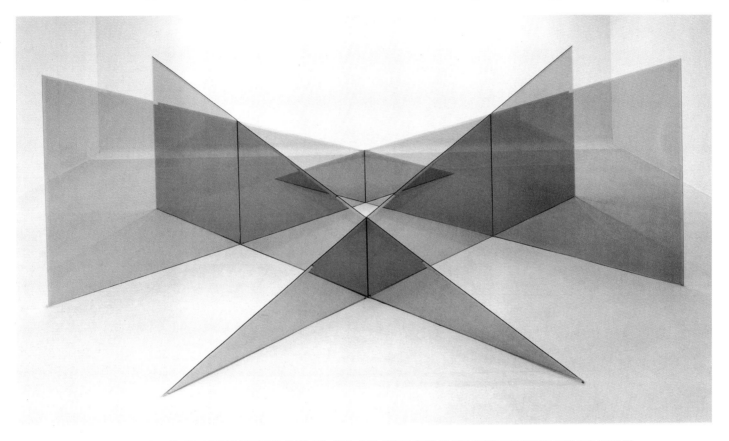

PINK COMPASS, *1983, ½" LAMINATED PINK ROSA GLASS, 72" x 216" x 216", INSTALLATION AT ARCO CENTER FOR VISUAL ARTS, LOS ANGELES. COLLECTION OF LAURA STERNS. PHOTOGRAPH BY THOMAS P. VINETZ.*

mid-70s. By the mid to late 80s, however, the imagery had grown looser, more painterly, more complex. Although the coated paper lacks pigment as we know it, the coating creates a reflective surface that transmits color in the way a prism presents the color spectrum. When light strikes the surface of the coated paper it is reflected back through a varying thickness of quartz or some other substance. The color seen by the viewer is established by the thickness of a particular wavelength of the reflected light. Color and intensity shift as either the light moves or changes or the person perceiving the piece changes the angle of view.

Bell's process of painting with light ascended to a high point in the Mirage Works. These canvases, his most sophisti-

only the lyrical stroke of the brush. Or he simply applies paint directly onto the collaged materials, still working with the same lavish strokes. Their monumental size, exploitation of materials, lyrical use of light, and brilliant color elevate the Mirage Works to the degree of a major achievement.

Fundamental to an understanding of Larry Bell the artist is knowing that to him no part of his work is final. He collects, he saves, he hoards—in his art as in his life. His shelves burgeon with unused elements, pieces he failed to complete, components he found unusable but felt compelled to keep. His art is largely about process; the process goes on continuously. He takes unsuccessful glass panels, orders them recut and mitered, and they work. Or they don't. Like a poet revising a

line, his art is organic; it grows; it evolves. His artistic ruminations span decades.

His ongoing series of collages, which he calls Fractions, small pieces assembled in his mounting press, have resulted from a kind of massive recycling effort. Nothing about them is new, except the paper. He cut choice sections from older, larger, canvases he once rejected out of the Mirage Works and from sheets of the laminate film with brush strokes in black, white, and the primary colors, and began assembling the elements. His excitement pressed him to work at a feverish pace. Not only had he returned to earlier works on canvas for his materials, he had used a side panel cut to fit a glass cube as a template for tearing the French watercolor paper. In addition, the component pieces he applied to the paper were often cut in the pattern of a rough square and once they had been fused to the paper their form became hauntingly reminiscent of the early group of canvases that prefigured the cubes. These small, painterly renditions illustrating the volume of the cube again brought him full circle. Back to the beginning.

The Stickman series came as a surprise to Bell. Standing in juxtaposition to everything he has produced in three decades, they present a puzzle, a conundrum that stretches credibility. Bell himself does not find that particularly troubling.

Recently, while he was engaged in thinking through the ideas for a site-specific light sculpture, he began to experiment with a computer drawing program he felt might be functional to the project. A copious series of sketchlike drawings representing the human figure, which he called Stickman, or Sumerian, resulted.

Rendered with an intuitive freedom characteristic of Bell's best work, Stickman represents a giant step. He created the figures complete with a mythology based on ancient texts appropriated and altered to fit his purpose, which he may have written as much to appease his own reluctance about the figures as anything else. Still, the narrative, which he calls Sumer, serves to compound the irony and lend Stickman a strange credibility. Bell's Sumerian stands mute, enigmatic, and featureless. Imposingly impersonal on one level, on yet another level he is imbued with personality. He exhibits an affecting presence and an attitude rich in humor. Increased to full size, Stickman gains astonishing power and looms ominously, becoming the embodiment of the abstract, the apparitional, and the impersonal.

Most striking about Stickman is the fact that its power and essence arises from shadow, from chiaroscuro, indeed, from illusion. None of the familiar features dominate. In the paintings, rendered in acrylic on canvas, with the hard edge style Bell employed in his early works, the figures come across with the flat, reversible quality of pure shadow. They also recall in a curious way the early frame shop boxes into which he fitted a cracked glass panel to make the shadow of the crack his focal point. Stickman stands as the shadow of what is basically the personification of a shadow. And perhaps this abstract, notional quality, stemming from illusion, ties the figures to the larger body of Bell's work.

Stickman manifests bearing and generates the kind of silent presence inspired by Bell's most powerful glass sculptures. The paintings and especially the cast bronze Stickman figures present curious, somewhat awkward relationships. An attitude of isolation or loneliness occupies the single figures, theatrically amplified by their unwieldy though fluid posturing, as in *STMC #25*. In concert with a second figure, as we see in *STMC #12*, community begins to establish itself; this cautious relational unity lends humanity to the figures' more abstract aspects. Suggesting an array of meaning, literal and profound, they dominate and exude importance and presence.

Embodying neither the measured physical perfection found in Michelangelo's figure drawings nor the sensuousness of Cezanne's richly painted figure, the Stickman forms emanate from an unfamiliar quarter. They will undoubtedly arouse skepticism and generate controversy. Whatever their reception, these new Sumerians are pure Bell, product of the light and illusion that govern his work, and their purpose is decidedly his own. ∎

I love beginnings. Thinking about old work makes me nervous. Some of it I like.
The rest of it has me confused, not because I don't like it, but because I can't remember why I did it. I have a passion for the new, what's being done right at the moment. The conception.

In Reflection

Larry Bell

Having been given the opportunity to do a survey exhibition for The Albuquerque Museum allowed me to reflect on a vast body of projects. What's appealing about doing something like this is thinking about why I did it in the first place. In most cases I can remember the beginnings, how the genesis of the ideas developed. What they were all about mystifies me.

After many years in the studio I found that the light from the surface was my predominant media. The *interface of light and surface.* The reader may come across these words quite often in the ensuing statement. I beg patience. While "light and surface" is a rather technical triptych of words, my emotional concern is how it feels to make the art. I've always been a hands on artist. I like fussing with materials, arranging things, either sculptural or flat.

My studio is about putting things together. Whether the materials are tactile or conceptual. I love objects. I collect things: hats, guitars, tools, H.G. Wells signed editions, stuff that makes me feel good, or has some other sensual input to my imagination. My wife once told me that I had to get rid of stuff. Namely shoes. I had kept every pair of shoes I ever owned since high school. That's a lot of shoes. Each pair brought back memories of good and bad times; each pair was loaded with some special feeling. Recently I was asked to donate some shoes to a museum

54 of artists' shoes in Belgium. I'm sorry the invitation didn't come sooner. I had disposed of the shoes in lieu of my wife disposing of me.

Back to the concept of the studio: it's similar to a closet full of old shoes. Lots of options. New shoes are probably the most attractive, but the depth of the collection provides security. Each pair has a loaded manifestation, reminding me of ideas and places I have been through. My concept of style.

A survey exhibition is a bit like showing off the old shoes. It makes me ask myself: Do I still fit in the style or the shape? Am I still interested in the look?

When I think about the various projects with which I have been involved, I discover a *diverse continuity* to the studio activities. I will try and describe that diversity.

It may be the most important aspect of the work, and thinking about it while putting together this show may hold the greatest value for me.

The Albuquerque Museum installation presents various examples of the work from different periods. It also shows the feeling of my studio and the objects I saved that have melded my personal weirdness with my studio weirdness. The two elements are shown together to give the viewer a feeling of both the sensuous quality of the work and the amusement and humor that diverted me from the studio.

Light & Surface: I began making things after learning what art school teaches, such as perspective drawing, figure drawing, painting, and printing. I wasn't a student for very long.

I had a job at a picture framing shop at that time, and came into contact with glass as a potential art material for the first time. I played around with scraps of glass after framing someone's watercolors, or family pictures. The edges of the stuff fascinated me, and the way it simultaneously reflected and transmitted light. Using some shadow boxes sold in the store, I made constructions fabricated from glass and the paper used for the back of frames.

I placed pieces of glass in the shadow boxes, then cracked the glass. The result was an intriguing dual effect—the cracked glass threw a shadow and also a reflection of the crack on the paper. I made a series of small constructions in the idle time of that job.

At this same time, in my little studio, I painted with oils in a manner of the abstract expressionists. As I worked with these differing approaches, the imagery became more organized, and had the feeling of windows, and checker boards.

The small constructions influenced the paintings, although at the time I never consciously connected them.

When I discovered acrylics, I found the medium a lot easier to control, and the imagery began to illustrate volumes like I constructed at the framing shop.

The images I did in acrylic, with one color on unprimed canvas, led me to try and make the pieces more dimensional. Maybe I could include something other than paint in the imagery. I decided that glass would be perfect.

Adding glass was totally intuitive. I liked the work's feeling of simplicity, and the fact that the imagery now included the wall behind the canvas. This led to incorporating the light in front of the canvas in an "unpainterly" way. I chose mirrors to replace the clear glass. I scraped away the silvering so that the reflected light and the transmitted light created the shape of a tessera, which was also the shape of the canvases.

Representing volume, created with light, reflected and transmitted, was now part of my process.

I created pieces very quickly, and natural impatience and

MARKET STREET STUDIO, VENICE, 1962. PHOTOGRAPHER UNKNOWN.

passion to make changes in the work led to constructions that had no paint, were made out of glass and silver-leafed wood, and then just glass. Unconsciously, I had become a sculptor.

The above discussion technically describes how the idea of an image can metamorphose the character of the intent. It does not tell much about the stuff that changes the character of the person. My peers and mentors influenced me in an amusingly odd manner.

Shoes & Clothes: The personal style of the artists I admired and emulated affected me as much if not more than my own work. I didn't study the arts exhibited in the museums, or the books, or magazines; I studied the style of the artists whose work I loved and respected.

Personal style meant everything to the group I hung with. Fortunately, these mentors had strong feelings about work, discipline, and the role they played in the art scene. I loved it, and absorbed a lot vicariously.

In a not superficial way the humor of my Venice friends affected me more than the art being done by other young people in New York or San Francisco. Personal style was a way of showing faith in the work.

An acknowledged tyranny existed within the group. Each of us performed with the kind of style other members of the group respected. It not only dictated the uniqueness of our art, but also the way we dressed and the way we distracted each other from the work. In some cases those distractions included playing the horses, or hanging around the fancy hookers of Hollywood. Humor was everything.

Billy Al Bengston's style totally infatuated me. He was the kingpin and style maker of the group. He taught me to be competitive in my style, how I dressed, and to respect exaggerating the importance of my work.

Choosing the right clothing in which to make an appearance became as much of an obsession for me as trying to be unique

CHAIRS IN SPACE/GAME DE LUX, *PROTOTYPE, TAOS STUDIO, 1983.*
PHOTOGRAPH BY DOUGLAS KENT HALL

in the studio. I found myself in thrift shops hours a day looking for shoes, hats, and the right jackets. Bengston and I had a regular rendezvous rummaging for special seven-fold Sulka ties with moire patterns, or custom Brooks Brothers sports coats.

I still have a few items that were purchased in those days, and I have decided these things are as important to me as work that has survived the years. Both survived because I loved them so much.

Remembering shoes and clothes may seem a bit superficial to the reader, and it may in fact be. I am trying to convey the importance of the personal style I had to maintain to feel a part of the group. How I felt about myself reinforced my art work.

In those days I did not differentiate between the things I did to make myself feel important, and the importance of my work in the studio. To be important, I had to feel important. Having style as a hobby was creative, great fun, and extremely important to all of us. In a way the humor and style of my group affected the art scene of Los Angeles.

Almost no audience existed for the work created by my mentors. Yet people recognized the group's characteristic personal style. Not all of us specialized in buying used clothes.

Some of us bought used cars that cost less than fifty dollars, with a special one-of-a-kind style. Ed Moses collected top coats—top coats in Los Angeles were definitely esoteric.

Each member of the group demanded respect. The kind of unspoken respect that made us feel the importance we thought we deserved. If anyone ever let on that they didn't think they deserved respect, they definitely would not get it.

Guitars: I am straying from discussing my work in order to set the tone of the early 60s. As the years pass the lessons learned in those days fade, but collecting special "non-studio" items remains a passion.

I worked my way through art school by playing the guitar and singing folk songs at coffee houses around Los Angeles. I worked in a Hollywood club with Lenny Bruce. Because Bruce's humor impacted all of my mentors, and I worked with him, I felt Jewish.

I collect old acoustic guitars. I started collecting them when I played in coffee houses around town. Now I collect them because of their weird beauty, the memories they evoke, or for the strange sounds they make. Having them is sensuous, and inspirational. Collecting things that make me feel good is the same as collecting talismans, something charged with the ability to store mystical powers and then release those powers on command. Stored energy.

In my opinion all artwork is stored energy. The art releases its power whenever a viewer becomes a dreamer.

Art releases its energy to the artist in many different ways, and that energy always guides the direction of the artistic sensibility. Artists cannot escape who they are or what they do. Change comes within the work when the artist absorbs the energy created by the studio activities, thus creating more energy, and honing the sensibility. It happens in my studio unconsciously. It happens all the time. I like to call it dynamic energy.

The work presented in this exhibition is about that energy, and that sensibility.

Angles & Cubes: The corners of my studio seriously affected the architecture of my work.

Probably the most ubiquitous shape in our environment is the right angle. We live with it every day and have learned not to see it. I challenge the reader to take a moment from this text, look around, and count the number of ninety degree relationships they see. I don't believe it can be done; there are too many. I decided to use the ninety degree angle as a vehicle in my art because it is so common an element.

The other form that has given shape to my imagery is the forty degree ellipse. We view most circular objects from an oblique angle of about forty degrees. The tires of our car, the dishes on our dinner table, are rarely viewed directly at ninety degrees. Cosmic forces like the Andromeda Galaxy pro-

foundly influence our mundane everyday existence. Andromeda pulls on our Milky Way Galaxy from roughly forty degrees. To think that such power is irrelevant to our lives is to ignore the beauty of the influence. I chose to not ignore it.

I worked on the first series of cube sculptures for about eight years. They had patterns of ellipses, and checker boards, evolving to nothing more than subtle changes in reflected and transmitted light. Developing this work was singular to me. I had not seen anything that looked like this work before. It turned me on, and kept me feeling very aggressive about it. Part of the uniqueness of the cubes was in their construction method, and in the glass itself.

Emotionally and narratively invisible, glass is a common material used everywhere in our society; it's easy to get and relatively cheap. Because of its optical qualities, I could change the way light interfaced it by coating its surface with thin metal films.

A plating technique used commercially for optics and other hi-tech applications was readily available in Los Angeles. When I discovered the subtle visible changes possible using this technique, I became fascinated with it. "Charmed" is a better word.

For a few years I had my plating work done by a firm in Burbank, California. A chance encounter with a novelty metalizer in New York led to my buying a used piece of this equipment. I could do it myself. This acquisition changed everything, for not only was I the first kid on the block to own such a contraption, but the work began to flow with an ease that I had not experienced before. Most importantly, I was learning something new.

The learning curve was dramatic, and in a very short time I produced a vast amount of interesting work.

Some of my best work was done from the period of 1965 to 1968, during this initial learning period. The equipment was difficult to use—what it did seemed absurd and improbable, and I was naïve in the way I handled it. But this was lucky for me in a way. Not knowing the pitfalls, I was able to fabricate a large body of work. There's a lot to be said for naïveté.

Corners & Turnarounds: I felt that most of my focus in the cube format related to the corners, the way the light graduated out of them. I decided to change the cube, to make just the corners.

I next built a larger coating facility to handle the gradations on larger parts. The weaving of transmitted and reflected light was one of the unique qualities of the work. One of the others was that no one else worked with material in this manner. The cubes became standing walls and did such marvelous things in any environment.

Public interest in the work grew and I had many shows happening in New York and Europe. This was mainly due to the efforts of the Pace Gallery and Galerie Sonnabend in Paris. I should mention that the work of the Ferus Gallery in Los Angeles introduced me to Sidney Janis who showed my cubes in a group show in 1964. I believe it was there that the Pace people saw them. I moved to New York after my first show at Pace.

But I missed my friends and the Venice lifestyle. So I returned to California in 1966.

Venice & Taos: Venice had been an inexpensive place to live and a fun place to work, until the late 60s when developers in Los Angeles suddenly realized Venice Beach was the last unexploited beach front in the city. Rents and property values began to increase dramatically. Another thing hap-

IN TAOS STUDIO, 1996. PHOTOGRAPH BY PAUL O'CONNOR.

pened; Venice became very violent. I moved to Taos, New Mexico in 1973.

At that time Taos was a very quiet town of about thirty-five hundred people. It seemed to me there were that many people in the several blocks of my former Venice turf. I spent two peaceful, wonderful years starting a family and living in a rural community for the first time in my life.

I had locked up my studio in Venice and suddenly the studio building was sold. I was evicted from the premises. I had to build a studio in Taos.

During the initial two year period in Taos, I worked on a series of sketches for possible sculptures. The new ideas con-

cerned sculptures with tops not parallel to the ceiling plane. This led to my most ambitious project to date. I called it the *Iceberg and Its Shadow.*

The prior works were always symmetrical, parallel or perpendicular to the wall, floors, and ceiling. They were clear or neutral gray glass, with neutral gradient coatings of nickel/chrome. I decided to add color to the pieces by depositing quartz on the surface of the glass; this interfered with wavelengths close to the ultraviolet area of the visible spectrum. The gradients now emanated a bluish cast.

The difficulties of this process were enormous, but the challenge was great fun. I made a deal with the new owners of the Venice building that enabled me to finish a final large piece. I

Masking the paper with thin mylar strips to expose areas related to the shape of the page plane enabled me to generate images spontaneously. This work gave me a conscious glimpse of the inherent power of spontaneity and improvisation. The work happened intuitively.

In a short amount of time I created a number of interesting pieces. I liked this way of working. It was different from tediously coping with the weight and risk of glass. In my mind, I was investigating improbable visuals using improbable means. My work on the variations of *The Iceberg* led me to think about different ways of using the Vapor Drawings.

The potential advantages of using the same parts to create different installations was what *The Iceberg* was all about. So,

GALERIE SONNABEND, GERMANY, 1967. PHOTOGRAPH BY ANDRE MORAIN.

then moved all my equipment out of Venice to the new facility in Taos. I called that sculpture *The Iceberg and Its Shadow* because its numerous permutations, in any given installation, would only reveal the tip of the piece. *The Iceberg* consisted of fifty-six panels that could be put together with a factorial number of possibilities. For example, 56 x 55 = 3080 possibilities, 3080 x 54 = 166,320 possibilities, 166,320 x 52 = 8,814,960 possibilities.

After several years of working on different installations of *The Iceberg*, I began a new format for my experiments with the surface interface of light. Images generated on paper using the same techniques as with glass.

Vapor & Paper: I called the work *Vapor Drawings*. By working on paper I could add the element of absorbed light to the reflected light of my earlier experiments. Paper was a lot cheaper to work with than glass. The ability to use my coating technique expertise, and eliminate the tedious and back breaking lifting and cleaning of the glass, liberated me.

too, it became with the Vapor Drawings.

Lamps & Chairs: Back to glass and corners: I began a series based on earlier wall pieces I called *Shelves*. This work led me back to corners. The *Corner Lamps.*

While the beauty and simplicity of the concept appealed to me more than anything I had ever done, the installation of the work was demanding. The ambient light had to be controlled, the projectors that I used to illuminate the glass had to be finely tuned, and had to stay that way. The rooms in which I placed the *Corner Lamps* required high ceilings, square corners, and flat white wall surfaces. As unique installations they were fantastic; as a component of functional sculpture they were problematic. I wanted more.

I decided to use the lamps in concert with furniture based on the design of an old chair I found in a New York thrift store in 1965. The chair's profile seemed to be exactly one quarter of the forty degree ellipse that I had worked with in the past.

58 When the *Corner Lamps* were lit properly with a projector, they magically reflected and transmitted light into the corner of the room in which they were mounted. The shape of that light was the profile of the chair. In an improvised installation in Detroit I positioned the sculpture called *The Cat* with several chairs and *Corner Lamps*. This improvisation led to the development of my *Chairs in Space* game.

The parquet floor became the checker board, and the rest of the game's visuals were based on the ambiance of all my earlier sculpture installations.

It was a beautiful idea for an edition that sadly wasn't able to meet my expectations. More accurately, I wasn't able to fabricate, promote, and distribute the project successfully.

A sensate interactive concept, the *Chairs in Space* game required strict control of the ambient light to make the visuals obvious. I wanted to do a limited number of games that were table size, and began to develop the idea until my partner, friend, and collector, Dr. Charles Hendrickson passed away. The project languished for almost ten years when I decided to terminate thinking about any further development. The installation in this exhibit is the only finished version of the *Game De Lux*.

Light & Space: After developing the Vapor Drawings and the furniture, I decided to make some more large glass pieces. An undefined need brought me back to the glass. *The Cat*, mentioned previously, was the most successful of my new glass pieces. It consisted of twelve sections: four rectangular, and eight triangular. I coated the rectangular parts with the gradient neutral density films that typified my earlier work.

The Cat had numerous possible configurations. I used it in an improvisational manner wherever I had the opportunity to show it. I learned a lot from this work. The desire to change the way the piece was used became an imperative. It reflected the floor dramatically, creating endless possibilities for visual games.

I also learned from *The Iceberg* that it was not necessary to use every part of any sculpture, should a space be inadequate to accommodate it. My installations changed the feeling of the space the sculptures occupied. Each installation became a tableau of light and surface.

In The Albuquerque Museum exhibition *The Cat* and the chairs represent my environmental light and space work.

Light & Water: Sometimes commissions that *don't* happen lead to interesting ideas. The architect E. L. Barnes, designer of the IBM World Headquarters building in New York, asked me to do something with water and glass. The site was the plaza at the building's entrance at 56th Street and Madison Avenue. It was an interesting challenge. I had never worked with a client like IBM before. They were game for just about anything, as long as it represented the creative thinking with which the company wanted to be associated.

The building's design incorporated an interesting cantilever overhang on the corner where the artwork was to be installed. I designed a model for a large wedge-shaped polyhedron that used pulsed light and water flowing down a large drainboard to a slot on or near the sidewalk. The wedge was eighteen feet tall at the highest point. A slice of a pyramid.

I planned to skin the wedge with the same granite as the building. In the model a translucent central drainboard emitted light upwards under plummeting water. This light would be visible through the water that was pumped with an oscillating device down to the sidewalk.

To contain the water at the sides a series of resin prisms emitted light laterally across the water. The light from the

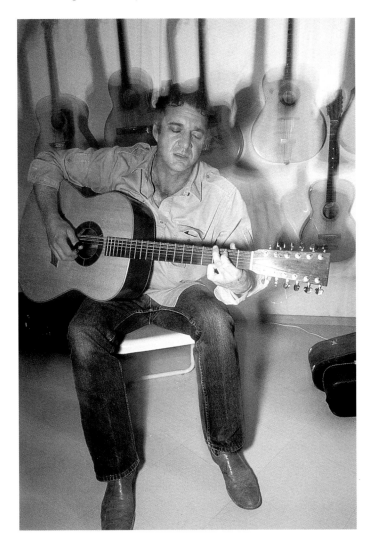

GUITAR COLLECTION, 1984. PHOTOGRAPH BY SHEL HERSHORN.

prisms, and the lower light source, pulsed at a different rate from the water's pulse. In effect the water appeared to flow up the drainboard instead of down. The water near the outer prisms appeared to be standing still. I called the piece the *Improbable Flow*.

For one reason or another, this commission never came to completion. But the engineering that was developed led to other fun ideas. I'm always hoping that some entity will like

the madness of my ideas enough to let me develop them into reality. I have never abandoned hope on this project, and given the right opportunity it could still be done.

Many other installations had that magical "other worldly" feeling. Opportunities arose through the years to explore environmental installations.

I tried pulsed light and water again for an installation at the Arco Center in Los Angeles. The Arco installation allowed me to use some of the talismanic objects found at various stages in my life: shoes, an old ash tray combined with my chairs, special dichroic filters from the dump at Los Alamos, and the strobe light system I built for the IBM project to create the ambient light for the environment. I placed potato

AT AN EXHIBITION OF DENNIS HOPPER PHOTOGRAPHS IN SANTA FE, CIRCA 1990. PHOTOGRAPH BY LISA LAW.

chip-shaped windows into the thick walls containing the light source. A large manifold dropped water, pulsed at sixty cycles per second, into a tank that collected and returned the water to the manifold. The lights were pulsed slightly faster than the water so the water drops appeared to be rising out of the tank, climbing to the ceiling.

At the same time that I worked on the Arco water piece, I did my first work with colored glass. The *Pink Compass* was shown at Arco in a separate room from the chairs and shoes environment. One room's lighting felt warm, the other cool.

In 1986 the Colorado Springs Fine Arts Center commissioned me to make a sculpture for the museum's courtyard. In a play on titles I called the piece *After Gainsborough*. It was made of blue and pink glass by a firm in Switzerland, the second time fabricators attempted to make a work to my

specifications. Recently I did another two-color glass piece in Germany.

I improvised a rather intricate environment called *Hydrolux* at the Boise Museum of Art. The addition of live, and recorded, video images projected into the falling water produced a wonderful, and totally inane viewing experience. The project cost me more to develop than the entire budget for the show. I think it was worth the effort.

The Boise commission illustrates the recycling of studio ideas that I like so much.

Fountains & Wind: Disasters happen. Many of my attempts to bring water into the same environment as glass ended in one form of disaster or another.

In 1981 the city of Abilene, Texas commissioned me to make a sculpture for their zoological gardens. The piece I called the *Wind Wedge* consisted of a series of fourteen triangular glass panes of varying heights, and a horizontal axis of ten feet to each of the panels. The panes were assembled into a series of right angles with an ascending profile as the viewer looked at the outer or inner corners of the units. The right angle pairs were three feet apart, each nesting into the space of the adjoining pair. On the top edge of the panels was a prism. I coated each panel with my gradient in a way that made them more reflective where they joined than at the outer end, or tip of the triangular shape. The seven pairs of right angles were positioned into a pond of water so that the corners faced the prevailing winds. The pond sat next to a small lake.

As the wind caused the water in the pond to ripple, and the shape of the pond caused the ripples to encircle the sculpture, the water appeared to climb up the hypotenuse edge of the glass on the prism. Sadly poor mount engineering coupled with a perplexing membrane at the bottom of the pond caused constant problems with the glass. The same panels kept breaking. I hired an engineering firm from Skidmore to help design new mounts for the glass. It was a hopeless effort as the pond had to be replaced, which it was, and then vandalism of one sort or another finished off the piece. I liked the triangular shapes of the panels and used them in several other installations.

I was commissioned by the National Institutes of Health in Bethesda, Maryland to make a piece for a "well," an area open to the sky, in a new ambulatory care wing. The piece was visible from the windows surrounding the well. The floor that the piece sat on was to be filled with water. That floor also served as the roof of a parking structure. It leaked. The NIH wouldn't fix it. The water element of the piece was never added, and eventually they built small offices around the windows that provided visual access to the sculpture. It was like Edgar Allan Poe's "Cask of Amontillado," walled off and forgotten.

A few years prior to the NIH commission, Eric Orr, a long time friend and great artist, decided to collaborate with me on the design of a sculpture. We came up with the idea of a fountain. It was to be a total collaboration in concept and design. Taking a bit from each of our bags of tricks we devised the concept of a golden *Solar Fountain,* called that because it used more sunlight than water to create the visual dynamics. Eric's input was more metaphysical than mine; he has always been interested in the mystical quality of gold, and its impact on mankind throughout history. My knowledge of gold started and stopped with the fact that it is an efficient reflector of infrared frequencies, and is expensive.

Essentially, we designed a glass bowl ten feet tall with a base diameter of thirty feet. The glass panels of the bowl were made of gold-colored heat reflecting glass, the same as that used in architectural facades to keep down the costs of air conditioning. Our fountain used a fine mist or fog created by a special pumping system that filled the bowl with airborne particles of water.

As the sun rose high enough in the sky to make it possible to see inside the bowl, the heat of the sun would be reflected back onto the fog. This mixture of heat and water created all kinds of beautiful and natural phenomena. The winds and inversion layers also played a part in the fountain's effect.

Installed in a Denver park, the piece caused a great deal of controversy from the outset. Local artists disliked outsiders encroaching on their turf. The director of a public theater located next to the park felt he alone should determine what kind of sculpture belonged there. The city neglected to care for the piece, and after thirteen years of abuse and carelessness, the *Solar Fountain* was taken down. The reason they gave was that they couldn't afford to fix it, or maintain it as it should be if they did fix it.

Finesse: Positive things happen. When the Museum of Contemporary Art opened in Los Angeles, I had the honor of being asked to participate in the first show at the Temporary Contemporary, a wonderful old castle of industrial space in the Little Tokyo neighborhood of Los Angeles. I decided to rebuild a piece from around 1968.

I had finessed the *Leaning Room* in an area of my studio for about two years. It took a vast amount of calories to create this eighteen foot by sixty foot room with no shadows. Having MOCA resources allowed me to build an extension of my strangest, and probably my goofiest, idea.

For the Temporary Contemporary I used a fluorescing blue paint as the external light. That paint, a series of reflecting baffles, and a false ceiling created a wonderful room where the light had the density of blue Jell-O. The slight cant to the walls created a weird sensation. I made a different colored entrance to the space, and when viewed from either inside the

space, or from the entry, the density of the light was nothing less than sticky.

I love grand and improbable projects of this type. The institutions that support this work are heroic. Ideas for other endeavors spring from the experience. Sometimes it's possible to follow through on them and move on to something else without institutional backing. But usually it takes a curator and a director with an uncanny sense of humor, great faith, and a reasonable amount of money to spend, for large installations to happen.

In this sense the public space becomes an extension of the studio.

Mirages & Hallucinations: An occasional error or disaster might be the most valuable learning tool. Some

KIYO HIGASHI GALLERY, 1985. PHOTOGRAPH BY THOMAS P. VINETZ.

years ago I had my hearing checked because I was getting concerned about it. I assumed my hearing problem originated from working with noisy equipment. The tests confirmed that I suffered from hereditary nerve degeneration. My equipment did not cause my hearing loss. The doctors explained that I had never heard any better than I did in the office during the testing; I was born this way. If it was starting to bother me, after forty-six years, they suggested I get hearing aids, which I did. Hearing changed the nature of my work profoundly.

Minimal imagery, and the surfaces I used as the stage for my visuals, no longer interested me. While depressed and distracted beyond anything I had ever experienced, strange hallucinations of my childhood kept percolating up into my consciousness.

Anger and rage accompanied the memories. Memories of being punished for doing things I was told not to do. The rage I felt at the unfairness of the punishment. I was lost, wondering what to do with myself and how to keep the studio activities going.

I began to make collages, using the equipment and supplies I had on hand.

I colored sheets of various paper materials, strips of mylar, and laminate film. Then I fused these to canvases and stretched them. Tapestries of woven light differentials resulted. The images were similar in feeling to John Chamberlain's sculptures, or so I was told. I never *felt* the connection, but I saw it. I love Chamberlain's work so I took it as a compliment.

The first collages were the most interesting. The best examples of the struggle with a new idea come at the beginning. Were I to say that I had a specific idea though, it would be a distortion of the truth. At best I was looking for a catharsis.

thing I can imagine. Corny might be a better way to describe them. I've included a brief list for the reader's amusement:

Chicago Attempt, Tarantula!, Daisy's Bedroom, Measles, Kiss My Bass, The Shower, Rosie's Indecision, Lois' Decision, The Boot & The Curtain, Old Paint, Closing the Gap, Two Pairs with Every Suit, Black Lung, Dangerous Cleavage, Falling Hare, Looking Old, Little Parts, Circle of Flesh, Believe It or Not, The Patriot's Throne, The Pleasure of the Spirit, Santa's Helper, Lost in the Wilds, Olivia's Visit, The Foreign Place.

Some of these pieces are phenomenal in every aspect, at least to me. One of the first successful canvases is titled

BELL WITH HYDRO LUX, *AT BOISE ART MUSEUM. 1986. PHOTOGRAPH BY THOMAS P. VINETZ.*

I wanted to do something with my tools and materials to alleviate the pain and isolation caused by the hallucinations. In a mysteriously *unnatural* way, the images were very representational. I could not escape them. They were like memories of dreams and hallucinations, pictures of somewhere, or something.

I titled these collages whatever came to mind when I first saw them completed. The process of making them allowed a brief period when they were pinned to the wall covered with a translucent release film which kept the materials from sticking to the equipment while being heated to liquid condition. When it was peeled off, the first thing the image reminded me of became the title, and the titles were as romantic as any-

Talpa, after the village in New Mexico where I live. The crosses within the imagery reminded me of Talpa's prevalent cemeteries. The material used to make the piece was simply laminate film coated with aluminum and quartz, and a scrap piece of mylar that had been used for holding something while in the coating tank. The crosses are the shadows of tape that blocked the metal deposition. I fused this combination of layers to a piece of black primed canvas.

Another strange and illustrative work is called *Old Dirt Road* because that was the first thing that came to my mind when it emerged from the tank. This piece not only includes the kinds of material used in the making of *Talpa,* but also has a piece of a rejected Vapor Drawing in it.

I kept a lot of material from earlier series of works; it was considered raw stock. Time and memory also became part of my materials. These things have a special habituating element.

I called the series Mirage Works. They assembled quickly. An entirely intuitive way of working developed. As improvisation strengthened, I looked for any way to increase it. I began making painted brush gestures on papers and laminate film. A serious inventory of calligraphic lines and swirls of acrylic paint. I wanted to add these elements to the collages.

I chose from the piles that were pre-painted and used as needed. The paint in these works was applied as a dry layer, just as any *normal* element in a collage would be, but it appeared to have been painted directly into the image.

In a funny way they were imitation paintings.

I think the most astounding collage from this period is titled *WWG.*

For reasons not worth going into I choose not to reveal what the letters abbreviate.

The Mirage Works series is the most important personal experience of my studio activities. Delineating reasons for this feeling clarifies, to the people most familiar with my minimal work, what it meant to do these pieces. First, the work allowed me to use the tools of the studio in a new manner, while also allowing the venting of a lot of pent-up frustration and anger. It allowed the exploration of what turned out to be automatic uncontrolled literal images. The Mirage Works taught me a great deal about light and surface. I also found I could use some of the vast inventory of rejected works that I had saved, originally considering them unworthy. There was an ecological soundness to this effort. Finally, the titles gave me a chance to explore narrative imagery.

Jell-O & Stick Figures: Los Angeles architect Frank Gehry asked me to take a look at a project he was doing for a client in Ohio. Perhaps Frank thought I could come up with an outdoor sculpture idea using glass or light. He planned an inventive use of glass in the house and the two would correlate. Frank likes eccentric stuff, and the work that transpired is my most bizarre, a complete departure as far as visuals are concerned.

I planned originally to develop a light piece based on something I had done several times before but never successfully in an exterior environment.

I had tried to make a conceptually new site specific piece for a show at the Fort Worth Art Museum in 1976, when I had my show for *The Iceberg.* It was to work in conjunction with the setting sun.

Re-using the concept eighteen years later, I planned to light the entire compound Frank had designed in Ohio with a blue light similar to that used for the *Leaning Room* at MOCA. Because of the light's particular wavelength, and because the

surface of the house, white Carrera marble, would be quite reflective, the blue light would be particularly effective at dusk. Reflecting off the marble until that reflection and the sky were the same color. *At that point the house would disappear.* As the sky got darker the blue light would hover over the compound with that sticky Jell-O feeling I described earlier.

When the sun started to rise, the *house would again disappear,* and then reappear as the sunlight overpowered my light source. It was a totally workable concept, and the client and Frank both liked it. I began to develop visuals to clarify the intent.

Needing some development software for my laptop computer, I purchased a sketching program and started to

PARIS, FRANCE, 1967. PHOTOGRAPH BY ANDRÉ MORAIN.

play around with its various tools. As a vehicle for the examination of the tools I used simple stick figures. My printer started spitting out calligraphic figures in endless reams of paper. I found the sketches rather interesting in themselves, and in a subsequent visit to Frank Gehry's office to work on the light piece, I asked him to take a look at them. His reaction was not what I expected: "These are fantastic. What can you do with them?"

Carrying with me his infectious enthusiasm, I returned to the studio, set aside the light piece and tried to bring the little drawings into three dimensions. Again I was hooked on the

process of doing something I had never done before. Discovered by accident with the use of a tool. My laptop computer.

I spent months in passionate development of forms based on this calligraphy.

Twenty-four figures were transformed into three dimensions in fabricated bronze. Roughly twenty-four inches tall, they had a scale of one inch to one foot. The forms actually could be developed to any scale. Gehry wanted them big. He chose twelve of the forms for a presentation to the client.

I felt that a weak spot existed in the presentation. I searched the visuals trying to find it. The vulnerability prevailed in the identity of the forms. They were conceptual. The figures *had no identity*. I had thought about them only as three

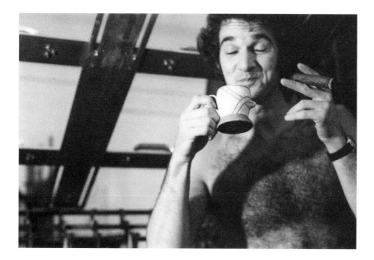

VENICE, CALIFORNIA, 1971. PHOTOGRAPH BY KEN PRICE.

dimensional calligraphy. Even though they had an obvious humanoid reference, their genesis was the calligraphy I did on the laptop.

I feared that if the client asked me "who are they?" and I couldn't answer in an articulate and literally narrative manner, it would be all over.

I began searching for that identity and came across an ancient poem called the "Epic of Gilgamesh," a story about an ancient king's search for immortality. It reminded me of my client's search for immortality with his collaboration with Gehry. Gilgamesh was a Sumerian king from about 2500 B.C.

Two thousand years before Gilgamesh the Sumerians invented bronze and later the first written language. Their cuneiform looked something like the calligraphy I designed on my laptop.

I started reading about Sumerian culture and its myths, and not only decided that my forms were Sumerian, but also wrote my own myths that supported the forms I presented to the client.

Everything about the Sumer project fell into place perfectly, in a most natural manner, from the computer generated figures to the completed sculptures and the narrative.

Eccentricity: *Sumer* is my most eccentric project. Eccentric because the sculptures do not relate to my previous work. The methodology that allows the use of a tool, a computer program, to create something improbable, is not eccentric. I use new methodology all the time.

I always look for something new with which to get engaged, but polishing an idea past its beginnings proves difficult. If my work holds any significance it will be seen in its variety.

As of this writing I continue recycling old works into new formats. I took a large body of the Mirage Works and cut them into small pieces roughly six inches square, releasing that "studio energy" trapped in the material. The results are a group of small and very intriguing *Fractions*.

Recombining elements from different compositions reveals the most amazing things. When the laminate films are remelted they flow, and become something different from what they were before. The Mirage Works no longer look like Chamberlains.

For some reason many of the *Fractions* have a landscape feeling that just happens. I did not choose the parts because of the horizon line. The "flow" is a metaphor of the flow of the work itself. I hope the works continue to flow as easily as they have. When the work flows well, a lot gets done.

Acknowledgements: I would like to thank the writers who contributed to this publication: Dean Cushman, my roommate at Chouinard Art Institute, and a neat guy; Douglas Kent Hall, a truly great photographic artist and terrific writer; and Peter Frank (Mr. White Man), whose insights into the contemporary art world are overwhelming.

Many of the pictures in this book were taken by my dear friend Thomas P. Vinetz, whose skill has earned him the nickname of Dr. Awesome. I thank the other photographers and all the museum people who made this exhibition possible.

A special thanks to my wife Janet Webb of Webb Design in Taos for her splendid work in designing this catalogue and especially for putting up with me all these years.

Not to be forgotten is the gracious loan by Mr. Peter Lewis, CEO of Progressive Insurance, of the large sculptures. His splendid trust in me to develop the project I call *Sumer* shows true art patronage. ∎

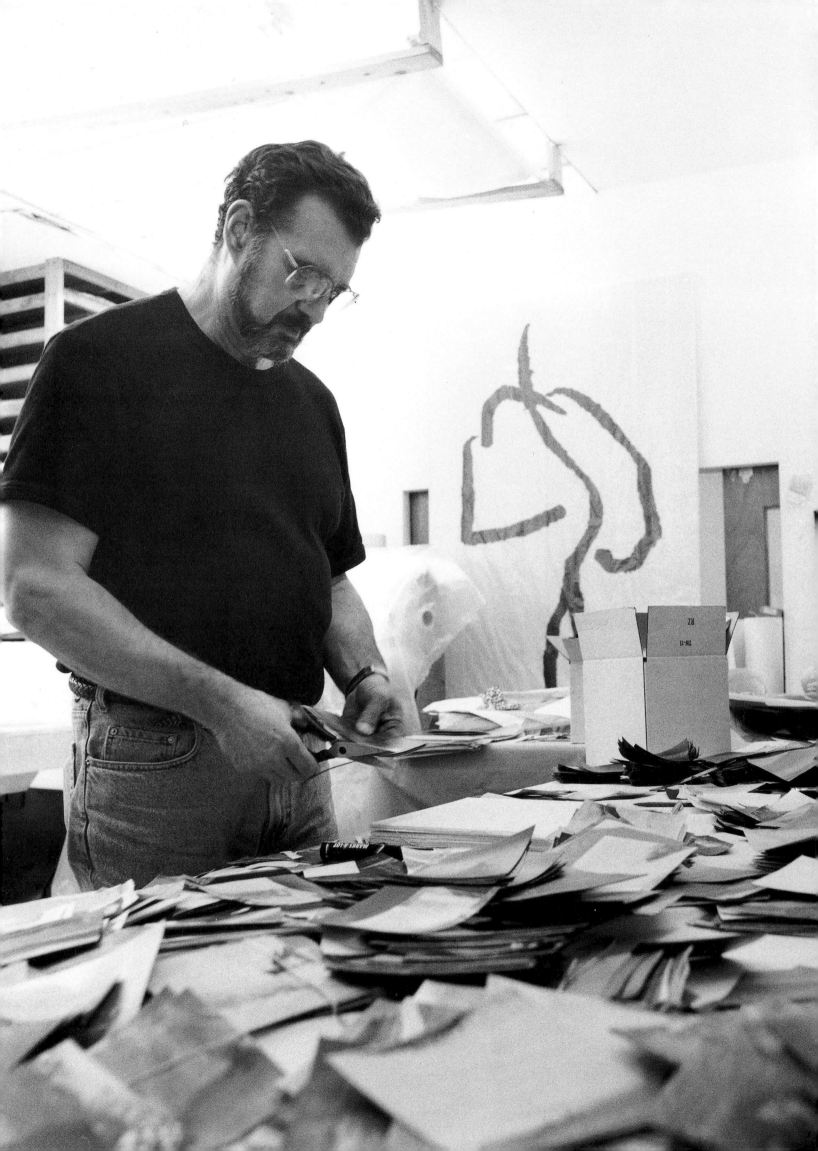

Zones of Experience

Paintings & Early Constructions

Cubes

Large Glass Sculptures

Furniture & Game

Light & Space Explorations

Vapor Drawings & Mirage Paintings

Sumer / Stickman

Fractions

PLATE 3. UNTITLED, 1959, OIL ON CANVAS, 39½" x 39½".

(LEFT) PLATE 5, UNTITLED, 1960, INK, PAPER, GLASS AND PAINT, 6" x 4". COURTESY OF DR. DOUGLAS GARLAND COLLECTION.
(RIGHT) PLATE 6, UNTITLED, 1960, INK, PAPER, GLASS AND PAINT, 6" x 4". COURTESY OF DR. DOUGLAS GARLAND COLLECTION.

PLATE 7. LI'L ORPHAN ANNIE, *CIRCA 1960, ACRYLIC ON CANVAS, 96" x 144".*

PLATE 8, CONRAD HAWK, 1961, ACRYLIC ON CANVAS, GLASS, 66" x 66". COURTESY OF THE MENIL COLLECTION, HOUSTON.
PURCHASED WITH FUNDS PROVIDED BY CAROLYN LAW.

PLATE 9, UNTITLED #7, 1961, MIRRORED GLASS, WOOD, PAINT, 12" x 12" x 5".

PLATE 10. OLD COTTON FIELDS BACK HOME, *1962, ACRYLIC ON CANVAS, 65" x 65". COURTESY OF LOS ANGELES COUNTY MUSEUM OF ART, DAVID E. BRIGHT FOUNDATION.*

PLATE 11, LUX AT THE MERRITT JONES, 1962, ACRYLIC ON CANVAS, 66" x 90". COURTESY OF DONALD JUDD ESTATE.

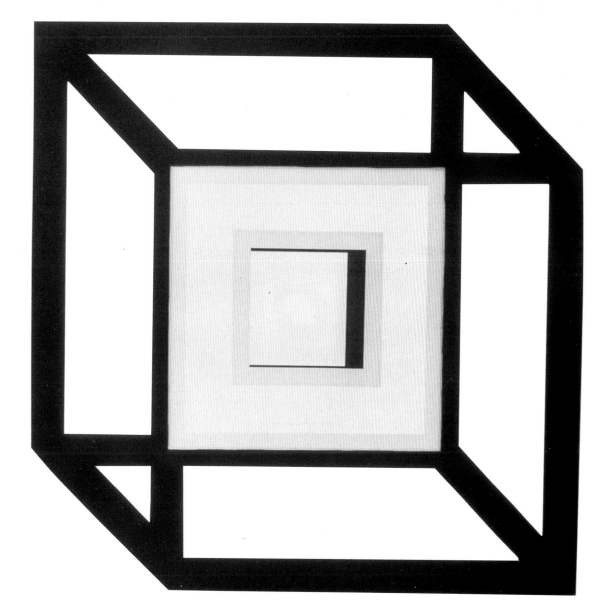

PLATE 12. GHOST BOX, 1962-63. VACUUM-COATED, MIRRORED AND SANDBLASTED GLASS, ACRYLIC ON CANVAS, 48¾" X 48½" X 3⅛".

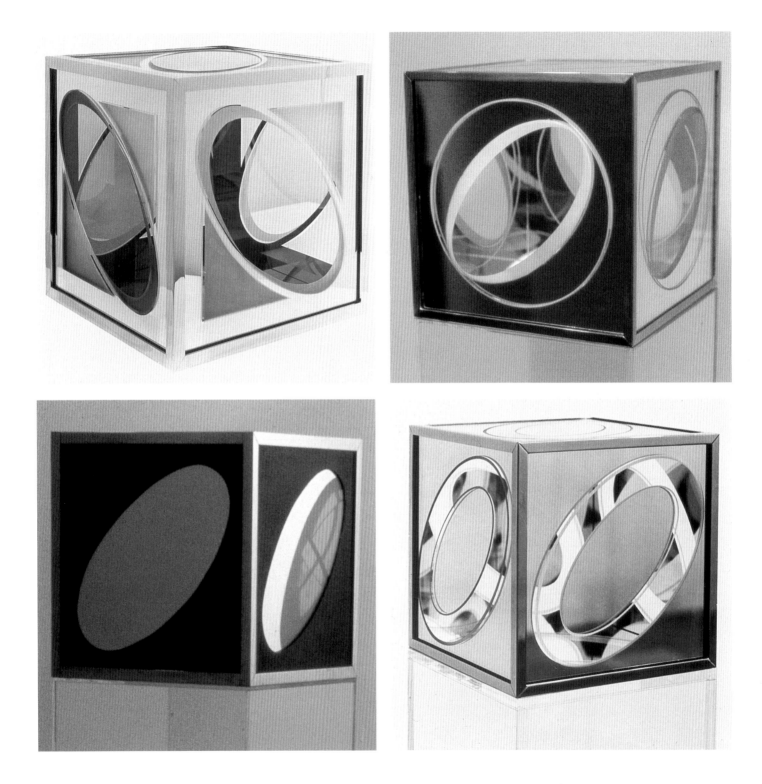

(ABOVE, LEFT) PLATE 14, UNTITLED, 1964, VACUUM-COATED ETCHED GLASS, CHROMIUM-PLATED BRASS, 14" x 14" x 14". (ABOVE, RIGHT) PLATE 16, UNTITLED, 1965,
VACUUM-COATED ETCHED GLASS, CHROMIUM-PLATED BRASS, 10¼" x 10¼" x 10¼". COURTESY OF NEWPORT HARBOR ART MUSEUM, GIFT OF EDWIN JANSS, JR.
(BELOW, LEFT) PLATE 13, UNTITLED, 1962-63, MIRRORED GLASS, FORMICA, CHROMIUM-PLATED BRASS, 14" x 14" x 14". COLLECTION OF STERLING HOLLOWAY ESTATE.
(BELOW, RIGHT) PLATE 15, UNTITLED, 1965, VACUUM-COATED ETCHED GLASS, CHROMIUM-PLATED BRASS, 10" x 10" x 10".

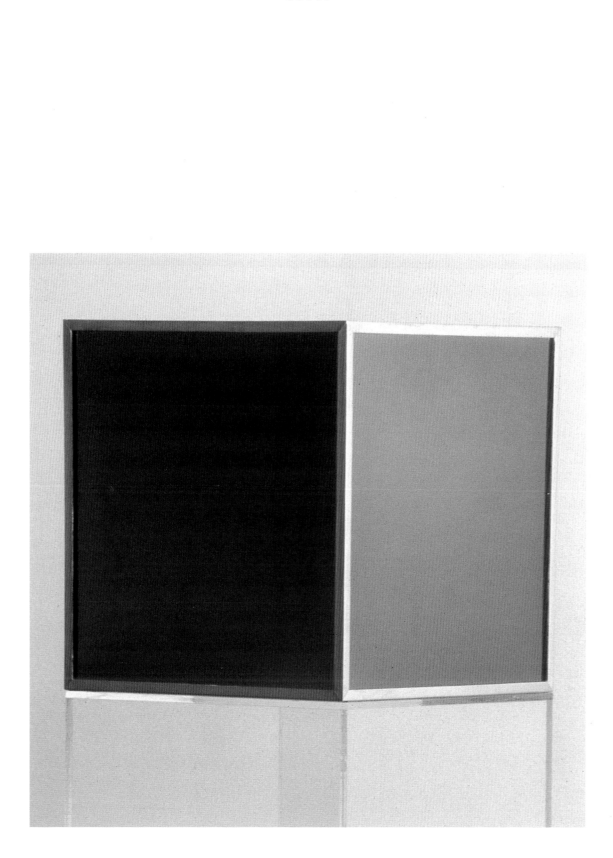

PLATE 17. UNTITLED, 1966, VACUUM-COATED GLASS, CHROMIUM-PLATED BRASS, 12¼" x 12¼" x 12¼".

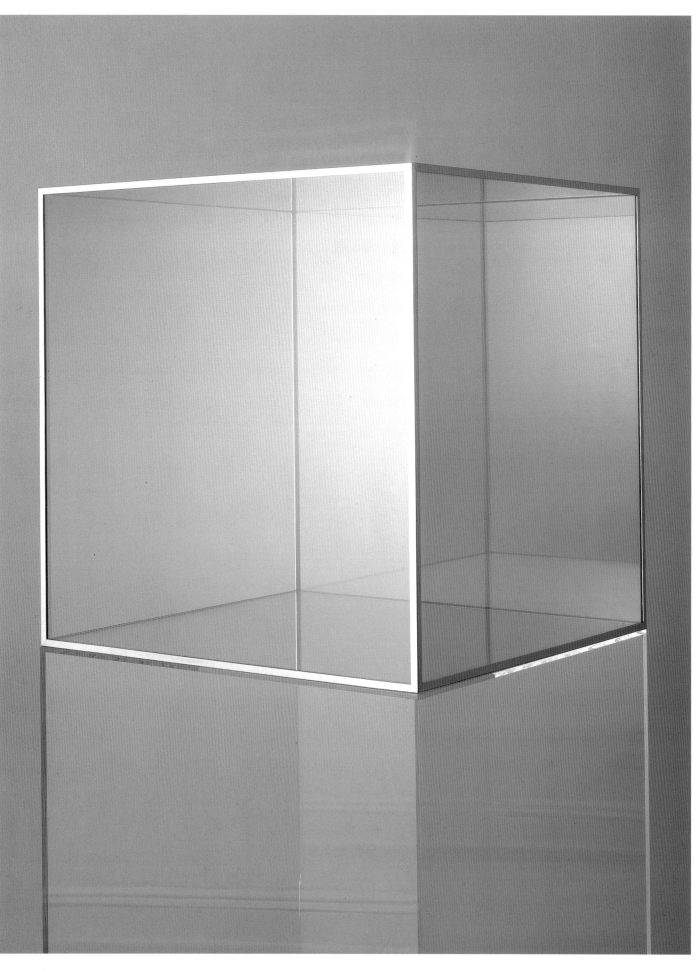

(ABOVE) PLATE 18, UNTITLED, 1968, VACUUM-COATED GLASS, CHROMIUM-PLATED BRASS, 20" x 20" x 20". COLLECTION OF GUGGENHEIM MUSEUM.
(OPPOSITE PAGE) PLATE 22, UNTITLED CUBE, 1969-70, PLATE GLASS COATED WITH INCONEL, 36" x 36" x 36". COLLECTION OF PACE GALLERY, NEW YORK.

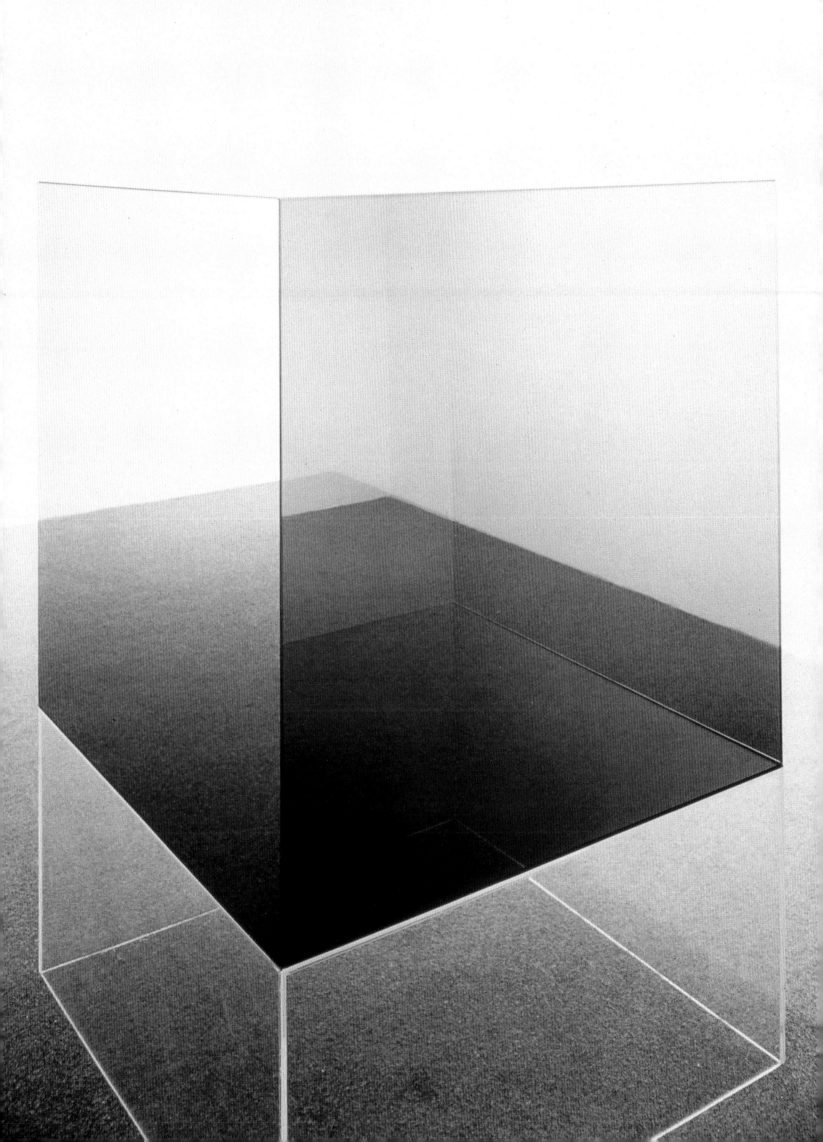

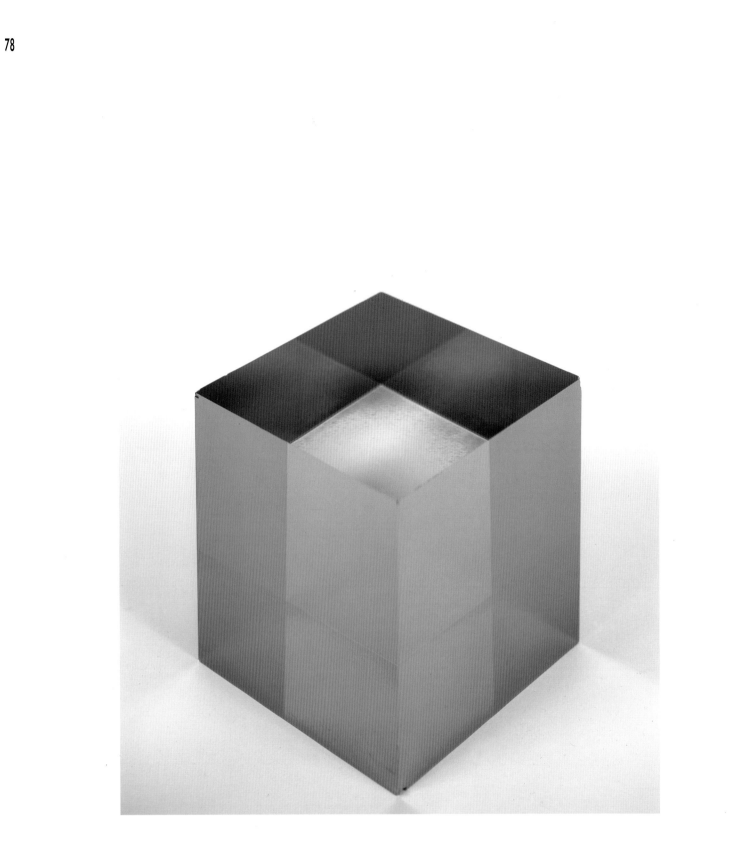

PLATE 23, UNTITLED CUBE, 1970, SOLID BARIUM CROWN GLASS COATED WITH INCONEL. 4" x 4" x 4", EDITION OF 25. COURTESY OF DR. DOUGLAS GARLAND COLLECTION.

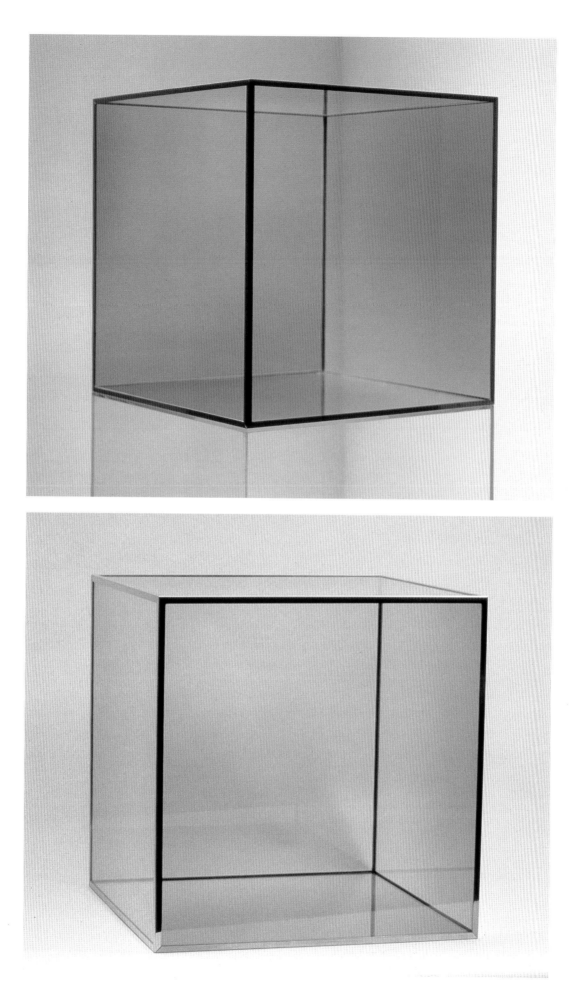

(ABOVE) PLATE 19, UNTITLED, 1968. VACUUM-COATED GLASS, CHROMIUM-PLATED BRASS, 20" x 20" x 20". COLLECTION OF NEWPORT HARBOR ART MUSEUM, GIFT OF EDWIN JANSS, JR. (BELOW) PLATE 61, UNTITLED, 1985, VACUUM-COATED GLASS, CHROMIUM-PLATED BRASS, 18" x 18" x 18". COURTESY OF NEWPORT HARBOR ART MUSEUM, GIFT OF WILLIAM G. PIGMAN AND SUSAN L. PIGMAN.

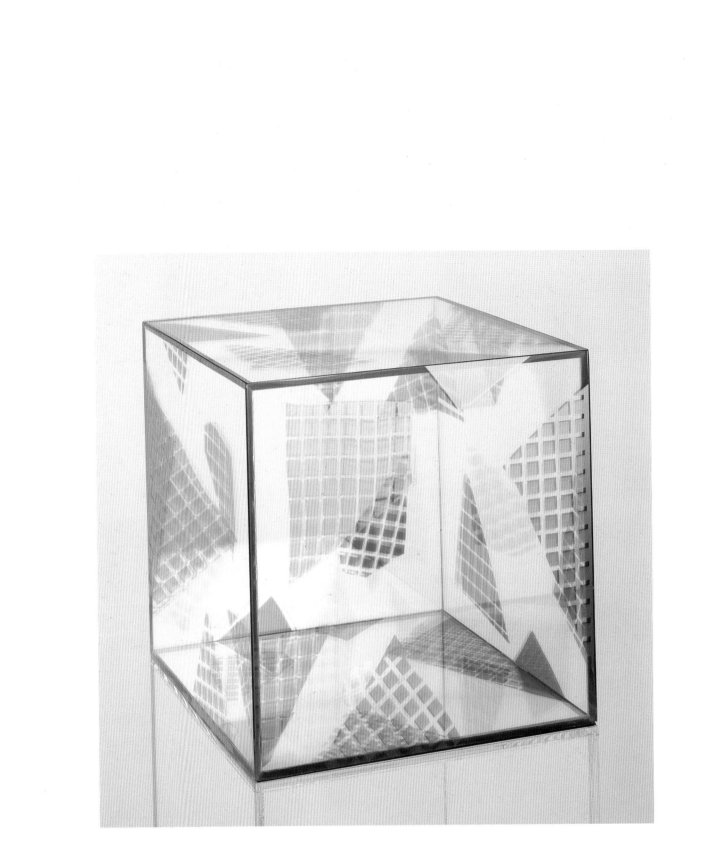

(ABOVE) PLATE 81, CUBE #10-1-92, 1992, COATED GLASS, 10" x 10" x 10". COURTESY OF DR. DOUGLAS GARLAND COLLECTION.
(OPPOSITE PAGE) PLATE 82, CUBE #20-2-92, 1992, COATED GLASS, 20" x 20" x 20". COURTESY OF KIYO AND ROBERT HIGASHI.

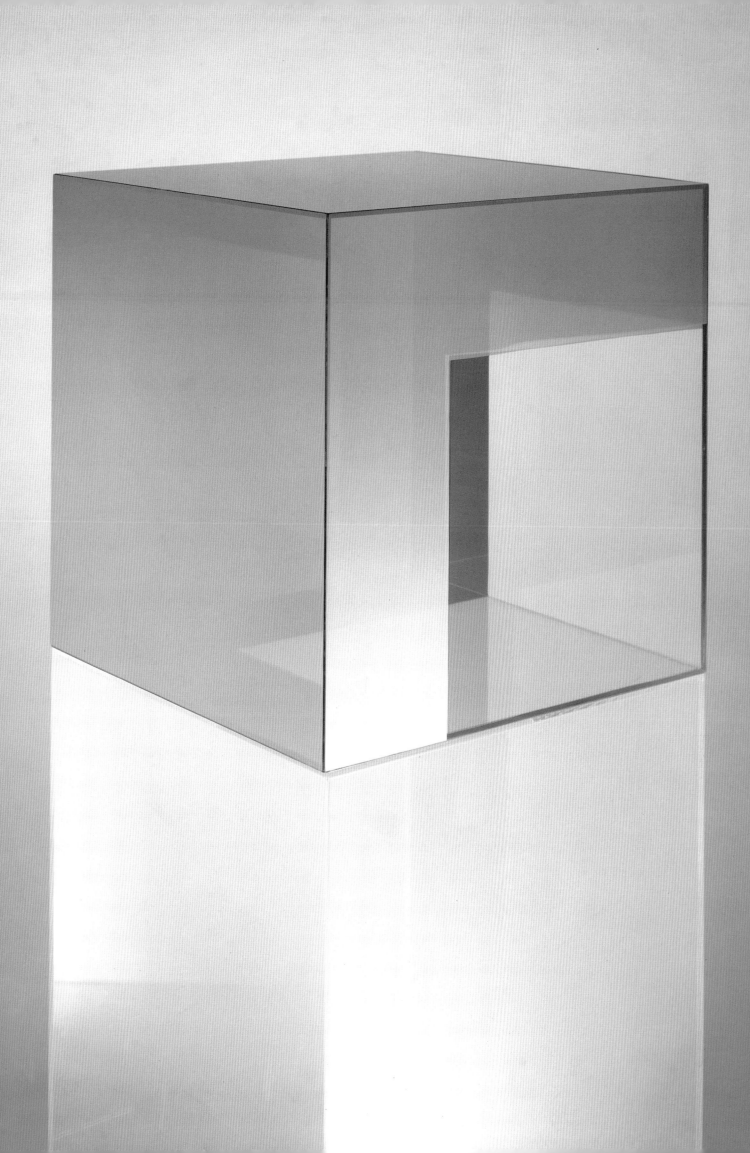

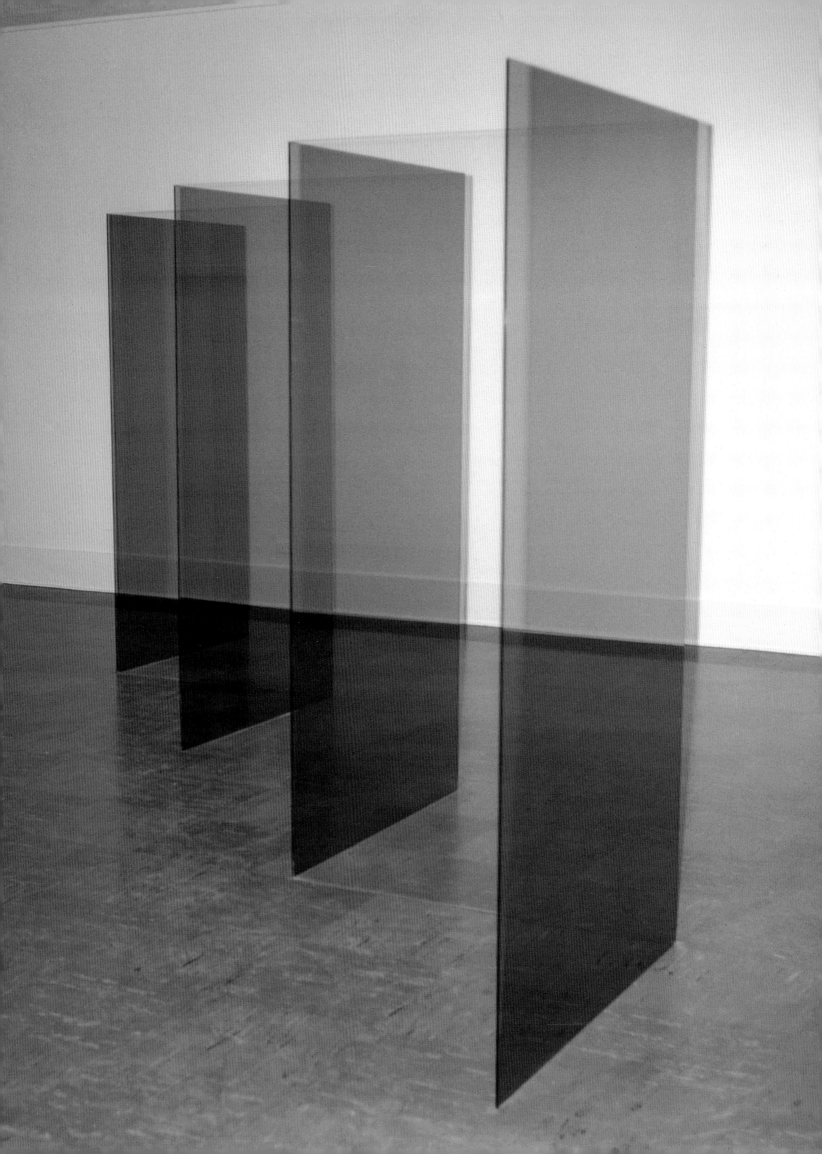

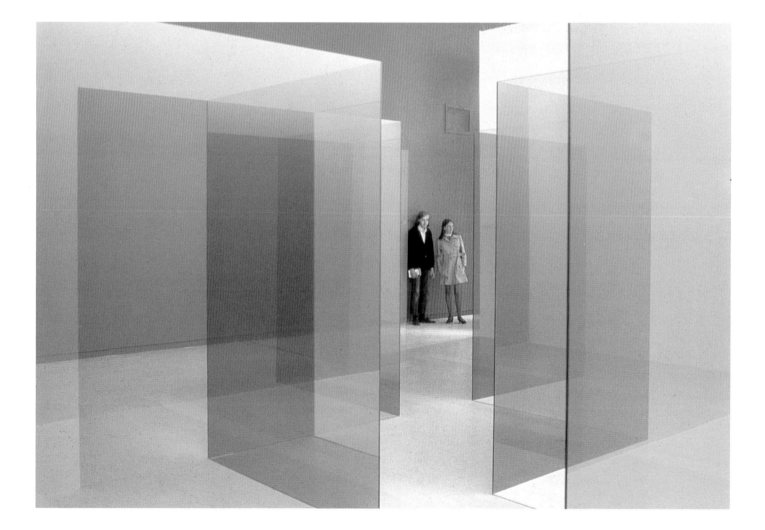

(OPPOSITE PAGE) PLATE 20, STANDING WALL, 1968, ⅜" CLEAR AND GRAY GLASS, 7 PANELS, 72" x 96", INSTALLATION AT VANCOUVER ART GALLERY, VANCOUVER, CANADA. PHOTOGRAPHER UNKNOWN. (ABOVE) PLATE 21, STANDING WALL, 1969, ⅜" CLEAR AND GRAY GLASS, 10 PANELS, 72" x 96", INSTALLATION AT WALKER ART CENTER, MINNEAPOLIS. PHOTOGRAPHER UNKNOWN.

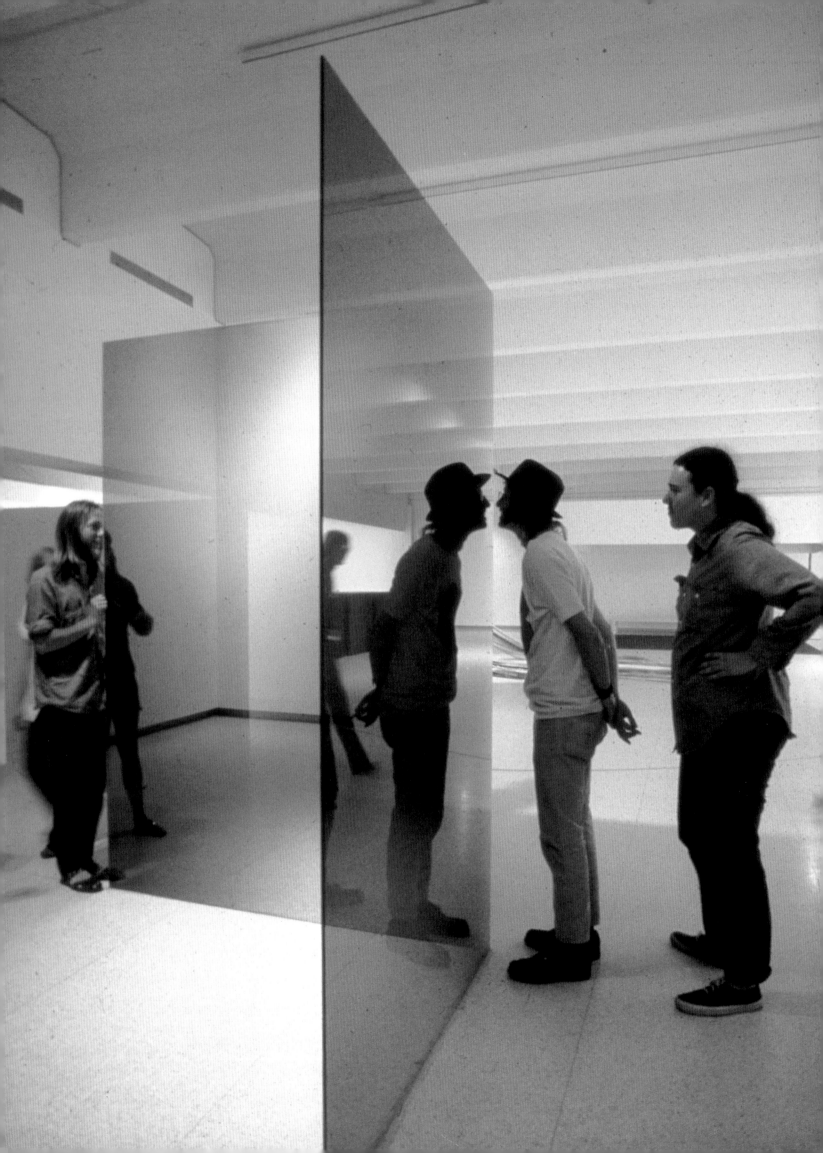

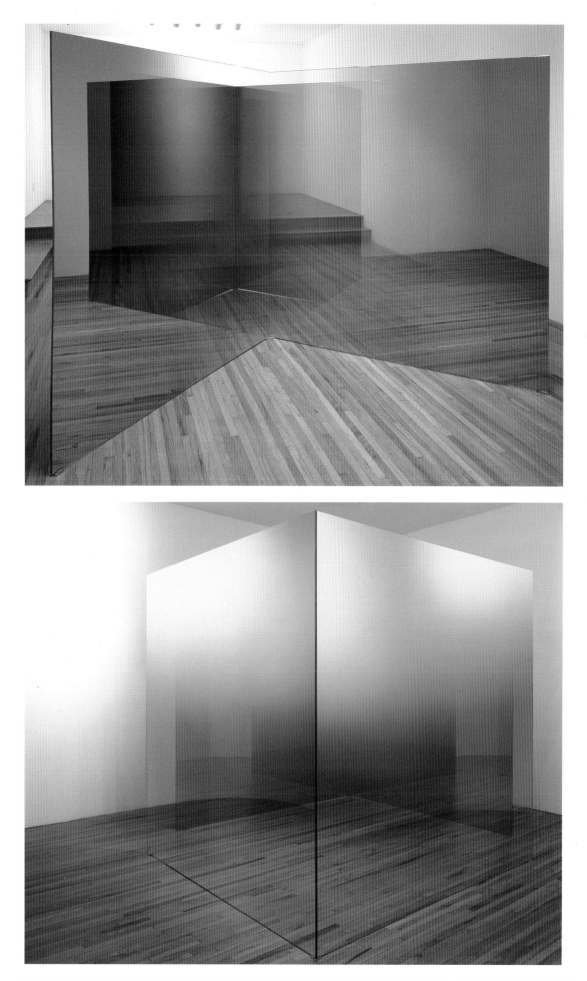

(OPPOSITE PAGE) PLATE 24, GARST'S MIND NO. 2, 1971, ⅜" PLATE GLASS COATED WITH INCONEL, 2 PANELS, 72" x 96". INSTALLATION AT WALKER ART CENTER, MINNEAPOLIS. PHOTOGRAPHER UNKNOWN. (ABOVE) PLATE 89, STANDING WALL, 6x6x4-AB, 1996, ½" COATED GLASS, 4 PANELS, 72" x 72", INSTALLATION AT KIYO HIGASHI GALLERY, LOS ANGELES. PHOTOGRAPH BY BRIAN FORREST. (BELOW) PLATE 90, STANDING WALL, 6x6x4-CD, 1996, ½" COATED GLASS, 4 PANELS, 72" x 72", INSTALLATION AT KIYO HIGASHI GALLERY, LOS ANGELES. PHOTOGRAPH BY BRIAN FORREST.

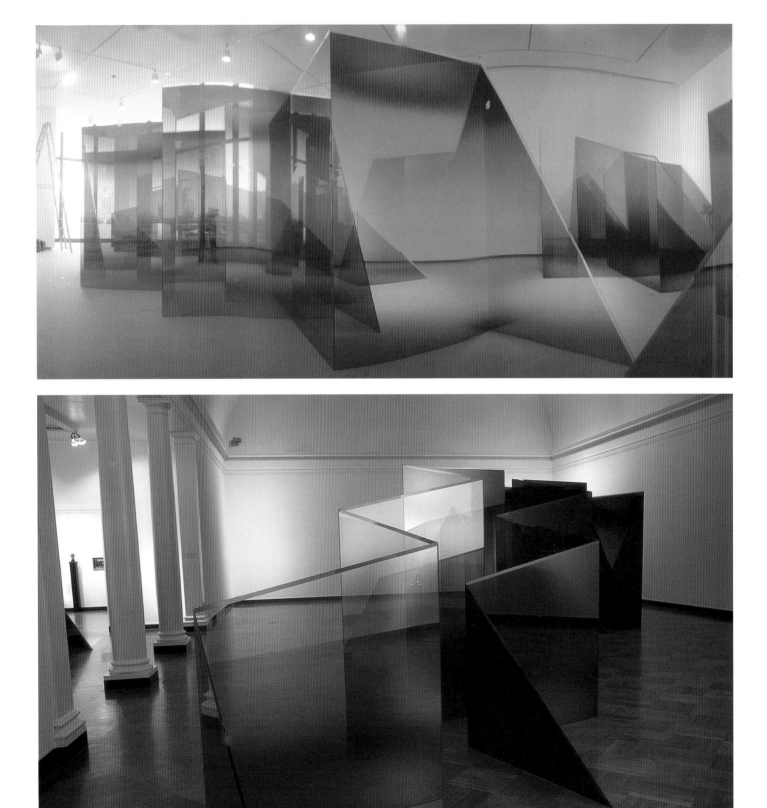

THE ICEBERG AND ITS SHADOW, 1974, ⅜" PLATE GLASS COATED WITH INCONEL AND SILICON MONOXIDE, 56 PANELS, 57" TO 100" EACH x 60". COLLECTION OF
MASSACHUSETTS INSTITUTE OF TECHNOLOGY, CAMBRIDGE. (ABOVE) PLATE 25, INSTALLATION AT FORT WORTH ART MUSEUM, 1975. PHOTOGRAPH BY LARRY BELL.
(BELOW) PLATE 26, INSTALLATION AT SANTA BARBARA ART MUSEUM, 1976. PHOTOGRAPH BY STEVE BURNS.

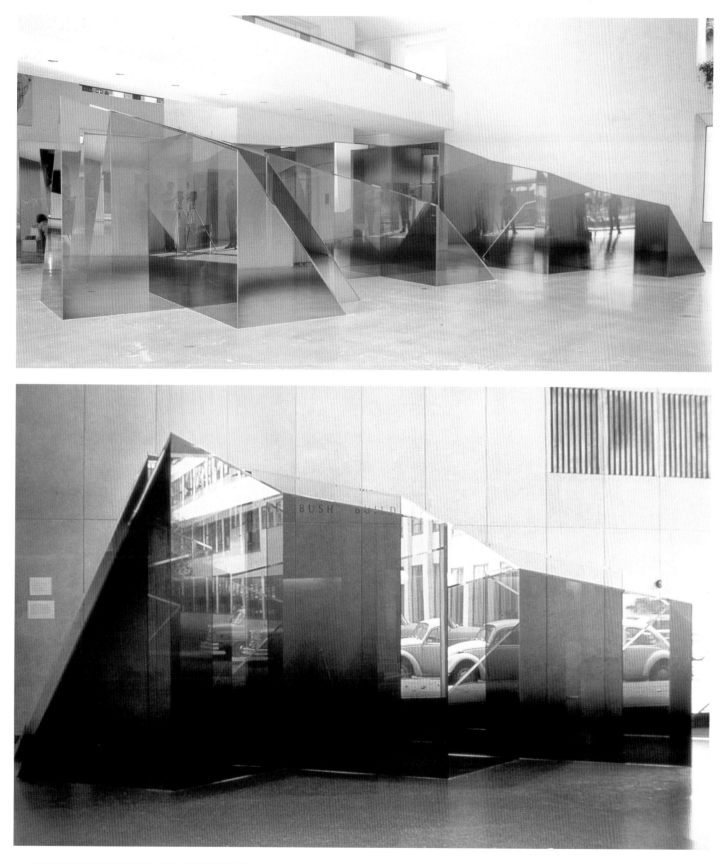

THE ICEBERG AND ITS SHADOW. 1974. ⅜" PLATE GLASS COATED WITH INCONEL AND SILICON MONOXIDE. 56 PANELS. 57" TO 100" x 60". COLLECTION OF MASSACHUSETTS
INSTITUTE OF TECHNOLOGY, CAMBRIDGE. (ABOVE) PLATE 27. INSTALLATION AT ART MUSEUM OF SOUTH TEXAS, CORPUS CHRISTI. 1976. PHOTOGRAPH BY LARRY BELL.
(BELOW) PLATE 28. INSTALLATION AT MASSACHUSETTS INSTITUTE OF TECHNOLOGY, CAMBRIDGE. 1977. COLLECTION OF MASSACHUSETTS INSTITUTE OF TECHNOLOGY.
GIFT OF ALBERT AND VERA LIST FAMILY FOUNDATION. PHOTOGRAPH BY DAN DE WILDE.

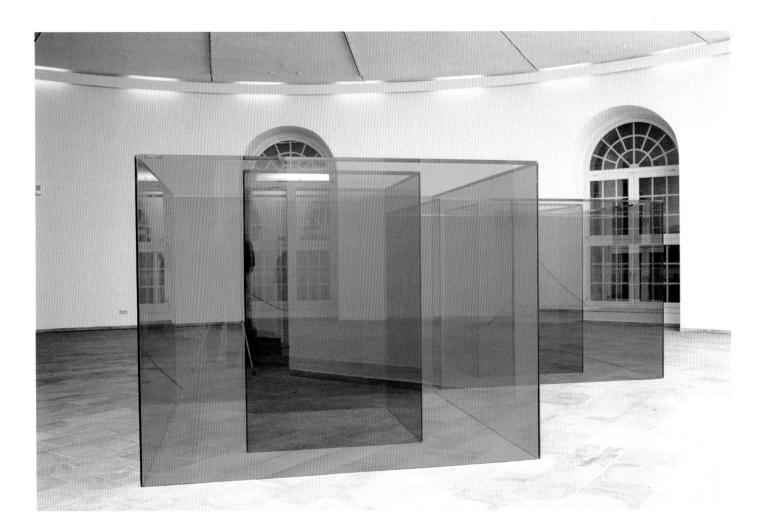

PLATE 79. MADE FOR AROLSEN, 1992. 10mm BLUE AND PINK GLASS, 8 PANELS, 72" x 48", 8 PANELS, 72" x 96".
INSTALLATION AT MUSEUM FRIDERICIANUM, KASSEL, GERMANY. PHOTOGRAPH BY D. SCHWERDTLE.

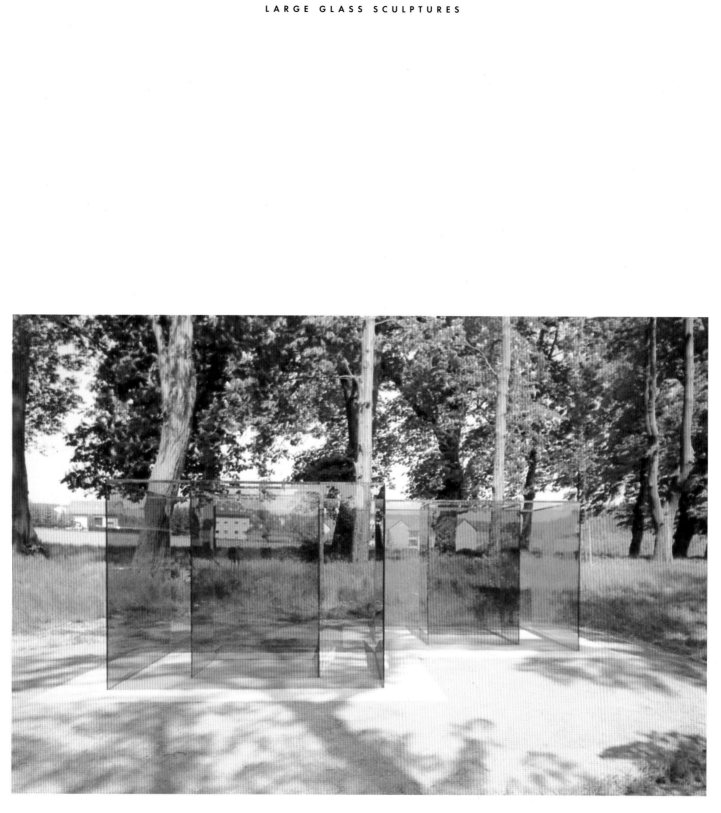

PLATE 80, MADE FOR AROLSEN, 1992, 10MM BLUE AND PINK GLASS, 8 PANELS, 72" x 48", 8 PANELS, 72" x 96",
INSTALLATION IN THE VILLAGE OF AROLSEN, GERMANY. PHOTOGRAPH BY LARRY BELL.

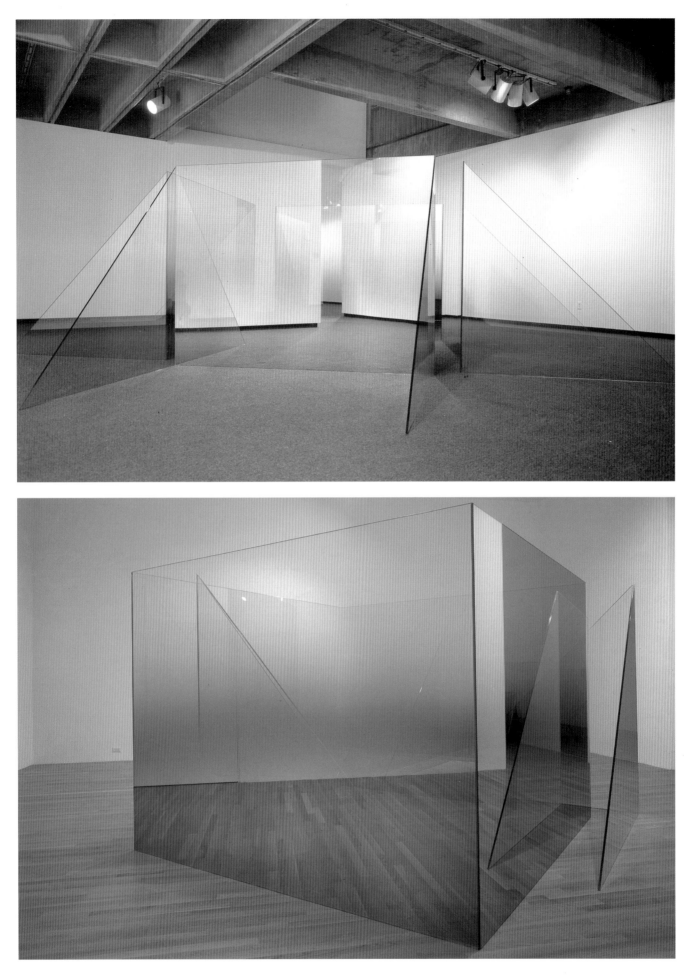

THE CAT, 1981, 4 PANELS, ½" FLOAT GLASS COATED WITH INCONEL, 72" x 96", 8 PANELS, ½" TRIANGULAR FLOAT GLASS, UNCOATED, 72" x 72". COURTESY OF THE ALBUQUERQUE MUSEUM COLLECTION. (ABOVE) PLATE 38, INSTALLATION AT HUDSON RIVER MUSEUM, YONKERS, 1981. PHOTOGRAPH BY MARY BACHMANN. (BELOW) PLATE 39, INSTALLATION AT L.A. LOUVER GALLERY, VENICE, 1981. PHOTOGRAPH BY THOMAS P. VINETZ.

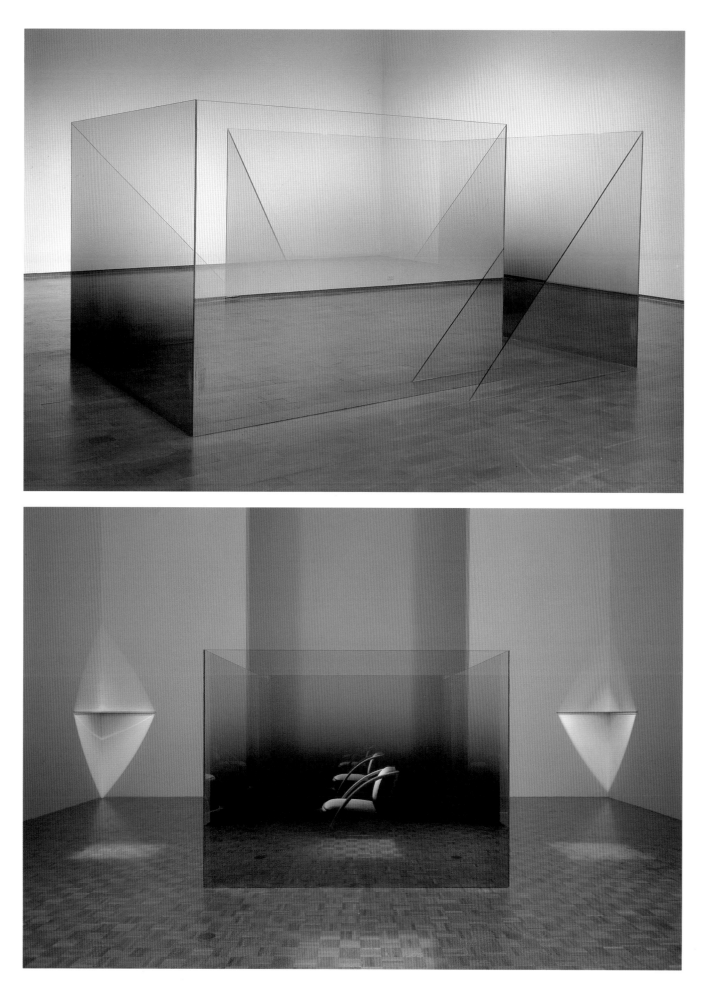

THE CAT, 1981. 4 PANELS, ½" FLOAT GLASS COATED WITH INCONEL, 72" x 96". 8 PANELS, ½" TRIANGULAR FLOAT GLASS, UNCOATED, 72" x 72". COURTESY OF THE ALBUQUERQUE MUSEUM COLLECTION. (ABOVE) PLATE 40. INSTALLATION AT NEWPORT HARBOR ART MUSEUM, 1982. PHOTOGRAPH BY THOMAS P. VINETZ. (BELOW) PLATE 41. THE CAT. (ALSO CALLED CHAIRS IN SPACE) INSTALLATION AT DETROIT INSTITUTE OF ARTS WITH CORNER LAMPS AND CHAIRS DE LUX IV, 1982. PHOTOGRAPH BY THOMAS P. VINETZ.

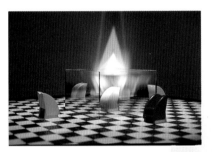

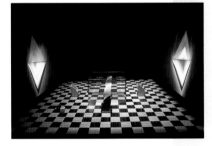

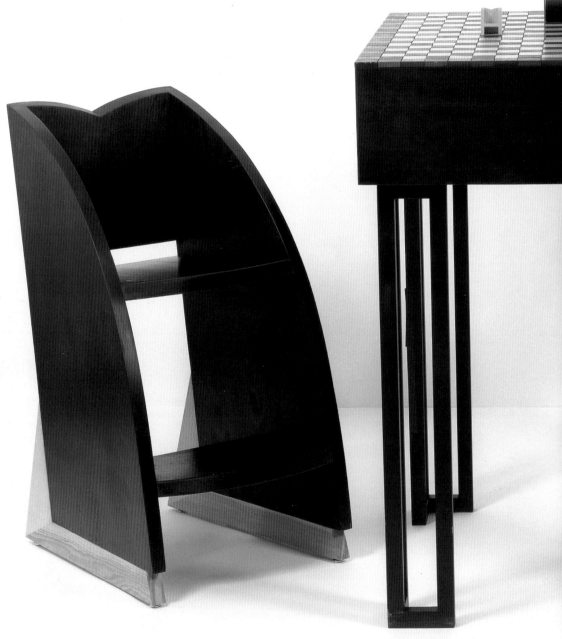

(LEFT, TOP & BOTTOM) PLATES 54-55, DETAILS OF CHAIRS IN SPACE, GAME DE LUX *WITH* CORNER LAMPS, *1984.*
INSTALLATION AT MUSEUM OF CONTEMPORARY ART, LOS ANGELES. PHOTOGRAPHS BY THOMAS P. VINETZ.

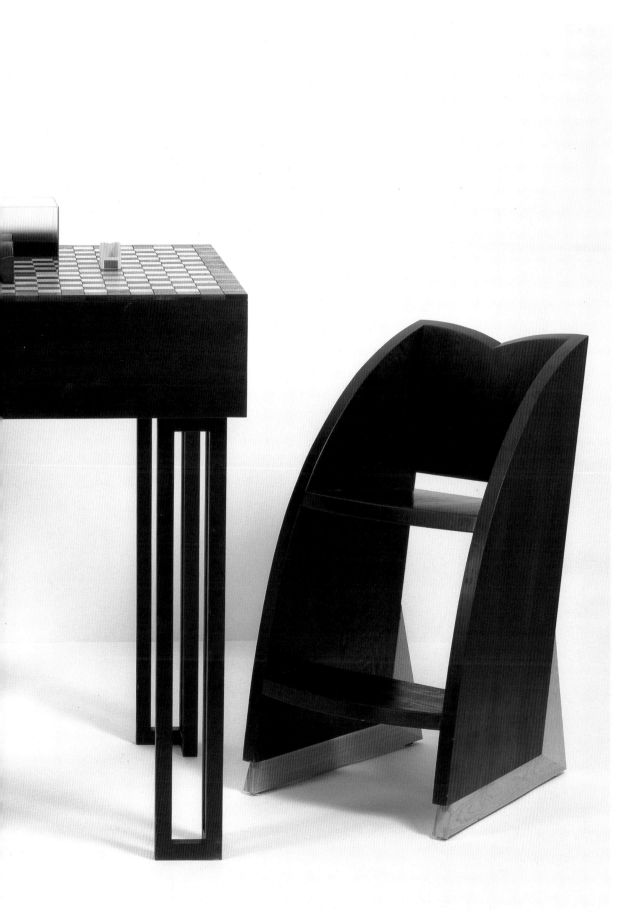

PLATE 56. CHAIRS IN SPACE / THE GAME DE LUX, PROTOTYPE #1. *1983. 50" x 42" x 42" TABLE. (ILLUSTRATED) TWO OF FOUR CHAIRS 44" x 22" x 23".*
ALL MADE OF LACQUERED WOOD; SCULPTURE, 6" x 10" x 10"; PLAYER CHAIRS 3¼" TALL. PRIVATE COLLECTION. PHOTOGRAPH BY THOMAS P. VINETZ.

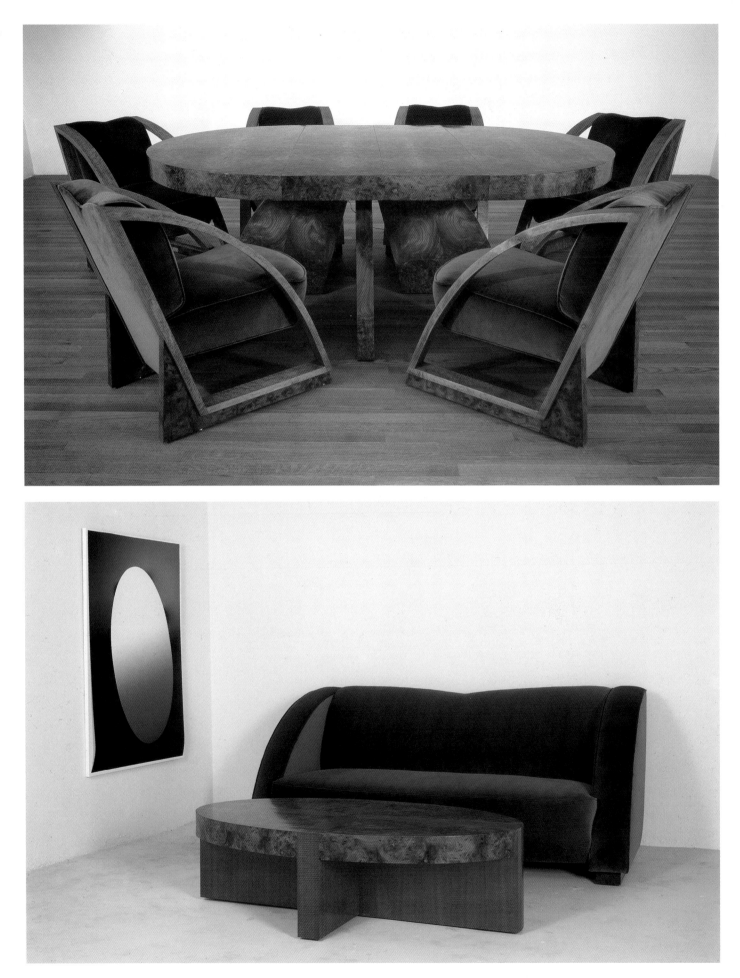

(ABOVE) PLATE 43, THE TABLE DE LUX #1, 1981, CARPATHIAN ELM BURL AND ROCK MAPLE, 54" x 96" WITH CHAIR DE LUX #4, 1982, CARPATHIAN ELM BURL AND COTTON VELVET, 32" x 26" x 32". INSTALLATION AT L.A. LOUVER GALLERY, VENICE, 1985. PHOTOGRAPH BY THOMAS P. VINETZ. (BELOW) PLATE 44, THE SOFA DE LUX II, 1981, CARPATHIAN ELM BURL AND COTTON VELVET, 33" x 35" x 88", AND COFFEE TABLE DE LUX I, 1981, CARPATHIAN ELM BURL AND MAKORE (AFRICAN CHERRY), 16" x 60" x 34", AND VAPOR DRAWING, ELBKIN 10, 1981, ALUMINUM AND SILICON MONOXIDE ON BLACK ARCHES PAPER, 55" x 33", INSTALLATION IN TAOS STUDIO. PHOTOGRAPH BY J. GORDON ADAMS.

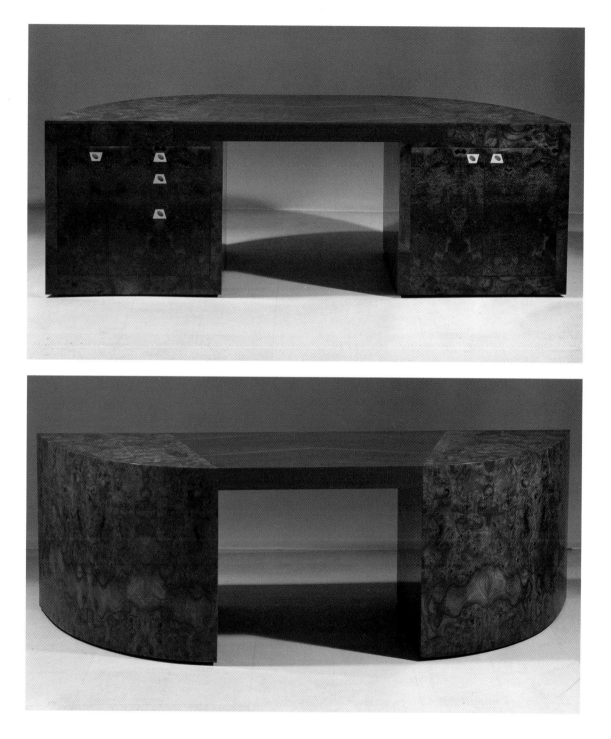

PLATES 45-46. THE DESK DE LUX I, *1981, FRONT AND BACK VIEW, CARPATHIAN ELM BURL AND MAKORE (AFRICAN CHERRY) WITH IVORY INSETS. 29" x 90" x 29".*
COLLECTION OF ROBERT ABRAMS. PHOTOGRAPHS BY J. GORDON ADAMS.

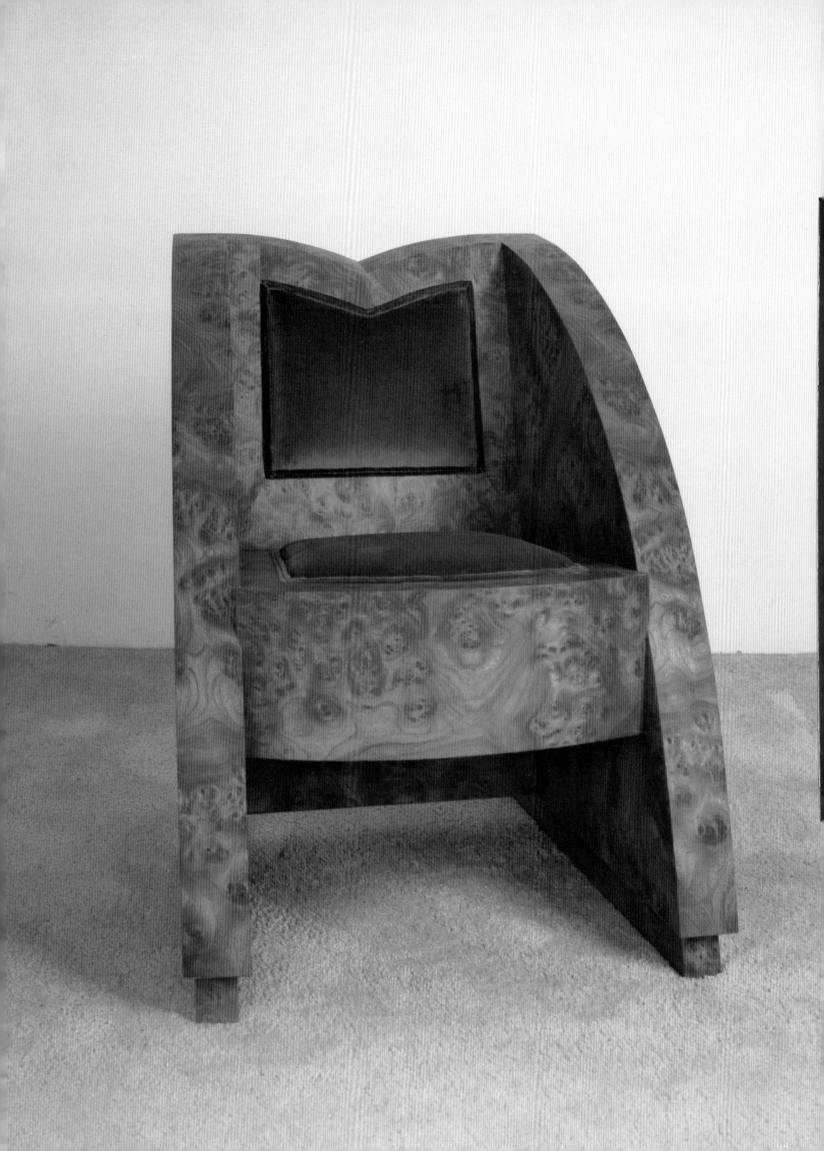

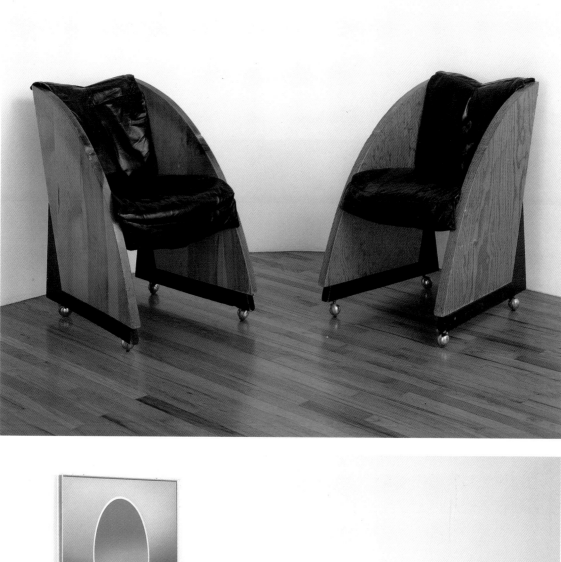

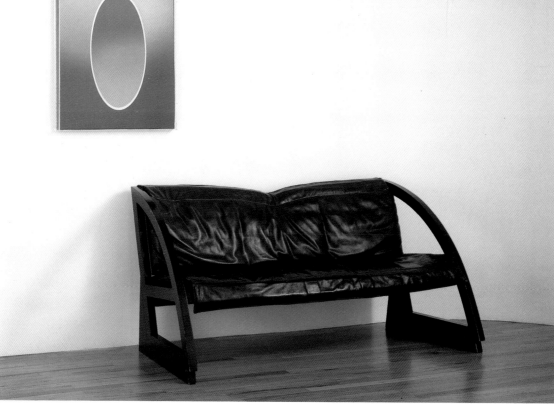

(OPPOSITE PAGE) PLATE 42, CHAIR DE LUX II, 1980, CARPATHIAN ELM BURL VENEER, COTTON VELVET, 32" x 26" x 32". PHOTOGRAPH BY J. GORDON ADAMS. (ABOVE) PLATE 47, CHAIR DE LUX, 1980-81, MARINE PLYWOOD, VARATHANE FINISH, BLACK LEATHER CUSHIONS, CHROME BALL WHEELS, 32" x 26" x 32". COURTESY OF KIYO HIGASHI GALLERY, LOS ANGELES. PHOTOGRAPH BY BRIAN FORREST. (BELOW) PLATE 48, BENCH DE LUX, 1980-81, MARINE PLYWOOD, BLACK LACQUER FINISH, BLACK LEATHER CUSHIONS, 31" x 26" x 63", AND VAPOR DRAWING MELBKIN-24, 1985, ALUMINUM AND SILICON MONOXIDE ON BLACK ARCHES PAPER, 29½" x 23¾". COURTESY OF KIYO HIGASHI GALLERY, LOS ANGELES. PHOTOGRAPH BY BRIAN FORREST.

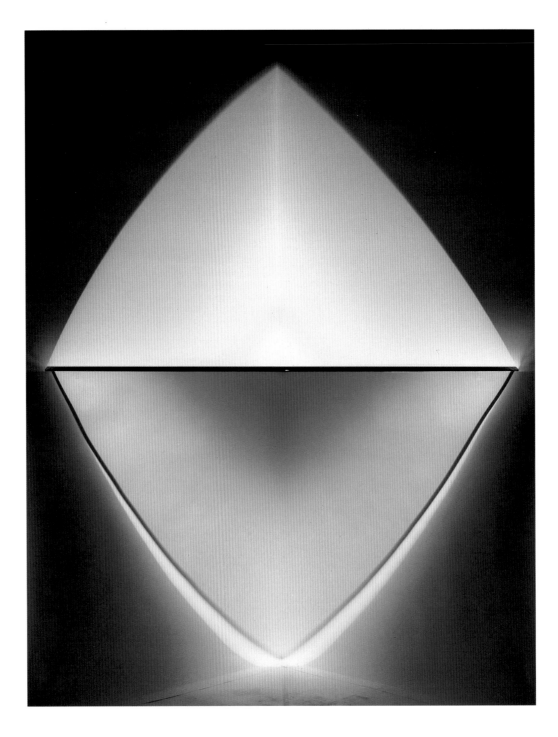

*(ABOVE AND OPPOSITE PAGE) PLATES 50-51, CORNER LAMP SB-1, 1981, (TWO VARYING INSTALLATIONS), ½" FLOAT GLASS
COATED WITH ALUMINUM AND SILICON MONOXIDE, 36" x 36", INSTALLATION IN TAOS STUDIO.*

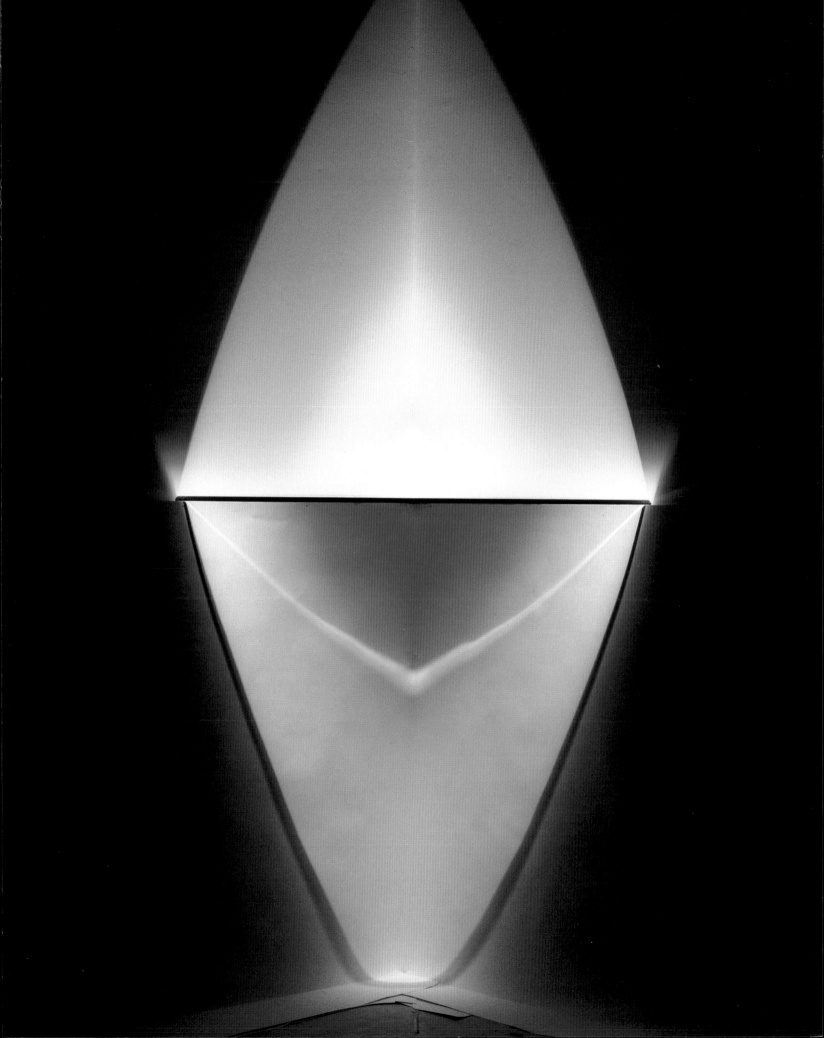

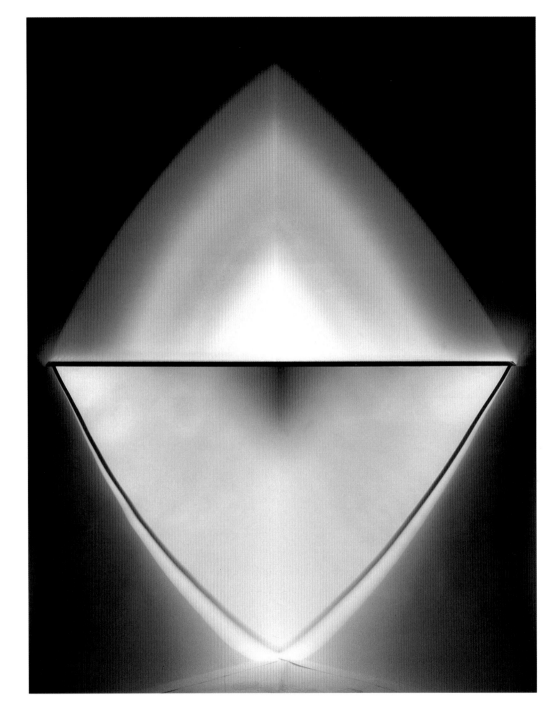

(ABOVE AND OPPOSITE PAGE) PLATES 52-53, CORNER LAMP SB-2, 1981, (TWO VARYING INSTALLATIONS), ½" FLOAT GLASS
COATED WITH ALUMINUM AND SILICON MONOXIDE, 36" x 36", INSTALLATION IN TAOS STUDIO.

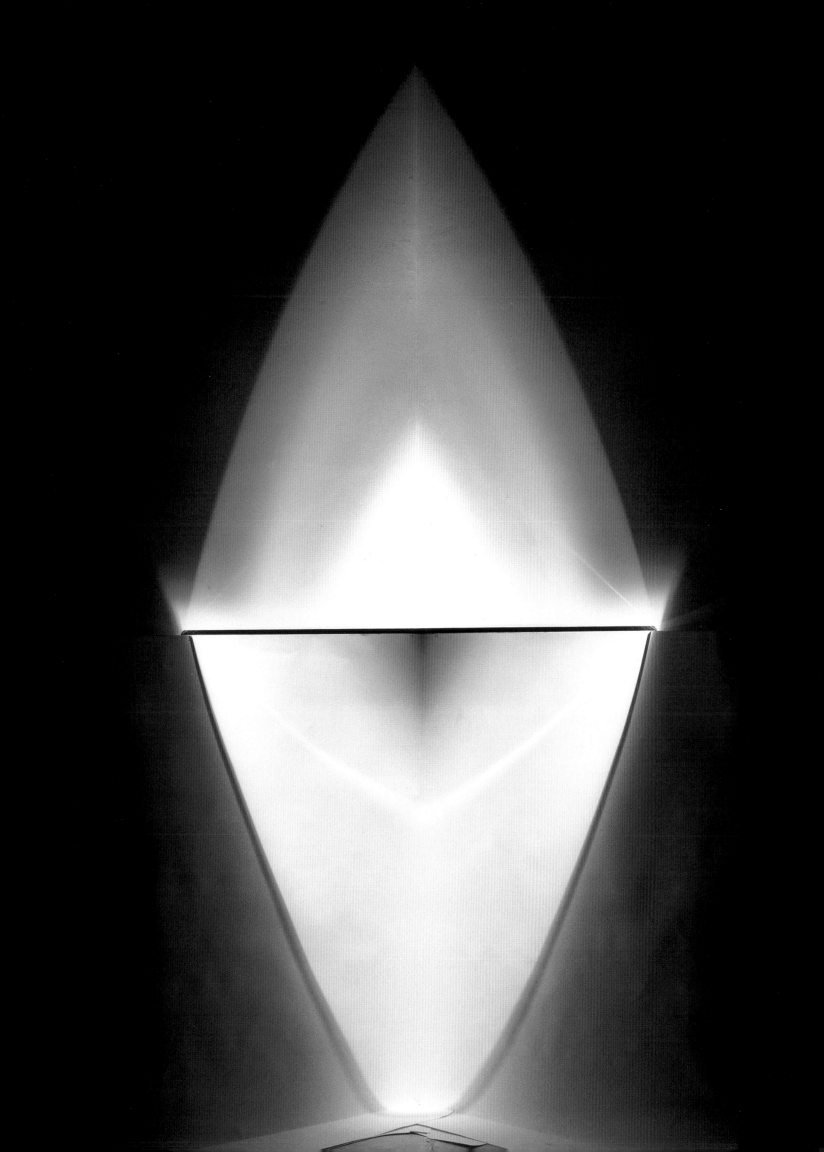

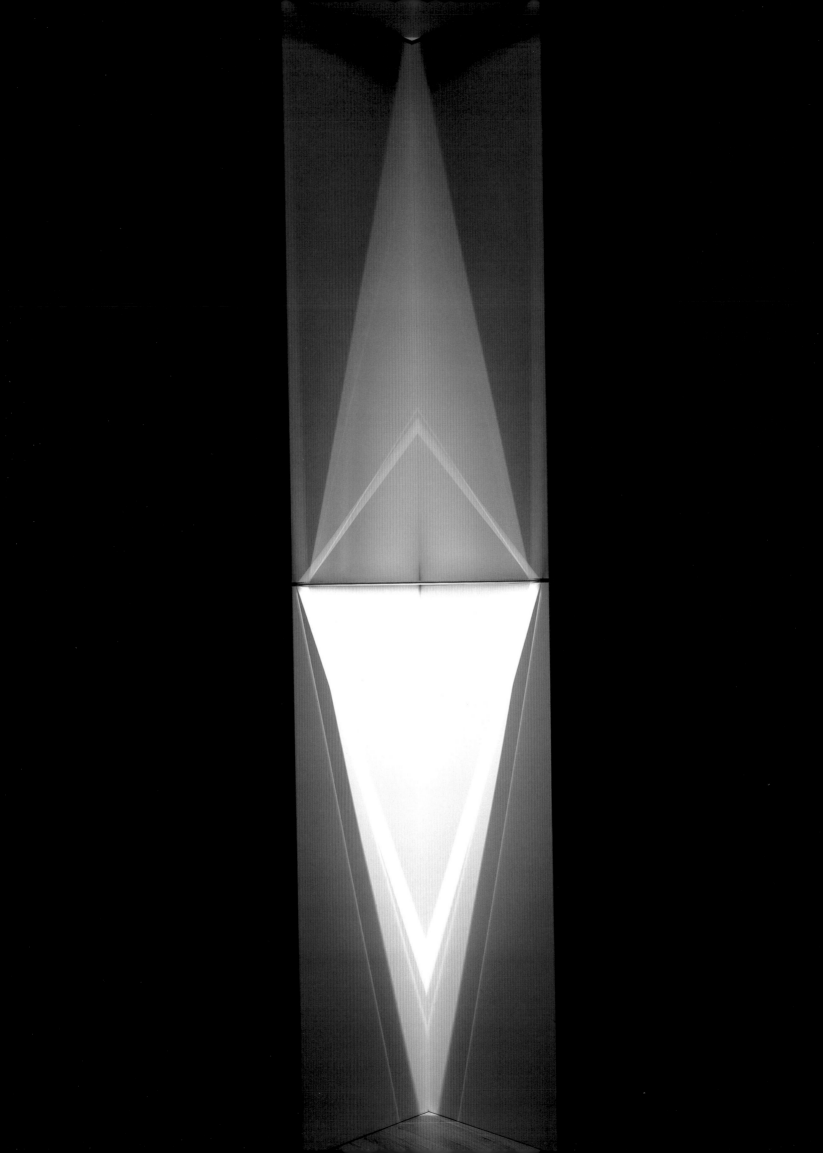

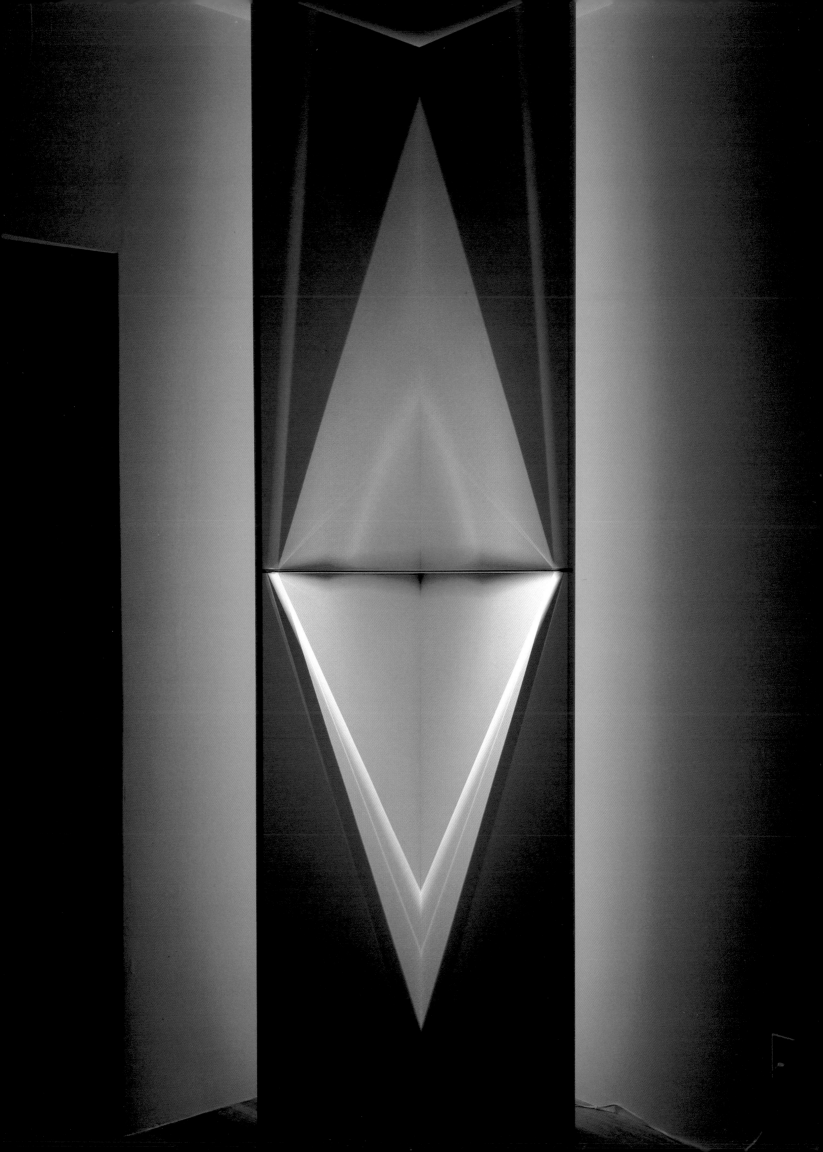

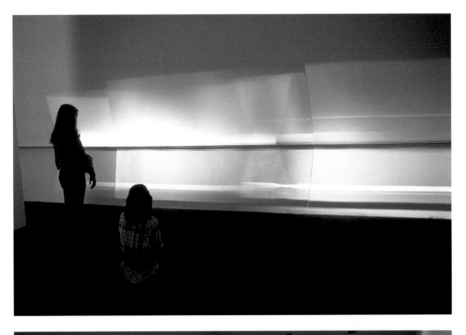

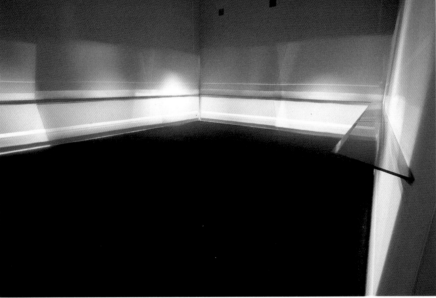

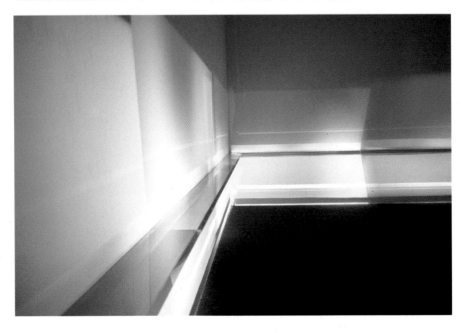

(PRECEDING SPREAD, LEFT) PLATE 70, CLTRI 1, 1987, COATED GLASS, 18" x 18". (PRECEDING SPREAD, RIGHT) PLATE 71, CLTRI 2, 1987, COATED GLASS, 18" x 18". (ABOVE) PLATES 35-37, UNTITLED, PRISM SHELF, 1980, ⅜" COATED FLOAT GLASS, INSTALLATION AT HUDSON RIVER MUSEUM, YONKERS. PHOTOGRAPH BY LEE BOLTON. (OPPOSITE PAGE) PLATE 62, LEANING ROOM FOR HIGASHI, 1986, DETAIL OF INTERIOR INSTALLATION AT KIYO HIGASHI GALLERY, LOS ANGELES. PHOTOGRAPH BY THOMAS P. VINETZ.

(ABOVE AND BELOW) PLATES 63-64, LEANING ROOM, 1986-87, INSTALLATION AT MOCA TEMPORARY CONTEMPORARY, LOS ANGELES. PHOTOGRAPHS BY THOMAS P. VINETZ.

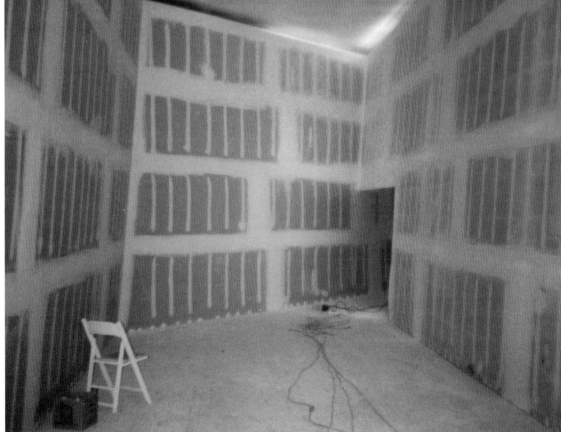

(ABOVE) PLATE 65, LEANING ROOM, 1986-87, INSTALLATION AT MOCA TEMPORARY CONTEMPORARY, LOS ANGELES. PHOTOGRAPH BY THOMAS P. VINETZ.
(BELOW) PLATE 66, CONSTRUCTION VIEW OF LEANING ROOM, 1986, AT MOCA TEMPORARY CONTEMPORARY, LOS ANGELES. PHOTOGRAPH BY THOMAS P. VINETZ.

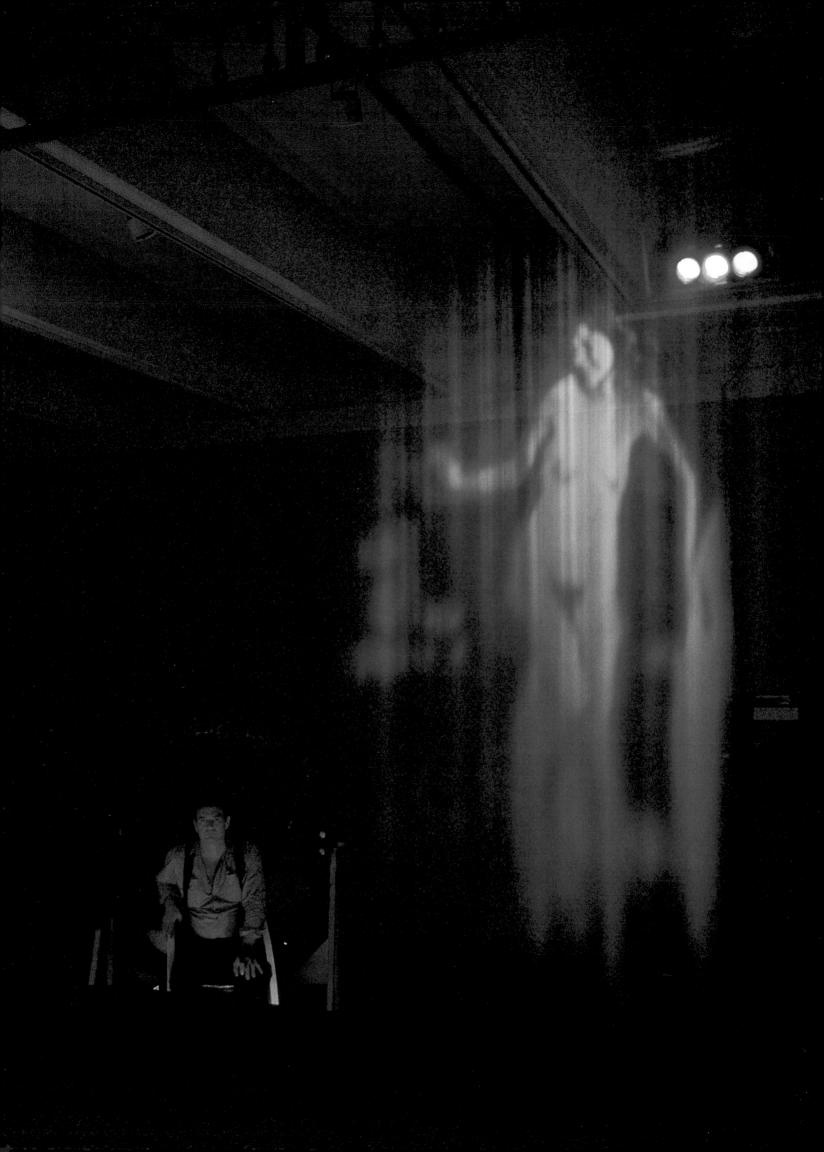

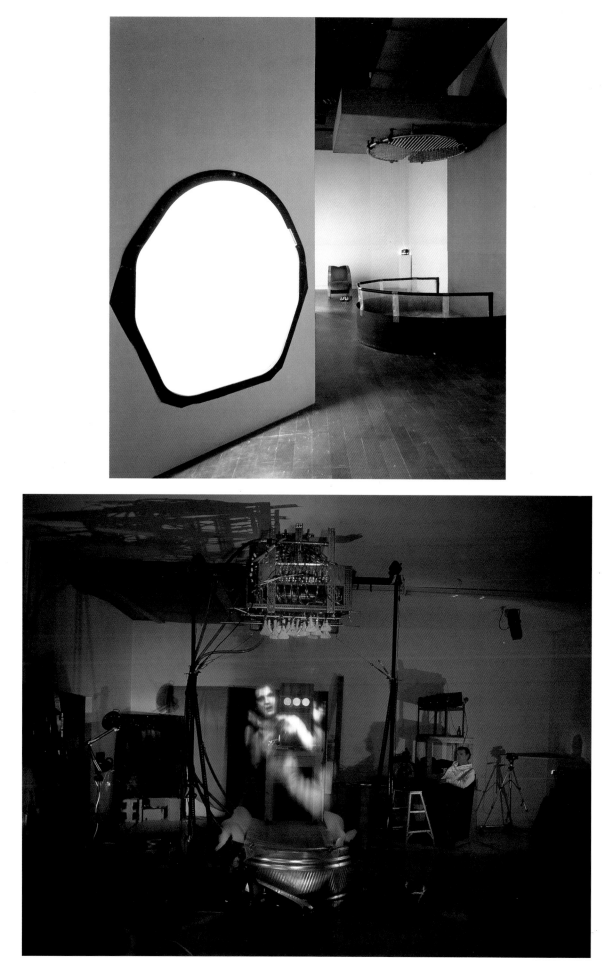

(OPPOSITE PAGE) PLATE 67, HYDROLUX, *1986, INSTALLATION AT BOISE ART MUSEUM, 1986. PHOTOGRAPHER UNKNOWN.*
(ABOVE) PLATE 57, THE IMPROBABLE FLOW, *1983, INSTALLATION AT ARCO CENTER FOR VISUAL ARTS, LOS ANGELES. PHOTOGRAPH BY THOMAS P. VINETZ.*
(BELOW) PLATE 68, HYDROLUX 1, THE IMPROBABLE FLOW, *1986, INSTALLATION IN TAOS STUDIO. PHOTOGRAPH BY THOMAS P. VINETZ.*

PLATE 29. ST 14, 1978. ALUMINUM AND QUARTZ ON VELOUR FINISH BRISTOL PAPER, 12" x 8".

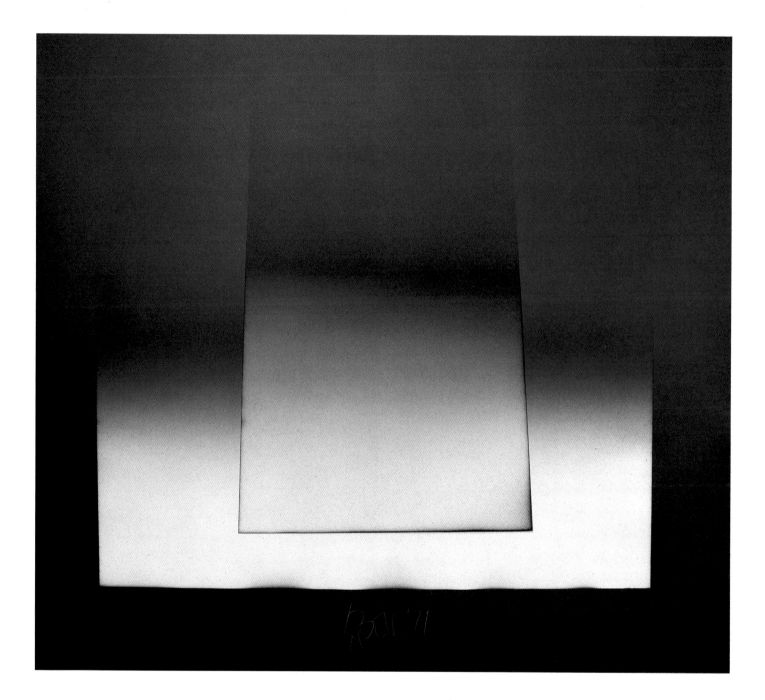

PLATE 34, BT 4, 1979, ALUMINUM ON BLACK ARCHES PAPER, 44" x 41". COURTESY OF DR. DOUGLAS GARLAND COLLECTION.

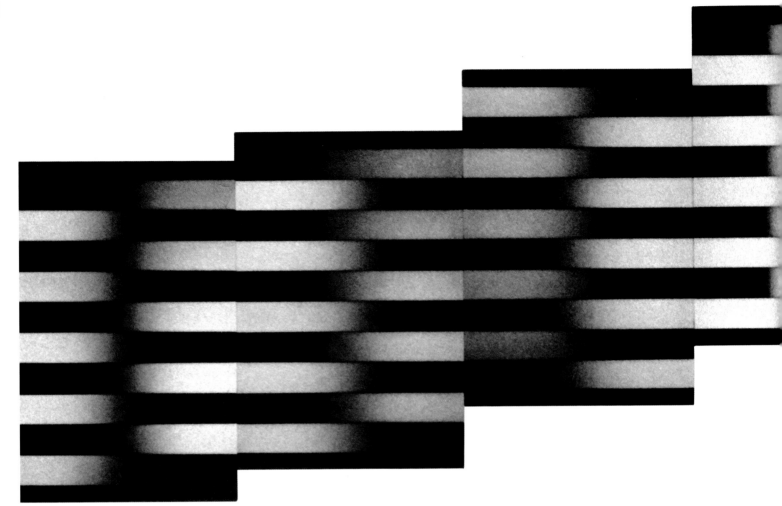

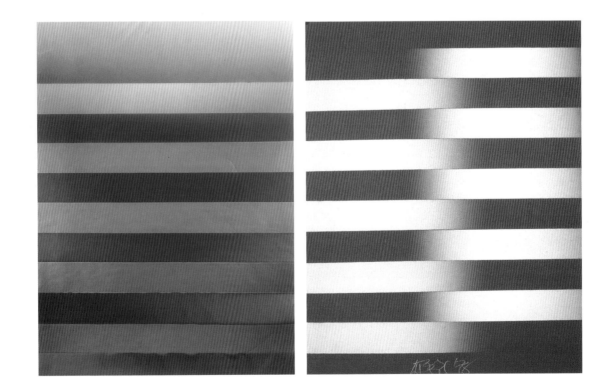

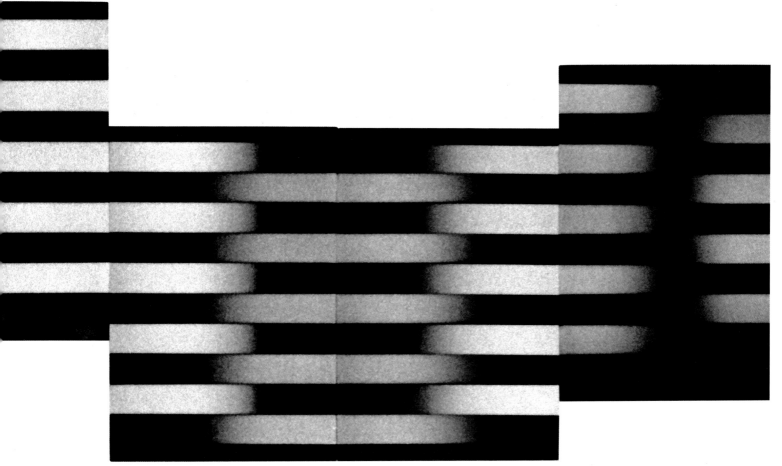

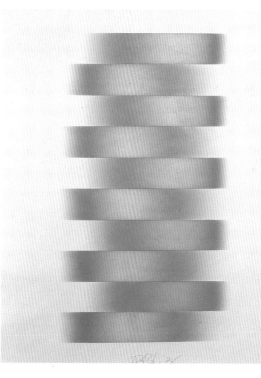

(OPPOSITE PAGE, LEFT) PLATE 30, MS 24, 1978, ALUMINUM ON ARCHES COVER PAPER, 47" x 37". COURTESY OF DR. DOUGLAS GARLAND COLLECTION.
(OPPOSITE PAGE, RIGHT) PLATE 31, SMMSHFX 1, 1978, ALUMINUM ON RED STRATHMORE CHARCOAL PAPER, 24" x 19". COURTESY OF DR. DOUGLAS GARLAND COLLECTION.
(TOP) PLATE 33, MOVING WAYS, MSHFBK, 1979, ALUMINUM ON BLACK FABRIANO PAPER, 8 PANELS, 30" x 40" EACH,
OVERALL LENGTH 210". INSTALLATION AT ROSWELL MUSEUM AND ART CENTER, ROSWELL. PHOTOGRAPH BY WILLIAM EBIE.
(BOTTOM) PLATE 32, SMMSHFPK 3J, 1978, ALUMINUM ON STRATHMORE CHARCOAL PAPER, 24" x 19". COLLECTION OF DR. DOUGLAS GARLAND.

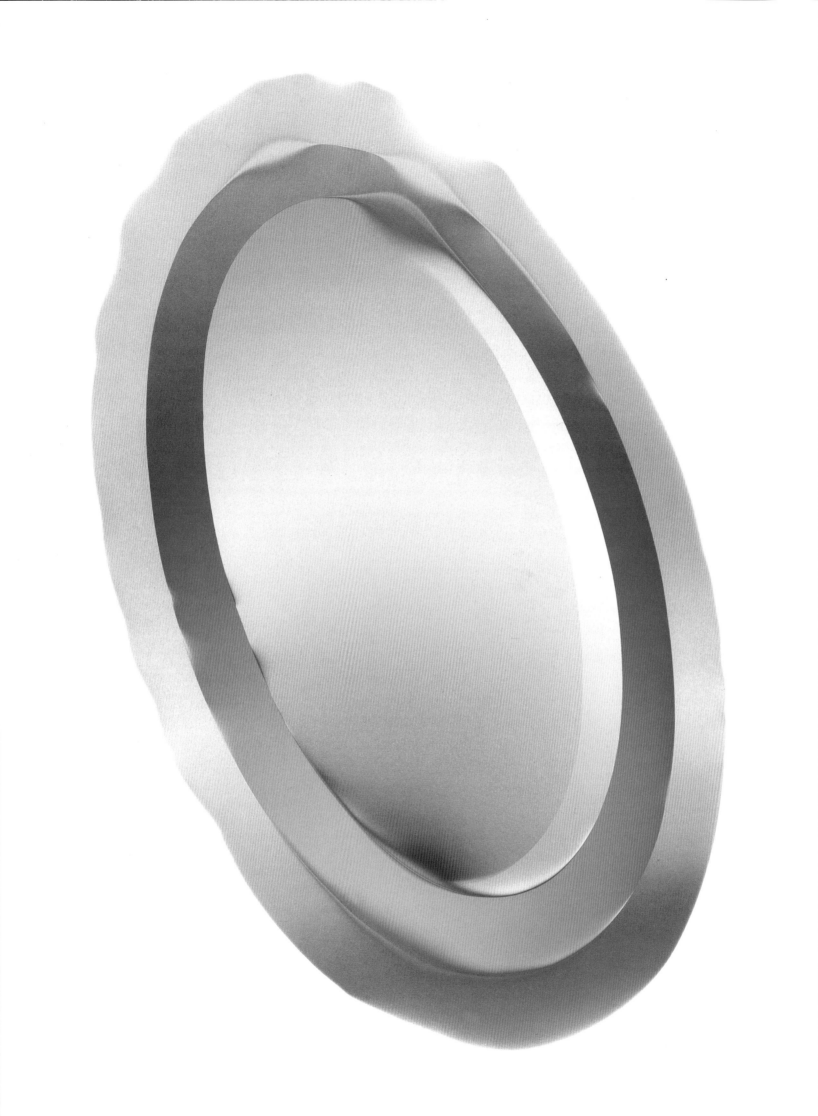

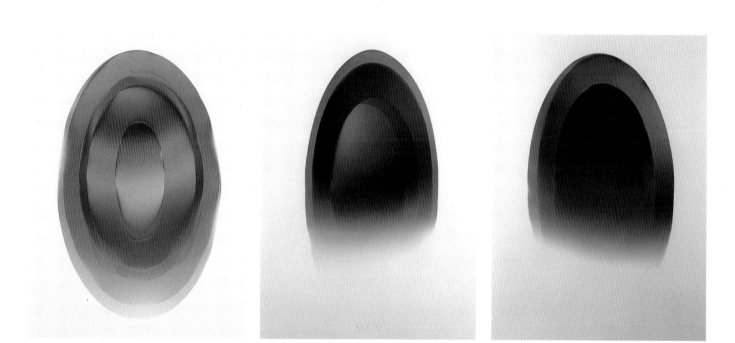

(OPPOSITE PAGE) PLATE 49, EL 25, 1981, ALUMINUM AND SILICON MONOXIDE ON WHITE ARCHES PAPER, 53" x 35". COURTESY OF RACHEL VICTORIA BELL COLLECTION.
(LEFT) PLATE 58, MEL 50, 1984, ALUMINUM AND SILICON MONOXIDE ON STONEHENGE PAPER, 30" x 24". COURTESY OF DR. DOUGLAS GARLAND COLLECTION.
(CENTER) PLATE 59, MEL 73, 1984, ALUMINUM AND SILICON MONOXIDE ON STONEHENGE PAPER, 30" x 24". COURTESY OF DR. DOUGLAS GARLAND COLLECTION.
(RIGHT) PLATE 60, MEL 81, 1984, ALUMINUM AND SILICON MONOXIDE ON STONEHENGE PAPER, 30" x 24". COURTESY OF DR. DOUGLAS GARLAND COLLECTION.

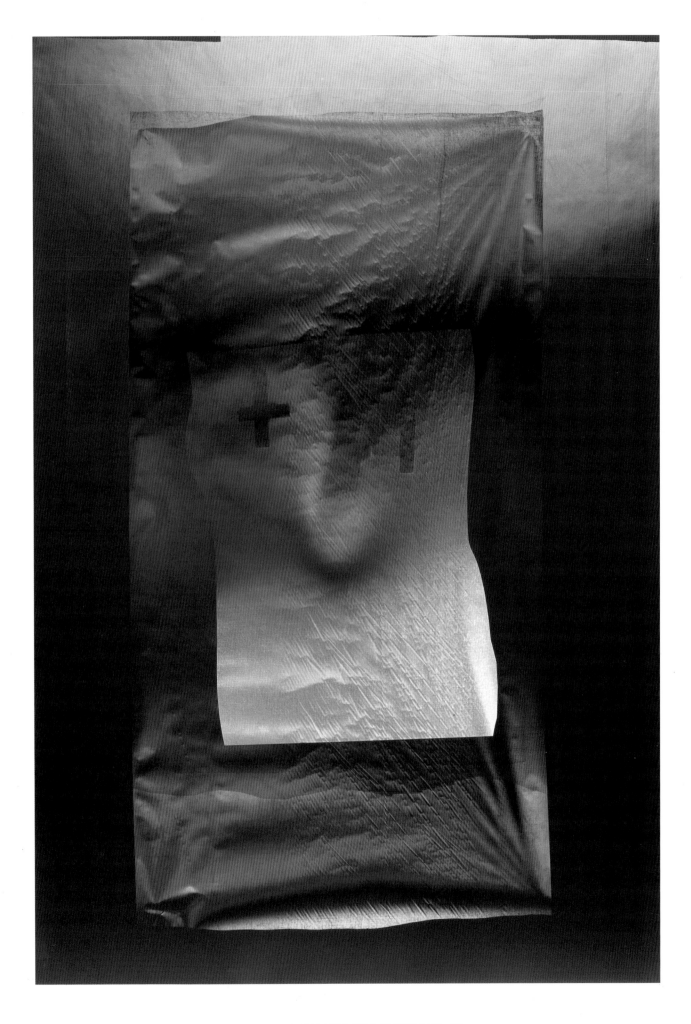

PLATE 72, TALPA, 1988, MIXED MEDIA ON CANVAS, 70" x 48".

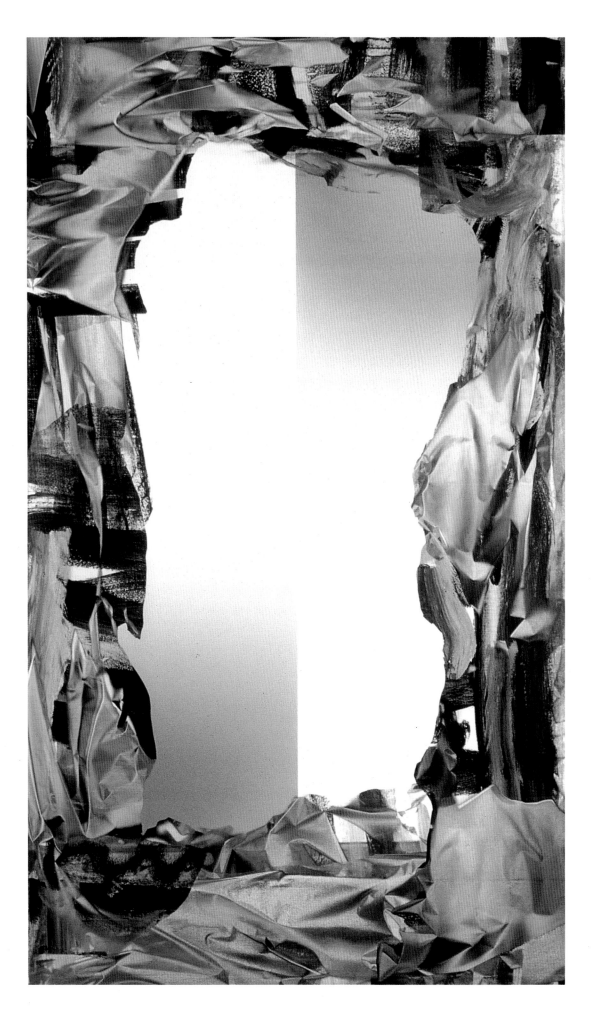

PLATE 76. FAIT ACCOMPLI, 1989. MIXED MEDIA ON CANVAS, 76" x 45". COURTESY OF ISABEL WILSON COLLECTION.

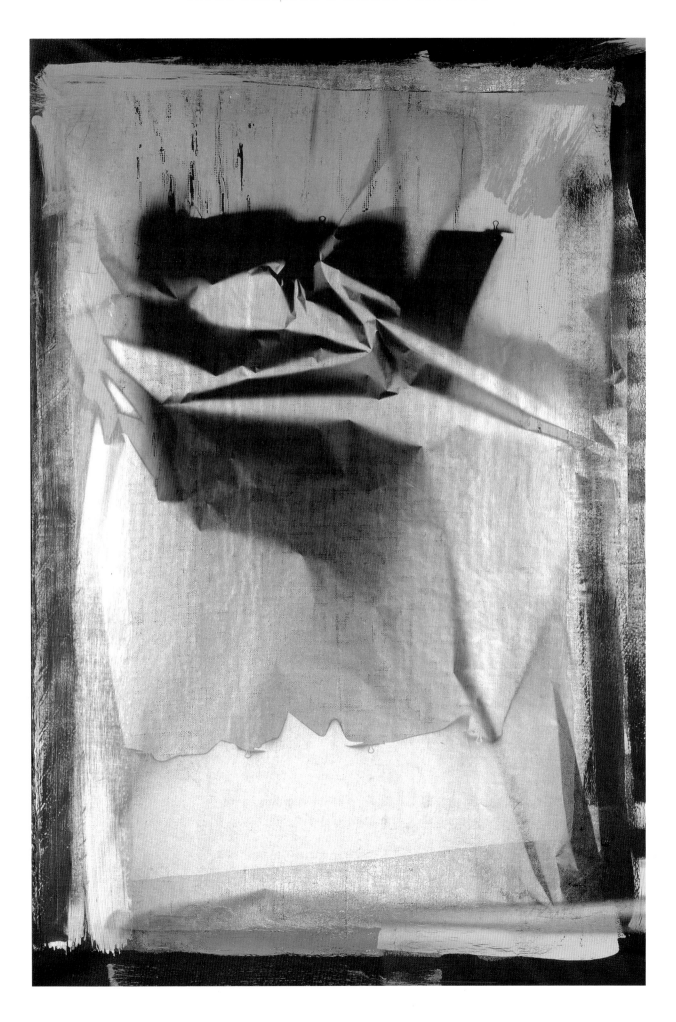

PLATE 77. EVENING PRAYER. 1989. MIXED MEDIA ON CANVAS. 64" x 43". COURTESY OF DR. DOUGLAS GARLAND COLLECTION.

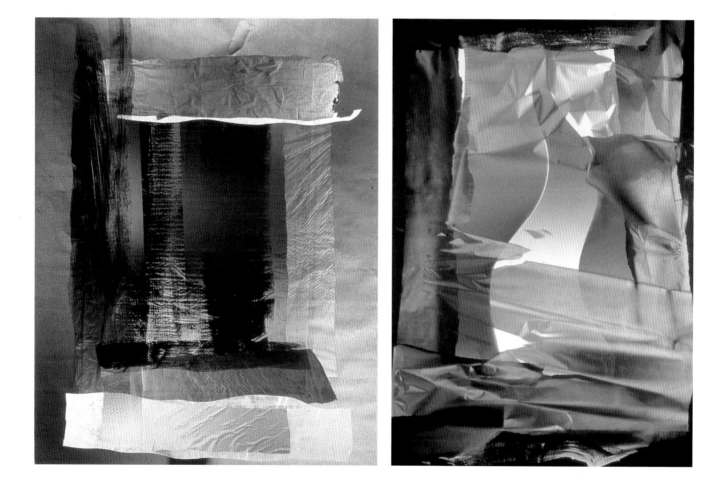

(LEFT) PLATE 74, THE VIEW, 1988, MIXED MEDIA ON CANVAS, 56" x 44". COURTESY OF MUSEUM OF NEW MEXICO/MUSEUM OF FINE ARTS, SANTA FE.
(RIGHT) PLATE 75, THE OLD DIRT ROAD, 1989, MIXED MEDIA ON CANVAS, 67" x 42½". COURTESY OF TONY AND CYNTHIA CANZONERI COLLECTION.

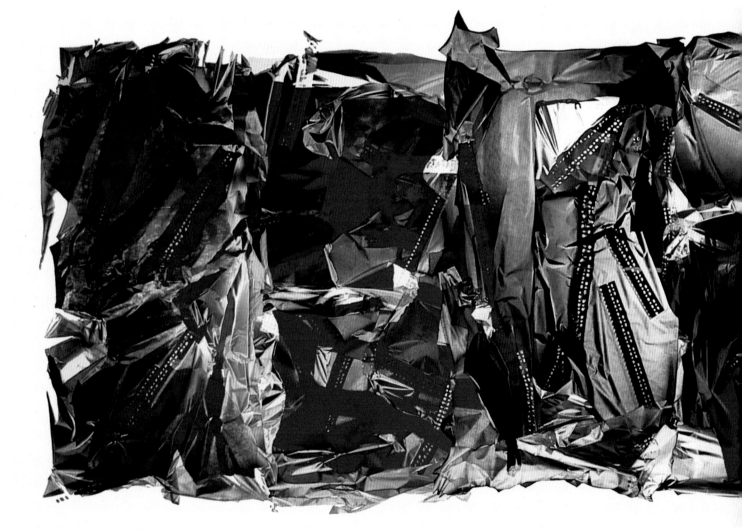

PLATE 78. MOSES X-ING THE DELAWARE, 1990. MIXED MEDIA ON CANVAS, 96" x 293". COLLECTION OF MINNEAPOLIS INSTITUTE OF ARTS.

PLATE 73. WOMAN WITH GUITAR. 1988. MIXED MEDIA ON CANVAS. 64" x 50". COURTESY OF NANCY NEGLEY COLLECTION.

PLATE 83. WINDOW BLACK DENIM #10, 1993. COATED GLASS, BLACK DENIM, 53" x 53". CENTER IMAGE 24" x 24". COURTESY OF MICHAEL L.V. LADD COLLECTION.

124

Plates 84-85. Illustrations shown are the computer generated calligraphy that was the genesis for this project, 1994.

(Opposite page) Plate 88, Stickman C-18, 1996, acrylic on canvas, 89 ½" x 70".
(Above) Plate 91, STMC-LAM #16, 1996, mixed media on canvas, 42" x 88".

Concept Narrative

A little more than 100 years ago, archeologists digging in lower Mesopotamia in their quest for Babylonian and Assyrian artifacts came across cuneiform tablets written in a language hitherto unknown. They had, by accident, found the remains and records of the lost civilization of Sumer, buried for more than 2000 years. The deciphering of the tablets from this astounding find have led to the belief that Sumer was the birthplace of western civilization.

The people of Sumer lifted mankind out of neolithic times and into the Bronze Age. They came mysteriously to Mesopotamia. From where? No one knows. They were not Semitic nor Aryan. There is no evidence that they were Negroid. The civilization they created lasted roughly 800 years before they were conquered by one horde or another. Babylonians, Assyrians, Hamites, Persians, Elamites, Hittites and others.

The conquerors were always subsumed by the culture of the Sumerians and in turn, the conquerors were consumed by later invaders. With this view the spirit of the original culture was never defeated.

The collective, creative genius of these people has been matched only by

man's outreach to space. From 3500 BCE to 3000 BCE this race of people contributed to the ongoing welfare of mankind with the most extraordinary developments. These included:

The first written language (cuneiform) pressed into thin clay tablets
> Double entry accounting
> The invention of bronze
> The first mechanical manufacturing device, the potter's wheel
> The wheel
> The first plow

The buried tablets tell the tale of a people who settled in the land called "SUMER" eons ago. These clay tablets were written in a language different from any known of the area and predate by centuries any written form. They shed light on the mysterious civilization that flourished for approximately eight centuries beginning in Neolithic times, roughly four thousand years BCE.

The vagueness of the time span is due to nomadic tribes that came and conquered them and were all subsumed by the Sumerian culture they conquered. In this view, Sumer was never defeated.

The tablets were ciphered using the most modern computer technology, and are very concise, there is little ambiguity in their meaning or content. Preliminary readings of the tablets suggest that the

culture may have contrived to invite invasion and conquest.

The discovery of site plans in the tablets directed archeologists to libraries where hundreds of thousands of records were found. Among the records, which were mostly information regarding private property and dealings of the kings and citizens, there was found a vast quantity of creative literature. In the writings of various poets and philosophers was found an account of daily life from the mundane to the exotic. These people had, in their natural aesthetic, the desire to discover and build upon those discoveries.

The writings reveal a distinction between the "art of writing" and that of visual arts. The highest echelon within the society (after the kings) was the creative writers. After them came the writers of official documents and decrees. Next were the official recorders of the social order (the first journalists) and the public recorders of private wealth for those who could not write. It should be noted that the amount of material discovered indicates that most Sumerians were literate. The artists who applied their talents to visual creativity were second in the hierarchy... potters, architects, furniture makers, and those who drew or carved likenesses of animals were considered of lesser importance than the more cerebral members of

128

the society who could describe the feelings and events of the various times in an abstract way. The nature of the libraries suggests that a great reverence was placed on abstract thought.

The site plan of the city shows a large area within the walls set aside for play or games. Specific calligraphy ascribed to various areas of the grounds suggest that organized recreation, possibly dance, was of utmost importance within the society. The mysterious calligraphy cannot be translated by computer programs and it was suggested that they may represent movements or dance positions for the participants. One of the tablets tells of a being who was chosen daily to sit in a precise position and manner and observe whatever was going on.

Example 1:
"On the rising of the source of all life and light we have chosen 'Simntack' to observe, till the source again returns to its resting place and the way is again obscured."

Example 2:
"On the rising of the source of all life and light we have chosen 'Minsckat' to observe, till the source again returns to its resting place and the way is again obscured."

This opening phrase is repeated at the beginning of each tablet with only the name being changed. The pronoun 'we' throughout the readings suggests that the society was very democratic in relegating the responsibility of "observing." As yet, we do not understand the significance of the daily observer. Further readings have uncovered a series of postures or attitudes that must be assumed by a chosen citizen and maintained throughout the day, ie: between the rising and setting of the 'source of all life and light.'

The distinguished Paraguayan archeologist, Dr. Vente Mente Swerlo of the University of Asunción, has suggested that the mysterious markings in the recreational areas of the city in some way relate to the responsibilities given to different citizens on a daily basis.

It is interesting to note that the ceremonial procedures described have included no reference to animal or human sacrifice to the gods. Dr. Swerlo has postulated... "the attitudes and postures may in some manner allow the citizenry to make homage and atonements to the gods without the elimination and loss of valuable intellect, labor or meat from the community."

A curious character that appears in the "Attitude Chronicle," is 'he who approaches as to harm but touches not.' This chosen citizen has the responsibility to "stalk" the "observer" while not touching him or being seen.

Example 3:
"On the rising of the source of all life and light we have chosen 'Thamkisc' to be he who approaches as to harm the observer but touches not and is seen not."

Apparently, the "observer must be observed" suggests Dr. Swerlo, but the responsibility associated with 'observing' is so great that the 'observer' must not be disturbed. Calligraphy of the recreational areas of the city shows forms which could be construed as assuming a "stalking attitude," although the calligraphy may also be interpreted in other ways. It is apparent from the writings that the interactions between the inhabitants of this area were conducted in both a

creative and formal manner. The punishment for failure to satisfy the customs of the day was as follows: the individual was seized by the temples and dragged by his hair through the city for all to witness.

Example 4:
"On the rising of the source of all life and light, he who has been chosen but shirketh the duties of the citizen shall be grasped by the front of the face above the eyes and thence taken by the hair to be pulled slowly through every road and passageway in the city. Thereby all citizens shall bear witness to them that hath not fulfilled the citizenry duties. On his buttocks and legs shall be left the stains and stench of the feces of dogs and the urine of asses and oxen. The flesh shall be scraped and made raw and the punished shall cry in pain. After the punishment has been administered the punished shall be brought forth to the King and there will be a feast

made. The punished shall have wine and meat and be made to hear the stories of those who have shirked before. The scribes shall be many so that the punished may bear many tales of mischief at once thereby lessening the time that the King must listen to the same. After, his wounds shall be cleaned and dressed and he shall be given the tablets that have been read to him to restore to the keep of these things. He shall be not asked to come forth to the tasks of citizenry till his wounds they have healed."

It appears that the laws of the community were based more on acceptance of responsibility to the customs of the group than to any rules on behalf of the king, who as we have seen, must endure the smell of the punished and the tedium of the records of those who have shirked before.

The commerce of the times is recorded in great depth. Double entry accounting practices were found to be a part of the records. This remarkable innovation has been used to this day, as a standard for record keeping. It was the custom for all to pay for what they needed at a fair price. Royalty was no exception. The king may have had an edge on getting a "better deal," but it wasn't the law as it was in Egypt where the Pharaoh was the "living god" and as such, owned all things. It seems that all had the right to bargain fairly for their goods.

Example 5:
"On the rising of the source of all life and light let it be known that all may barter as they choose and there shall be no law that speaketh to the betterment of any man in the matter, even shall he be the King."

The writings continue with the following anecdote about trade:

"On the rising of the source of all life and light we have chosen 'Timsanck' to procure the provisions and foodstuffs for our citizenry. He shall have the duty to care for the purity of the water and air by beseeching the gods of same to keep them pure and clean. He shall keep the soil productive and the milk sweet and yea so shall he oversee that the goods of the people are vended fair and none shall have advantage above another. If the harvest is weak, all shall be hungry; yea if the harvest is bountiful so shall all eat to the fullest of their want. Verily shall Timsanck observe and approve how doth his brother vend. Upon his shoulders shall be the burden of the judgment to what

is fair and not. This burden he shall bear till the source again returns to its resting place and the way is again obscured."

Poor Timsanck had a thankless job. It appears that the burden of "procurer" was also changed on a daily basis, and he was responsible for basic needs. How this method actually worked in the society we can only guess, but it certainly would have provided insulation against the accumulation of political power. In the mass of documentation being examined, there are but few examples of corruption and venality. Greed was another matter.

We find frugality unbearable for a few. The desire to take the advantage in dealings to get more than a normal share is a recurring theme in the writings. The king was the final judge of what was acceptable.

Example 6:

"On the rising...We have observed that the landowner 'Camskint' has told the growers of barley on his fields that they must pay three pecks more for the harvest than the harvest of the former year. This harvest is of a mean kind and the growers of barley saith the fee is too high and without justice; therefore it is unfair and shall not be paid as demanded. The landowner Camskint saith the greater charge must be paid as the family of Camskint grows larger and the land he owns doth not. Therefore the users of the land must forfeit a greater portion of their harvest to Camskint."

The records show that the farmers have appealed to the king for a solution to this grievance.

Example 7:

"On the rising...the King decideth in the favor of the growers of the barley. The barley is made to grow through the grace of the gods and not the commerce of the owner of the land. The growers of same barley shall vend it to the citizens for an amount fair and even with the capabilities of the citizens to pay. The owner Camskint may have a family as large as he wisheth. If he demandeth a greater portion of the harvest for his family he must provideth the growers with more land to grow more barley and the provision of more water needed to do so."

The king adds in a final note that Camskint's larger family now has the ability to provide that land and since he has chosen to have more children it is his family's responsibility to do so.

"Camskint's needs must also be considered in this matter. It is hereby made notice that he hath the King's blessings and the protection of the militia in clearing that land adjacent to the wall of the city which faceth the river Ur. Camskint may taketh water as needs be and maketh a canal for this same water. The growers of barley must yield unto Camskint, one half of one peck for the right to use the fields that Camskint's family shall prepareth."

The king has made a very wise political judgment. He has appeased the growers, made available more land to the land owner and kept inflation to minimum. It should be noted that the king was also selected by the people he governed.

Again Dr. Swerlo: "Within the community, 'he who sits and observes' may be observing the king as well as any of the king's subjects. Here we have evidence of a very democratic system."

The tablets have also uncovered interesting facts about the observation of the heavens as well as life on the land of Sumer. The libraries contain massive amounts of tablets referring to observations of the celestial bodies. The finding and translation of this material coincided with the translation of records regarding farming. Discoveries of agricultural information in the library were thought to have been misplaced by the original record keepers, until it was discovered that the toils of the earth were deeply rooted to the observations of the heavens.

Example 8:

"On the rising...the King shall go forth and choose a citizen for the task of observing the dwelling of the source of all life and light. He shall observe the wrinkles and smiles of the source and shall record for the use of the growers of barley and wheat

that which they must know for the bountiful harvest needed for the bread of life."

The writer of this chronicle gives us our first glimpse of the possible meanings of the mysterious calligraphy.

"The King shall choose "he who moves" as the markings say. The King shall be the observer of the shadow of the mover and shall inscribe himself, the meaning of the symbols and the growers of wheat and barley shall know this upon the completion of the account."

Apparently, the king was responsible for not only the selection of the sky watcher but the recording of the movements of the sky watcher as directed by the sky. The observation of the sky took place at a specific location. Dr. Swerlo again postulates that the markings on the ground were like "stage placement cues." Those "cues" may be a key to understanding the writings which combined the shadow of the observer of the sky and calligraphy inscribed in the earth. The reader need only imagine the workings of a sun dial to understand the concept of this interaction. The difficulty of interpretation lies in the inconsistency of the written cuneiform or wedge type symbols etched into the clay tablets, and the apparently meaningless forms of the calligraphy on the ground. While the translated tablets have shed some light on this wonderful culture, there is nothing to indicate the meaning of the calligraphy, even as we explore in depth the culture of the inhabitants of the area.

The writings of the kings who witnessed the actions of those chosen to observe the "dwelling of the source" tell us in the traditional language the message from the heavens. These reports, which are plentiful, are recorded in the cuneiform style.

Earlier discussions regarding the lack of use of sacrifice in ceremonial activities reaffirm by omission of said sacrifice, the reverence that the Sumerians placed on all animal life. The slaughter for food was not considered a trespass on life, as the meat was consumed by the inhabitants. Great formality was accorded the killing of a sheep or an oxen for a feast and somber prayers were made to the specific gods of the animals.

Many of the tablets that have been translated discuss the eating habits of these people and it is interesting to note that custom stated that before any of the Sumerians ate, their flocks, beasts of burden and domestic pets were fed. The affection shown for animals is so prevalent within the

130

writings that the reader has to wonder if these people weren't a bit neurotic. We have learned that the younger animals were fed tender greens and milk. The mature animals were fed only fodder that had been examined for purity and wholesomeness. The dietary laws that were subscribed for the community were also quite strict. We have noted specific rules that pertain to combinations of foodstuffs that were healthful comestibles. Grains, breads, and cheeses were always served separately from meats and on different utensils. Later Hebraic laws have similar considerations. It is assumed that certain combinations caused colic-like conditions and those combinations were avoided. The tablets have described very few situations of ill health; it is assumed proper diet may have been responsible. There are accounts of lean harvest where "all shall be in need of more sustenance," but hunger was democratically shared and the animals were fed first.

One of the more interesting and enigmatic translations recounts an intuitive thought by one of the philosophers:

Example 9:
"On the rising...'Tamsnick' maketh an announcement. His very astute observation of the home of the source maketh him believe that if two runners start at one place and runneth in opposite directions they will meet at the place of their starting. Tamsnick hath wagered with Kiscmnat that this is so. Each has ordered his fastest running son to arrangeth a time and place to test this theory of Tamsnick."

The tablets describe Tamsnick as an intelligent man and also very frugal. He was not given to "wagering." It is this fact that Kiscmnat knows and while believing in the powers of Tamsnick's intelligence, he:

"believeth that Tamsnick is wrong."

The story goes that the two runners agreed to run to the point that they could no longer see the place from which they had started and then run the like amount. The theory of Tamsnick was, that at the point where they could no longer see the beginning point of their run, they would be beginning their return. The amazing truth in this concept was not to be fully understood for another four thousand years.

Our translation goes on to talk of the waiting of the parents for return of the sons:

"When the source of all life and light has left and the way is again obscured our children are still on their quest. They have not returned and they will probably rest till the rising of the source. I, Tamsnick have walked in the direction of my son's footfalls and called his name, but he harketh not; I walked then in the direction of the son of Kiscmnat and called the name of my son, again he harketh not. Of this we have repeated for the rising of the source as many times as I have fingers and toes and yea neither my son nor the son of Kiscmnat shall be found, and our hearts are heavy with worry and grief."

An interesting theory and a simple wager has cost two sons. The tablets go on to say that they never returned nor were they found. This is the stuff that myths are made of.

Later writings from the Akkadian era tell of the myth of the two sons that raced to the sky on behalf of a wager of their fathers.

Canmiskt and Imacsknt were told by their fathers that the son who was first to reach the stars by running would collect the silver of the stars and bring it back to his family. They would be rewarded by the precious metal and gain great strength and knowledge by the test. It is said that the race began and the two were gone in a flash and every now and then, if we watch the heavens, we can see either Canmiskt or Imacsknt streaking across the heavens, with silver spilling from their hands, on the journey back to their fathers.

Thus the tablets of these ancients told of the lives and legends of their forefathers and the customs and practices of the times at hand. We have found an interesting

series of writings that tell of prophecies from different periods. The mass of prophesy is nearly equal to the amount of records concerning the customs of the day. We offer here a sampling of some of the most important prophesies uncovered so far. It is interesting to note that the tablets in this area of the libraries were all damaged in the same manner. It is as if someone intentionally removed the preface that accompanied the writings described earlier.

A carbon dating of the tablets indicates that they are not forgeries from a later time. The dilemma of this body of writings is that it predates the introduction of the written form. It is, however, written in the same idiom as later writings, using the same cuneiform text. It can only be described as part of the mystery of Sumer and paradoxically as: 'written before writing existed.'

Example 10:
(from the earliest tablets found)
"Thou shalt appear as is needed when the source of all life and light calls. Upon being called thou shalt go forward and help those of innocence without guile, from the stones of the mountains wilt thou make fire and cause to flow the essence of the stone. Thou wilt witness the use of this gift and give its purpose to those who know not the use."

This is an obvious reference to the smelting of copper from ore.

Example 11:
"As the innocents find the tools hidden within the essence of the stone, so shall ye show the way to give strength to the tools and the variety of the essence."

The interpretation of this is the alloying of tin with copper to create bronze.

Example 12:
"There shall be a time when it is needed for the harvest to yield greater bounty of foodstuffs for the people and the flocks. It will be wise to guide the tools to the earth with harness and oxen. As the issue of the innocents grow so shall be the needs for food. If a man toils the earth with a stick for the growth of wheat his family will be for want. The tools of the earth, with strength of the oxen shall bring forth a greater bounty and feed the greater number."

Here we have the first mention of the bronze plow and the assistance of the beast of burden.

Example 13:

"As the foodstuffs multiply the innocents will need the way to keep these foods wholesome and a way to draw water from the rivers to wash and have the comfort of water by the place of dwelling. There shall be made a device to allow the molding of earth to be made a vessel that is round and pleasant to hand and eye. The innocents shall be taught that this earth may be hardened by fire as is the wood of the spear. Also shall the innocents discover the wonder of movement in the device and shall their thoughts bring forth new discoveries for movement."

Here we find the first industrial manufacturing tool, the 'potters wheel' and the reference to the discovery of the wheel by nature of intuitive evolvement. As we attempt to unravel the mystery of the earliest tablets that speak of the prophesy for the coming times, we are confounded by cryptic, antithetical dichotomies. The following poem is a good example:

Example 14:

"There needs be a method of the
 numbers of the hand, and yet it
 shall exist not.
There needs be a method of travels for the thought, and yet it
 shall exist not.
A story for the soul will be found
 and then lost and found
 not again.
So shall ye travel to the end of the
 land and yet shall ye not leave
 thy home.
Thou shalt feel pain in thy heart
 and thy heart shall exist not.
Thy issue shall multiply and yet
 there shall be none.
The path shall flow yet the traveler
 be still."

The poetry of this is as beautiful and mysterious in its meaning as the culture itself.
 The poem continues:

"They shall come in skins yet shall they be
 naked.
The lion shall visit yet shall not be there.
The song of the river shall not be heard.
The word of the gods shall not be known.
Thou shalt have gifts and yet shall have
 none.
Thou shalt find words that cannot be read.
Thy enemy shalt conquer and yet have
 naught.
Thy victory will be joyous yet ye shall know

only sadness.
When thy knowledge is greatest thy
 wisdom will be dumb.
When comest the word thy mind will fail.
Thy house shall be grand and yet small.
When these words shall ye read the clay
 shall be blank.
The stranger shall come and ye will know
 him well."

The most enigmatic verse is the one that foretells the meeting with Abraham and the eventual departure from Sumer.

"The son of the son one hundred count
 shall be found.
The son of the son of one called Shem.
On the banks of Ur will thy waters dry.
When thou meetest the one called Abrim.
And with thy issue shall ye leave this land
 and to south find the sea.
And there thy vessels will wait and great
 fortune and trade shall be.

SUMERIAN ART: Domestic Animals Feeding.

For the time will be to leave this land and
 give the chosen thy bread.
And be blessed for the work thee have
 done and the goodness that maketh
 thou free.
For the work of thy people will be done.
And shall be time to return unto me."

While the writer has no presumptions that this brief on the culture of Sumer is anything but cursory and incomplete, the attempt is to feel the magic and mystery of these great people. It can be surmised from the mass of literature discovered and processed that the relative democracy existing within the culture was unique. The human race can thank them for the most astounding creations that have changed the course of mankind's development. "For

better or for worse," it might be said, but there is one universal truth: that each civilization is responsible for the intent of its people. We all must take the responsibility for what we do with the tools and innovations we choose to implement in our lives. Picking up a stick to plow the ground is an act of conscious will, as is picking up the same stick to strike down one's neighbor.

The tablets uncovered, show the Sumerians as a very giving society, and certainly subject to the foibles and failures of any people. Their strength was in their creativity and their desire to build a better life through innovation and discovery. The reason for this desire has yet to be determined. It may never be.

As of this writing, we can only guess many things about the Sumerians. Particularly, the early civilization before the conquests by so many other cultures. But that is the value of subjective history, it appeals to the dreamer in us. It gives us a vision of where we came from and of the tools that brought us to where we are.

Given the determination to be creative at all cost, and the willingness to share our inventions, is truly civilized. Is it possible this culture invented so many things with the intent of having them taken away by force so that the culture would not become insular? So that the conquering hordes would feel good about their strength and about the intelligence that allowed them to assume the tools that they had plundered, thereby attaining intelligence vicariously? We can only guess at these questions and answer them for ourselves by the way we handle our own daily lives.

In the mass of writings that the Sumerians left us, they were conspicuously careful to leave nothing that depicts their persona. The few carvings and pictures left for posterity have told us that they were not particularly interested in reproducing their own likeness. Their passion for their flocks and domestic animals is all we have as a pictorial account, left by artisans who, as we have learned, were less important than the scribes and writers of their culture.

In closing this article, I have chosen one of the better reproductions taken from a dig at Meskalamdu, near Ur. It is from the Tsackmin period, circa 2700 BCE, and shows the beloved domestic animals feeding. ∎

©1994 Text by Larry Bell, research assistant Zara Bell

132

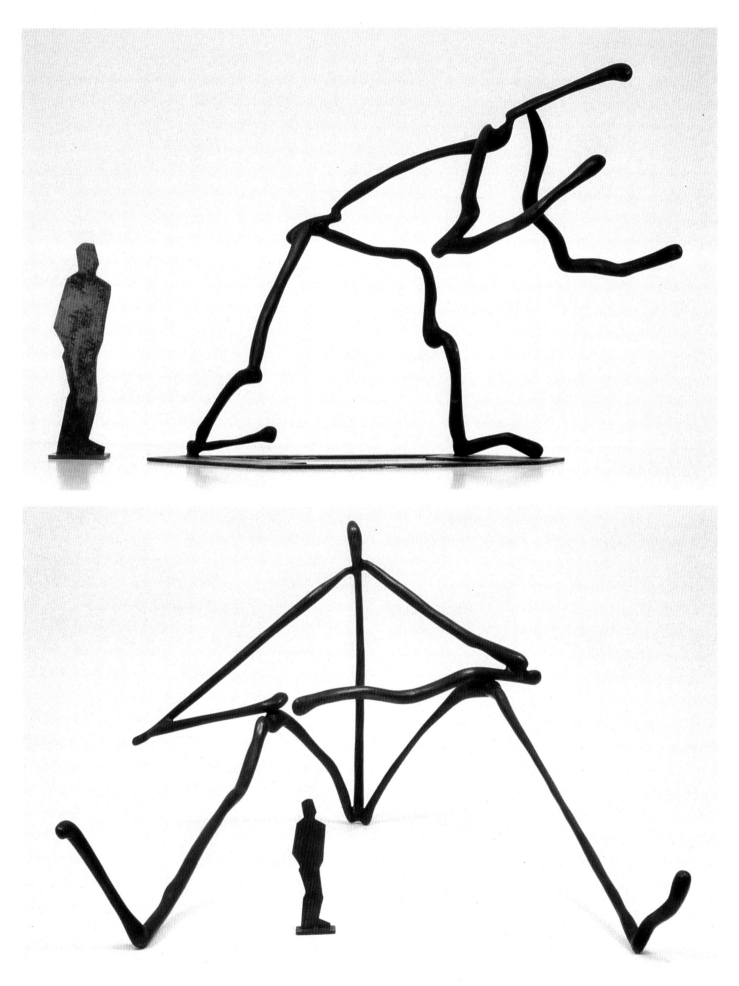

(Above) Plate 86, Stickman #1, 1994, fabricated bronze maquette, approximately 20" tall.
(Below) Plate 87, Stickman #12, 1995, fabricated bronze maquette, approximately 19" tall.

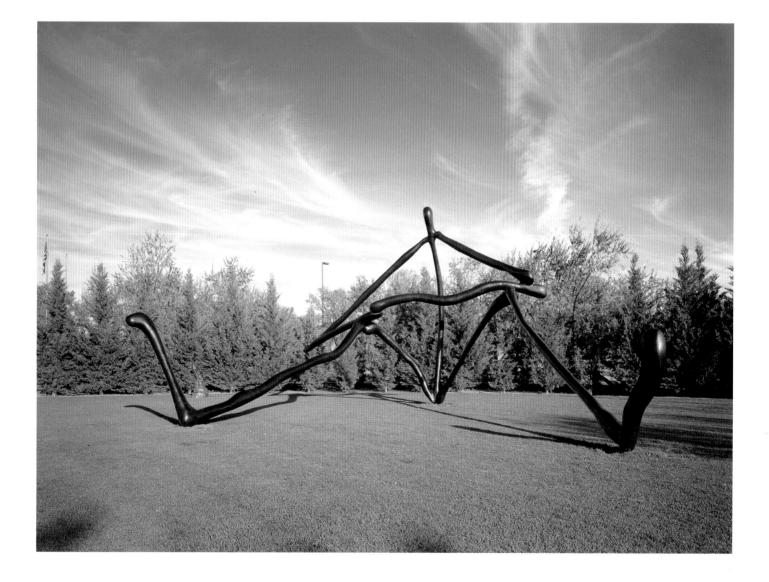

Plate 92, Figure #12, *1996, cast bronze, 22' x 37' x 35', installation at The Albuquerque Museum. Collection of Peter B. Lewis. Photograph by Robert Reck.*

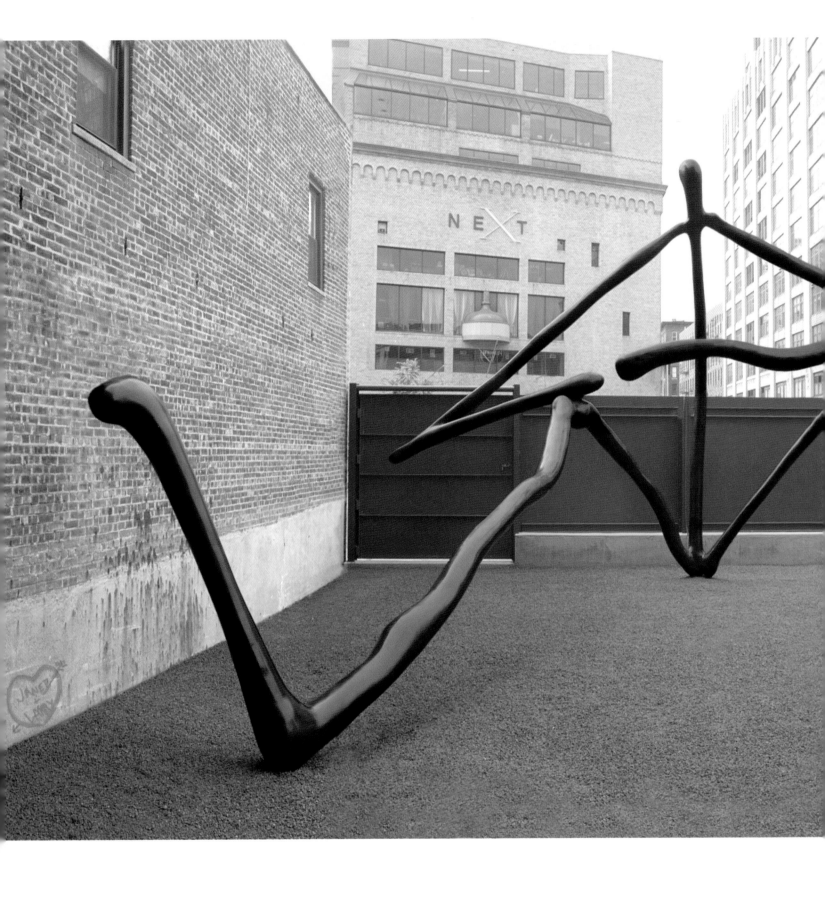

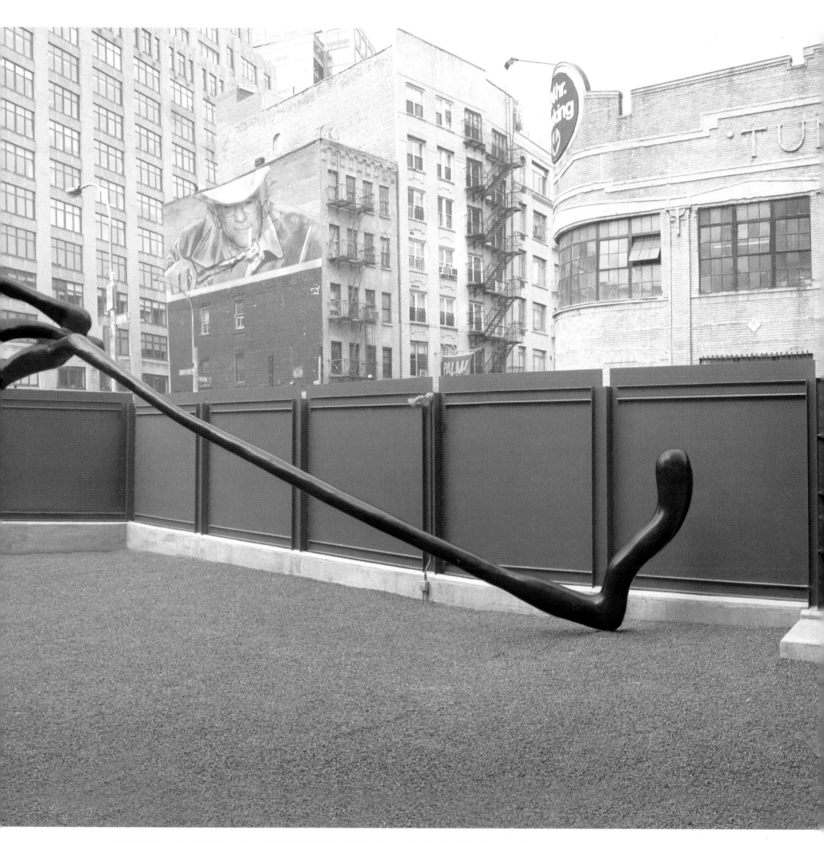

Plate 93, Figure #12, *1996, cast bronze, 22' x 37' x 35', installation at Art et Industrie, New York. Collection of Peter B. Lewis. Photograph by Thomas P. Vinetz.*

(TOP, LEFT) PLATE 94, FRACTION #981, 9¼" x 10". (TOP, RIGHT) PLATE 95, FRACTION #987, 9¼" x 10". (BOTTOM, LEFT) PLATE 96, FRACTION #1004, 10" x 10".
(BOTTOM, RIGHT) PLATE 97, FRACTION #1008, 9¼" x 10". COLLECTION OF ROBERT CREELEY. ALL FRACTIONS ARE MIXED MEDIA ON WATERCOLOR PAPER, 1996.

(TOP, LEFT) PLATE 98, FRACTION #1102, 10" x 10", COLLECTION OF AL TAYLOR. (TOP, RIGHT) PLATE 99, FRACTION #1057, 9½" x 10". (BOTTOM, LEFT) PLATE 100, FRACTION #1094, 9½" x 10". (BOTTOM, RIGHT) PLATE 101, FRACTION #1120, 10" x 10". ALL FRACTIONS ARE MIXED MEDIA ON WATERCOLOR PAPER, 1996.

(TOP. LEFT) PLATE 102. FRACTION #1132. 9¾" x 10". (TOP. RIGHT) PLATE 103. FRACTION #1142. 9¾" x 10".
(BOTTOM. LEFT) PLATE 104. FRACTION #1163. 9¾" x 10". COLLECTION OF JOHN CHAMBERLAIN. (BOTTOM, RIGHT) PLATE 105. FRACTION #1188.
9¾" x 10". COURTESY OF DEAN CUSHMAN COLLECTION. ALL FRACTIONS ARE MIXED MEDIA ON WATERCOLOR PAPER. 1996.

(TOP, LEFT) PLATE 106, FRACTION #1275, 10" x 10". (TOP, RIGHT) PLATE 107, FRACTION #1340, 9½" x 10". (BOTTOM, LEFT) PLATE 108, FRACTION #1361, 10" x 10". (BOTTOM, RIGHT) PLATE 109, FRACTION #1369, 10" x 10". ALL FRACTIONS ARE MIXED MEDIA ON WATERCOLOR PAPER, 1996.

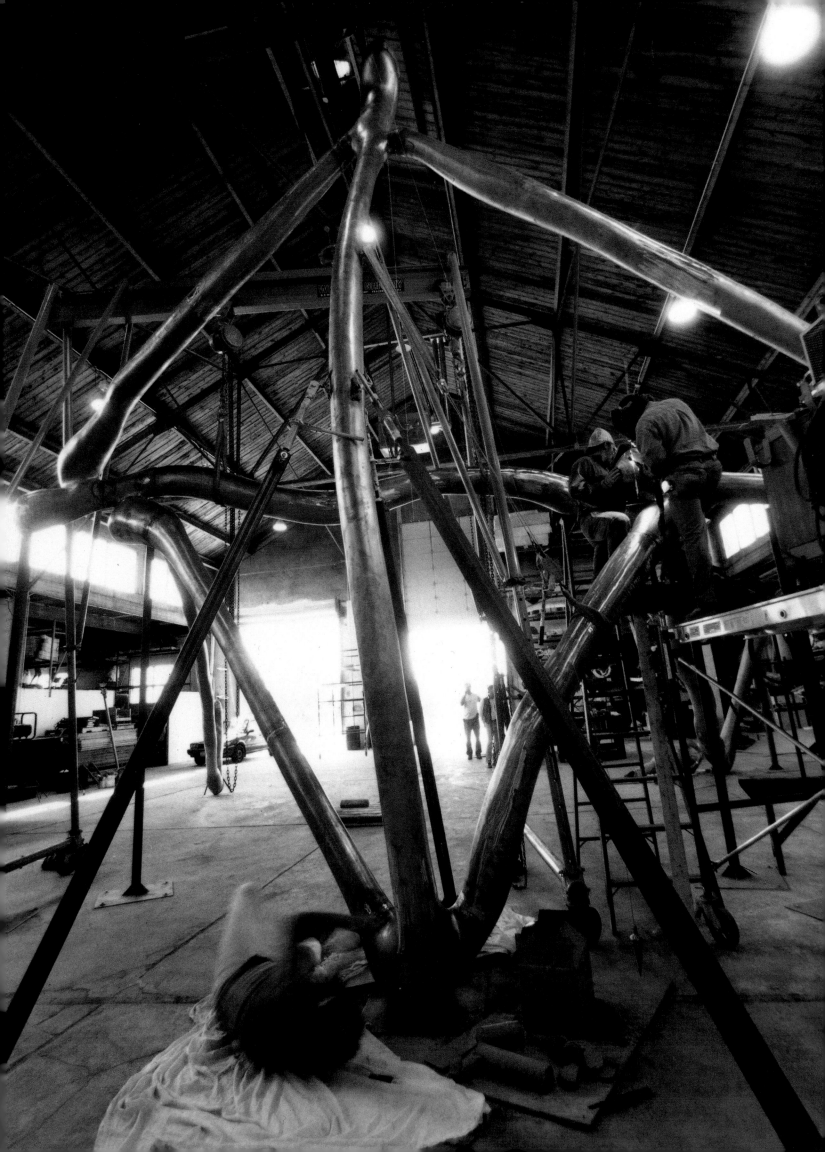

Plate List

Bold Type represents the Exhibition List

Plate 1 (page 21)
Teachers, #19-27, circa 1955
india ink on Strathmore Bristol paper
17" x 14"

Plate 2 (page 11)
Untitled, 1959
cracked glass, wood, paper
12" x 14" x 3"
Collection of Michael Asher

Plate 3 (page 66)
Untitled, 1959
oil on canvas
39½" x 39½"

Plate 4 (page 14)
L. Bell's House, 1959
oil on canvas
66½" x 71½"
Collection of Vivian Rowan

Plate 5 (page 67)
Untitled, 1960
ink, paper, glass and paint
6" x 4"
Collection of Dr. Douglas Garland

Plate 6 (page 67)
Untitled, 1960
ink, paper, glass and paint
6" x 4"
Collection of Dr. Douglas Garland

Plate 7 (page 68)
Li'l Orphan Annie, circa 1960
acrylic on canvas
96" x 144"

Plate 8 (page 69)
Conrad Hawk, 1961
acrylic on canvas, glass
66" x 66"
Collection of the Menil Collection, Houston
Purchased with funds provided by
Carolyn Law.

Plate 9 (page 70)
Untitled #7, 1961
mirrored glass, wood, paint
12" x 12" x 5"

Plate 10 (page 71)
Old Cotton Fields Back Home, 1962
acrylic on canvas
65" x 65"
Collection of Los Angeles County
Museum of Art, David E. Bright Foundation

Plate 11 (page 72)
Lux at the Merritt Jones, 1962
acrylic on canvas
66" x 90"
Collection of Donald Judd Estate

Plate 12 (page 73)
Ghost Box, 1962-63
vacuum-coated, mirrored
and sandblasted glass, acrylic on canvas
48¾" x 48½" x 3⅛"

Plate 13 (page 74)
Untitled, 1962-63
mirrored glass, formica,
chromium-plated brass
14" x 14" x 14"
Collection of Sterling Holloway Estate

Plate 14 (page 74)
Untitled, 1964
vacuum-coated etched glass,
chromium-plated brass
14" x 14" x 14"

Plate 15 (page 74)
Untitled, 1965
vacuum-coated etched glass,
chromium-plated brass
10" x 10" x 10"

Plate 16 (page 74)
Untitled, 1965
vacuum-coated etched glass,
chromium-plated brass
10¼" x 10¼" x 10¼"
Collection of Newport Harbor Art Museum
Gift of Edwin Janss, Jr.

Plate 17 (page 75)
Untitled, 1966
vacuum-coated glass,
chromium-plated brass
12¼" x 12¼" x 12¼"

Plate 18 (page 76)
Untitled, 1968
vacuum-coated glass,
chromium-plated brass
20" x 20" x 20"
Collection of Guggenheim Museum

Plate 19 (page 79)
Untitled, 1968
vacuum-coated glass,
chromium-plated brass
20" x 20" x 20"
Collection of Newport Harbor Art Museum
Gift of Edwin Janss, Jr.

Plate 20 (page 82)
Standing Wall, 1968
⅜" clear and gray glass
7 panels, 72" x 96"
Installation at Vancouver Art Gallery,
Vancouver, Canada

Plate 21 (page 83)
Standing Wall, 1969
⅜" clear and gray glass
10 panels, 72" x 96"
Installation at Walker Art Center,
Minneapolis

Plate 22 (page 77)
Untitled Cube, 1969-70
plate glass coated with Inconel
36" x 36" x 36".
Collection of Pace Gallery, New York

Plate 23 (page 78)
Untitled Cube, 1970
solid barium crown glass
coated with Inconel
4" x 4" x 4", edition of 25
Collection of Dr. Douglas Garland

Plate 24 (page 84)
Garst's Mind No. 2, 1971
⅜" plate glass coated with Inconel
2 panels, 72" x 96"
Installation at Walker Art Center,
Minneapolis

Plates 25-28 (pages 86-87)
The Iceberg and Its Shadow, 1974
⅜" plate glass coated with Inconel
and silicon monoxide
56 panels, 57" to 100" x 60" each
Installation at Fort Worth Art Museum,
Texas, 1975
Installation at Santa Barbara Art Museum,
California, 1976
Installation at Art Museum of South Texas,
Corpus Christi, 1976
Installation at Massachusetts Institute
of Technology, Cambridge, 1977
Collection of Massachusetts Institute
of Technology, Cambridge
Gift of Albert and Vera List Family Foundation

Plate 29 (page 110)
ST 14, 1978
aluminum and quartz
on velour finish Bristol paper
12" x 8"

Plate 30 (page 112)
MS 24, 1978
aluminum on Arches cover paper
47" x 37"
Collection of Dr. Douglas Garland

Plate 31 (page 112)
SMMSHFX 1, 1978
aluminum on red Strathmore
charcoal paper
24" x 19"
Collection of Dr. Douglas Garland

FIGURE #12, *JOHNSON ATELIER, MERCERVILLE, NEW JERSEY, NEARING COMPLETION, JULY 1996. COLLECTION OF PETER B. LEWIS. PHOTOGRAPH BY RICARDO BARRAS.*

Plate 32 (page 112)
SMMSHFPK 3J, 1978
aluminum on Strathmore charcoal paper
24" x 19"
Collection of Dr. Douglas Garland

Plate 33 (pages 112-113)
Moving Ways, MSHFBK, 1979
aluminum on black Fabriano paper
8 panels, 30" x 40" each,
overall length 210"
Installation at Roswell Museum
and Art Center, Roswell

Plate 34 (page 111)
BT 4, 1979,
aluminum on black Arches paper
44" x 41"
Collection of Dr. Douglas Garland

Plates 35-37 (page 104)
Untitled, Prism Shelf, 1980
⅜" coated float glass
Installation at Hudson River Museum,
Yonkers

Plates 38-41 (pages 90-91)
The Cat, 1981
½" float glass coated with Inconel
4 panels, 72" x 96"
½" triangular float glass, uncoated
8 panels, 72" x 72"
Installation at Hudson River Museum,
Yonkers, 1981
Installation at L.A. Louver Gallery,
Venice, 1981
Installation at Newport Harbor
Art Museum, 1982
Installation at Detroit Institute of Arts
with *Corner Lamps* and *Chairs de Lux IV*
(also called *Chairs in Space*), 1982
Collection of The Albuquerque Museum

Plate 42 (page 96)
Chair de Lux II, 1980
Carpathian elm burl veneer
and cotton velvet
32" x 26" x 32"

Plate 43 (page 94)
The Table de Lux I, 1981
Carpathian elm, burl and rock maple
54" x 96"
Chair de Lux IV, 1982
Carpathian elm burl and cotton velvet
32" x 26" x 32"
Installation at L.A. Louver Gallery,
Venice, 1985

Plate 44 (page 94)
The Sofa de Lux II, 1981
Carpathian elm burl and cotton velvet
33" x 35" x 88"
Coffee Table de Lux I, 1981
Carpathian elm burl and
Makore (African cherry)
16" x 60" x 34"
ELBKIN 10, 1981
aluminum and silicon monoxide
on black Arches paper
55" x 33"
Installation in Taos studio

Plates 45-46 (page 95)
The Desk de Lux I, 1981
(front and back view)
Carpathian elm burl and Makore
(African cherry) with ivory insets
29" x 90" x 29"
Collection of Robert Abrams

Plate 47 (page 97)
Chairs de Lux, 1980-81
marine plywood, varathane finish,
black leather cushions, chrome ball wheels
32" x 26" x 32"
Collection of Kiyo Higashi Gallery,
Los Angeles

Plate 48 (page 97)
Bench de Lux, 1980-81
marine plywood, black lacquer finish,
black leather cushions
31" x 26" x 63"
MELBKIN 24, 1985
aluminum and silicon monoxide
on black Arches paper
29½" x 23¾"
Collection of Kiyo Higashi Gallery,
Los Angeles

Plate 49 (page 114)
EL 25, 1981
aluminum and silicon monoxide
on white Arches paper
53" x 35"
Collection of Rachel Victoria Bell

Plate 50-51 (pages 98-99)
SB-1, Corner Lamp, 1981
(two varying installations)
½" float glass coated with
aluminum and silicon monoxide
36" x 36"
Installation in Taos studio

Plates 52-53 (pages 100-101)
SB-2, Corner Lamp, 1981
(two varying installations)
½" float glass coated with
aluminum and silicon monoxide
36" x 36"
Installation in Taos studio

Plates 54-56 (pages 92-93)
**Chairs In Space / The Game de Lux
prototype #1**, 1983
table 50" x 42" x 42"
(illustrated) two of
four chairs 44" x 22" x 23"
all made of lacquered wood;
sculpture, 6" x 10" x 10";
player chairs 3¼" tall
Private collection

Plate 57 (page 109)
Improbable Flow, 1983
Installation at Arco Center for Visual Arts,
Los Angeles

Plate 58 (page 115)
MEL 50, 1984
aluminum and silicon monoxide
on Stonehenge paper
30" x 24"
Collection of Dr. Douglas Garland

Plate 59 (page 115)
MEL 73, 1984
aluminum and silicon monoxide
on Stonehenge paper
30" x 24"
Collection of Dr. Douglas Garland

Plate 60 (page 115)
MEL 81, 1984
aluminum and silicon monoxide
on Stonehenge paper
30" x 24".
Collection of Dr. Douglas Garland

Plate 61 (page 79)
Untitled, 1985
vacuum-coated glass and
chromium-plated brass
18" x 18" x 18"
Collection of Newport Harbor Art Museum
Gift of William G. Pigman
and Susan L. Pigman

Plate 62 (page 105)
Leaning Room for Higashi, 1986
detail of interior installation
at Kiyo Higashi Gallery, Los Angeles

Plates 63-66 (pages 106-107)
Leaning Room (four views), 1986-87
Installation at MOCA Temporary
Contemporary, Los Angeles

Plates 67-68 (pages 108-109)
Hydrolux, 1986
Installation at Boise Art Museum, 1986
Hydrolux 1, The Improbable Flow, 1986
Installation in Taos studio

Plate 70 (page 102)
CLTRI 1, Corner Lamp, 1987
coated glass
18" x 18"

Plate 71 (page 103)
CLTRI 2, Corner Lamp, 1987
coated glass
18" x 18"

Plate 72 (page 116)
Talpa, 1988
mixed media on canvas
70" x 48"

Plate 73 (page 122)
Woman with Guitar, 1988
mixed media on canvas
64" x 50"
Collection of Nancy Negley

Plate 74 (page 119)
The View, 1988
mixed media on canvas
56" x 44"
Collection of Museum of New Mexico/
Museum of Fine Arts, Santa Fe

Plate 75 (page 119)
The Old Dirt Road, 1989
mixed media on canvas
67" x 42½"
Collection of Tony and Cynthia Canzoneri

Plate 76 (page 117)
Fait Accompli, 1989
mixed media on canvas
76" x 45"
Collection of Isabel Wilson

Plate 77 (page 118)
Evening Prayer, 1989
mixed media on canvas
64" x 43"
Collection of Dr. Douglas Garland

Plate 78 (page 120-121)
Moses X-ing the Delaware, 1990
mixed media on canvas
96" x 293"
Collection of Minneapolis Institute of Arts

Plates 79-80 (pages 88-89)
Made for Arolsen, 1992
10mm blue and pink glass
eight panels, 72" x 48"
eight panels, 72" x 96"
Installation at Museum Fridericianum,
Kassel, Germany
Installation in the Village of Arolsen,
Germany

Plate 81 (page 80)
Cube #10-1-92, 1992
coated glass
10" x 10" x 10"
Collection of Dr. Douglas Garland

Plate 82 (page 81)
Cube #20-2-92, 1992
coated glass
20" x 20" x 20"
Collection of Kiyo and Robert Higashi

Plate 83 (page 123)
Window Black Denim #10, 1993
coated glass, black denim
53" x 53", (center image 24" x 24")
Collection of Michael L.V. Ladd

Plates 84-85 (pages 124-125)
Computer-generated calligraphy, 1994
The genesis for the *Sumer Project*,
figures 1-12 and 13-24.

Plate 86 (page 132)
Stickman #1, 1994
fabricated bronze maquette
approximate 20" tall

Plate 87 (page 132)
Stickman #12, 1995
fabricated bronze maquette
approximate 19" tall

Plate 88 (page 126)
Stickman C-18, 1996
acrylic on canvas
89½" x 70"

Plate 89 (page 85)
Standing Wall, 6x6x4-AB, 1996
½" coated glass
four panels, 72" x 72"
Installation at Kiyo Higashi Gallery,
Los Angeles

Plate 90 (page 85)
Standing Wall, 6x6x4-CD, 1996
½" coated glass
four panels, 72" x 72"
Installation at Kiyo Higashi Gallery,
Los Angeles

Plate 91 (page 127)
STMC-LAM #16, 1996
mixed media on canvas
42" x 88"

Plates 92-93 (pages 133-135)
Figure #12, 1996
cast bronze
22' x 37' x 35'
Installations at The Albuquerque Museum
and at Art et Industrie, New York
Collection of Peter B. Lewis

Plate 94 (page 136)
Fraction #981, 1996
mixed media on watercolor paper
9¼" x 10"

Plate 95 (page 136)
Fraction #987, 1996
mixed media on watercolor paper
9¼" x 10"

Plate 96 (page 136)
Fraction #1004, 1996
mixed media on watercolor paper
10" x 10"

Plate 97 (page 136)
Fraction #1008, 1996
mixed media on watercolor paper
9¼" x 10"
Collection of Robert Creeley

Plate 98 (page 137)
Fraction #1102, 1996
mixed media on watercolor paper
10" x 10"
Collection of Al Taylor

Plate 99 (page 137)
Fraction #1057, 1996
mixed media on watercolor paper
9¼" x 10"

Plate 100 (page 137)
Fraction #1094, 1996
mixed media on watercolor paper
9¼" x 10"

Plate 101 (page 137)
Fraction #1120, 1996
mixed media on watercolor paper
10" x 10"

Plate 102 (page 138)
Fraction #1132, 1996
mixed media on watercolor paper
9¼" x 10"

Plate 103 (page 138)
Fraction #1142, 1996
mixed media on watercolor paper
9¼" x 10"

Plate 104 (page 138)
Fraction #1163, 1996
mixed media on watercolor paper
9¼" x 10"
Collection of John Chamberlain

Plate 105 (page 138)
Fraction #1188, 1996
mixed media on watercolor paper
9¼" x 10"
Collection of Dean Cushman

Plate 106 (page 139)
Fraction #1275, 1996
mixed media on watercolor paper
10" x 10"

Plate 107 (page 139)
Fraction #1340, 1996
mixed media on watercolor paper
9¼" x 10"

Plate 108 (page 139)
Fraction #1361, 1996
mixed media on watercolor paper
10" x 10"

Plate 109 (page 139)
Fraction #1369, 1996
mixed media on watercolor paper
10" x 10"

Works in the exhibition not reproduced
in this catalogue:

LMSHBK 40, 1978
aluminum and silicon monoxide
on Black Fabriano paper
90" x 42"

SB3, Corner Lamp, 1980
coated glass
36" x 36"

SB7, Corner Lamp, 1980
coated glass
36" x 36"

DB7, Corner Lamp, 1980
coated glass
36" x 36"

DB8, Corner Lamp, 1980
coated glass
36" x 36"

Figure #1, 1996
forged sheet bronze
23' x 11' x 25'
Collection of Peter B. Lewis

Fraction #1504, 1996
mixed media on watercolor paper
10" x 10"

Fraction #1520, 1996
mixed media on watercolor paper
10" x 10"

Fraction #1604, 1996
mixed media on watercolor paper
10" x 10"

Fraction #1674, 1996
mixed media on watercolor paper
10" x 10"

Fraction #1707, 1996
mixed media on watercolor paper
10" x 10"

Fraction #1714, 1996
mixed media on watercolor paper
10" x 10"

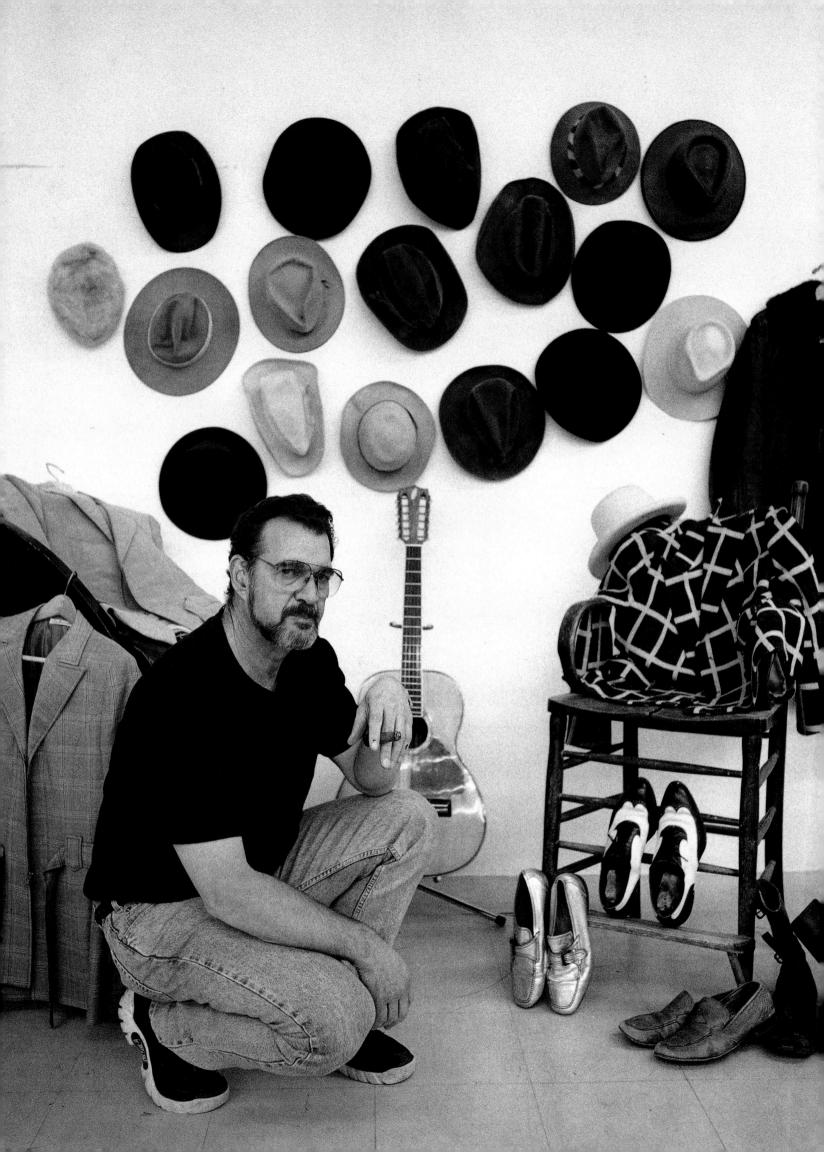

Larry Bell, *Born 1939, Chicago, Illinois. Lives and works in Taos, New Mexico.*

Biography
*Solo Exhibitions

1959
LOS ANGELES COUNTY MUSEUM of ART, CA. *Southern California Painting and Sculpture Annual.*

1961
HUYSMAN GALLERY, Los Angeles, CA. *War Babies.* May 29–June 17.
ART CENTER of LA JOLLA, CA. *Fourth Art Center Annual of California Painting and Sculpture.* November 17–December 5. Catalogue.

1962
FERUS GALLERY*, Los Angeles, CA. *Larry Bell.* March 27–April 14.
COPLEY FOUNDATION, Grantee.

1963
FERUS GALLERY*, Los Angeles, CA. *Larry Bell.* November 5.

1964
DWAN GALLERY, Los Angeles, CA. *Boxes.* February 2–29. Catalogue.
PAVILION GALLERY, Balboa, CA. *California Hard Edge Painting,* March 11–April 12. Catalogue.
SIDNEY JANIS GALLERY, New York City. *Seven New Artists.* May 5–29.

1965
MUSEUM of MODERN ART, New York City. *The Responsive Eye.* February 23–April 25. Catalogue . Also shown at: CITY ART MUSEUM of ST. LOUIS, May 20–June 20; SEATTLE ART MUSEUM, July 15–August 23; PASADENA ART MUSEUM, September 25–November 7; BALTIMORE MUSEUM of ART, December 14–January 23.
PACE GALLERY, New York City. *Five at Pace.* March 9. Catalogue.
MUSEO DE ARTE MODERNA, São Paulo, Brazil. *VIII Biennale de São Paulo.* (US Section selected by the Pasadena Art Museum) September 4–November 28. Also shown at: NATIONAL COLLECTION of FINE ARTS, SMITHSONIAN INSTITUTION, Washington, DC. January 27–March 6. Catalogue.
FERUS GALLERY*, Los Angeles, CA. *Larry Bell.* From October 26.
PACE GALLERY*, New York City. *Larry Bell.* November 6–December 6.
TIBOR DE NAGY GALLERY, New York City. *Shape and Structure.*

1966
ART GALLERY, University of California, Irvine. *Five Los Angeles Sculptors and Sculptors' Drawings.* January 7–February 6. Catalogue.
ROBERT FRASER GALLERY, London. *Los Angeles Now.* January 31–February 19. Catalogue.
JEWISH MUSEUM, New York City. *Primary Structures.* April 27–June 12. Catalogue.
MUSEUM of CONTEMPORARY ART, SAN DIEGO, La Jolla, CA. *New Modes in California Painting and Sculpture.* May 20–June 26. Catalogue.
LARRY ALDRICH MUSEUM, Ridgefield, CT. *Highlights of the '65-'66 Art Season.* July 10–September 11. Catalogue.
SEATTLE ART MUSEUM PAVILION, WA. *Ten From Los Angeles.* July 15–September 5. Catalogue.
WHITNEY MUSEUM of AMERICAN ART, New York City. *Annual Exhibition: Contemporary American Sculpture and Prints.* December 16–February 6. Catalogue.

Bibliography

LANGSNER, Jules. *Los Angeles Letters,* Art International, September, vol. 6, No. 7, p. 50.

COPLANS, John. *Three Los Angeles Artists,* Artforum, April, vol. 1, No. 10, pp. 29-31.
LANGSNER, Jules. *America's Second Art City,* Art in America, March–April, vol. 51, No. 2, pp. 127-131.

DANIELI, Fidel. *Larry Bell, Ferus Gallery,* Artforum, January, vol. 2, No. 7, p. 41.
LANGSNER, Jules. *Art News from Los Angeles,* ARTnews, January, vol. 62, No. 9, p. 50.
HOPPS, Walter. *Boxes,* Art International, March, vol. 8, No. 2, pp. 38-41.
FACTOR, Donald. *Boxes,* Artforum, April, vol. 2, No. 10, pp. 20-23.
WOLFE, Claire. *California Hard Edge Painting,* Artforum, May, vol. 2, No. 11, pp. 14-15.
ASHTON, Dore. *Art,* Art and Architecture, June, vol. 81, No. 6, pp. 9, 33.
COPLANS, John. *Circle of Styles on the West Coast,* Art in America, June, vol. 52, No. 3, pp. 24-41.
COPLANS, John. *Formal Art,* Artforum, Summer, pp. 42-43.
LEIDER, Phillip. *The Cool School,* Artforum, Summer, p. 47.
TILLIM, Sidney. *In the Galleries,* Arts Magazine, September, vol. 38, No. 10, pp. 62-63.

LEIDER, Phillip. *Saint Andy (Statement by Bell on Warhol),* Artforum, February, vol. 3, No. 5, pp. 26-28.
LIPPARD, Lucy. *New York Letter,* Art International, March, vol. 9, No. 32, p. 46.
HESS, Thomas B. *You Can Hang It in the Wall,* ARTnews, April, vol. 64, No. 2, pp. 41-43, 49-50.
RICKEY, George. *Scandale de Succes,* Art International, May, vol. 9, No. 4, pp. 16-23.
COPLANS, John. *New Abstraction on the West Coast, USA,* Studio International, June, vol. 169, No. 865, pp. 192,199.
ASHTON, Dore. *New Sculpture Fresh in Old Techniques,* Studio International, June, vol. 169, No. 866, p. 263.
COPLANS, John. *Larry Bell,* Artforum, June, vol. 43, No. 9, pp. 27-29.
JUDD, Donald. *Specific Objects,* Arts Yearbook, vol. 8, pp. 74-82.
GLUECK, Grace. *New York Gallery Notes,* Art in America, December–January, vol. 53, No. 6, p. 121.
HOPPS, Walter. The U.S. catalogue for the *8th São Paulo Biennale,* organized by the Pasadena Museum of Art.

BOCHNER, Mel. *In the Galleries: Larry Bell,* Arts, January, vol. 4, No. 3, pp. 54-55.
COPLANS, John. *Los Angeles: Object Lesson,* ARTnews, January, vol. 64, No. 9, p. 40.
FACTOR, Don. *Larry Bell, Ferus Gallery,* Artforum, January, vol. 4, No. 5, pp. 12-13.
ROSE, Barbara. *Los Angeles, the Second City,* Art in America, January–February, vol. 54, No. 1, pp. 110-115.
COPLANS, John. *5 Los Angeles Sculptors at Irvine,* Artforum, February, vol. 4, No. 6, pp. 33-37.
BOURDON, David. *Boxing Up Space,* The Village Voice, February 18.
LIPPARD, Lucy. *New York Letter,* Art International, February, vol. 10, No. 2, pp. 52-53.
DANIELI, Fidel. *Art News from Los Angeles,* ARTnews, March, vol. 65, No. 1, pp. 20, 74.
von MEIER, Kurt. *Los Angeles Letter,* Art International, March, vol. 10, No. 3, pp. 48, 53.
SMITHSON, Robert. *Entropy and New Moments,* Artforum, June, vol. 4, No. 10, pp. 26-31.
ALDRICH, Larry. *New Talent USA,* Art in America, July–August, vol. 54, No. 4, pp. 22-69.
PLAGENS, Peter. *Present Day Styles and Ready Made Criticism,* Artforum, December, vol. 5, No. 4, pp. 36-39.
COPLANS, John. *Larry Bell, Ten from Los Angeles,* exhibition catalogue, Seattle Art Museum, p. 10.

146

1967

PACE GALLERY*, New York City. *Larry Bell.* April 22–May 20.
LOS ANGELES COUNTY MUSEUM of ART, CA. *American Sculpture of the Sixties.* April 28–June 25. Catalogue.
WASHINGTON GALLERY of MODERN ART, DC. *A New Aesthetic.* May 6–June 26. Catalogue.
GALERIA ILEANA SONNABEND*, Paris, France. *Larry Bell.*
SOLOMON R. GUGGENHEIM MUSEUM, New York City. *Guggenheim International Exhibition.* Catalogue.
MUSEUM of MODERN ART, New York City. *The 1960's.*
LYTTON CENTER FOR THE VISUAL ARTS, Los Angeles, CA, *Mini-Things.*
STEDELIJK MUSEUM*, Amsterdam, Netherlands. *Larry Bell.* December 8–January 14.

DAVIS, Douglas. *From New Materials...Sculpture,* National Observer, February 20, p. 22.
CANADAY, John. *Art: Some Recent History of Sculpture,* New York Times, April 29, p. 31.
Sculpture, Time Magazine, May 12, vol. 89, No. 19, pp. 80, 83.
TRAVERS, D. *American Sculpture of the 60's,* Art and Architecture, June, vol. 84, No. 5, pp. 26-43.
DANIELI, Fidel. *Bell's Progress,* Artforum, Summer, vol. 5, No. 10, pp. 68-71.
TUTEN, Frederick. *In the Galleries, Larry Bell,* Arts Magazine, Summer, vol. 41, No. 8, p. 46.
WALDMAN, Diane. *Reviews and Previews,* ARTnews, Summer, vol. 66, No. 4, pp. 12-13.
ROSE, Barbara. *American Art Since 1900,* Thames and Hudson, London, p.68.
ROSE, Barbara. *Larry Bell, A New Aesthetic,* exhibition catalogue, Washington Gallery of Modern Art, pp. 21-25.
MORRIS, Robert. *Notes on Sculpture, Part 3, Notes and Nonsequiturs,* Artforum, Summer, vol. 5, No. 10, pp. 24-29.
LEIDER, Phillip. *American Sculpture at Los Angeles County Museum of Art,* Artforum, Summer, vol. 5, No. 10, pp. 6-11.
SORIN, R. *Des Cubes en Plein Arc-en-Ciel;* MICHELSON, A., *Larry Bell,* Galéria Ileana Sonnabend, Paris, November.

1968

VANCOUVER ART GALLERY, Canada. *Los Angeles 6.* March 31–May 5. Catalogue
WALKER ART CENTER, Minneapolis, MN. *6 Artists: 6 Exhibitions.* May 12–June 23. Catalogue.
MUSEUM FRIDERICIANUM, Kassel, Germany. *Documenta IV.* June 27–October 6. Catalogue.
PASADENA ART MUSEUM, CA. *Serial Imagery.* September 17–October 27. Catalogue. Also shown at: HENRY ART GALLERY, UNIVERSITY OF WASHINGTON, Seattle. November 17–December 22; SANTA BARBARA MUSEUM of ART, CA. January 25–February 23, 1969. ART GALLERY, UNIVERSITY OF CALIFORNIA, San Diego.

MULLER, Gregoirs. *Paris: Art's Common Market,* Art and Artists, January, vol. 2, No. 10, pp. 45, 47.
LEIDER, Phillip. *Gallery '68: High Art and Low Art,* Look, January 9, vol. 32, pp. 12-22.
See Throughs, Time, vol. 91, No. 6, pp. 40, 41, 45.
SCHWARTZ, Paul W. *Paris,* Studio International, February, vol. 175, No. 897, pp. 95-96.
TRINI, Tommaso. *Larry Bell: Le Pareti dell'Infinito (Vacuum Vision),* Domus, March, No. 460, pp. 42-44.
COPLANS, John. *Larry Bell, Serial Imagery,* catalogue for exhibition by Pasadena Art Museum, p. 60. Reprinted in Artforum, October, vol. 7, No. 2, pp. 34, 43.
KIRBY, Michael. *Sculpture as Visual Instrument,* Art International, October, pp. 35-37.
COPLANS, John. *Los Angeles 6,* exhibition catalogue, Vancouver Art Gallery. Interview with Bell.
BANNER, Bode, Imdahl, Leering, Harten. *Documenta IV,* exhibition catalogue, Museum Fredericianum, Kassel, Germany.

1969

WALKER ART CENTER, Minneapolis, MN. *14 Sculptors: The Industrial Edge.* May 29–June 21. Catalogue.
STEDELIJK VAN ABBE MUSEUM, Eindhoven, Holland. *Kompas IV—West Coast USA.* November 21–January 4, 1970. Catalogue.
PASADENA ART MUSEUM, CA. *West Coast '49-'69.* November 24–January 18,1970. Catalogue.
MUSEUM of MODERN ART, New York City. *Spaces.* December 30–March 1, 1970. Catalogue.
RHODE ISLAND SCHOOL of DESIGN, Providence. *George Waterman Collection.*
RICHMOND ART CENTER, CA. *Invisible Painting and Sculpture.*
MIZUNO GALLERY*, Los Angeles, CA. *Larry Bell.*

ROSE, Barbara; FINCH, Christopher; FRIEDMAN, Martin. *14 Sculptors: The Industrial Edge,* exhibition catalogue, Walker Art Center, Minneapolis, MN. Reprinted in Art International, February, vol. 4, No. 2, pp. 31-40,55.
KRESS, Peter. *Kompas IV–West Coast USA,* Kunstwerk, April–May, vol. 23, No. 7-8, pp. 32, 38, 50.
WILSON, William. *Art Walk: A Critical Guide to the Galleries,* Los Angeles Times, May 30, p. 5.
LICHT, Jenifer. *Spaces,* The Museum of Modern Art, New York .
COPLANS, John. *West Coast, 1945-1969,* catalogue for exhibition by Pasadena Art Museum.
SELDIS, Henry J. *Pasadena's Lopsided West Coast Survey,* Los Angeles Times Calendar, November 30, p. 58.
LEERINGS, Jan. *Kompas IV–West Coast USA,* exhibition catalogue for Stedelijk Van Abbe Museum, Eindhoven, Holland, November 21–January 4, p. 13. *Work in Progress,* Esquire, December, vol. 72, No. 6, p. 216.

1970

ART INSTITUTE of CHICAGO, IL. *69th American Exhibit.* January 17–February 22. Catalogue.
PACE GALLERY*, New York City. *Larry Bell.* February 14–March 11.
TATE GALLERY, London, England. *Larry Bell, Robert Irwin, Doug Wheeler.* May 5–31. Catalogue.
MIZUNO GALLERY, Los Angeles, CA. July–August.
GALERIE RUDOLF ZWIRNER*, Koln, Germany. *Larry Bell.* September 14–October 10.
JOSLYN ART MUSEUM, Omaha, NE. *Looking West.* October 18–November 29. Catalogue.
ACE GALLERY*, Los Angeles, CA. *Larry Bell.* November.
PACE GALLERY, New York City. *A Decade of California Color.*
PRINCETON UNIVERSITY, NJ. *American Art Since 1960.*
GUGGENHEIM FOUNDATION, New York City. *Fellowship.*

GLUEK, Grace. *Museum Beckoning Space Explorers,* New York Times, January 3, p. 34.
KRAMER, Hilton. *Participatory Aesthetics,* New York Times, January 11, p. 25.
LEIDER, Phillip. *New York,* Artforum, February, vol. 8, No. 6, pp. 60-70.
RATCLIFF, Carter. *New York Letter,* Art International , February, vol. 14, No. 2, p. 78.
ASHTON, Dore. *New York Commentary,* Studio International, March, vol. 179, No. 920, pp. 118-119.
KLINE, Katherine. *Reviews and Previews,* ARTnews, April, vol. 69, No. 2, p. 12.
WASSERMANN, Emily. *New York,* Artforum, April, vol. 8, No. 8, p. 78.
VINKLERS, Bitite. *New York,* Art International, April, vol. 14, No. 4, pp. 64-65.
COMPTON, Michael. *Controlled Environment,* Art and Artists, May, vol. 5, No. 2, p. 45.
TARSHIS, Jerome. *San Francisco,* Artforum, June, vol. 8, No. 10, p. 91.
COMPTON, Michael. *U.K. Commentary,* Studio International, June, vol. 179, No. 923, pp. 269-270.
ROBERTS, Keith. *London and Leeds,* Burlington Magazine, June, vol. 11A, No. 807, pp. 415-416.
FULLER, Peter. *Larry Bell, Doug Wheeler, Robert Irwin,* Connoisseur, August, vol. 174, No. 7092, p. 285.
RUSSELL, David. *London,* Arts Magazine, Summer, vol. 44, No. 8. p. 53.
MARANDEL, J.P. *Lettre de New York,* Art International, October, vol. 14, No. 5, p. 75.
PLAGENS, Peter, *Los Angeles,* Artforum, October, vol. 9, No. 2, p. 887.

COMPTON, M.; REID, N. *Larry Bell, Robert Irwin, Doug Wheeler*, exhibition catalogue for Tate Gallery, London.
TUCHMAN, Phyllis. *American Art in Germany: History of a Phenomenon*, Artforum, November, vol. 9, No. 3, pp. 58-69.
TERBELL, Melinda. *Los Angeles*, Arts Magazine, November, vol. 45, No. 2, P. 53.
Los Angeles Artists' Studios, Art in America, November–December, vol. 58, No. 6, p. 103.

1971

UCLA ART GALLERIES, Los Angeles, CA. *Transparency, Reflection, Light, Space: 4 Artists*. January 11–February 14. Catalogue.
PACE GALLERY*, New York City. *Larry Bell*. April 10–May 5.
WALKER ART CENTER, Minneapolis, MN. *Works for New Spaces*. May 18–July 25. Catalogue
HAYWARD GALLERY, London, England. *11 Los Angeles Artists*. (Sponsored by Arts Council of Great Britain.) September 30–November 7. Also shown at: PALAIX DES BEAUX ARTS, Brussels, Belgium. January 20–March 1.
KUNSTVEREIN, Berlin, Germany. April 5–30, 1972.
ACE GALLERY*, Los Angeles, CA. *Larry Bell*. November.
LONG BEACH MUSEUM of ART, CA. *Reflections*.
HELMAN GALLERY*, St. Louis, MO. *Larry Bell*.
MIZUNO GALLERY*, Los Angeles, CA. *Larry Bell*.
ACE GALLERY, Los Angeles, CA.

MACHECK, Joseph. *New York*, Artforum, January, vol. 9, No. 5. pp. 72-73.
SELDIS, Henry J. *Four Artists in Space Exploration at UCLA Galleries*, Los Angeles Times Calendar, January 24, p. 49.
PLAGENS, Peter. *Los Angeles*, Artforum, February, vol. 9, No. 6. pp. 88-89.
TERBELL, Melinda. *Los Angeles*, Arts Magazine, February, vol. 45, No. 4, pp. 45-46.
PLAGENS, Peter. *Los Angeles*, Artforum, March, vol. 9, No. 7. pp. 68-71.
TERBELL, Melinda. *Los Angeles*, Arts Magazine, March, vol. 45, No. 5. pp. 47-48.
MELLOW, James R. *Through the Looking Glass*, New York Times, April 25, p. 19.
BAKER, Kenneth. *New York*, Artforum, June, vol. 9, No. 10, pp. 80-82.
DOMINGO, Willis. *New York Galleries*, Arts Magazine, Summer, vol. 45, No. 8, pp. 52-53.
SIEGEL, Jeanne. *Reviews and Previews*, ARTnews, Summer, vol. 70, No. 4, p. 10.
WIGHT, Frederick S. *Transparency, Reflection, Light, Space*, exhibition catalogue for UCLA Art Galleries.
FRIEDMAN, Martin. *Works for New Spaces*, exhibition catalogue for Walker Art Center.
Larry Bell, A Report on the Art and Technology Program of the L.A. County Museum of Art, p. 51.
BAKER, E. *Los Angeles, 1971*, ARTnews, September, p. 30.
TUCHMAN, Maurice: LIVINGSTON, Jane. *11 Los Angeles Artists*, exhibition catalogue for Hayward Gallery, London, September 30–November 7.
KENNEDY, R.C. *London Letter*, Art International, December, vol. 15, pp. 87-88.

1972

PACE GALLERY*, New York City. *Larry Bell: Boxes at Pace. The 1969 Terminal Series of Boxes*. January 8–February 2.
PASADENA ART MUSEUM*, CA. *Larry Bell*. April 11–June 11.
UCLA ART GALLERIES, Los Angeles, CA. *20Th Century Sculpture from Southern California Collections*. Spring. Catalogue.
MIZUNO GALLERY, Los Angeles, CA. Summer.
DENNIS HOPPER GALLERY, Taos, NM. September.
A C A GALLERIES, New York City. *Looking West*.
WILAMARO GALLERY*, Denver, CO.
FELICITY SAMUEL GALLERY*, London, England.
KUNSTVEREIN, Hamburg, Germany. *USA West Coast*. Catalogue. Also shown at: KUNSTVEREIN, Hanover, Germany; KÖLNISCHER KUNSTVEREIN, Wurtt, Germany; KUNSTVEREIN, Stuttgart, Germany.

MACKINTOSH, Alastair. *Larry Bell*, Interview, Art and Artists, January, 1972, vol. 6, No. 70, pp. 39-41.
Hard Edge Environmental Social Images, Sch. Arts., April, vol. 71, pp. 42, 43.
HASKELL, Barbara. *Larry Bell*, exhibition catalogue for Pasadena Art Museum, April 11–June 11.
ST. JAMES, Ashley. *20Th Century Innovator*, The Christian Science Monitor, September 23, p. 6.
PLAGENS, Peter. *Larry Bell Reassesses*, Artforum, October, vol. 11, pp. 71-73.
HEISSENBUTTEL and WINER. *USA West Coast*, exhibition catalogue for Hamburg Kunstverein.
The Tate Gallery, *Larry Bell*, exhibition catalogue, The Tate Gallery: 1970-1972, pp. 80-81.

1973

PACE GALLERY*, New York City. *Larry Bell: New Work*.
NEW YORK CULTURAL CENTER, New York City. *3D into 2D: Drawing for Sculpture*. January 19–March 11.
OAKLAND MUSEUM*, CA. *Larry Bell*. January 23–March 11.
BONYTHON GALLERY*, Sydney, Australia. *Possibilities for Glass Sculpture*. April 12–28. Catalogue.
DETROIT INSTITUTE of ARTS, MI. *Art in Space: Some Turning Points*. May 15–June 24. Catalogue.

DUNHAM, Judith. *Larry Bell*, Artweek, February 10, vol. 4, No. 6, p. 5.
ADAMS, Bruce. *Sculpture to Reflect Upon*, Sunday-Telegraph, Sydney, Australia, April 22.
BORLASE, Nancy. *More Words Less About*, The Bulletin, Australia, April 28, p. 43.
GOOSEN, E.C. *Art in Space: Some Turning Points*, exhibition catalogue for Detroit Institute of Arts, May 15–June 24.
SELDIS, Henry J. *A Lot of Talent...*, Los Angeles Times, October 21, p. 76.

1974

WHITNEY MUSEUM of AMERICAN ART, New York City. *Illuminations and Reflections*. April 10–May 16. Catalogue.
MARLBOROUGH GALLERIA D'ARTE*, Rome, Italy. *Larry Bell*. June–July. Catalogue. Also shown at: Torino, Italy; Verona, Italy; Venice, Italy; Milano, Italy through 1975.
JOHN F. KENNEDY CENTER FOR THE PERFORMING ARTS, Washington, DC. *Art Now: 1974*.
GALERIE SONNABEND, Paris, France. *Projects pour "La Defense,"* collaboration du Larry Bell, Frank Gehry, Newton Harrison, Robert Irwin, Dr. Ed Wortz, Joshua Young. October 11.

HASKELL, Barbara. *Quote from Pasadena Art Museum exhibition catalogue in Illuminations and Reflections*, exhibition catalogue for Whitney Museum of American Art, April 10–May 16.
LEVINE, Les. *The Pace Makers*, Arts Magazine, May, pp. 54-57.
Statement by Larry Bell in *Larry Bell*, exhibition catalogue for Marlborough Galleria d'Arte, Rome, June–July.
RUCCHI, Lorenza. *Larry Bell at Marlborough*, Momento-Sera, Rome, July 10.
ORIENTI, Sandra. *Personal Space and Historical Reality*, Il Popolo, Rome, August, 11.
VIATTE, Germain. *Rever la Defense*, L'Oeil, October, No. 231, Larry Bell, p. 6.
MOGELON, Alex and LaLIBERTE, Norman. *Art in Boxes*, Van Nostrand Reinhold Co., pp. 198-199, 224.
PLAGES, Peter. *Sunshine Muse: Contemporary Art on the West Coast*, Praeger, pp. 24, 28, 120, 122, 126, 127.
HART, John. *Magic Mirrors*, Daily American, Rome.

1975

HAYWARD GALLERY, London, England. *The Condition of Sculpture*. May 29–July 13. Catalogue.
TALLY RICHARDS GALLERY of CONTEMPORARY ART*, Taos, NM. *A Fracture from the Iceberg*. August 17–September 14.
THE ART GALLERIES, CALIFORNIA STATE UNIVERSITY, Long Beach. *A View Through*. September 22–October 19. Catalogue.

Statement by Larry Bell in *Larry Bell*, exhibition catalogue for Galleria del Cavallino, Venice, Italy, January 14–February 5 (traveling exhibition from Marlborough Galleria d'Arte, Rome).
SELDIS, Henry J. *Art Walk, Part IV*, Los Angeles Times, January 31.
Creative Problem Solving, Sch. Arts, January, vol. 13, pp. 28-29.
WORTZ, Melinda. *Americans in Paris: 1974*, Arts Magazine, January, pp. 52-53.

148

FORT WORTH ART MUSEUM*, TX. *Larry Bell: Recent Work.* September 27–
November 9. Catalogue.
NATIONAL COLLECTION of THE FINE ARTS, SMITHSONIAN INSTITUTION,
Washington, DC. *Sculpture: American Directions, 1945-1975.* October 2–
November 30. Catalogue.
MUSEUM of CONTEMPORARY ART, SAN DIEGO, La Jolla, CA. *University of
California Irvine, 1965-75.* November 7–December 14. Catalogue.
NATIONAL ENDOWMENT FOR THE ARTS, Washington, DC. Grantee.

COPLANS, John. *Diary of a Disaster,* Artforum, February, vol. 13, No. 6, pp. 39, 42.
Larry Bell, ARTnews, March, pp. 63-64.
Larry Bell's Taos Iceberg, Rocky Mountain News, August 31.
BELL, Larry. *The Iceberg,* Vision, California, September, No. 1, pp. 36-37.
RICHARDS, Tally. *Larry Bell,* Southwest Art, September, pp. 34-35.
FRIEDMAN, Martin. The Fort Worth Art Museum, *Larry Bell: Recent Work,* Fort
Worth Star Telegram, October 19, newspaper catalogue.
WORTZ, Melinda. University of California, Irvine, 1965-75, exhibition catalogue
for Museum of Contemporary Art, San Diego, La Jolla, California, November 7–
December 14, p. 8.
ARNASON, H.H. History of Modern Art, Prentice Hall. pp. 615, 244.
JACOBS, Jay, The Color Encyclopedia of World Art, Crown Publishers, p. 29.
One Fracture from the Iceberg, A Magazine of the Fine Arts, vol. 1, No. 13, p. 49.
ROSE, Barbara. ed., *Readings in American Art, 1900-1975,* Praeger,
pp. 175-176, 261.
WALKER, John A. *Art Since Pop,* Thames and Hudson, pp. 24-25, 30-31.

1976

WASHINGTON UNIVERSITY*, St. Louis, MO. *The Iceberg and Its Shadow.*
February 6–March 21. Catalogue.
NEWPORT HARBOR ART MUSEUM, Newport Beach, CA. *The Last Time I Saw
Ferus: 1957-1968.* March 7–April 17. Catalogue
WHITNEY MUSEUM of AMERICAN ART, New York City. *Two Hundred Years of
American Sculpture.* March 16–September 26.
SANTA BARBARA MUSEUM of ART*, CA. *The Iceberg and Its Shadow.*
July–August. Artists Statement. Also shown at: Venice, Italy, July. *The Venice
Biennale,* October.
SAN FRANCISCO MUSEUM of MODERN ART, CA. *Painting and Sculpture in
California: The Modern Era.* September 3–November 21.
ART MUSEUM of SOUTH TEXAS*, Corpus Christi, TX. *The Iceberg and Its
Shadow.* Gallery Notes. October 6–November 18.
HEINER FRIEDRICH GALLERY, New York City. *War Resisters League Exhibition.*
December.
MUSEUM of FINE ARTS, Santa Fe, NM. *Contemporary Sculpture in New Mexico.*

KUTNER, Janet. *Larry Bell's Iceberg,* Arts Magazine, January, pp. 62-66.
PERLMIUTTER, E. *A Hotbed of Advanced Art,* ARTnews, January.
St. Louis Globe-Democrat, February 4. Photo: *The Iceberg and its Shadow.*
FRIEDMAN, Martin. Catalogue essay for Steinberg Hall, Washington University,
St. Louis, February 8–March 21.
TURNBULL, Betty. *The Last Time I Saw Ferus,* exhibition catalogue for Newport
Harbor Art Museum, March 7–April 17.
HASKELL, Barbara. *Two Decades of American Sculpture, A Survey: 1950-1976,
Two Hundred Years of American Sculpture,* exhibition catalogue for Whitney
Museum of American Art, March 16–September 26, pp. 198, 201-2, 259.
The Iceberg and Its Shadow, Curtain Call, March, p. 11.
AMES, Richard. *Museum Exhibit of Contemporary Sculpture,* Arts/Artists, News-
Press, Santa Barbara, California, May 8.
RUSH, David. *Larry Bell on New York,* Artweek, May 15, pp. 1,16.
SELDIS, Henry J. *Magical Tint in 'The Iceberg,'* Los Angeles Times, May 17.
Larry Bell: A Statement, Gallery Notes, The Santa Barbara Museum of Art,
July–August.
The Faces of California, Newsweek, September 6, p. 19.
Larry Bell's Plate Glass..., photo, M.I.T. ARTnews, September 13, vol. 5, No. 1, p. 3.
The Iceberg and Its Shadow, Gallery Notes, Museum of Southern Texas, Corpus
Christi, October 6–November 18.
HUNT, John, director. *A Video Portrait: Larry Bell,* 30-minute color video tape.
Environmental Communications catalogue, Venice, California.

1977

HAYDEN GALLERY*, MASSACHUSETTS INSTITUTE OF TECHNOLOGY,
Cambridge. *The Iceberg and Its Shadow.* January 5–February 26.
NATIONAL COLLECTION of FINE ARTS, SMITHSONIAN INSTITUTION,
Washington, DC. *Painting and Sculpture in California: The Modern Era.* May
20–September 11.
UNIVERSITY of CALIFORNIA, Santa Barbara. *Photographs by Southern California
Painters & Sculptors.* June 3–30. Catalogue.
UNIVERSITY of MASSACHUSETTS*, Amherst. *The Iceberg and Its Shadow.*
September–October.
FORT WORTH ART MUSEUM*, TX. *Solar Fountain Drawings. Larry Bell and Eric
Orr.* October 8–November 15.
FEDERAL RESERVE BANK*, Boston, MA. *The Iceberg and Its Shadow.*
November–December.

GARRETT, R. *Only Tip of the Iceberg,* Boston Herald American, January 23, p. 28.
BAKER, K. *The Grip of the Iceberg,* Boston Phoenix, February 8, Section II, pp.
1,12.
Artist Larry Bell, photo, M.I.T. Tech Talk, February 9, vol. 21, No. 25, p. 2.
Statement by Larry Bell, *Photographs of Southern California Painters and Sculptors,*
exhibition catalogue for University of California, Santa Barbara, June 3–30.
TAYLOR, R. *A Glass Menagerie,* Boston Globe, June 16, pp. B1, B7.
The Iceberg Cometh, East Wind (Federal Reserve Bank of Boston Employee
News), December 12.
NAYLOR, Colin and ORRIDGE, Genesis P., eds., Contemporary Artists, St. James
Press, pp. 85-86.

1978

MULTIPLES GALLERY*, New York City. *Season of the Fountain. Larry Bell and Eric
Orr.* January.
DELAHUNTY GALLERY*, Dallas, TX. *Seasons of the Fountain. Larry Bell and Eric
Orr.* March.
TEXAS GALLERY*, Houston. *New Works on Paper.* July 13–August 12.
SANTA FE FESTIVAL of THE ARTS, NM. *Santa Fe Selects.* October.
CALIFORNIA STATE UNIVERSITY, Long Beach. *Selections from Frederick Weisman
Company: Collection of California Art.* November 20–December 17. Also shown
at: CORCORAN GALLERY of ART, Washington, DC. September 15–November 4,
1979. THE ALBUQUERQUE MUSEUM, NM. July 14–October 12, 1980.
MUSEO DE ARTE CONTEMPORANESO DE CARACAS, Caracas, Venezuela.
12 Artistas Internacionales en la Collection. November.
ERICA WILLIAMS / ANNE JOHNSON GALLERY, Seattle, WA. *Vapor Drawings.*
November.
UNIVERSITY of NEW MEXICO, Albuquerque. *Sculpture.* November–December.
ROSWELL MUSEUM AND ART CENTER*, NM. *Vapor Drawings.* December 17–
January 16, 1979.
TALLY RICHARDS GALLERY of CONTEMPORARY ART*, Taos, NM. *Vapor
Drawings.* December–January.

KUTNER, Janet. *Solar Energy Powers Kinetic Glass Sculpture,* The Dallas Morning
News, March 7.
Artforum, March, p. 6.
Bell-Orr: Solar Fountain, Domus Magazine, Milan, Italy, April, No. 581, p. 52.
BURNSIDE, M. *Larry Bell and Eric Orr,* Ocular Magazine, Spring Quarter, vol. 3,
No. 1, pp. 36-43
WINN, Steven. *Vapour Drawings by Larry Bell at Erica Williams/Anne Johnson,*
The Weekly, Seattle, Washington, November 8–14.
CAMPBELL, R.M. Art Review, Seattle Post-Intelligencer, November 17, p. 11.
SAVAGE, Sue. *Larry Bell,* from exhibition catalogue for The Frederick Weisman
Company Collection of California Art, shown at California State University, Long
Beach, November 20–December 17, p. 33.
CARNEVALI, Gloria. *12 Artistas Internacionales en la Collection,* exhibition
catalogue for the Museo del Arte Contemporaneo de Caracas, Venezuela,
November.
McKINNEY, Robin. *Bell Makes Art with Technology,* The Taos News, December 7,
p. B1.
Marilyn Butler Fine Art, Arizona Living, December 22, vol. 9, No. 26, p. 10.
NEWMAN, Jay Hartley and NEWMAN, Lee Scott. *The Mirror Book,* Crown
Publishers, p. 46.

1979

MULTIPLES GALLERY*, New York City. *Vapor Drawings.* January 15–February 17.
SEBASTIAN-MOORE GALLERY*, Denver, CO. *Vapor Drawings.* February–March.
ARMORY SHOW, Santa Fe, NM. March.

PARKS, Steve. Artspace, Winter 1978-79, p. 56-57.
FREEMAN, Genevieve. *Larry Bell's Work: Weaving Light Together,* Westword,
Denver, February 2-16.

MUSEUM of MODERN ART, New York City. *Contemporary Sculpture: Selections from the Collections of MOMA.* May 18–August 7. Catalogue.
HANSON FULLER GALLERY*, San Francisco, CA. May 31–June 23.
HILL'S GALLERY of CONTEMPORARY ART*, Santa Fe, NM. *Vapor Drawings.* May.
TEXAS GALLERY, Houston. *From Alan to Zucker.* September.
TALLY RICHARDS GALLERY of CONTEMPORARY ART*, Taos, NM. October 6–21.
THE ALBUQUERQUE MUSEUM, NM. *Reflections of Realism.* November 4–January 27, 1980.
CALIFORNIA STATE UNIVERSITY, Fullerton. *California Perceptions: Light and Space. Selections from the Wortz Collection.* November 16–December 13. Catalogue.
MARION GOODMAN GALLERY*, New York City. *Larry Bell, New Work.* November 27–January 5.
JANUS GALLERY*, Venice, CA. *Noble Metals.* December 1–29.

MILLS, James. *Bell Drawings Create Fleeting Images,* Sunday Denver Post, February 11.
CLURMAN, Irene. *'Solar Fountain' Proposal for Denver,* Arts Now, Rocky Mountain News, February 18.
BUONAGURIO, Edgar. Arts, April, p. 25.
PARKS, Steve. *Larry Bell: Proteus on paper,* High Country Profile, April, pp. 13-14, 23.
LONIAK, Walter. *Technological Artistry in Process and Imagery,* The Reporter, Santa Fe, NM, May 10, pp. 14-15.
FABRICANT, Don. *Bell, Voulkos Open Impressive Show,* The New Mexican, Santa Fe, May 11.
WASSERMAN, Isabelle. *Sculptor's Glass Cubes...,* The San Diego Union, May 12, p. D-1.
HENRY, Gerrit. Artnews, May, p. 182.
BOURDON, David. *What's News, Art,* Vogue, August, p. 30.
BRIDGERS, Bill. *Mirrors, Glass, and Larry Bell: The Surface Layer of Perception,* Wisconsin Engineer, October, pp. 16-18.
LANDIS, Ellen. Introduction, catalogue for *Reflections of Realism* at The Albuquerque Museum, November 4–January 27.
LUSK, Jennie. *'Realism' Designed to Trick the Eye,* Albuquerque Journal, November 4, p. 4, D-1.
WORTZ, Melinda. *California Perceptions: Light and Space. Selections from the Wortz Collection* exhibition catalogue for California State University, Fullerton, November 16–December 13.
WILSON, William. *The Galleries,* Los Angeles Times, December 14, Part IV.
NADEL, Norman. *Taos Artists Creates Best Pieces While Working in a Vacuum,* Rocky Mountain News, Denver, December 17, p. 82.
L.A. Weekly, Los Angeles, December 14-30
FAHR, Barry. *Art in a Vacuum,* Artweek, December 22, p. 5.
MOSER, Charlotte, *Bell's 'Vapor Drawings' Use Industrial Metallic Deposits,* Houston Chronicle.
DeWILDE, Daniel, producer and director. *Contemporary Artists at Work: Sculptors,* vol. 1, part 1, Sound Filmstrips Teacher's Manual, Harcourt Brace Javanovitch Films.

1980

ASPEN CENTER FOR THE VISUAL ARTS, CO. *Beyond Object.* May 27–July 12.
SEBASTIAN-MOORE GALLERY*, Denver, CO. *Larry Bell, Vapor Drawings, Recent Works.* May 29–July 12.
THE VICE PRESIDENT'S HOUSE, Washington, DC. *Loan Collection from Pacific Coast States Museums.* May 1980–April 1981. Catalogue.
HILL'S GALLERY of CONTEMPORARY ART*, Santa Fe, NM. *Larry Bell: New Sculpture and Vapor Drawings.* June.
FRUIT MARKET GALLERY, Edinburgh, Scotland. *New New Mexico.* August 16–September 21. Catalogue.
TALLY RICHARDS GALLERY of CONTEMPORARY ART*, Taos, NM. *Larry Bell, New Work.* October 18–November 8.
THE ALBUQUERQUE MUSEUM, NM. *Here and Now: 35 Artists in New Mexico,* November 2–January 4. Catalogue.

YOUNG, Joseph E. *Photography, Ceramics Gain...,* The Arizona Republic, January 6, p. G10.
Solar Fountain of the Future, photo, Rocky Mountain News, Denver, May 31, p. 6.
FRIEDMAN, Mary Lou. The Vice President's House, exhibition brochure for *Loan Collection from Pacific Coast States Museums* at the Vice President's House, Washington, DC, May 1980–April 1981.
SIMON Joan. *Report from New Mexico,* Art in America, Summer, p. 33-41.
ADLMANN, Jan. *New New Mexico,* exhibition catalogue for Fruit Market Gallery, Edinburgh, Scotland, August 16–September 21.
PETERSON, William. *Larry Bell and Bruce Nauman at Hill's...,* Artspace, September, p. 52.
HALL, Douglas Kent. *Lunch with Dr. Lux,* Artlines, Taos, New Mexico, November, pp. 4-5, 15.
DINNER, Gregory. *Some Sun Shines on Art in Public Places,* Westword, November 28–December 12, vol. IV, No. 7, p. 6.
Here and Now, catalogue for 35 Artists in New Mexico, The Albuquerque Museum, November 4–January 4.
Further Furniture, introduction by Nicolas Calas, Marian Goodman Gallery, New York , December 9–31.
JONES, Dianna. *Huntington: Glass Artists See It Clearly,* Tri-State Scene, The Herald Dispatch, Huntington, West Virginia, June 12, p. 25.
Larry Bell, Keynote Speaker, 10th Annual conference, Glass Art Society Journal, Summer 1980, Marshall University, Huntington, West Virginia, pp. 4-7, 20. Photo: *The Iceberg and Its Shadow.*
Bell at Tally Richards, Taos News, New Mexico, October 16.
Chairs Sensual, Taos News, October 23.
SLESIN, Suzanne. *Furniture Created by Artists,* New York Times, December 11.
Light, Notes and Comments, The New Yorker, December 15.

1981

MARION GOODMAN GALLERY*, New York City. *Larry Bell, New Work.* January 27–February 17.
HUDSON RIVER MUSEUM*, Yonkers, NY. *Larry Bell, New Work.* January 31–March 22.
ANN JACOB GALLERY*, Atlanta, GA. *Sculpture by Larry Bell /Eric Orr: Vapor Paintings on Glass.* February 6–March 31.
LONNY GANS & ASSOCIATES, Venice, CA. *California I, Light and Space, 1960-1980.* February 14–March 31.
FEDERAL RESERVE BANK of BOSTON, Organized by the de Cordova Museum, Lincoln, MA. *The Fine Art of Business.* March 16–May 1.
MAGNUSON-LEE GALLERY, Boston, MA. *Artists and Furniture.* May 17–June 17.
L A LOUVER GALLERY*, Venice, CA. *New Works by Larry Bell.* May 29–July 15.
WILDINE GALLERIES*, Albuquerque, NM. *Larry Bell New Works.* June 15–July 11.
HEYDT-BAIR GALLERY, Santa Fe, NM. *Group Show of Gallery Artists in New Gallery Space.* June 16–July 29.
MUSEUM of MODERN ART, New York City. *Summer Penthouse Exhibition: Summer Light.* June 1–September 15.

WORTZ, Melinda. *Larry Bell;* CREELEY, Robert. Introduction, exhibition catalogue for *Larry Bell: New Work* at The Hudson River Museum, Yonkers, New York, January 31–March 22.
Hudson River Museum Rings in Bell Exhibition, Daily News, Yonkers, New York, February 1.
BEALS, Kathie. *A Different View of Reality,* Weekend.
Glass Sculpture at Museum, New York Times, February 10.
Art and Furniture: Blurring the Lines, New York Times, February 12.
On View, Los Angeles Times, February 17.
RAYNOR, Vivian. *Technology as Medium for Artists,* New York Times, February 22.
A Tour, San Antonio Light Sunday Women's Magazine, February 22, p. 1.
MINUTAGLIO, Bill. *Art Museum's Opening, A Cultural Happening,* Lively Arts, San Antonio Express News, p. M-1.
When Artists Make Furniture, Is It Furniture or Is It Art?, ARTnews, February, vol. 3, pp. 93-98.
URRUTIA, Judy. *'Griffin's Cat' Appears Reflecting, Fascinating,* San Antonio Light, Art Section, March 6.
FOX, William L. *The Combination of Art and Architecture,* Reno, Nevada Gazette/Journal, March 8, p. E-6.

150

LEIGH YAWKEY WOODSON ART MUSEUM, Wausau, WI. *Americans in Glass.* 1981. June 20–August 2. Catalogue.

LOS ANGELES COUNTY MUSEUM of ART, CA. *Art in Los Angeles: Seventeen Artists in the Sixties.* July 16–October 4. Catalogue. Also shown at: SAN ANTONIO MUSEUM of ART, TX. November 30–January 31, 1982.

LAGUNA BEACH MUSEUM of ART, CA. *Southern California Artists: 1940-1980.* July 24–September 13. Catalogue.

THE ART GALLERY, CALIFORNIA STATE UNIVERSITY, Fullerton. *California Innovations.* September 11–October 15. Catalogue. Also shown at: PALM SPRINGS DESERT MUSEUM, CA. December 15–January 17.

FINE ARTS GALLERY, CALIFORNIA STATE UNIVERSITY, Northridge. *Abstraction in Los Angeles 1950-1980: Selections from the Ruth and Murray Bribin Collection.* September 27–October 23. Also shown at: FINE ARTS GALLERY, UNIVERSITY OF CALIFORNIA, Irvine. November 5–December 5.

DORD FITZ GALLERY, Amarillo, TX. *Group Show '81.* October 1–20.

TALLY RICHARDS GALLERY of CONTEMPORARY ART*, Taos, NM. *Larry Bell, New Vapor Drawings: The "EL" Series.* October 3–24.

FESTIVAL of THE VISUAL ARTS, Santa Fe, NM. *Rosiland Constable Invites.* October 9–18. Catalogue.

HILL'S GALLERY, Santa Fe, NM. *The Best of the Decade.* October 10–24.

HEYDT-BAIR GALLERY, Santa Fe, NM. October 28–January 28.

TRISOLINI GALLERY*, UNIVERSITY OF OHIO, Athens. *Larry Bell: New Work.* October 19–November 21. Catalogue.

STABLES ART CENTER, Taos Art Association, NM. *Artlines: The First Eighteen Months.* November 16–24. Also shown at: HEYDT-BAIR GALLERY, Santa Fe, NM. January 16–23.

HEINECK GALLERY, Pasadena, CA. November 27–December 31.

STABLES ART CENTER, Taos Art Association, NM. *Wood and Wool.* December 19–January 10.

WILSON, William , *San Antonio Art Museum and the Kiss of the Hops,* Los Angeles Times Calendar, March 15, pp. 1, 100-101.

ANCO-STARRELS, Josine. *New Sculpture by Larry Bell,* Los Angeles Times Calendar, March 24, p. 77.

TENNANT, Donna. *Stunning/San Antonio Brews Up a Memorable Museum,* Houston Chronicle, March 29, Lively Arts Section, pp. 12, 31.

Curators Take Fresh Approach..., The Riverdale Press, New York City, April 2, Section 2, p. 9.

MORROW, Suzanne Stack. *A Design for Today,* Architectural Digest, April, pp. 108-115.

Bell's Art Stretches Senses, Albuquerque Tribune, May 29.

BELL, David L. *Santa Fe Gallery's New Quarters Showcase Contemporary Art,* Albuquerque Journal, June 12, p. D-9.

WARREN, Jill. *Contemporary Art, Southwestern Style: A Transformation from Artifacts to Art,* The New Mexican, June 12, p. 4.

AVER, James. *Wausau Exhibit a Glass Act,* The Milwaukee Journal, June 12, Lively Arts Section, pp. 1,4.

KNIGHT, Christopher. *Environment as Sculpture,* Los Angeles Herald Examiner, June 14, p. E-5.

MAZOR, Carole. *Taos Artist's Magical Machine Creates Unique Visual Images,* Albuquerque Journal, June 14, p. D-1.

MARVEL, Bill. *Brewing Up a Dandy Museum,* Dallas Times Herald, June 14, Arts Section, pp. 1-2.

OLSEN, James. *Vapor Drawings at Wildine Combine Real, Illusionary World,* Albuquerque Journal, June 14, p. D-1.

MUCHNIC, Suzanne. *Pulling the Walls Over Our Eyes,* Los Angeles Times Calendar, June 15, Part VI, pp. 1-2.

KNIGHT, Christopher. *Art Exhibit Recaptures the Sixties...County Museum Shows Best L.A. Artists but Not Always Their Best Works,* Los Angeles Herald Examiner, July 22.

Art in Los Angeles: 17 Artists in the Sixties, Los Angeles County Museum of Art Members' Catalogue, July, vol. 19, No. 7, p. 39. B&W photo: *Untitled '64-'69.*

PERRAULT, John. *Usable Art,* Portfolio, July/August, pp. 60, 63.

PETERSON, William. *Portrait: The Southwest,* Portfolio, July/August, pp. 66-76.

SLESIN, Suzanne. *Blurring the Boundaries Between Art and Furniture,* New York Times, Home Section, pp. C-1, C-8.

Los Angeles County Museum of Art, Art in Los Angeles: 17 Artists in the Sixties, Portfolio, July/August, p. 18.

STEVENS, Mark. *California Dreamers,* Newsweek, August 17, Art Section, pp. 78-79.

HUNT, John. *A Video Portrait,* Independents Network Video, Painters & Sculptors, August.

SCHJELDAHL, Peter. *Spanning Time Zones,* The Village Voice, September 2-8, p. 70.

Abstraction in Los Angeles, 1950-1980: Selections from the Murray and Ruth Bribbin Collection, exhibition catalogue from California State University, Northridge, September 27–October 23.

NADELMAN, Cynthia. *New York Reviews: Larry Bell,* ARTnews, September, vol. 80, No. 7, pp. 240, 242.

DOMERQUE, Denise. *Furniture by Artists,* Art and Architecture, vol. 1, No. 1, (new series), pp. 12-13.

Santa Fe Festival of the Arts/Rosalind Constable Invites, exhibition catalogue, October 24.

Hill's Gallery Puts Best Foot Forward, Albuquerque Journal, October 24.

LIN, Henry. *Larry Bell,* exhibition catalogue for Trisolini Gallery of Ohio University, Athens, Ohio, October 19–November 21.

Fashion, California Magazine, October, pp. 92-93, 161.

SPALDING, Jill. *Notebook: L.A. on the Move,* Vogue, London, November.

HAMMOND, Pamela. *Larry Bell at L.A. Louver,* Images and Issues, Fall, vol. 2, No. 2, pp. 67-68.

BUTTERFIELD, Jan. *Those Were the Days: Los Angeles in the Sixties,* Images and Issues, Fall, vol. 2, No. 2, pp. 41-43.

FIDEL, Danieli. *Setting the Scene for the Sixties,* Images and Issues, Fall, vol. 2, No. 2, pp. 36-37.

FIDEL, Danieli. *Seventeen Artists,* Images and Issues, Fall, vol. 2, No. 2, pp. 44.

HUGO, Joan. *The Sixties Were...,* Images and Issues, Fall, vol. 2, No. 2, pp. 38-40.

HURST, Tricia. *Larry Bell's Creative Premise...* Art Voices, November/December, pp. 16-17.

CLURMAN, Irene. *Fountain Budget Bubbles Over: $60,000 Sought,* Rocky Mountain News, December 15, Entertainment/Arts, p. 62.

WILSON, William. *Reflections on a Maverick Decade,* Los Angeles Times, Home Section, p. 21.

KNIGHT, Christopher. *A Decade of Artistic Euphoria,* Los Angeles Herald Examiner.

FOSS, Marilyn. Photo *The Iceberg and Its Shadow,* Albuquerque Journal.

MICHELSON, Maureen, ed. *In Reflection—Larry Bell and His Art,* Glass Studio, December, No. 26. Cover photo, pp. 9, 45, 50.

The Tate Gallery: Illustrated Catalogue of Acquisitions, 1978-'80, Tate Gallery Publications Department, Milbank, London, pp. 62-63.

┌─ **1982**

CROWN POINT GALLERY, Oakland, CA. *Artists' Photographs.* January 10–February 7. Catalogue.

STABLES ART CENTER, Taos Art Association, NM. *Prints and Drawings: An Invitational and Juried Exhibition.* January 23–February 28.

HEYDT-BAIR GALLERY, Santa Fe, NM. *Group Show of Recent Work.* February 20–April 3.

RICKIE, Carrie. *Studs & Polish: L.A. in the Sixties,* Art in America, Special Section, Los Angeles, January, p. 81.

DOE, Donald Bartlett. *Santa Fe/Taos,* Nebraska Art Association, Sheldon Memorial Art Gallery, University of Nebraska, Lincoln, p. 19.

KUTNER, Janet. *L.A. Art Doesn't Miss a Beat,* The Dallas Morning News, January 22, Today Section, pp. C-1-2.

NEWPORT HARBOR ART MUSEUM*, Newport Beach, CA. *On the Ellipse, Works by Larry Bell.* March 5–May 1. Catalogue.
MARION GOODMAN GALLERY, New York City. *New Vapor Drawings from the "EL" Series.* March 16–April 10. Poster.
SONOMA STATE UNIVERSITY ART GALLERY, Rohnert Park, CA. *Sculpture '82, A Contemporary Survey, Parts One and Two.* March 18–August 29. Poster.
RUTH S. SCHAFFNER GALLERY*, Santa Barbara, CA. *Larry Bell, Vapor Drawings.* March 21–April 17.
ERICA WILLIAMS / ANNE JOHNSON GALLERY*, Seattle, WA. *Larry Bell, New Vapor Drawings.* May 6–29.
YALE UNIVERSITY ART GALLERY, New Haven, CT. *Prints by Contemporary Sculptors.* May 18–August 31. Catalogue.
ART INSTITUTE of CHICAGO, IL. *74th American Exhibition.* June 8–August 1. Catalogue.
MILWAUKEE ART MUSEUM*, WI. *Larry Bell: New Work.* June 18–August 15.
SAN FRANCISCO INTERNATIONAL AIRPORT, CA. *Artists' Furniture.* June 21–September 17. Catalogue.
HEYDT-BAIR GALLERY, Santa Fe, NM. *Group Show of Gallery Artists.* July 2–24.
OAKLAND MUSEUM, CA. *100 Years of California Sculpture.* August 7–October 17. Catalogue.
SHELDON MEMORIAL ART GALLERY, UNIVERSITY OF NEBRASKA, Lincoln. *Santa Fe/Taos.* August 31–October 3. Also shown at: SPIVA ART CENTER, Joplin, MO. February 6–23, 1983; WYOMING STATE MUSEUM, Cheyenne. April 3–May 1, 1983; SALINA ART CENTER, KS. May 8–June 5; SIOUX CITY ART CENTER, IA. June 12–July 17.
ABILENE FINE ARTS MUSEUM, TX. *New Dimensions and Statements in Design.* July 26–September 5.
MUSEUM of FINE ARTS*, Santa Fe, NM. *Larry Bell, the Sixties.* September 16–December 5. Catalogue. Poster.
TALLY RICHARDS GALLERY of CONTEMPORARY ART*, Taos, NM. *Larry Bell, Small Images: New Vapor Drawings.* September 18–October 2.
DETROIT INSTITUTE of ARTS*, MI. *Larry Bell: New Work.* October 13–December 19.

ANCO-STARRELS, Josine. *Bell's Sculpture: Glass and Light,* Los Angeles Times Calendar, February 28, p. 93.
BRYANT, Kathy. *Perfection Through the Looking Glass,* The Register, Orange County, California, March 5, p. E-1.
HASTINGS, Debi. *What's Doing in Orange County,* Los Angeles Times, March 5, Section 14, pp. 19-20.
HASTINGS, Debi. *He Draws a Line at Distractions,* Los Angeles Times, March 5, Part VI, p. 17.
LEVINE, Melinda. *A Contemporary Survey, Sculpture '82,* exhibition catalogue essay, March 18–August 29, University Art Gallery, Sonoma State University, Rohnert Park, California, pp. 3, 5, 12, 13, 16, 17. Photo: Corner Lamp.
PARKER, Jeff. *Two Major Exhibits Open at Southland Museums,* Pilot Weekender, March 19, p. 13.
WILSON, William. *Larry Bell: Heeding the Siren Song of Technology,* Los Angeles Times Calendar, March 28, p. 90.
GABRIEL, Bertram. *New Mexico: the Mainstream and Local Currents,* ARTnews, April, vol. 81, No. 4, pp. 120-125.
On the Ellipse, Works by Larry Bell, Newport Harbor Art Museum Calendar, March/April, p. 1.
NORKLUN, Kathi. *Technology Competes with Art,* Artweek, April, 10.
Photo: Larry Bell with Dr. Richard Newquist, Newport Harbor Art Museum Calendar, May/June.
Major Exhibitions, Milwaukee Art Museum Calendar, May/June.
Sculpture, Drawings on Exhibit, Wausau Daily Herald, June 16.
AUER, James. *Bell Epoch at Art Museum,* The Milwaukee Journal, June 17.
RORIMER, Anne. *74th American Exhibition,* catalogue for the Art Institute of Chicago, June 12–August 1, pp. 5-10, 16.
JENSEN, Dean. *Out of Time,* Milwaukee Sentinel, July 16.
SIMS, Patterson: GRAZE, Sue: GOLDWATER, Marge; HARTIGAN, Lynda Roscoe. *Larry Bell Sculpture, The Wind Wedge,* Dedication Brochure, Nelson Park, Abilene, Texas, September 25.
MEYER, Jon. *Larry Bell,* Arts Magazine, September, vol. 57-1, p. 29.
HURST, Tricia. *Larry Bell—His First Ten Years (1959-1969),* Southwest Art, Museum Notebook, September 10–December 5, vol. 12, No. 4, pp. 117-118.
DUNHAM, Marry. *Through a Peep-Hole,* Santa Fe Reporter, September 22.
REED, Jerry. *'Wedge' to Reside Beside Lake,* Abilene (Texas) Reporter-News, September 24, pp. 1A, 9A, 2B.
CLOLERY, Paul H. *Glass Sculpture Celebrates the Centennial of Abilene,* Abilene (Texas) Reporter-News, September 26, p. 12A.
COOKE, Regina. *Larry Bell Retrospective Show The Sixties in Santa Fe,* The Taos News, September 30.
McKENNA, Kathryn. *Bell Mirrors Abilene's Pride,* Austin American Statesman, October 3, Show World, pp. 1,35.
MUCHNIC, Suzanne. *Larry Bell Gets Into Flow of Things,* Los Angeles Times Calendar, October 3.
SHERMAN, Lisa. *Tracing an Evolution,* Artweek, October 13, vol. 13, No. 36.
DIA's Featured Artist, LB's Got Glass, Monitor, Detroit, Michigan, October 14.
Larry Bell Display, News, Saginaw, Michigan, October 14.
BELL, David. *Realist Complements Breaker of Images,* Albuquerque Journal, October 17.
COLBY, Joy Kakanson. *Is It Show Time, or Sell Time?,* The Detroit News, October 17, pp. 1E, 6E.
MIRO, Marsha. *The Raw Material of Time and Space,* Detroit Free Press, October 26.
FAILING, Patricia. *Oakland: Sculpture for all Reasons,* ARTnews, November, vol. 81, No. 9, pp. 155-156.
Wind Wedge Panels Replaced, The Abilene (Texas) Reporter-News, November 18.

1983

SHELDON MEMORIAL ART GALLERY*, UNIVERSITY OF NEBRASKA, Lincoln. *Larry Bell: Major Works in Glass.* February 23–April 3. Catalogue.
BUTLER INSTITUTE of AMERICAN ART, Youngstown, OH. *The Chinese Chance: An American Collection.* March 6–27. Catalogue.
LESLIE LEVY GALLERY, Scottsdale, AZ. *Santa Fe Comes to Scottsdale. A New Mexico Invitational.* February 4–March 21.
TAOS INN, NM. *Spring Arts Celebration.* April 20–June 21.
WILDINE GALLERY, Albuquerque, NM. *Gallery Artists/Summer.* July 22–September 2.
UNICORN GALLERY, Aspen, CO. *Larry Bell, Richard, and Salvatore Pecoraro.* August 18–September 30.
SEBASTIAN-MOORE GALLERY, Denver, CO. August 18–September.
ADVANCED ART GALLERY*, Rinconada, NM. *Larry Bell: Recent Work.* July 26–31.
ARCO CENTER FOR VISUAL ART*, Los Angeles, CA. *Larry Bell: New Sculpture.* September 20–October 29. Catalogue.
KACHINA LODGE, Taos, NM. *Taos Invites Taos.* October 1–7.
WILDINE GALLERY, Albuquerque, NM. *Larry Bell, Vapor Drawings.* October 28–December 2.

CARLOCK, Marty. *Guidebook Spotlights MIT Art Collection,* The Boston Globe, January 9.
DOE, Donald Bartlett. *Larry Bell: Major Works in Glass,* Sheldon Memorial Art Gallery Catalogue, University of Nebraska, Lincoln, February.
URLICH, Linda. *Sculpture Bell Offers Looking Glass World,* Sunday Journal and Star, Lincoln, Nebraska, February 20, p. 6H.
KARSON, Robin. *A New Work of Art Distinguished by Its Color,* The Sunday Republican, Springfield, Massachusetts, March 20, p. D-6.
LEFFINGWELL, Edward. Introductory essay in exhibition catalogue for *The Chinese Chance: An American Collection,* The Butler Institute of American Art, Youngstown, Ohio, March 6-27.
RICKEY, Carrie. *Six-Sided Constructions,* Art in America, April, vol. 71, No. 4, pp. 150-154.
BARTLETT, Lynn. *Larry Bell's 'The Wind Wedge,'* Artspace, New Mexico, Spring, vol. 7, No. 2, p. 1.
PLETT, Nicole. *Art Among the Fruitstands,* The New Mexican, Pasatiempo, Santa Fe, September 2, p. 21.
Color is Key to Upcoming Design Activity, Los Angeles Times, Part VI, September 25, pp. 1, 3.
DANIELI, Fidel. *Larry Bell,* Artscene, October, pp. 1, 6, 28.

1984

MULTIPLES / MARION GOODMAN GALLERY, New York City. *Artists Call.* January.

STEWART, Judy L. *Larry Bell's Elusive Art,* Colorado Springs Sun, March 30, Weekend, pp. 12B, 13B.

152

UNIVERSITY of EL PASO*, TX. Vapor Drawings. Lecture. March.
COLORADO SPRINGS FINE ARTS CENTER*, CO. Chairs in Space; How the Game Evolved. March 24–May 13.
THE ALBUQUERQUE MUSEUM, NM. Frederick Weisman Collection.
OAKLAND MUSEUM, CA. The Art of California: Selected Works from the Collection of the Oakland Museum. May. Book.
LEIGH YAWKEY WOODSON ART MUSEUM, Wausau, WI. Americans in Glass. May 26–July 8. Catalogue. European tour of exhibition selections: Düsseldorf, Germany; Hanover, Germany; Copenhagen, Denmark; Arnhern, Netherlands; Manchester, England; Reykjavik, Iceland; Frankfurt, Germany; Zurich, Switzerland; Paris, France.
SANTUARIO DE GUADALUPE, Santa Fe, NM. Arts New Mexico. September 4– October 14. Catalogue. Washington DC Exhibition, November 1.
SANTA BARBARA ART MUSEUM, Santa Barbara, CA. Contemporary Viewpoint: Works from the Permanent Collection. November 1 through 1987.
WILDINE GALLERY, Albuquerque, NM. December 8–30.
MUSEUM of CONTEMPORARY ART*, Los Angeles, CA. Chairs in Space: The Game. November 17–January 6. Book.
THE WORKS GALLERY*, Long Beach, CA. Larry Bell—The Game. November 17– January 8.
8332-1/2 MELROSE*, Los Angeles, CA. Chairs in Space. December 17– January 7.

Lifestyles: Larry Bell: Artist, Taos, New Mexico, Casa Brutus, Cassina, Spring, pp. 10-13.
ROBASEN, George. Forget the Price, It Looks Interesting, Press-Telegram, May 21.
The Art of California: Selected Works from the Collection of the Oakland Museum, catalogue. The Oakland Museum, May.
HURST, Tricia. Larry Bell: An Interview with a 'Grand Illusionist,' Heartland Craft Range, September/October, vol. 15, No. 5, pp. 4-5.
GALLOWAY, David. Report from Italy, Count Panza Divest, Art in America, December, pp. 9-18.
New Works Gallery Opens in 19th-Century Fire Station, Los Angeles Times, December 20, Part IV, p. 14H.
DOMERQUE, Denise. Artists Design Furniture, book.

1985

DAVIS/McCLAIN GALLERY, Houston, TX. Art/Furniture. February 22–March 23.
LAICA*, Los Angeles, CA. Bell/Victoria Iridescent Vapor Gowns. April.
DORD FITZ GALLERY, Amarillo, TX. Lee Mullican and Larry Bell. April 20–May 17.
THE WORKS GALLERY*, Long Beach, CA. Larry Bell: New Works. April 27– May 27.
ATHENAEUM GALLERY, Manchester, England. Americans in Glass. 1984/85. May 30–July 21.
RUFINO TAMAYO MUSEUM, Mexico City. Images in Boxes. July 17.
RUTH BACHOFNER GALLERY, Los Angeles, CA. Accent on Glass. July 27– September 7.
L A LOUVER GALLERY*, Venice, CA. American and European Painting and Sculpture, 1985. Part II. August 20–September 21.
NEWPORT HARBOR ART MUSEUM, Newport Beach, CA. Permanent Collection. October 12–27.
L A LOUVER GALLERY*, Venice, CA. Larry Bell: New Sculpture and Larry Bell: Vapor Drawings on Paper and Glass. November 15–December 14.
LINDA DURHAM GALLERY*, Santa Fe, NM. Chairs in Space: The Game. December 7–January 14.

GOTTLIEB, Shirle. 'Chairs in Space' Take Front Seat at Opening of New Gallery, Weekend Plus, Long Beach, California, January 4, p. 4.
HURST, Tricia. Taos: Magnetic Attractions—A Southwest Art City View, Southwest Art, February, vol. 14, No. 9, pp. 76-83.
QUINN, Joan. Photo: Larry Bell, Santa Fe Arts and Leisure, Joan Quinns Instamatics, center page.
WALDMAN, Diane. Transformations in Sculpture: Four Decades of American and European Art, Solomon R. Guggenheim Museum catalogue, New York City, pp. 220-221.
McKAY, Gary. Artistic License?, Houston, Home and Garden, March, col. 11, No., 6, pp. 74-76
RICO, Diane. Functional at a Junction, Western's World, April, p. 38-41, 80, 81.
GOTTLIEB, Shirle. Elegance of Painting with Light, Press-Telegram, May 17.
Magenes en Cajas, exhibition catalogue, Museo Rufino Tamayo, Mexico City, July 18–September 8, p. 10.
McKENNA, Kristine. The Art Galleries, Los Angeles Times, September 6, Part VI, p. 10.
SILVEY, Kitty Gibbons. Sculptors of Light, Art Gallery International, October/November, vol. 7, ed. 1, pp. 34-37.
SCHERCH, Meg. State of the Arts, The Taos News, Taos Arts '85, Taos Arts Festival Official Program, October 1-7, p. 21.
JACOBS, Jody. A Serious Chair: It's More than Seat, Los Angeles Times, October 10, Part IV, p. 4.
Serious Chair, announcement for symposium, Los Angeles Times, October 14.
KRANTZ, Les. Bell, Larry Stuart, American Artists—An Illustrated Survey of Leading Contemporary Americans, The Krantz Company Publishers, Inc., p. 28.
JACOBS, Jody. Art Vapor Made, Los Angeles Times, Weekend Guide, November 15.
COOKE, Regina. Art Notes, The Taos News, Tempo, November 21.
DEATS, Suzanne. A Season of Excellence, Santa Fe Reporter, December.
BRADBURY, Ellen. Top Artist's Game, Brings Here, Now, Albuquerque Journal, December 13.
DEATS, Suzanne. Searching for the Gift, Santa Fe Reporter, December 18.
Industrialist Art Teacher, Arts Business Merger, Winter, vol. IV, No. 4, p. 4.
JACOBSON, Stuart E. Only the Best, book, pp. 94-95.
The Security Pacific Collection 1970-1985: Selected Works, Works on Paper, Nissha Printing Company, Kyoto, p. 76.

1986

COLORADO SPRINGS FINE ARTS CENTER, CO. The New West. January 12– March 16.
NEWPORT HARBOR ART MUSEUM, Newport Beach, CA. California Art Since 1945. January 15–April 12.
LOS ANGELES INSTITUTE of CONTEMPORARY ART, CA. Fashion Show. February 7.
ELAINE HORWITCH GALLERY, Scottsdale, AZ. Art Expo. February 14–16.
SOTHEBY'S, New York City. Artaid. May 19–25.
SAN ANTONIO MUSEUM of ART, TX. Box Art. Auction March 16, Exhibition June 1.
AMBASSADOR HOTEL, Los Angeles, CA. Glass Art Society Conference. The Invisible Presence: Light and Glass. Keynote speaker Larry Bell, Light and Surface. April 17.
LOS ANGELES MUNICIPAL ART GALLERY, CA. Kindred Spirits. April 29–June 1.
HARWOOD FOUNDATION, Taos, NM. New Acquisitions. May 2– September 28.
STABLES ART CENTER, Taos Art Association, NM. Art On and of Paper. March 29–May 4.
NAVY PIER, Chicago, IL. Chicago International Art Exposition. Represented by Braunstein/Quay Gallery, Booth #2-139. May 8–13.
MUSEUM of FINE ARTS, HOUSTON, TX. Texas Landscape. May 16–September 7.

SCHERCH, Meg. Art has to Have a Breath of its Own, The Taos News, Tempo, January 2, p. 3.
Works from the Permanent Collection, Newport Harbor Art Museum Calendar, January/February, p. 1.
PRICE, Max. Colorado Springs Gallery is Noting its 50th Year, The Denver Post, January 5.
The New West, exhibition catalogue, Colorado Springs Fine Arts Center, January 11–March 16, pp. 12, 13.
DUVAL, Linda. The New West Modern Art Exhibit Celebrates Anniversary of Fine Arts Center, Colorado Springs, Colorado, January.
COOKE, Regina. Art Notes, The Taos News, Tempo, January 30, p. 30.
CHRISTY, George. The Great Life, The Hollywood Reporter, February 19, vol. CCXC, No. 42, p. 20.
ArtAid, catalogue, New York City, March 19-25, No. 26, p. 15.
Collectors Guide: The Art Colony, Art and Antiques, April, p. 84.
MUCHNIC, Suzanne. Exploring Emotional Connections in Spirits, art review, Los Angeles Times, May 5, pp. 1-6.
BULMER, Marge. Critic's Choice: Kindred Spirits, Los Angeles Free Weekly, May 9, Reader Section 2, p. 1.
KALIL, Susie. The Texas Landscape: 1900-1986, catalogue, The Museum of Fine Arts, Houston, May 17–September 7. Photo: The Wind Wedge, p. 86.

FINE ARTS GALLERY, NEW MEXICO STATE FAIRGROUNDS, Albuquerque. *Statements '86.* May 30–June 22.
SIGALA GALLERY, Taos, NM. *Taos Moderns.* June 1–15.
BRAUNSTEIN GALLERY*, San Francisco, CA. *Chairs in Space and Vapor Drawings.* June 3–28.
BOISE GALLERY of ART*, ID. *Contained Space and Trapped Light: Larry Bell's Sculptural Environments.* June 8–July 27.
LEEDY-VOULKOS GALLERY, Kansas City, MO. July 11.
COLORADO SPRINGS FINE ARTS CENTER, CO. *1986 Summer Gala Dedication of After Gainsborough.* August 2–October 21.
PERFORMING ARTS COUNCIL: MERCADO, Los Angeles, CA.
NEW GALLERY*, Houston, TX. *The New Cubes and Other Works.* September 13–October 11.
POGZEBA STUDIO/HOUSE, Taos, NM. *Taos Invites Taos.* September 27–October 7.
SEWALL ART GALLERY, RICE UNIVERSITY, Houston, TX. October 1–December.
THE GALLERY, COLLEGE of SANTA FE, Santa Fe, NM. *New Mexico Selections '86.* October 17–November 17.
MUSEUM of MODERN ART, New York City. *Contemporary Galleries.* November 7–March 31.
AMARILLO ART CENTER*, TX. *Larry Bell: Chairs in Space.* November 8–30.
AMERICAN ACADEMY AND INSTITUTE of ARTS AND LETTERS, New York City. *38th Annual Academy-Institute Purchase Exhibition.* November 17–December 14.
MUSEUM of CONTEMPORARY ART*, Los Angeles, CA. *Installation of The Leaning Room.* November 30.

LaPALMA, Marina. *A Conjunction of Affinities,* Artweek, May 17, vol. 17, No. 19, p. 1.
DEITCH, Jeffrey. *Modern Objects: A New Dawn,* exhibition catalogue, Bakerville/Watson, New York City, June–August 2.
STEELE, Judy McConnell. *Magical Work Shines at Boise Gallery of Art,* The Idaho Statesman, June 8.
BAKER, Kenneth. *Larry Bell's Lights,* At the Galleries, review of Chairs in Space at Braunstein/Quay Gallery, San Francisco Chronicle, June 14.
BAKER, Kenneth. *A Modest and Upbeat Show of Sculpture,* review of California Sculpture 1959-1980 at San Francisco Museum of Modern Art, San Francisco Chronicle, July 27, pp. 12, 13.
HURST, Tricia. *Larry Bell: The Grand Illusionist,* Taos Magazine, July, vol. III, No. 3.
SMITH-DEMI, Janeen. *Paint, Glass, or Water; Bell Works with them All,* review of After Gainsborough installation, Gazette Telegraph Leisuretime Magazine, August 2.
CURTIS, Cathy. *Rerun Steals the Show,* review of Artists/Works: A Gallery Group show at The Works Gallery, Los Angeles Times, August 10, Entertainment Section.
GOTTLIEB, Shirle. *Show Satisfies Varied Artistic Hunger Pangs,* Press-Telegram, Spotlight, August 10.
DELP, Laurel; HALM, Mary. *Chairman of the Board,* L.A. Style, August, vol. II, No. 3, pp. 31-32.
CHADWICK, Susan. *Houston Art Season Shaping Up With Notable Shows,* The Houston Post, September 21.
WEST, Carroll. *Glass: A Sculptural Medium,* International Sculpture , September/October, vol. 5, No. 5, p. 12.
PRICHETT, Jack. *Magic and Light: The New Art,* photographs by Lawrence Manning, Southwest Airlines Spirit, October, pp. 41-37, 74. Cover: *Chairs in Space* game.
New Mexico Selections '86, exhibition catalogue, Fogelson Library Center, College of Santa Fe, October 17–November 17.
HACKMAN, William. *Seven Artists in Search of a Place to Hang,* California, November, pp. 88-95, 108; photos.
COOKE, Regina. *Larry Bell's Work in Glass 'An Agent of Awareness,'* The Taos News, November 6, p. C-5.
BELL, David. *Eclectic Exhibit Entertains—Contemporary Art Traces New Mexico Trends:* critique of *Selections '86* at College of Santa Fe, Albuquerque Journal, November 8.
Art Center Opens Exhibits, Amarillo Sunday News-Globe, November 9, p. E-1.
KNIGHT, Christopher. *The L.A. Art Scene Comes of Age,* California Living, November 16, pp. 4, 5.
SINGERMAN, Howard, ed. *Individuals: A Selected History of Contemporary Art,* MOCA Abbeville, Cross River Press.
CHETHAM, Charles; GROSE, David F.; SIEVERS, Ann, eds., *A Guide to the Collections,* Smith College Museum of Art, Northhampton, Massachusetts, 1986, p. 200.

1987

ARIZONA ART MUSEUM, ARIZONA STATE UNIVERSITY, (Matthews Center), Tempe. *3+3x7: Sculpture in Glass and Works on Paper.* January 18–February 22. Catalogue.
GALERIE GILBERT BROWNSTONE et Cie*, Paris, France. *Larry Bell.* March 24–April 18.
BRAUNSTEIN/QUAY GALLERY, San Francisco, CA. *New Works by Larry Bell and Peter Voulkos.* April 1–May 2.
THE WORKS GALLERY, Long Beach, CA. *A View Through / Revisited. Five artists explore light on surface.* April 4–May 17.
DAVIS/McCLAIN GALLERY, Houston, TX. *American Sculpture: Investigations.* April 30–June 20.
FINE ARTS GALLERY, NEW MEXICO STATE FAIR, Albuquerque, NM. *A Perspective on Contemporary Art in New Mexico. Statements '87.* May 23–June 21.
STABLES ART CENTER, Taos Art Association, NM. *Artists of Taos.* June 22–July 19. Catalogue.
THE WORKS GALLERY, Long Beach, CA. *Artists/Works Two.* July 4–August 20.
UNIVERSITY of WYOMING ART MUSEUM, Fine Arts Building, Laramie. *Art and the West: Tradition and Innovation.* From the collection at the Colorado Springs Fine Art Center.
MARGO LEAVIN GALLERY, Los Angeles, CA. *Sculpture of the Sixties.* July–August.
PHOENIX ART MUSEUM, The Contemporary Forum. AZ. *1987 Phoenix Biennial.* August 22–October 4.
RHONA HOFFMAN GALLERY, Chicago, IL. *Primary Structures.* September 11–October 10.
FINE ARTS GALLERY, NEW MEXICO STATE FAIR, Albuquerque, NM. *Art and Science Exhibition 1987.* October 4–23.
LAGUNA ART MUSEUM, Junior Council, Laguna Beach, CA. Exhibition and Auction. October 24.
SOLOMON R. GUGGENHEIM MUSEUM, New York City. *Sculpture of the Modern Era.* November 13–March 13. Catalogue.
KIYO HIGASHI GALLERY*, Los Angeles, CA. *Larry Bell—Light and Space.* Gallery space designed by Larry Bell. Inaugural Exhibition. November 7.
CLEVELAND CENTER FOR CONTEMPORARY ART, OH. *Light-Space-Time.* Part of Case Western Reserve University Centennial Celebration. September 11–October 31.
CENTINEL BANK of TAOS*, NM. *Moving Ways.* December 4–January 15.

3+3x7 = Fine Art, Art-Talk, January, p. 28.
3+3x7, catalogue, University Art Museum, Matthew's Center, Arizona State University, January, pp. 27-31.
Eight Artists Equal Promising Formula for Glass Sculpture, State Press, Tempe, Arizona, January 21.
HALL, Albert. *Glass Art,* Southwest Art, February, pp. 48-49.
JALON, Allan. *Larry Bell's Undimmed Fascination with Light,* Los Angeles Times Calendar, February 7, p. 49.
KNIGHT, Christopher. *Sixties Sculpture Relieves Summer Doldrums,* review of Sculpture of the Sixties, Los Angeles Herald Examiner, July 17, Art Section, p. 33.
ZELANSKI, Paul and FISHER, Mary Pat. *Shaping Space: The Dynamics of Three-Dimensional Design,* CBS College Publishing, New York City, p. 150.
WHITE, Carrie. *Hang it Up,* Mesa Tribune, August 16, p. C-6.
Art Museum Celebrates Phoenix Biennial, The Mojave Daily Miner, Kingman, Arizona, August 19, p. 6.
YOUNG, Joseph. *Phoenix Biennial—the Art is Southwest, the Concepts New York,* Scottsdale Progress, August 28, Weekend p. 9.
KNIGHT, CHRISTOPHER. *Phoenix Creates an Oasis of Art,* Los Angeles Herald Examiner, August 30.
Larry Bell , City Magazine, Albuquerque, September.
A New Frame of Reference, Art & Leisure, The Arizona Republic, September 4, p. D-8.
CULLINAN, Helen. *Exhibitions to Honor Light Experiment (Fringe Patterns at Cleveland Center for Contemporary Art),* The Plain Dealer, September.
KURTZ, Bruce D. *1987 Phoenix Biennial* exhibition catalogue, Contemporary Art Forum of the Phoenix Art Museum, p. 6.
CAMPBELL, Suzan. *Glass and the New Mexico Artist,* slide lecture, St. John's College, Santa Fe, New Mexico, September 23.
CZOR, Doug. *Art and Science Exhibition 1987* exhibition catalogue October 4–23, Fine Arts Gallery, New Mexico State Fairgrounds, pp. 7-8.
CARD, Margaret. *Invitation Only,* Arizona Arts Visual, Phoenix Biennial, Phoenix Art Museum, p. 67.
CULLINAN, Helen. *Shadow Hangs Over Lighted Work,* The Plain Dealer, October 1.
CHARNAS, Suzy McKee. *Art on the Cutting Edge (Art and Science Exhibition, New Mexico State Fairgrounds),* New Mexico Magazine, October, p. 44, 46, 49.
D'AMBROSIO, Nancy. *US Arts,* Horizon—The Magazine of the Arts, October, p. 52. Photo: *Corner Lamp.*

154

JAMES CORCORAN GALLERY, Santa Monica, CA. *The Early Show: California Art from the Sixties & Seventies.* December 10–January 5.
ART L/A/8/7, Los Angeles Convention Center, CA. Davis/McClain Gallery, Booth 232. December 10–14.

CLARK, William. *Art, Science Inseparable for Modern Day 'da Vincis,'* Albuquerque Journal , October 18, pp. G-1, G-3.
Fringe Patterns, exhibition catalogue, Cleveland Center for Contemporary Art, Cleveland, Ohio.
WEBB, Lynzee. *Bell's Moving Ways' Plays in Taos—Finally,* The Taos News, p. B-4.
MUCHNIC, Suzanne. *La Cienega Area,* The Galleries, Los Angeles Times, December 11, part VI, p. 17.
LOCKE, Donald. *The 1987 Phoenix Biennial,* Artspace, Winter 1978-88, pp. 30-31.

1988

LAGUNA ART MUSEUM*, Laguna Beach, CA. *Light on Surface.* January 14–February 28.
GILBERT BROWNSTONE & CIE, Paris, France. *Primary Structures.* January 30.
KIYO HIGASHI GALLERY and GEMINI G.E.L.*, Los Angeles, CA. *Larry Bell at Gemini.* February 5.
NEW DIRECTIONS GALLERY, Taos, NM. *Inaugural Group Show.* February 14–March 15.
NEW GALLERY*, Houston, TX. *Larry Bell, Major Glass Sculpture and Related Maquettes.* April 7–May 21.
FOGG ART MUSEUM, HARVARD UNIVERSITY, Cambridge, MA. *Modern Art from the Pulitzer Collection—50 Years of Connoisseurship.* April 16.
ANNEMARIE VERNA GALLERY, Zurich, Switzerland. April.
PALM SPRINGS DESERT MUSEUM, CA. *Collection of Frederick R. Weisman.* May–June.
SENA GALLERIES WEST*, Santa Fe, NM. *Larry Bell, New Work.* June 3–30.
TRUMP'S RESTAURANT*, Los Angeles, CA. June–December.
STABLES ART CENTER, Taos Art Association, NM. *Spring Arts Celebration.* June 18–July 31.
SPASO HOUSE, US Embassy Residence, USSR. *Twentieth Century American Art.* July 1.
TEACHING GALLERY, UNIVERSITY of NEW MEXICO, Albuquerque. *Views of Reality.* August 12–31.
KIYO HIGASHI GALLERY*, Los Angeles, CA. *Mirage Paintings.* September 8.
GEMINI EDITIONS LIMITED*, Los Angeles, CA. *Larry Bell at Gemini.* September–October.
SOLOMON R. GUGGENHEIM MUSEUM, New York City. *Return to the Object: American and European Art from the 1950's and 1960's in the Guggenheim Museum Collection.* September 23–November 27.
STABLES ART CENTER, Taos Art Association, NM. *In conjunction with the National Theater for the Deaf.* October 6–7.
THE ART STORE GALLERY, Los Angeles, CA. *Vessels (In collaboration with Victoria Shields).* November 3–December 11.
HIGH MUSEUM of ART*, Atlanta, GA. *Spectacles, Leaning Room.* November 11, 1988–May 31, 1994.
COLOGNE ART FAIR, Köln, Germany. November.
FORUM RESOURCES LIMITED, Minneapolis, MN. December 3–January 7.
LOS ANGELES MUNICIPAL ART GALLERY, CA. *One of a Kind.* December 8–January 15.
CALIFORNIA ARTS COUNCIL, *Art in Public Buildings Program.* December 11–January 29.
SOLOMON R. GUGGENHEIM MUSEUM, New York City. *Viewpoints: Postwar Painting and Sculpture from the Guggenheim Museum Collection and Major Loans.* December–January 22.

MEDINA, Danny. *Los Angeles' Gala Night of Art,* Art-Talk, January, vol. VII, No. 4, p. 35. Photo: *Larry Bell with Art Maven Marcia Weisman.*
TUCHMAN, Laura. *Reflective Artist is Exhibiting Work with a Light Touch,* Orange County (California) Register, January 20.
METZLER, Douglas. *Images of Artists by Artists.*
CURTIS, Cathy. *Larry Bell's Light Images: Through a Filter Darkly,* Los Angeles Times, Orange County Edition, February 4, p. 10. Photo: Rod Boren of *Moving Ways* and *ELIN 59.*
ISAACSON, Gene. *Larry Bell—Sculptor...May 2, 1988,* Contemporary Art Issues, Art Forum Newsletter, Rancho Santiago College Art Department, Santa Ana, California , April–May, vol. 7, No. 4. Excerpts by: Melinda Wortz, Hudson River Museum catalogue 11/80; Allan Jalon, Los Angeles Times, February 7, 1988; Dinah McClintock, Laguna Art Museum catalogue. Photos: *The Iceberg and Its Shadow* and *Larry Bell in Taos Studio.*
McCREADY, Eric S. *The Huntington at 25, Selected Acquisitions 1982-1987,* exhibition catalogue, p. 41.
SNYDER, Virginia. *Art Tours—Are They Worth It?,* Orange County Home and Garden Magazine, April, pp. 54-56. Photo: *DCF 37.*
PHILLIPS, Aileen Paul. *Quality is Critical—The Santa Fe Institute Used the Best to Teach the Best,* Santa Fe Lifestyle, Spring 1988, p. 30. Cover Photo: Robert Muller, Edward T. Hall sitting on *Chair de Lux; Vapor Drawing* in background.
CHADWICK, Susan. *Through a Glass Brightly: Meet a High-Tech Romantic,* The Houston Post, April 17, p. 4-F.
RUDENSTINE, Angelica Zander, with contributions by Emily & Joseph Pulitzer Jr., *'Larry Bell' #242,* Modern Painting, Drawing & Sculpture collected by Emily & Joseph Pulitzer Jr., vol. IV, Cambridge: Harvard University Museums, 1988, pp. 573-6. Photos: *Artists of Taos, 1988* brochure, p. 3, Art & Antiques, May 1988. 2 color views of *Leaning Room,* Artist's Statement.
ISAACSON, Gene. *Larry Bell, Sculptor,* Artists of Art Forum, Rancho Santiago College, Santa Ana, California, Fall 87/Spring 88. Photo: *The Iceberg and Its Shadow.*
VOGELBANG, Jerilyn. *Weisman Collection a Treat for Art Lovers,* Desert Community Newspapers, week of May 4, p. 3.
Artists Selected for Art-in-Arch, 4 Downtown News/Home Edition, Los Angeles, August 1.
Artist Larry Bell Chosen for L.A. Project, The Taos News, August 4, Arts Section, p. 34.
ESCOBAR, Patrick. *Trio of Artists Selected to Help With Convention Center Design,* California Jewish Press, Vol. 43, No. 44, August 5, 6, 7, People Today Section, p. 20.
FORMAN, Joanne. *What did You Do on Your Summer Vacation?,* The Taos News, September 15, Tempo Section, p. B-4.
DONOHUE, Marlena. Review, Los Angeles Times, September 23, Part IV, P. 21.
WEBB, Lynzee. *What Makes Good Art?,* The Taos News, Fall Arts Guide 1988, p. 9.
WILSON, William. *The Galleries, Santa Monica,* Los Angeles Times, October 28, Part IV.
Art Against AIDS Kicks Off Campaign, Art-Talk, December, p. 14.
POLITI, Giancarlo. *'Art Against AIDS Campaign Starts in L.A.,* Flash ARTnews, Milan, Italy. Flash Art Supplement, No. 143, November/December, p. 1.
Panza Collection, p. 10.
PREBLE, Duane and Sarah. *The Modern World,* chapter in ARTFORMS, An Introduction to the Visual Arts, Harper & Row, 1989, Fourth Edition, p. 442. Photo: *#586, The Iceberg and Its Shadow.*
CURTIS, Cathy. *Assessing the Current Vitality of Repetition,* Los Angeles Times, December 30, Art Review Section, Part VI, p. 22.

1989

MUSEUM of FINE ARTS, Santa Fe, NM. *Modern Masterworks from the Permanent Collection.* January 21–June 18.
BROSCHOFSKY GALLERY, Ketchum, ID. *Rendezvous.* March 3–April 8.
STABLES ART CENTER*, Taos Art Association, NM. *Larry Bell Studio Investigations.* April 7–23.
LOS ANGELES VALLEY COLLEGE, Van Nuys, CA. *Exhibition in Memory of Fidel Danielli.* April 17–May 10.
MANNY SILVERMAN GALLERY, Los Angeles, CA. *Recent Acquisitions.* April 8.
TONY SHAFRAZI GALLERY, New York City. May 3–27.
SANTA FE FESTIVAL of THE ARTS, Santa Fe, NM. *Black & White.* May 18–29.
THE WORKS GALLERY, Long Beach, CA. June 1–9.
COLORADO SPRINGS FINE ARTS CENTER, CO. *The Taos Art Colony, from the Mel Weimer Family Collection.* June 10–September 24.
BASEL ART FAIR, Switzerland. Nicolina Pon Fine Art. June 13–21.
STABLES ART CENTER, Taos Art Association, NM. *Artists of Taos Group Exhibition.* June 24–July 23.
KIYO HIGASHI GALLERY*, Los Angeles, CA. *Larry Bell—New Work.* August 12–September 23.

SCHERCH, Meg. *Larry Bell Mirage Works,* Artspace: Southwestern Contemporary Arts Quarterly, Albuquerque, New Mexico, Winter 88/89, pp. 18-19.
Photos: *Woman with Guitar* and *Mirage Construction #5.*
MAGEE, Nancy. *Taos Institute of Arts Plans Summer Session,* The Taos News, March 2, Tempo Section, p. B-5.
PARKS, Stephen. *Southwest Profile,* Whitney Publishing Co., Taos, New Mexico, March, p. 13.
COLLMER, Kathryn. *Trickster of Light,* Southwest Art (Museum Notes), Houston, April.
ELWELL, Melody. *Master Illusionist, Larry Bell's Mirage Works; Scraps of an Illusory Space,* The Taos News, Tempo Section, March 30, cover, pp. B-2, B-6, B-12.
New Acquisitions, Calendar of Events, Spring and Summer 1989, Museum of Fine Arts, Museum of New Mexico.
BALLATORE, Sandy. *Artist Larry Bell Proves Making Magic is Still Viable,* Albuquerque Journal, April 30, p. G-7.
BALLATORE, Sandy. *Two Spaces, One World,* Artspace Magazine, May/June, pp. 70-74.
CHAPMAN, Don. *A Star is Born,* Daily Breeze, April 176, Travel, p. E-1.

NEW DIRECTIONS GALLERY*, Taos, NM. *Larry Bell—New Work.* August 1–September 14.

DARTMOUTH STREET GALLERY, Albuquerque, NM. *7th year Anniversary Show.* August 25–September 9.

CONTEMPORARY ART CENTER*, Kansas City, MO. October 20–November 25.

LEEDY-VOULKOS GALLERY*, The Art Center, Kansas City, MO. *Larry Bell Mirage Paintings.* October 27–December 9.

SENA GALLERIES WEST*, Santa Fe, NM. September 7–30.

TAOS ARTS FESTIVAL, NM. *Taos Invites Taos.* September 23–October 8.

PACIFIC ENTERPRISES, Corporate Collection, Los Angeles, CA. *Contemporary American Artists & Sculptors.* September 19.

GALERIE JOAN PRATS, Barcelona, Spain. *Daylight Savings.* September 28–October 25.

ARTGRAFIC - GALERIA D'ART, Barcelona, Spain. *Billy Al Bengston, Peter Alexander, Larry Bell, Laddie John Dill, Craig Kauffman, Ed Moses, Eric Orr, Ed Ruscha in Barcelona.* September 28–October 25.

SENA GALLERIES WEST, Santa Fe, NM. October 11–November 15.

MUSÉE D'ART CONTEMPORAIN*, Lyon, France. *Larry Bell, Work from New Mexico,* October 11–November 19.

EARL McGRATH GALLERY, Los Angeles, CA. *Contributor to Blinds & Shutters by Michael Cooper.* October 16–November 7.

THE WORKS GALLERY, Los Angeles, CA. *Art L.A. '89.* December 4–10.

SENA GALLERIES WEST, Los Angeles, CA. *Art L.A. '89.* December 4–10.

THE HARCUS GALLERY, Boston, MA. In association with the Museum of Fine Arts. *Artists' Furniture.* December 9–January 20. Catalogue.

SOLOMON R. GUGGENHEIM MUSEUM, New York City. *Geometric Abstraction and Minimalism in America.* December 15–February 11.

VEDOE, Harry. *Taos 3010* (cartoon), The Taos News, June 22, p. A-4. *Innovatique,* Innovatique SA, Societe de Recherche et de Development du GROUPE HIT, brochure, Neuilly-en-Thelle, France. Cover: *Vapor Drawing 'MELINBK.'*

Larry Bell Art-Talk, August/September, p. 58.

Summertime Fun, Taos Magazine, The Arts, August, pp. 23-24. Photos: *Wrinkle Space,* (mirage painting, 1989), *Larry Bell* (in studio).

FENTER, Therese. *Taos Squeezed Creative Juices of Artists, Writers,* Times Record News, Las Vegas, Nevada, p. 3F.

PAINE, Kay Mohr. *Those That Do, Teach,* Daily News, Amarillo, Texas, August 10, Intermission Section, p. 1B.

SOTHEBY'S: ISC International Sculpture Center Benefit Auction of Contemporary Sculpture, September 19. *Improvisational Maquette 1987,* p. 12, item 5.

Daylight Savings, Galerie Joan Prats, Barcelona, La Poligrapha SA, Barcelona, September–October 1989.

Eight West Coast Artists, Galerie Joan Prats.

Very Special Arts New Mexico, exhibition catalogue, Roswell Museum, New Mexico, October 1–29. Photo: *Woman in Metamorphosis.*

Larry Bell, Works from New Mexico, exhibition catalogue, Musée d'Art Contemporain, Lyon, France, October 11–November 19. Color Photos: *The Cat* (1983 sculpture); *Oriental Garden* (1989 mirage painting).

MEDINA, Danny. *Larry Bell ...a Fiercely Independent Artist,* Art-Talk, November. B&W photos: *Big Number One* (1989 mirage painting); Larry working with material, furniture; *The Cat, Part IV* (1982 glass sculpture); 20x20x20 glass cube (1985).

WEBB, Lynzee. *Investigations with Larry Bell:,* interview, *You don't really know what it is until you've been through the adventure,* Taos Magazine, New Mexico. B&W photos: *The Dream* (1989 mirage painting); *The Iceberg and Its Shadow* (1974 glass sculpture).

PRABHU, Vas. *Together at MOCA: A Guide for Families,* Museum of Contemporary Art, Los Angeles. Color Photo: *36" glass cube.*

Tucson Museum of Art, 1989-1990 Season, Tucson, Arizona. Photo: *The Old Dirt Road* (1989 mirage painting).

1990

OLD CITY HALL, Redding, CA. *Art in Public Buildings, 1978-1989.* January 3–March 3. Sponsored by the State of California.

NEW GALLERY*, Houston, TX. January 6–February 6.

SAN ANTONIO ART INSTITUTE*, TX. January 12–February 23.

DARTMOUTH STREET GALLERY, Albuquerque, NM. January 15–February 23.

COLORADO SPRINGS GALLERY of CONTEMPORARY ART, CO. *On the Edge: Artworks of New Mexico and Wyoming.* January 15–February 23.

DEAF ARTISTS of AMERICA, Rochester, NY. February 16–March 23.

OLGA DOLLAR GALLERY, San Francisco, CA. In association with SENA GALLERIES WEST. February 20–April 14.

CENTER FOR THE ARTS of THE SOUTHWEST, Santa Fe, NM. *Taos Art: A New Decade.* March 3–May 31.

CARL'S FRENCH QUARTER*, Taos, NM. In association with NEW DIRECTIONS GALLERY. March 9.

BRAUNSTEIN/QUAY GALLERY*, San Francisco, CA. March 14–April 17.

EARL McGRATH GALLERY, Los Angeles, CA. *Barcelona 8.* April 12–May 5.

GALERIE ROLF RICKE*, Köln, Germany. April 27.

MILAGRO GALLERY, Taos, NM. *Taos Artists Against Apartheid.* May 1–31.

FRED HOFFMAN GALLERY, Santa Monica, CA. *Artists Unite for Big Green.* May 29–June 9. Also shown at: WEST BEACH CAFE, Venice, CA. June 11–22.

NEW GALLERY*, Houston, TX. *The Houston/Taos Art Summit.* July 7.

TAOS ARTS CELEBRATION, Taos Civic Plaza, NM. July 14.

BRAUNSTEIN/QUAY GALLERY, San Francisco, CA. *Artists' Kids Art.* August 7–25.

MUSEUM of CONTEMPORARY ART, Temporary Contemporary, Los Angeles, CA. *Perceptual Investigations: Light and Space Works in the Permanent Collection.* August 1990-1991.

GALERIE MONTENAY*, Paris, France. September 6–29.

CORCORAN GALLERY, Santa Monica, CA. *Heal the Bay's Surfboard Invitational.* September 10–18.

MUSÉE D'ART CONTEMPORAIN, Lyon, France. *Collections: U.S. Art.* September 15–October 29.

SENA GALLERIES WEST*, Santa Fe, NM. September 21.

TAOS ARTS FESTIVAL, Taos Civic Plaza, NM. *Taos Invites Taos.* September 22–October 7.

MISSION GALLERY, Taos, NM. *Taos Up Close.* September 22–October 6.

MUSÉE DE GRENOBLE, Centre d'Art Concret de Mouans-Sartoux, France. *From the Permanent Collection.* September 29.

PACIFIC ENTERPRISES, Corporate Collection, First Interstate World Center, Los Angeles, CA October 4.

GOVERNOR'S AWARD FOR EXCELLENCE AND ACHIEVEMENT IN THE ARTS, Visual Arts. Office of Cultural Affairs, New Mexico Arts Division. Ceremony and exhibition, El Dorado Hotel, Santa Fe, NM. October 17.

GALERIE KAMMER*, Hamburg, Germany. October 18–November 24.

KIYO HIGASHI GALLERY*, Los Angeles, CA. October 27–December 23.

CENTINEL BANK of TAOS, NM. *Consider the Child.* Benefit for Trudy's Discovery House. October 29–December 7.

THE WORKS GALLERY, Long Beach, CA. November 1–December 30.

THE WORKS GALLERY, Long Beach, CA. *Heal the Bay. Surfboard Exhibit.* November 12.

NEWSLETTER, Special Issue, Spring 1989. The Gallery, p. 6. February 16–March 23, 1990.

HINES, Alan. *Sky Light Conversations,* Vista USA Magazine, Exxon Travel Club, spring. Color photos: *Oriental Garden* (1989 big mirage painting #7); Larry working in laminating room.

CHADWICK, Susan. *Deep in the Art of Texas,* The Houston Post, January 7, p. H-12.

Mizue Magazine, Summer, New Gallery, Houston, Texas. B&W photo: *Two Pairs With Every Suit,* (1989 mirage painting), p. 127.

KNIGHT, Christopher. *MOCA Light is Just Half a Show,* Los Angeles Times, August 24.

EPSTEIN, Pancho. *Exploring Larry Bell's Intuitive Decisions,* Pasatiempo, Santa Fe, September 21, pp. 18-19. Photos: *MVD #208, MVD #165* (mirage vapor drawings), Larry working in studio.

CHAATFIELD-TAYLOR, Joan. *Contemporary Eclat: A Collector's San Francisco Residence,* Architectural Digest, September, pp. 142-143, 148.

Local Artist Wins Governor's Award, The Taos News, October 11, Tempo Section. B&W photo of Larry.

The Shape of Art!, the Works Gallery Report, October. B&W photo: *The Emerald* (1990 mirage painting).

Sotheby's Contemporary Art, New York , October 4. Color photo: *#169 cube.*

CHADWICK, Susan. *Marfa Delights Shine in Desert,* Houston Pot, October 11, Style Section.

MOORE, Ann. KGGM–TV 10:00 news, interview in Taos studio, re: Governor's Award for Excellence and Achievement in Visual Arts, October 17. Video tape available.

1990 Governor's Awards for Excellence and Achievement in the Arts Announced, Badlands Banner, October 17–30.

TERHUNE, Linda. *New Breed of Artists makes Santa Fe, Taos Centers for Contemporary Works,* Gazette Telegraph, Colorado Springs, Colorado, October 21, Lifestyle Section. B&W photo: Larry with *Cyclone* (1990 mirage painting).

CLARK, William. *What's New? Familiar Names Promote Lesser-known Artists,* Albuquerque Journal, November 2.

TURNER, David; McCARTHY, Tom. *A Spirited Place: The Arts in New Mexico* (video tape), Museum of Fine Arts, Santa Fe, New Mexico, 1990.

Industrial Light, Los Angeles Times, November 9, Friday Section, p. F-17.

DONNELY, Cheryl. *Finely Chiseled Furniture,* Vogue Decoration International, Ed. No. 28, pp. 104-109.

Governor's Arts Awards Recognize Special Efforts, Albuquerque Journal, October 14.

Mirage Works opens at Institute Featuring Works by Larry Bell, North San Antonio Times, January 11, p. 6.

GODDARD, Dan R. *Texas Dialogues Heads List of Exhibit Openings,* Express News, San Antonio, Texas.

WESER, Marci Goren. *Mirage Works with Great Vision,* San Antonio Light, February 1, pp. H-1, H-6.

GODDARD, Dan R. *Sculptor Colors the Light Fantastic,* Express News, San Antonio, Texas, February 1.

What Is Art For, Art-Talk Magazine, February, p. 38.

NETSKY, Ron. *Three Dimensions into Two, a New Mexico Artist Creates Paper Illusion,* Rochester Democrat and Chronicle, March 4. B&W photos: *SMVD #67* and *SMVD #91.*

156

BROSCHOFSKY GALLERIES, Ketchum, ID. *Taos Up Close.* November 23–
December 20.
RUTH BACHOFNER GALLERY, Santa Monica, CA. *Enigmatic Light.* November
29–January 5.
BAKERSFIELD ART FOUNDATION, CUNNINGHAM MEMORIAL ART GALLERY,
CA. December 6–January 28.
CIRRUS, Los Angeles, CA. *Minimal 1960-1990*, Los Angeles. December 8–
February 2.

ALBERTAZZI, Liliana. Contemporanea International Art Magazine, March, vol. III,
pp. 38-39. B&W photo: *First and Last* (1989 glass sculpture).
PARKS, Steve. *Pictures of Memories*, Southwest Profile Magazine, March, pp. 24-25.
B&W photos: *The Old Dirt Road* (1989 mirage painting); Larry working in studio.
SISSON, Deborah. *A Place of Illusion and Iridescence*, The Taos News, Tempo
Section. B&W photo: *Mirage Study #46* (1990).
A New School of Thought in Design, Art and Architecture has Arrived, Santa
Monica College of Design, Art and Architecture, 1990 Brochure/Poster.
ANDERSON, Phil. *The Friedman Legacy*, City Pages, Minneapolis, Minnesota,
March 7. B&W photo: Larry with Martin Friedman.
Abstract and Non-objective, Artists of Taos, New Mexico, Spring. B&W photo:
Spider Webb (1989 mirage painting).
BAKER, Kenneth. *Larry Bell's Latest at Braunstein/Quay*, San Francisco Chronicle,
April 5.
Larry Bell bei Ricke, Kolner, Stadt-Anzeiger, Köln, Germany, April 27.
BARILOTTI, Steve. *Art Under Glass*, Surfer, vol. 32, No. 2, pp. 58-61.
McKENNA, Kristine. *Cirrus Offers Minimalism with a West Coast Slant*,
Los Angeles Times, December 12, p. F-8.
FOSS, Phil. Tyuonyi, ed. No. 8, 1990. Cover photo: *Linoleum* (1990 mirage painting).
GORDON, Judith R. A Diagnostic Approach to Organizational Behavior,
ed. No. 3, 1991, Allyn & Bacon, Needham Heights, Massachusetts. Cover photo:
Corner Lamp (1987).

1991

JAMES CORCORAN GALLERY, Santa Monica, CA. *L.A. When It Began.*
January 12–February 9.
ARCO/91/MADRID, Spain. Tony Shafrazi Gallery, Booth. February 7–12.
COLLINS-PETTIT GALLERY, Taos, NM. *Artists Against the Expanded Airport.*
Benefit exhibition and raffle. February 14–April 6.
TONY SHAFRAZI GALLERY*, New York City. February 16–March 23.
LOS ANGELES COUNTY MUSEUM of ART, CA. *Retrospective and Prospective:
The Art Rental & Sales Gallery Salutes the 25th Anniversary of the Los Angeles
County Museum of Art.* February 22–March 28.
NATIONAL HONOR SOCIETY CONFERENCE, Taos High School, NM.
Speaker. March 8.
ETHERTON/STERN GALLERY, Tucson, AZ. March.
VISION GALLERY, San Francisco, CA. *National Institute of Art and Disabilities*
exhibit for benefit auction. March 11–16.
UNIVERSITY of SOUTHERN CALIFORNIA, LOS ANGELES (USCLA),
Fisher Gallery, CA. *Finish Fetish, LA's Cool School.* Exhibition and panel.
March 12–April 20.
TUCSON MUSEUM of ART*, AZ. *Larry Bell Mirage Works.* Docent Council
Lecture. March 28–June 9. Catalogue.
TOKYO ART EXPO, Japan. Sena Galleries West, Booth. March 29–April 3.
ESPACE LYONNAIS D'ART CONTEMPORAIN (E.L.A.C.). Organized by
Musée d'Art Contemporain, Lyon, France. *Histories d'Oeil.* April 18–June 2.
TREEBEARDS, Houston, TX. *Daydreams from Taos.* April 27–May 5.
NEW GALLERY*, Houston, TX. May 1–July 1.
INTERNATIONAL SCULPTURE AT TAOS (IS...AT), NM. Collaborative on-site
sculpture project. May.
DYANSEN GALLERY, New York City. Masks. *Benefit auction for Victim Services,*
NYC. Silent auction, May 22. Exhibition May 8–19.
DARTMOUTH STREET GALLERY*, Albuquerque, NM. *Larry Bell New Work.*
May 10–June 22.
GALERIE MONTENAY, Paris, France. June 6–22.
TAOS INSTITUTE of ARTS, NM. Instructor. *Improvisational Surface Treatment.*
June 24–27.
PHILLIP BAREISS CONTEMPORARY EXHIBITIONS, Taos, NM. *International
Sculpture At Taos (IS...AT).* June 22–July 7.
MUSEUM of NEW MEXICO FOUNDATION, Laboratory of Anthropology,
Santa Fe, NM. *Third Annual Auction to Benefit the Museum of Indian Arts
and Culture.* July 20.
SENA GALLERIES WEST*, Santa Fe, NM. July 31–August 25.
GALERIE ROLF RICKE, Köln, Germany. *Works on Paper.* Two-person show with
Donald Judd. July–August.
KIYO HIGASHI GALLERY, Los Angeles, CA. August 3.
BRAUNSTEIN/QUAY GALLERY, San Francisco, CA. *Gallery Group Show.*
August 6–24.
TAOS CIVIC CENTER, NM. *Child-Rite Art Auction.* Preview, August 17.
SANGRE DE CRISTO ARTS & CONFERENCE CENTER, Pueblo, CO.
Under Southwestern Skies: 1991 Biennial of Contemporary Art. Juror.
August 31.
PAT HEARN GALLERY, New York City. September 7.
NEW DIRECTIONS GALLERY*, Taos, NM. *Larry Bell: Recent Work.*
September 16–October 14.
WHITNEY MUSEUM of AMERICAN ART AT EQUITABLE CENTER,
New York City. *Immaterial Objects.* September 14–December 28.
TAOS ARTS FESTIVAL, Taos Civic Plaza, NM. *Taos Invites Taos.*
September 21–October 6.
FIAC 1991, Paris, France. Tony Shafrazi Gallery, Booth. October 2–15.
TAOS ART ASSOCIATION, Stables Art Gallery, NM. *Contemporary Work
in Taos.* October 5–November.
BRAUNSTEIN/QUAY GALLERY*, San Francisco, CA. November 7.

HORN, Rebecca; GRAY, Maurice; SHAW, Jim; WILLIAMS, Robert. *Art Picks of the
Week*, L.A. Weekly, No. 97, January 10, p. 97.
BENNETT, Kate. *Live Long and Make Art*, Albuquerque Voice, November 7.
Contemporary Art Society of New Mexico, Albuquerque Metro Artscrawl,
November 16, p. 1.
CLARK, William. *Familiar Names Promote Lesser-Known Artists*, Albuquerque
Journal, November 2, pp. C-1, C-8.
ROMANCITO, Rick. *From Artist to Customer to Uncle Sam*, The Taos News,
February 7, p. C-3.
CLARK, William. *Taos Artists Take Stand Against Airport Addition*, Albuquerque
Journal, March 1, p. C-8.
Art Today, Arts Video News Service, Inc., New York City, February, vol. III, No. 1.
CERUTTI, Stephen. *But is it Art?*, SCH&G, Los Angeles, February.
NILSON, Lisbet. *Art Galleries of Every Description Add Another Splash of Color to
Melrose*, Los Angeles Times, March 10, Art Notebook.
Finish Fetish, exhibition catalogue, *Larry Bell*, The Fisher Gallery, University of
Southern California, April 13–20.
Larry Bell Mirage Works, Contemporary Southwest Images V, Stonewall
Foundation Series, Tucson Museum of Art.
Collection 1989, *Larry Bell*, pp. 40-43; Dons 1989, pp. 94-95; 2.
Uberzeugungen, p. 133, Musée d'Art Contemporain, Lyon, France.
Perceptual Investigations, exhibition catalogue, *Light and Space Works in the
Permanent Collection*, August 1990 – August 1991, Museum of Contemporary
Art, Los Angeles.
SCHNEIDER, Greg. *Only Skin Deep: Finish Fetish: L.A.'s Cool School at USC
Fisher Gallery*, Artweek, Los Angeles, April 4, vol. 22, No. 13, pp. 1, 22.
PLESSNER, Joan. *Willie Elliot—Junk Art...or New Wave Action Art?*, Inland Empire
Magazine, January, p. 38.
SALTZSTEIN, Katherine. *Gallery Features pair of Complex Artists*, Albuquerque
Journal, May 19, p. E-2. Photo.
SULLIVAN, Meg. *60's Movement Secure in Return*, Daily News, Art and News
Notes, March 8.
Transcript, University of Southern California, March 11. Photo: etched glass box.
SALDITO, Christy. *L.A. Art Moves to Fisher Gallery...Finish Fetish Movement
Re-Evaluated by USC*, Daily Trojan, University of Southern California, March 19,
vol. CXIV, No. 46, p. 1.
WILSON, William. *A Study in Plastic in Finish Fetish*, Los Angeles Times,
March 22, pp. 1-2.
American Abstraction at the Addison, April 18–July 31, Color photo: *Leadbelly's
Dance*, (1960/61 construction).
KNIGHT, Christopher. *From Out West and the 'Cool School,' It's Abstract Pop*,
Los Angeles Times, April 14.
OSTRO, Saul. *Larry Bell*, Arts Magazine, Summer, p. 68.
Angeles, *City Snaps*, Los Angeles, June, No. 6, p. 126.
ENSOR, Deborah. *Artists Tell a Story of Triangular Importance*, The Taos News,
June 20, p. C-6.
STEINBERG, David. *City Lacks Art Havens' Reputation*, Albuquerque Journal,
pp. G-1-2.
HEARTNEY, Eleanor. *Larry Bell at Shafrazi*, Art in America, July, pp. 124-125.
Inside Art/NMRA, *Bell Presents*, New Mexico, Shorts, p. 9.
PARKS, Stephen. *Bell, Larry*, New Mexico Registry of the Arts, Embudo, New
Mexico. Photo: *Mirage Painting #294*, p. 20.
Wingspread Collector's Guide, New Directions Gallery, Taos, New Mexico,
vol. 5, No. 1, p. 186. Color photo: *MVD #223*.
CHADWICK, Susan. *Artist Abandons 1960's Ideas With Light-Filled Works*,
The Houston Post, May 13. Color photo: *Catalon* (1991 mirage painting).
Immaterial Objects; excerpts from Larry Bell's First Person Singular, Whitney
Museum of American Art, pp. 24-25. Color photo: *Untitled Cube* (1967).
SHIZUYO. *News from Abroad*, Japanese Arts Magazine, Kyoto Seika University.

DESIGN CENTER GALLERY, Taos, NM. *Live from Taos.* November 8-22.
FENIX GALLERY, Taos, NM. *Benefit auction for Taos Land Trust.* December 8.
RUSSELL SENATE OFFICE BUILDING, Rotunda, Washington DC. *Live From Taos.* December 9-13.
SENA GALLERIES WEST, Santa Fe, NM. *Amnesty International Artists Invitational Benefit.* December 13-January 17.
BUFFALO GALLERY, Alexandria, VA. *Live From Taos.* December-January.

RAPKO, John. *Larry Bell,* Artweek, November 28. B&W photo: *Calderon* (1991 mirage painting).
Collection 9, Musée d'Art Contemporain, Lyon, France, p. 70. Color photo: *La Fayette* (1990 mirage painting).
Visions Art Quarterly, Kiyo Higashi Gallery, Los Angeles, Winter, p. 23. Color photo: *MVD #176* (1990 mirage painting).

1992

THE WORKS GALLERY/COSTA MESA, CA. *The Presence of Absence: Minimal, Conceptual and Contemplative.* January 17-February 16.
KIYO HIGASHI GALLERY*, Los Angeles, CA. February 15-March 28.
NEW DIRECTIONS GALLERY, Taos, NM. *Donation: Taos Institute of Arts Winter Fund Raising Raffle.* Drawing. March 13.
DARTMOUTH STREET GALLERY*, Albuquerque, NM. May 2.
JANUS GALLERY*, Santa Fe, NM. Private showing May 6. Exhibition May 7-16.
CIAE 1992, Chicago International Art Expo, Navy Pier, IL. The Works Gallery, Booth. May 13-17.
MADE FOR AROLSEN — SKULPTUREN UND PROJEKTIONEN, Arolsen, Germany. May 22-September 20.
SOMA CONTEMPORARY GALLERY, San Diego, CA. May 23.
GALERIE ROLF RICKE, Köln, Germany. *New Work & the Return of the Cube.* June 13.
THE WORKS GALLERY / LONG BEACH, Long Beach, CA. *The Spirit of Matter: A Survey of Process Art.* June 19-July 12.
TAOS INSTITUTE of ARTS, NM. Instructor (with Douglas Kent Hall). *I've Been To The Desert And Taken The Course With No Name.* June 22-26.
NEWPORT HARBOR ART MUSEUM, Newport Beach, CA. *Selections from the Permanent Collection of Max Ernst.* July 10-September 6.
KIYO HIGASHI GALLERY*, Los Angeles, CA. September 2-October 10.
NEW GALLERY*, Houston, TX. September 12-October 16.
TAOS ARTS FESTIVAL, Taos Civic Plaza, NM. *Taos Invites Taos.* September 19-October 4.
TAMPA MUSEUM of ART*, FL. *Mixing Media and Metaphor: LB's Abstract Painting.* October 25-January 10.
ROSALIE AND HUBERT DOUGLASS GALLERY, MIAMI UNIVERSITY ART MUSEUM, Oxford, OH. *Drawing on Experience.* November 24-April 4.

SIME, Tom. *Living Artists Society,* Jesuit Dallas Museum, Dallas Observer, Artsweek Section, January 28.
BARON, Todd. *Larry Bell,* ArtScene, vol. 11, no 7. Photo: *Mirage Painting #272.*
San Diego Arts Monthly, SOMA Gallery, May, vol. 6, no 5. Color photo: *Child's Play* (1990 mirage painting).
Arte Americana 1930-1970, pp. 283, 337. Photos: *Untitled* (1970 glass sculpture); Larry Bell.
Von STAHL, Enno. *Hochdruck auf der Leinwand,* Kolner Stadt Anzeige, Galerie Rolf Ricke, Koln, Germany, July 7.
Wingspread Collector's Guide, New Directions Gallery, vol. 6, No. 1. Color photo: *Barcelona* (1991 mirage painting).
Made for Arolsen, Arolsen, Germany, 1992. Color photo: *Untitled 1992,* pp. 30-31; Larry Bell, p. 16.
DEATS, Suzanne. *Santa Fe versus Taos; The Overstuffed Art Scene,* Art-Talk, June/July. Photo: *The Big V* (1990 mirage painting).
BALSMO, Dean. *Larry Bell's New Work is Rich With Color,* The New Mexican, Santa Fe, May 15, Pasatiempo Section, p. 14. B&W photo: *Madrid* (1991 mirage painting).
Take Five Magazine, KNME-TV, Dartmouth Street Gallery, November, vol. 14, No. 11. Cover photo: *SMS #296* (detail).
MILANI, Joanne. *What You See May Be What You Don't Get,* Tampa Museum of Art, *Mirage Painting.* Tampa Tribune, December 4, p. 15. Color photo: *Ground Plane* (1989 mirage painting).
New L.A. Abstraction, 1992. Color photo: *Mirage Painting #276* (1991).

1993

GALLERY AT THE REP, NEW MEXICO REPERTORY THEATRE, Santa Fe. *Artists' Choice II.* February 12-March 9.
NEWPORT HARBOR ART MUSEUM, Newport Beach, CA. *American Art from the Addison Gallery.* February 22-May 2. Lecture: "Tuesday Talks at Noon." March 16. Panel Discussion: March 20.
GOLDEN WEST COLLEGE, Huntington Beach, CA. Lecture: "Art Week Celebration." March 17.
SANTA MONICA COLLEGE of DESIGN AND ARCHITECTURE, CA. Lecture: "Visiting Artist Series." March 18.
TAOS SPRING ARTS FESTIVAL, NM. May 15-31.
KIYO HIGASHI GALLERY*, Los Angeles, CA. *Glass Constructions.* May 22-July 3.
LEEDY/VOULKOS GALLERY, Kansas City, MO. *8th Annual Summer Invitational.* June 9-July 31.
TAOS INSTITUTE of ARTS, NM. Instructor: "Light on Surface." June 28-July 2.
BROSCHOFSKY GALLERY, Ketchum, ID. July 9-August 3.
CARLSBAD MUSEUM of ART, NM. July 16-August 31.
CONTEMPORARY ART SOCIETY of NEW MEXICO at CAFE, Albuquerque. *CAS Fifth Anniversary Exhibition at CAFE.* August 16-September 18.
TAVELLI GALLERY*, Aspen, CO. September 9-October 20.
NEW DIRECTIONS GALLERY*, Taos, NM. September 14-October 15.
TAOS FALL ARTS FESTIVAL, NM. *Taos Invites Taos.* September 18-October 4.
MUSÉE du PALAIS du LUXEMBOURG, Paris, France. *CIRVA—le Verre, Manieres de Faire.* September 20-November 20.
NATIVE PEOPLES DAY CELEBRATION, Taos, NM. *Taos: The Next Generation.* October 9-15.
NEW GALLERY*, Houston, TX. October 14-November 17.
WHITNEY MUSEUM of AMERICAN ART, New York City. *In a Classical Vein, Works from the Permanent Collection.* October 18-April 3.

MENTZINGER, Bob. The Taos News, Tempo Section, May 27, p. C-8.
WILSON, Malin. THE Magazine, July p. 45. Kiyo Higashi Gallery. Photo: *WBKD #1* (1993 glass & denim).
NELSON, Mary Carrol. *Taos Institute Nurtures Creativity,* Albuquerque Journal, August 1, p. E4. B&W photo in studio.
MENTZINGER, Bob. *Taos Fall Arts Festival* Official program, The Taos News, Fall, 1993, p. 8, 12. Color photo: cover *Perseus* (1989 mirage painting), Photos of studio.
PULKKA, Wesley. NuCity, December 3-, vol. 2, No. 26. Art Section. Photo: *Lux III* (1961).
BUTTERFIELD, Jan. The Art of Light and Space, 1993, pp. 174-188. Photo: Larry Bell (1962), *Cube* (Pace Gallery, 1962).*Untitled Cube* (1964/64), *Untitled Glass Sculpture* (1969), *Untitled* (1970 glass sculpture, Tate Gallery), *Iceberg and Its Shadow,* 1975 glass sculpture): Color photos: *The Solar Fountain* (1983 sculpture, Denver, CO), *The Leaning Room* (1988 installation, Museum of Contemporary Art, Los Angeles).
Denver Art Museum Annual Report, 1992-1993, p. 22.
History and Collection, Harwood Foundation, p. 26. Color photo: *Mirage Painting,* (1991).
CACCAVALE, Guiseppe. CIRVA, Comet de bord. Plate, 26. Photo: *Fabrication of sculpture First and Last* (1989).
In a Classical Vein, Whitney Museum of American Art, p. 20.
Arts-In, On & Out of the Bag, Nevada Institute for Contemporary Art, auction, August 5-September 17, p. 9. Color photo: *Untitled* (1993).
CASA'S Pleasure of the Palette and Palate, auction, 1993. Color photo: *BMP* (1991 big mirage painting).
Taos Valley School Art Auction, 1993. Color photo: *SMS #129* (1990).
Dallas Museum of Art, auction, p. 29.

1994

DARTMOUTH STREET GALLERY*, Albuquerque, NM. January 8-February 19.
LAGUNA GLORIA ART MUSEUM, Austin, TX. *The Light Fantastic.* January 22-March 13.
H. & W. BECHTLER GALLERY, Charlotte, NC. *Double Take.* February 4-August 14.
CALIFORNIA CRAFTS MUSEUM, San Francisco. *Transparency + Metaphor.* February 26-April 10.
BRAUNSTEIN/QUAY GALLERY*, San Francisco, CA. *Larry Bell Glass and Denim Constructions.* March 4-April 2.
LEEDY/VOULKOS GALLERY*, Kansas City, MO. *Larry Bell: Recent Improvisations.* April 22-June 4.
SOCIETY of VACUUM COATERS 37TH TECHNICAL CONFERENCE, Boston, MA. Larry Bell Keynote Speaker. May 10. *The Art of Light and Surface.* May 8-13.
WHITNEY MUSEUM of AMERICAN ART, Stamford, CT. *Evolutions in Expression: Minimalism and Post Minimalism in the Permanent Collection.* May 13-July 6.
KIYO HIGASHI GALLERY*, Los Angeles, CA. *Paintings, 1960s.* May 21-July 9.

STATON, David. *Canvases Evoke Questions, Demand Viewers' Attention.* Albuquerque Journal, Artlines Section, January 13, p. F16. Color photo: *Mirage Painting* (1993).
PULKKA, Wesley. *Ask Not For Whom the Bell Toils,* NuCity, Art Review, January 24-30, vol. 3, No. 3, p. 6. Dartmouth Street Gallery. Color plate: *Mirage Painting* (1993).
Wingspread Gallery News Radio broadcast transcript. KHFM 96, January 28. Dartmouth Street Gallery.
Art-Talk, Section II, p. 43, March, 1994. Braunstein/Quay Gallery. Photo: *WBKD #2* (1993 glass and denim).
SOBAL, Leah. The Taos News, Tempo Section. May 26, Kiyo Higashi Gallery.
GREENE, David. *The Shapes of Things to Come,* Los Angeles Reader, July 1, vol. 16, No. 38, pp. 20, 26. Kiyo Higashi Gallery. Photo: *Ghost Box* (1962/63 construction).

MADISON ART CENTER, WI. *Southern California: The Conceptual Landscape.*
August 31–November 13.
PARRISH ART MUSEUM, Southampton, NY. *The Second Parrish Art Museum
Design Biennial: Mirrors.* August 28–September 11. Auction: September 10.
STABLES ART GALLERY, Taos, NM. *Third Generation.* September 6–October 7.
KIYO HIGASHI GALLERY, Los Angeles, CA. *Drawings.* December.

TURNER, William. Venice, July, pp. 77-90 Kiyo Higashi Gallery. Color photos:
Larry Bell, Larry Bell with *Ghost Box* (1962/62 construction), Larry Bell with *Lil
Orphan Annie* (1960 canvas).
Wingspread Collector's Guide, Santa Fe, Taos. New Directions Gallery, vol. 8,
No. 1, pg. 229. Color photo: *Barcelona* (Big Mirage Painting).
Artforum, Summer, p. 73.
Evolution's in Expressions, Whitney Museum of American Art, 1994, pp. 6, 7.
Photo: *Untitled* (1967 cube), *Via Del Hombre Rojo* (1991 mirage painting).
Art Fundamentals, Seventh Edition, 1994, p. 300. Color photo: *First and Last*
(1989 glass sculpture).
MOCA Art Auction, 1994. Auction catalogue. Photo: *SMS #424* (1993 small
mirage study).
Denver Art Museum Alliance for Contemporary Art, auction catalogue. Photo:
MSMS #52, (1993 medium size mirage study).
From the Collection of John and Mary Lou Paxton, collection catalogue, p. 21.
Color photo: *DCF 35* (1978 vapor drawing).
El Mundo Del Arte De Nuevo Mexico, New Mexico Cultural Festival, November
26–December 4, Jalisco, Mexico, p. 7.
LITT, Steven. *Art lover challenges renowned architect,* The Cleveland Plain Dealer,
Arts & Living Section, October 3, p. E1, E3.
Madison Art Center, Southern California, exhibition catalogue, August 13–
November 13, p. 6.

1995

UNIVERSITY of WYOMING ART MUSEUM*, Laramie. *Larry Bell's Vapor
Drawings.* January 14–March 26. Catalogue.
INDIGO GALLERY*, Boca Raton, FL. February 9–May 5.
DENVER MUSEUM of ART*, CLOSE RANGE GALLERY, CO. *Larry Bell
Untitled x 2.* February 25–June 18.
NEWPORT HARBOR ART MUSEUM, Newport Beach, CA. *Works from the
Permanent Collection.* March.
UCLA-ARMAND HAMMER MUSEUM OF ART AND CULTURAL CENTER,
Art Rental and Sales Gallery, Los Angeles, California. *New Visions: Los Angeles
Art in the 90's.* April 25–September 7.
NEW DIRECTIONS GALLERY, Taos, NM. May 16–June 14.
WHITNEY MUSEUM OF AMERICAN ART, New York City. *Views from Abroad:
European Perspectives on American Art I.* July 24–30.
GALERIE NÄCHT ST. STEPHAN, Vienna, Austria. *Donald Judd and Artist Friends.*
September 21–November 18.
HARWOOD MUSEUM, Taos, NM. *SUMER: A Work in Progress.* October 20–
December 23.
UCLA - ARMAND HAMMER MUSEUM, Art Rental and Sales Gallery,
Los Angeles, CA. *La Current: Works On Paper.* October 10–January 7, 1996.
THE MAIN ART GALLERY, CALIFORNIA STATE UNIVERSITY, Fullerton. *Shape:
Forming the L.A. Look.* November 4–December 3.
GALERIE MONTENAY-GIROUX, Paris, France. *New Glass Sculpture.*
November 9–December 3.

University of Wyoming, Laramie, exhibition catalogue, January 14–March 26.
Color photos: *MSHFBK 9* (1978 vapor drawing), *Made for Arolsen* (1992 glass
sculpture), *ST 14* (1978 vapor drawing); B&W photo: Larry Bell in Taos studio.
Sotheby's Contemporary Art, Part II, May 3, plate No. 164. Color photo:
Untitled (6" cube).
An Artist's Taste of Taos, Longview Art Museum, May 6–July 8, exhibition cata-
logue, Wichita Falls Museum and Arts Center, July 29–September 8, exhibition
catalogue, B&W photo: *SMVD#119* (small mirage vapor drawing, 1989).
CROSS, Guy. *Universe of Larry Bell,* THE Magazine of the Arts, May, pg. 12-13.
B&W photos: *Larry Bell w/WBKD #7* (Window, Black Denim #7), *Drawings for
Standing Walls,* 1995.
Denver Art Museum, exhibition catalogue, February 25–June 18. Color photo:
Untitled 1971 (1971 glass sculpture).
PULKKA, Wesley. *Sculptural Renaissance In Bronze,* Albuquerque Journal, June 4,
p. D2. B&W photo: *Stickmen #14 & #23, Stickman #11* (1994 bronze maquettes).
ROMANCITO, Rick. *What's so contemporary about contemporary art?* [At the
Stables Art Center], The Taos News, Tempo Section, June 15. B&W photo;
Stickmen, (computer-generated drawing).
Art-Talk, Scottsdale, AZ, October, 1995. Joy Tash Gallery, Scottsdale, AZ, p.18
B&W photo: *Dusty Landscape* (mirage painting, 1989).
METZGER, Rainer. *Der Freundeskreis der Monomanen,* Der Standard/Observer,
October 10. Galerie Nächts St. Stephan, Vienna, Austria. B&W photo: *24-2-95
Cube,* 1992.
The Taos News, October 19. *Birth of the 'Stickman,' a blend of technology and
art.* Harwood Foundation Art Museum, pp. B6, B18. B&W photos: *Stickman #15
on base* (1994 bronze maquette), Larry Bell in studio.
PULKKA, Wesley. *Huge, haphazard exhibit proves artist's talent,* Albuquerque
Journal, November 5, Harwood Museum, Taos. B&W photos of exhibition space.
Valley of the Sun Gallery Guide, November–January. Joy Tash Gallery,
Scottsdale, AZ. p. 3. Color photo: *Better Red than Dead* (mirage painting, 1989).
Shape, Forming the LA Look. California State University, Fullerton, Mail Art
Gallery. Exhibition catalogue, November 5–December 3. pp. 21, 22. Color
photos: *DB6* (1980 corner lamp), *SMS405* (small mirage study, 1993), p. 31.
B&W photo: *Adobe Surfboard* (1990).
CURTIS, Cathy. Los Angeles Times, Calendar, November 14. *Surfboard Installation
goes Beneath Surface.* pp. 1, 2.
Fractions. Traduit de l'americain, par Marie-Caroline Aubert et Regis Couturier.
eds. Jannink, Paris, 1995. Limited Edition.
CLEMMER, David. *Larry Bell. Sumer, A Work in Progress.* THE Magazine of the
Arts, December, p. 51. B&W photo: *Bronze Stickman #6* (1995 bronze model).
Los Angeles Reader. ART section. *Shape: Forming the LA Look.* California State
University, Fullerton, Mail Art Gallery. November 24, pp. 14, 21, 22.
GREENWOOD, Phaedra. Taos News. *Larry Bell: A Tapestry of Woven Light.*
Tempo Section, January 4, p. C8. B&W photo: Larry Bell and *Running Stickman*
(1994 painting).
CLEMMER, David. THE Magazine of the Arts. *Larry Bell: Sumer, A Work in
Progress.* The Harwood Foundation, Taos, NM. December. B&W photo: *Stickman
#6* (1994 bronze model).
Contemporary ARTISTS. St. James Press, Fourth Edition. p. 104-107. B&W photo:
Triangles of Grid (1984 glass sculpture).

1996

GALERIE ROLF RICKE, Köln, Germany. *In dem Man schaut, erkennt Man. (Donald
Judd).* January 12–February 2.
JOY TASH GALLERY, Scottsdale, AZ. *Larry Bell–Mirage Works.* February 8–March 5.
BOULDER MUSEUM OF CONTEMPORARY ART, CO. *Sumer: A Work in
Progress.* March 1–May 5.
KIYO HIGASHI GALLERY, Los Angeles, CA. *Larry Bell, New Work.* March 9–
May 4.

Art & Antiques. February. Joy Tash Gallery, Scottsdale, AZ. Color photo:
Ground Plane (1990 mirage painting).
ART-TALK. February. Joy Tash Gallery, Scottsdale, AZ. p. 9. B&W photo:
Ground Plane (1990 mirage painting).
MILLET, Catherine. Artpress. February. Gallerie Montenay-Giroux, November 9–
December 2, 1995. p. 58. B&W photo: *Sans titre, 1995* (1995 glass sculpture, 4
panels).

COLORADO SPRINGS FINE ARTS CENTER, CO. *Art From the Source: Artists Celebrating 60 Years of the Colorado Springs Fine Arts Center.* March 16–April 14.
MUSEUM OF FINE ARTS, Santa Fe, NM. *Curatorial Selections: Acquisitions to the Historic, Contemporary and Photographic Collections.* March 29–May 13.
BRAUNSTEIN/QUAY GALLERY*, San Francisco, CA. *New Work,* June 4–September.
ART et INDUSTRIE*, New York, NY. *Sumer.* September 6–October 5.
NEW DIRECTIONS GALLERY*, Taos, NM. *Fractions.* September 17–October 14.

HAYDEN, Niki. Daily Camera, FRIDAY Magazine, Section D, March 1.
ART/LARRY BELL. *Stickmen leap into 3-D world.* Boulder Museum of Contemporary Art, Boulder, CO. p. 7D. B&W photo: *Straight Man,* (1995 bronze stickman model #1).
PAGEL, David. Los Angeles Times, Art Review. *Wall-to-Wall Energy Fills Bell's Work.* Friday, April 12. Kiyo Higashi Gallery. B&W photo: *6x6x4, 1995,* glass sculpture.
MILLET, Catherine. ARTPRESS. February. *Larry Bell, Galerie Montenay-Giroux.* p. 58. B&W photo: *6x8x4, 1995* (untitled, four panels, glass sculpture). Translation by C. Penwarden.
Sculpture Magazine, April. Johnson<>Atelier. p. 1. B&W photos: *Figure #12* (foam and plaster mold of full scale bronze sculpture).
VIEW, Museum of Contemporary Art, San Diego. April-May-June Quarterly Newsletter, 1996. p. 1. B&W photo: *Untitled* (detail, 1964 cube).
BAKER, Kenneth. San Francisco Chronicle. June 13. GALLERIES: *Sculpture of Wood and Glass.* Larry Bell at Braunstein/Quay.
FOREMAN, B.J. Sculpture Magazine. April, 1996. *Is This Any Way to Make a Living?* p. 33-36.
Sculpture Magazine, May/June. Johnson<>Atelier. p. 41. B&W photos: *Stickman #12* (mold of bronze sculpture).
Venice Magazine, July. p. 75. B&W photo: Larry Bell, 1964.
THE Magazine, September. p. 44. B&W photo: *Fraction #1188* (1996).
Santa Fean, September. p. 63. Color photo: *Fraction #10* (1996).
Art Now Gallery Guide, September. *Larry Bell at Art et Industrie Gallery,* Art et Industrie, New York Cover. Color photo: *Stickman #2* (1996 bronze model). p. 14. Color photo: *Stickman #12* (1996 bronze sculpture, full scale).
BELL, J. Bowyer. Review. September 15. *Larry Bell,* Art et Industrie Gallery, New York. p. 31
Art in America, September. Art et Industrie Gallery, September 6–October 5. p. 15. B&W photo: *Stickman #12* (1996 sculpture)

1997 SCHEDULED EXHIBITIONS:
THE ALBUQUERQUE MUSEUM*, NM. *Zones of Experience: the Art of Larry Bell,* retrospective. February 16–May 18.
DARTMOUTH STREET GALLERY*, Albuquerque, NM *Fractions.* February 1–28.
THE REYKJAVIK MUNICIPAL ART MUSEUM*, Kjarvalsstadir, Iceland. *Glass and Paper.* April 5.
NEW GALLERY*, Houston, TX. *Fractions.* May.

Zones of Experience: the Art of Larry Bell, catalogue for retrospective, The Albuquerque Museum, New Mexico, February 16–May 18.

Works in Public Collections

Albright-Knox Gallery, Buffalo, New York
The Albuquerque Museum, New Mexico
Art Gallery of New South Wales, Sydney, Australia
Art Institute of Chicago, Illinois
Australian National Gallery, Canberra, Australia
The Berardo Collection, Funchal, Portugal
Centre Georges Pompidou, Paris, France
The Contemporary Museum, Honolulu, Hawaii
Corning Museum of Glass, Corning, New York
Dallas Museum of Arts, Texas
Denver Art Museum, Colorado
Des Moines Art Center, Iowa
Detroit Institute of Arts, Michigan
Fort Worth Art Center, Texas
Solomon R. Guggenheim Museum, New York City
Hirshhorn Museum and Sculpture Garden, Smithsonian Institution, Washington, DC
The Archer M. Huntington Art Gallery, University of Texas, Austin
Los Angeles County Museum of Art, California
Massachusetts Institute of Technology, Cambridge
The Menil Collection, Houston, Texas
Milwaukee Museum of Art, Wisconsin
Minneapolis Institute of Art, Minnesota
Musée Saint-Pierre Art Contemporain, Lyon France
Museum Ludwig, Köln, Germany
Museum of Contemporary Art, Caracas, Venezuela
Museum of Contemporary Art, Los Angeles, California
Museum of Fine Arts, Houston, Texas
Museum of Modern Art, New York City
Museum of New Mexico, Santa Fe
National Collections of Fine Arts, Smithsonian Institution, Washington, DC
Oakland Museum of Art, California
Roswell Museum and Art Center, New Mexico
San Francisco Museum of Modern Art, California

Norton Simon Museum, Pasadena, California
Stedelijk Museum, Amsterdam, Holland
Stedelijk Museum, Rotterdam, Holland
Tate Gallery, London, England
University of Arizona, Tucson
University of Texas, Austin
Walker Art Center, Minneapolis, Minnesota
Victoria and Albert Museum, London, England
Whitney Museum of American Art, New York City

Commissioned Works

Center for Contemporary Arts, Santa Fe, New Mexico
City of Abilene, Abilene Zoological Gardens, Texas
City of Denver, North Bank Park, Colorado (collaboration with Eric Orr)
Colorado Springs Fine Arts Center, Colorado
General Electric Corporate Headquarters, Fairfield, Connecticut
General Service Administration, Federal Building and US Courthouse, Springfield, Massachusetts
Peter B. Lewis, Cleveland, Ohio
National Institutes of Health, Bethesda, Maryland
Dr. & Mrs. Richard Neuquist, Santa Ana, California
San Antonio Museum of Art, Texas
Carol and Eric Schwartz, Golden, Colorado
State of California, Long Beach Veterans' Memorial Building, California
Valley Bank of Nevada, Reno

Honors & Awards

Copley Foundation, grantee, 1962
Guggenheim Foundation, fellowship, 1970
National Endowment for the Arts, grantee, 1975
Governor's Award for Excellence and Achievement in the Arts (Visual Arts), State of New Mexico, 1990

Design Burrell Brenneman, Webb Design Studio, Taos, New Mexico / **Typography** Karen A. Sanderson, Webb Design Studio, Taos, New Mexico
Editing Dawn Hall, Albuquerque, New Mexico / **Printed in** Korea